來自
山與海的異人

The Strangers from
beyond the Mountain
and the Sea

策展人 ——

許家維 | 何子彥

Curators ——

HSU Chia-Wei | HO Tzu-Nyen

二○一九 亞洲藝術雙年展
2019 Asian Art Biennial

Contents

目次

館長序

臺灣的地理位置、與鄰近國家的歷史關係以及對多元言論的包容和自由度，都讓亞洲不同議題的交流得以在此產生對照與探討。國立臺灣美術館自 2007 年開辦「亞洲藝術雙年展」以來，迄今已邁入第 7 屆。歷經這 10 多年來的發展，雙年展持續以「亞洲」作為觀察、研究、探索的對象，引介亞洲區域當代藝術發展與多元面貌，更藉由不同的策展命題，以藝術的視角思索各式亞洲議題。此外，本館更嘗試在每一屆雙年展的策畫機制與組構方式上進行不同程度之變革與實驗，透過這兩年一度的大型國際藝術交流平台，推進展覽實踐與實驗的更多可能性。

「2019 亞洲藝術雙年展」邀請來自臺灣與新加坡的藝術家許家維與何子彥攜手擔綱策畫重任，其「藝術家—策展人」（Artist-Curator）的身分，為展覽注入了更加貼近藝術生產過程的策展視野，以靈活與彈性的展覽操作模式，推進不同層次的研究與跨領域協作的策展實踐；並以更多維度的視角，深入探索亞洲藝術創作過程裡獨特的複合型態與多向度的文化議題。

兩位策展人的藝術實踐與研究皆長期關注亞洲地區歷史事件的挖掘、鬆動與重構。面對亞洲歷經的特殊歷史與政經狀態，「2019 亞洲藝術雙年展」以「來自山與海的異人」為題，打破以國土、疆界來作地域劃分的概念，改從「他者」、「異人」的異質文化觀點拓展「山」、「海」、「雲」、「礦」等異地思考與非人維度，呈現當代藝術家如何對亞洲地區政治、歷史、經濟層面的人文議題以及科技議題進行重新解讀，打破主流敘事以開啟更多的想像與討論，進而將亞洲諸多關乎政治與歷史的意識形態詮釋框架進行鬆綁。

本屆「亞洲藝術雙年展」共邀集來自 16 個國家 30 組藝術家及團隊參與，呈現當代藝術實踐的多元面貌，包含錄像、裝置、攝影、繪畫、行為表演、聲音劇場、工作坊等豐富的作品類型，更有近三分之一的參展計畫為受邀針對本次主題所發展的全新創作，其中不乏涉及繁複技術及深度的研究型計畫。而充滿實驗精神的駐地研究與共創行動，探索了當下藝術生態中多元形式的生產過程，更在雙年展的架構下，展現了另一種跨文化交流的可能。展場中，除了與藝術作品的感性相遇，由協同研究林怡秀所規畫的「註腳」（Footnotes）資料閱讀區，讓觀眾得以在藝術語彙之外，從不同面向解讀本展脈絡並觸發思考。展期間，本館亦將辦理系列論壇及相關教育推廣活動，邀請國內外專家學者共襄盛舉，期盼能開啟更多討論對話與思想交流之契機。

本展得以順利展出，首先要感謝策展人許家維和何子彥為本屆雙年展所付出的極大心力與努力，以及來自世界各地藝術家的熱烈參與。另外，感謝文化部、以及所有協助本展的個人、借展單位、機構及團體對「亞洲藝術雙年展」的支持與參與，才得以促成「2019 亞洲藝術雙年展」的成功呈現，在此致上最誠摯的謝意。

林志明

國立臺灣美術館 館長

Director's Preface

Taiwan's geographical location, its historical relationships with its neighbours, and its high level of tolerance and freedoms provide a space for exchanges on various issues in Asia that produce contrasts and deep discussions. The National Taiwan Museum of Fine Arts has been holding the *Asian Art Biennial* since 2007. The aim is to observe, study and explore visions of Asia, as well as support the development and diversity of contemporary arts in the region. Over the years, through the Biennial's different themes, a wide range of concerns have been addressed through artistic perspectives and thought. Based on the curatorial mechanisms and structural fabric of each edition of the Biennial, this museum encourages change and experimentation, and through this large-scale international arts exchange platform, organised once every two years, more possibilities for exhibition practices and experimentation are created.

For the *2019 Asian Art Biennial*, Taiwanese artist Hsu Chia-Wei and Singaporean artist Ho Tzu-Nyen were invited to serve as curators. As artist-curators, they bring a curatorial perspective that is close to the artistic process. Together, these two have created an agile and flexible exhibition model, with curatorial practices that encourage research and interdisciplinary engagement on different levels. Moreover, by incorporating multidimensional perspectives, they explore the uniquely complex forms and multidirectional cultural issues of the creative process.

In their artistic practices and research, both curators have long been concerned with the excavation, mobilisation and refactoring of historic events in Asia. Based on the unique histories and political and economic situations in Asia, *The Strangers from beyond the Mountain and the Sea* was chosen as the theme for the *2019 Asian Art Biennial*. This concept questions the notions of national borders and boundaries, which, arguably, divide both places and peoples. Instead, from heterogamous cultural views of "the other", the curators argue for an expansion of our worldviews to include thought from other places and non-human dimensions, from mountains to seas, clouds and minerals, so as to articulate how contemporary art can be used to reinterpret political, historical, economic as well as technological frameworks. This perspective breaks through mainstream narratives to initiate imagination and discussion and further mobilise the many ideological possibilities of politics and history in Asia.

For this Biennial, 30 artists and art collectives from 16 countries were invited to present multiple aspects of contemporary art practices through different artforms, including video, installation, photography, painting, performance, sound-theatre and the workshop. Nearly one-third of the artworks were new commissions created especially for this exhibition. There is no lack of complex techniques or in-depth research in this Biennial, which demonstrates a spirit of experimentation, research and collaboration and a drive to explore new possibilities of artistic production and cross-cultural exchange. In addition to the artworks in the exhibition spaces, there are footnotes provided by researcher Lin Yi-Hsiu, which aim to encourage visitors to generate interpretations from different aspects, as well as to stimulate thinking. During the course of the Biennial, the museum has organised a series of forums and educational activities. Experts and scholars from Taiwan and across the world have been invited to initiate discussions and dialogues and to create further opportunities for thought and exchange.

Special thanks are given to curators Hsu Chia-Wei and Ho Tzu-Nyen for their efforts in planning and execution, and to the artists from all over the world for their enthusiastic participation. Appreciation is also due to the Ministry of Culture and to all the individuals, lenders, organisations and groups who assisted with this major project. It is because of the support and participation of all these persons and partners that the *2019 Asian Art Biennial* is a success, and I would like to express my sincerest thanks to them all.

Lin Chu-ming

Director of National Taiwan Museum of Fine Arts

專文
Essays

文 —— 何子彥

I 異人和稀人

展名當中的「異人」靈感來自日本古語「稀人」（marebito），mare（まれ）是指「稀有」，而 bito（びと）則同時意味著「人」和「神」。日本民族學者折口信夫（Shinobu Orikuchi）描述「稀人」為稀有的客人，是來自地平線以外，或是遙遠的山林中超自然的存在，在諸如節慶或大興土木等特殊場合，會帶著禮物來訪村莊。與這樣一種超脫的存在相遇是相當不可思議的，往往徘徊在好客和敵對、歡迎和疏離的態度之間[1]。但是，如果能以恰當的方式回應——以儀式和慶典來款待，「稀人」將賜予知識和智慧當作禮物。

我們以「稀人」延伸而來的「異人」指涉眾多的「他者」。不只是靈體與神，還有異族、薩滿、異國商人、移民、少數民族、殖民者、走私者、黨羽、間諜和叛徒等——異人是一個中介者，是我們與另一個世界溝通的管道。透過與異人相遇，我們或許可以重新審視自我、所在之社會，甚至是物種的界限。這是來自異人的禮物，而有些禮物是很難得的。

II 贊米亞和蘇祿海

展名中的「山」和「海」，我們腦海浮現了「贊米亞」（Zomia）和「蘇祿海」（Sulu Sea）。贊米亞，如人類學家詹姆斯・史考特（James C. Scott）所解釋：

> 「是在印度–孟加拉國–緬甸邊境，使用數種高地藏緬語系的區域。更準確地說，Zo 是一個相關詞，意思是『遙遠』，因此具有生活在山中的意涵；Mi 則意味著『人』。就如同東南亞其他地方 Mi-zo 或 Zo-mi 是指在偏遠山丘的人一樣，族群標籤同時也涉及地理棲位。」[2]

在史考特開創性的《不受統治的藝術：東南亞高地無政府主義的歷史》一書中，贊米亞專門用以描述一個從越南中部高地至印度東北這一片海拔 300 公尺以上的廣大高地範圍。贊米亞的高海拔和崎嶇地形構成了一個天然的屏障，使此區難以被圍繞它的平地國家所控制，從而成為被遺忘的戰爭游擊隊、毒梟、少數民族和逃離平地民族國家者的庇護所。

1. 參見石井敏總結西方學院傳統中的「外來者」理論，與他所謂的「日本的歡迎與冷淡–情感矛盾」中，有關日本的「稀人、異人和外人」之間的歷史性和概念性的相互關係。石井敏認為，這些見解和參考架構可以進一步研究日本和世界各地的跨人種、異族和跨文化問題。〈*Ishii Satoshi, The Japanese Welcome-Nonwelcome Ambivalence Syndrome toward Marebito—Its Implications for Intercultural Communication Research*〉，摘自《Japan Review》第 13 期（2001），146 頁。

2. 詹姆斯・史考特，《不受統治的藝術：東南亞高地無政府主義的歷史》，耶魯大學出版社（2009），14-16 頁。

來自山與海的異人

文 —— 許家維

今日新的科學發現帶領物理學超越了絕對空間、時間和運動、固態物質的假設，以及「牛頓／現代主義範型」特有的客觀方法。也就是說，新科學重新想像了現實，但我們誤以為的客觀，在若干年後也可能會再次翻轉。在朴贊景（Park Chan-Kyong）的〈天象列次分野之圖〉（2015）中，就呈現了穿越古今的宇宙觀想像，一個巨大的天文台圓頂緩緩打開，望向浩瀚宇宙，打開了我們與未知世界的通道。曾經 17 世紀伽利略（Galileo Galilei）所揭示的新宇宙，引發當時教廷的強烈反彈，科學與信仰產生斷裂。藝術家在這裡做了一個剪接處理，將本應是代表當代科學的望遠鏡視野，與朝鮮王朝在 1395 年所制定的古代天文圖結合，不同時代的宇宙觀包含了對於現實不同的想像，打破了科學與信仰的不當二分。在影片的結尾出現了韓國 19 世紀末的黑白影像，其中也包含了韓國薩滿，就如同當代的望遠鏡一般，為當時的人開啟一條通往未知的道路。

朴贊景，〈天象列次分野之圖〉
2015，高畫質影片，5 分 10 秒，
國際非物質遺產電影節提供

透過仰賴薩滿的視野，澤・春（Tcheu Siong）的作品以刺繡呈現少數民族心中的靈體。當她剛從山上搬進城裡時，為了維持經濟來源，她做了許多小尺寸的刺繡。但現在這些作品的尺幅越來越大，這些圖像是來自藝術家的丈夫——苗族巫師法老（Phasao Lao）的解夢，他從靈修萬神殿中為妻子所識別的靈體。這樣巨大的尺幅並不是為了人的觀看，對於澤・春來說，這些作品是與靈體對話，祂們圍繞著她的生活，保護著人與房子。這是與異人的對話，也導向了背後獨特的宇宙觀。

在詹姆斯・史考特（James C. Scott）的研究中，從國家與定耕農業之間永久的關聯，辯證了歷史數百年以來，贊米亞地區的化外之民如何透過移耕農業，以躲避國家控制與國家權力形構，同時，他們亦位處低地帝國軍隊無法喘息的高海拔地區。這種無狀態的贊米亞在今日似乎已經過時，但令人不禁感到疑問的是，在今日衛星與無人機等等的現代統治技術之下，為何周邊國家仍然無法有效控管這個山區？我們可以從當地游擊隊勢力的興起，來理解贊米亞與周邊國家更為綿密交織的新狀態。例如 1960 年代緬甸軍閥坤沙因反共的時空背景，接收了原先國民黨的孤軍力量，並取得緬甸佤邦及撣邦大片土地的控制權，在這個階段，贊米亞的武裝部隊與冷戰時期的意識形態衝突形成複雜的關係。爾後，為了維持當地經濟，在泰國、寮國和緬甸「三邊為界」的贊米亞區域「金三角」，興起了鴉片與海洛因產業。儘管周邊這些民族國家的法律禁止這種貿易，但其業務的實際日常運作不僅遍及跨越國界，也模糊了合法與非法之間的界線。

對於傳統的農業國家來說，國族敘事往往是從大陸中心所展開。14 世紀明朝祭出的海禁，迫使原先以海洋貿易維生的沿海人民鋌而走險，再加上破產農民的加入，產生了延續數百年的海盜現象。我們可以看到南中國海的海盜文化與帝國之間形成一種對峙的關係，在藝術家黃漢明（Ming Wong）的作品〈竹製飛船的故事〉（2019）中，以清末明初在東南亞海域巡迴的京劇劇班「紅船」為主軸，描述少林武僧逃離帝國的迫害，轉而加入粵劇劇班，在那個時代，粵劇與武術承載了反清復明的思想，成為了對抗帝國的工具，而海洋則是他們的基地。

蘇祿海是太平洋和南中國海之間的邊緣海，南部與婆羅洲接壤，北部則是錯綜複雜的菲律賓群島。這片「三邊交界」的水域與菲律賓、印尼和馬來西亞相鄰，難以被控管。除了歷史悠久的海上貿易，自殖民時代以來，蘇祿海也因俘虜奴隸與海盜行為等活動而聲名狼藉。對歐洲殖民者而言，海盜和劫掠奴隸的行為是文化失序和落後的一種顯化，如果地區要發展文明和商業，就必須剔除此惡習。但是歷史學家詹姆斯·法蘭西斯·華倫（James Francis Warren）告訴我們，這些活動應該被視為「聖戰的延伸，不僅是經濟動機，同時也具備政治性。」[3]

在過去的幾十年裡，蘇祿海已經成為菲律賓聖戰組織活動的主要舞台之一，例如阿布沙耶夫集團（Abu Sayyaf Group，ASG），他們進行了一連串引人注目的海上綁架，並襲擊眾多潛水勝地[4]。這些水域也成為恐怖分子在東南亞之間移動的途徑。例如，東南亞激進極端主義的伊斯蘭反叛組織回教祈禱團（Jamaah Islamiyah，JI），在印尼、新加坡、馬來西亞和菲律賓都有據點，其成員利用這條路線前往菲律賓的訓練營[5]。對某些人而言，這些活動是 16 世紀對抗西班牙殖民者的「莫洛聖戰」組織的最新化身[6]。

除了反殖民和政治宗教方面外，歷史學家艾瑞克·泰利可佐（Eric Tagliacozzo）告訴我們，這些海上暴力、俘虜奴隸、襲擊貿易船隻等事件，「可以在當地政治和經濟體系的脈絡下更確切地理解，它提供必

3. 詹姆斯·法蘭西斯·華倫，《1768–1898 年的蘇祿地區──東南亞海洋國家蛻變中的對外貿易，奴隸制和種族情勢》，第二版，新加坡國立大學出版社（2007），xxi 頁。

4. 梅根·科倫（2019-05-24），〈海洋和阿布沙耶夫的奪命發展〉，摘自 www.maritime-executive.com/editorials/the-deadly-evolution-of-abu-sayyaf-and-the-sea

5. 法布莉卡·塞尼亞，〈確保蘇祿─蘇拉威西海域免受海上恐怖主義侵襲–棘手的合作？〉，《恐怖主義的觀點》第 8 卷第 3 期（2014 年 6 月），64-83 頁。

6. 總稱「莫洛」指的是民答那峨島、蘇祿和巴拉望的 13 個伊斯蘭文化語言群體。根據謝赫·阿布·扎希爾（Sheik Abu Zahir）的說法，莫洛聖戰組織迄今已分三個階段開展：「首先，16 世紀開始作為反對西班牙入侵（1521 年至 1898 年）莫洛聖戰的一部分，接著是反對美國殖民者的第二階段（1898 年至 1946 年），現在的階段始於 1970 年左右，在反對菲律賓聖戰」。見謝赫·阿布·扎希爾，〈莫洛聖戰組織 - 菲律賓南部伊斯蘭獨立的持續鬥爭〉，首次發表於《伊斯蘭之聲》（Nida'ul Islam / The Call of Islam）雜誌第 23 期（1998 年 4-5 月），摘自 fas.org/irp/world/para/docs/ph1.htm

藝術家伊謝（Roslisham Ismail (a.k.a Ise)）的作品〈時間邏輯〉（2018）所關注的海洋則是家鄉吉蘭丹州的故事出發，從神話的角度翻轉了陸地與海洋的關係。他裝置作品呈現了一個令人眼花撩亂的龐大系統，貫穿其中的是有關大洪水的神話，散落在東南亞海域的群島被認為是一萬五千年前的「姆大陸」（Continent of Mu）所遺留下來的，古代「姆」的人民因不公不義，違背律法而被降下大洪水，姆大陸曾經佔據了南太平洋的大半部，東西長約 8000 公里，大洪水之後沈沒在海底。而失落大陸的一些居民倖存下來，成為後來的馬來波利尼西亞人。2014 年 12 月吉蘭丹州遭遇了史上最嚴重的洪災，被視為是第二次上天的懲罰。不同於帝國的傳統故事，伊謝處理的敘事呈現了一種由海洋望向陸地的視角。

而于一蘭（Yee I-Lann）的攝影作品《蘇祿海的故事》（2005）則在海洋的背景下，呈現了一種特殊的空間感，就像是姆大陸遺留下來的群島一般，影像呈現了在海洋遼闊平坦的空間當中，還有許多中介的空間，就像是跳板或是洞孔，例如岸邊的小島、珊瑚礁、海灣等，這些空間是海盜掩護行蹤的所在，也是藏匿故事的地方，提供了多重的管道，進入蘇祿海的故事當中。

于一蘭，〈群島〉
2005，數位輸出，61x183 公分（圖為本次展出的 13 件作品之一）
藝術家與 Silverlens 畫廊提供

黃漢明，〈竹製飛船的故事〉
2019，有聲單頻道高畫質錄像，15 分 35 秒
藝術家提供

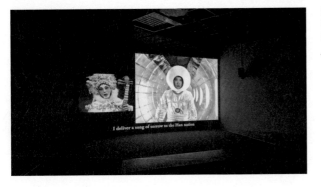

要的環境和利潤使整個社會運轉。」[7] 正如 18 和 19 世紀，蘇祿地區的海盜活動可能與新殖民網絡破壞本土貿易格局的情況相似，劫掠奴隸的情形猖獗，與歐洲和中國的地緣政治核心地區的貿易活動，高利潤的鴉片、槍支、茶葉等所產生的人力需求密不可分。

III　內與外

要了解贊米亞和蘇祿海的情勢，需要一種「歷史無國界」的模式，在此模式下，包括合法和非法商品的流動，不僅與種族、文化和國家形成的問題糾纏在一起，更與世界貿易體系有關。為此，詹姆斯·法蘭西斯·華倫提出，將蘇祿海概念性地重構為一個「蘇祿帶」，指的是一個「本質上不穩定」且「常態性流動」的系統，而並非可以「持久」、「自持」或「自治」[8]。

也許我們可以將蘇祿地帶形象化為一個輪廓模糊且不斷變動的樣貌，很難知道它的來源始末，其組成也不斷地變動。試想一下 19 世紀的場景，當被俘虜的奴隸大量湧入蘇祿地帶，他們是如何不可逆地改變了核心文化和種族矩陣，「種族和文化的區分變的模糊不清；成千上萬的『外來者』被納入迅速發展的伊斯蘭貿易社會的下游。」[9] 不過不同於華倫的是，我們認為蘇祿地帶具備某種程度的自主性，它並非以自身組成元素的不變性而長久存在，反倒是因為一直維持某種結構上的一致性，經由吸納、消化「輸入的異質元素」而存留下來——也就是說，蘇祿地帶的「內部」是透過它與「外部」的溝通來定義。

對我們來說，「贊米亞」和「蘇祿海」不僅是地理和政治、海拔和無政府主義的交會點。贊米亞高地和低地蘇祿海並非完全將平地民族國家的法律和秩序屏除在外，或是與之相對立。相反的，這些偏遠地帶的「非正規」和「非法」活動深深融入了現代民族國家的政治經濟核心。進一步的理解，我們只需沿著鴉片和海洛因在蘇祿海漂流的蹤跡，沿著贊米亞的紋理行進[10]。

7. 艾瑞克·泰利可佐，《秘密的交易，多孔的邊界－走私與東南亞沿岸的邊境國家，1865-1915》，109 頁。

8. 詹姆斯·法蘭西斯·華倫，《1768-1898 年的蘇祿地區——東南亞海洋國家蛻變中的對外貿易，奴隸制和種族情勢》第二版，新加坡國立大學出版社（2007），xxvii - xxviii 頁。

9. 詹姆斯·法蘭西斯·華倫，《1768-1898 年的蘇祿地區——東南亞海洋國家蛻變中的對外貿易，奴隸制和種族情勢》，第二版，新加坡國立大學出版社（2007），xxxv 頁。

10. 當約翰·赫伯特被任命為巴蘭邦岸島，在蘇祿蘇丹國境內毗鄰北婆羅洲的一個島嶼的英國東印度公司貿易站負責人時，他寫信給他的上級：「我不得不竭力推薦……提供大量的鴉片，這可能被視為生活必需品；印度西部的所有製造商都比不上這個物品吸引力的一半，它將在所有其他類型的商品上起作用，希望單單這一承諾可以突破淒涼的前景。」引自詹姆斯·法蘭西斯·華倫，《1768-1898 年的蘇祿地區——東南亞海洋國家蛻變中的對外貿易，奴隸制和種族情勢》第二版，新加坡國立大學出版社（2007），19 頁。

來自山與海的異人

「這個故事終結在一個著名的場景，年輕人切腹自殺，乳白色的液體從他的腹部流淌而出。這個液體將海水變成乳白色，變成海岸上佈滿白色泡沫的海浪。」這段文字節錄自田村友一郎（Yuichiro Tamura）作品〈背叛的海〉（2016），從三島由紀夫（Mishima Yukio）傳奇性的一生，連結了來自海洋的意象。如同影片當中所說「美好的事物總是從海上來」，1853 年美國以炮艦威逼日本打開國門的黑船事件，再到 1945 年以後橫濱港成為美軍基地，藝術家揉和了不同的神話、歷史碎片，穿梭在美軍所帶來的健美文化、三島對希臘雕塑的迷戀、曾經發生在橫濱海岸的分屍事件等等，這些材料有時如同海水一般的流動，但某些瞬間又凝固成塊。就像是作品當中所提到的健身，「健身的概念建立在分別訓練身體的個別肌肉。今天這個肌肉，明天那個肌肉⋯⋯這就是對身體拆解式思維。碎片式的思考方式。」這件作品可能既是單獨肌肉，抑或是整體肉體間的振盪。

這種流動的雕塑特質也能夠在邱承宏的作品中找到，而且巧合的是黑船的意象也同樣出現在他的作品〈破碎的羅曼史〉（2019）當中。展場中倒掛著一組黑色的巨大帆船，形式取材自大航海時代的克拉克帆船，以及法國探險家迪蒙・笛維爾所發現的蝙蝠物種。這看似柔軟的風帆布幔是以花蓮堅硬的閃玉再合成纖維所製成，桅桿則是由四種不同的木料所構成，包括 17 世紀重要的貿易木材桃花心木，以及需透過森林大火的高溫種子才得以繁衍的花旗松。在桅桿的尖端閃爍的碎片則是來自藝術家祖父所拾得的隕石。這些不同的物質在各自的流動過程中，最後交織在一起，就像是田村友一郎作品當中的一句台詞：「藝術家與時間的共同創作，名為碎片的暫時雕塑。」

對我們而言，高地贊米亞和低地蘇祿海構成了垂直軸的兩端，而水循環與板塊運動則成為水平軸的結構，這兩條軸線拉扯著平地國家的根基。為了想像這個力場可能的樣貌，我們製作了一個圖表，成為此次展覽的概念藍圖。

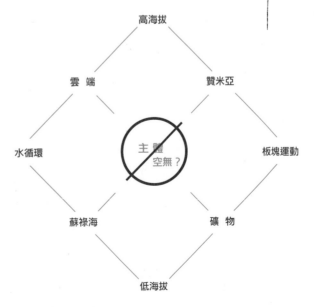

IV 罌粟與政治－經濟

東南亞地區的撣邦鴉片——海洛因產業位於由泰國、寮國和緬甸「三邊為界」的贊米亞地區——即「金三角」，雖然這些民族國家的法律禁止此類貿易，實際上每日運作的產業活動不僅跨越國界，也模糊了合法及非法之間的界線。

如曹張·良瑞（Chao-tzang Yawnghwe）所述，當地的鴉片和海洛因生產、處理、儲存和運輸不單單由無國籍、非正式的民兵部隊所控制，也受正式國家的官員所掌控，如泰國、緬甸、中國和寮國等軍隊幹部、駐軍指揮官、警察和海關人員等，而鴉片和海洛因產業的資金和出口則牽涉另一群參與者，即「在各種體面的貿易協會、宗教社會組織、扶輪社和商會中活躍的合法商人、商店業主、玉石和寶石銷售商、餐廳老闆、銀行經理、商品經紀人、飯店業者等」[11]，這些經濟－商業參與者不僅在經濟和政治上維繫了緬甸的運作，也讓該國經濟連接上「中國」、「泰國」、「寮國」、「馬來西亞」、「香港」、「臺灣」、「菲律賓」和其他更廣大地區的經濟體和海外金融資金的迴路。依據曹張·良瑞所舉的例子，這些國家的名稱之所以引號表示，是因為「對以鴉片／違禁品為主、非正式／地下或『非法』的貿易和投資世界來說，邊界基本上不符合傳統賦予的意義。」[12]

V 金三角 2.0 和贊米亞 2.0

如今，金三角的毒品貿易已經從農業模式「更新」為合成模式，著重在生產甲基安非他命（甲基苯丙胺 methamphetamines，又名「冰毒」和「瘋藥」）。可以在實驗室中廉價生產，也不再像罌粟一樣受制於氣候的變幻莫測，我們正看著金三角 2.0 興起。這些甲基安非他命的流通在中國「一帶一路」的倡議中受到極大的歡迎。正如約書亞·貝林格（Joshua Berlinger）在 CNN 上報導的那樣，這個「大規模基礎建設發展計畫，意圖連結全球主要的開發中經濟體」，也使販毒者更容易將其產品從撣邦遷至東南亞其他地區，中國、香港、臺灣、日本、韓國、紐西蘭和澳洲[13]。

冰毒交易的獲利據悉是透過中國商人趙偉擁有的金木綿賭場進行非法洗錢，趙偉與寮國政府簽有長達 99 年的金三角經濟特區（Golden Triangle Special Economic Zone，SEZ）經營權，2000 年時，他在名為

11. 曹張·良瑞，〈鴉片貿易的政治經濟學〉，《當代亞洲期刊》，第 23 卷第 3 期（1993），312-3 頁。

12. 曹張·良瑞，〈鴉片貿易的政治經濟學〉，《當代亞洲期刊》，第 23 卷第 3 期（1993），309 頁。

13. 約書亞·貝林格（2018-11-02），〈亞洲的冰毒熱潮－毒品戰爭如何走遍全亞洲〉，CNN 亞洲，摘自 edition.cnn.com/2018/11/02/asia/asia-methamphetamine-golden-triangle-intl/index.html

1947 年翁山將軍（General Aung San）以緬甸臨時政府領袖的身份，與撣族、克欽族、欽族等領袖簽訂《彬龍協議》，宣稱緬甸是各個民族所共同擁有。1948 年緬甸建國後，由緬族人吳努（U Nu）擔任總理、客家人的奈溫（Ne Win）擔任軍隊領袖、而撣族的蘇瑞泰（Sao Shwe Thaik）則是擔任首任總統。然而《彬龍協議》隨著翁山將軍被暗殺，成為從未實現的幻夢，緬甸的種族衝突與動盪至今仍然持續不斷。1962 年奈溫政變，緬甸的首位總統蘇瑞泰被逮捕入獄，這位蘇瑞泰就是藝術家薩望翁・雍維（Sawangwongse Yawnghwe）的祖父。而薩望翁的父親曹張・良瑞（Chao-tzang Yawnghwe）在當時轉入地下武裝革命撣邦軍與軍政府對抗，與其他少數民族以游擊戰的方式在山區對抗軍政府。然而在冷戰期間，種族衝突與緬甸共產黨和撣邦鴉片問題更錯綜複雜的交織成不同的路線衝突，薩望翁的家族最終流亡加拿大。薩望翁以繪畫的方式，呈現家族史以及背後所涉及的地緣政治，其中〈鴉片視差〉（2019）切入贊米亞地區由毒品所形成的關係網絡，這是層層交疊著種族衝突、冷戰框架、新自由主義的圖表，而且沒有明確的界線。

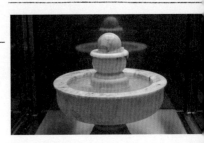

jiandyin（紀拉德・明瑪萊 & 朋琵萊・明瑪萊）
〈磨擦流動：魔幻之山計畫〉
2019，單頻道錄像、鈉鋁矽酸鹽粉末、C10H15N 人類尿液、冷藏櫃、玉石、大理石球體噴泉、防水接觸式麥克風、錄音介面、控制器、擴音喇叭、畫作、紀錄文件、1990 年中國人民幣百元紙鈔、壁畫
藝術家提供
2019 亞洲藝術雙年展委託新作

罌粟花經過提煉加工之後變成了海洛因，在 1980 年代金三角地區提供了全球 80% 的海洛因產量，如今當地不再有罌粟花田，取而代之的是家庭式的冰毒生產線，其原料可從商店日用品當中獲得，在廚房或客廳就能夠透過化學的方法製造，二戰期間曾經作為士兵的興奮劑，現在則是有許多開採緬甸玉的工人在使用，支撐著這個世界最大的玉石出口地。來自聯合國毒品暨犯罪辦公室的報告，在 2018 年的前三季，單是走私被查獲的甲基安非他命就有 116 噸，而運送的過程中，臺灣的跨國走私集團扮演了重要的角色。在泰國的許多傳說中，贊米亞山區被描述為具有黑魔法的神秘區域，如今毒品對神經的麻醉與催情作用成為了當代的黑魔法。在這背景下，泰國藝術家雙人組 jiandyin（紀拉德・明瑪萊 & 朋琵萊・明瑪萊 (Jiradej Meemalai and Pornpilai Meemalai)）的〈磨擦流動：魔幻之山計畫〉（2019）透過創作行動，將緬甸玉與冰毒這兩種物質的流動路徑作為線索，切入贊米亞地區的地緣政治。他們與泰國警方合作，收集了含有冰毒成分的尿液樣本，這些樣本來自警方在邊境的緝毒行動。接著再透過合法的管道將這些尿液運至臺灣，成為了一個噴泉裝置，尿液所構成的噴泉持續推動著緬甸玉石轉動，這是一組精巧的裝置作品，背後呈現的是從贊米亞到臺灣的物質流動路徑。

毒品是贊米亞地區重要的地下經濟，現在還增加了區塊鏈經濟這種新型態的經濟模式，在劉窗的作品〈比特幣礦與少數民族田野錄音〉（2018）中，就關注到贊米亞地區在今天數位技術層面的轉變。影像從清朝末年的電纜工程開始，到中國西南部的水利工程與比特幣礦的關係，再到安德烈・塔可夫斯基（Andrei Tarkovsky）導演的科幻電影《飛向太空》（1972），呈現了一段宏大的旅程。其中聲音的政治性也是其中一個切入點，從中國周朝制禮作樂開始，國族敘事開始萌發，而少數民族則被打成正統以外的雜音。對劉窗而言，這個類比也反映在由國家所主導的貨幣系統與去中心化的數位貨幣之間；在人類中心的語言體系與外星人溝通的聲音之間。影片最終結束在喬治・盧卡斯（George Lucas）導演的《星際大戰》（1999）中的那卜星球女王與過去少數民族的老照片不斷切換之間，我們在科幻片題材當中，對於陌生世界的想像就是以地球上的他者來投射。在劉窗的影像實踐中，從技術史的角度出發，從贊米亞到那卜星球，梳理了一套國族的控制技術之外，另一條解域與逃逸的技術史。

勐拉（Mong La）的村鎮設立賭場，該地座落在中緬邊界上一處俗稱第四特區（Special Region No. 4）的狹長的自治區，這個自 1989 年兩國停火後出現的第四特區，一直由具有撣族和中國血統的林明賢治理，這些賭場最初依賴毒品資金來營運，1990 年代開始在勐拉出現，而自 2000 年起，林明賢也開始投資日益成長的線上博奕產業[14]。

社會人類學家亞歷山卓・理帕（Alessandro Rippa）提議了解在寮國的金三角經濟特區旁邊的勐拉，並非將勐拉視為史考特無法無天的贊米亞中「最後的遺跡」（last remains），而是一個旨在「達到逃脫國家權力的同一目的」被企業滲透的區域。理帕將這種「更新」稱為「贊米亞 2.0」，在這裡政治的疏遠性和新自由主義的特點共存[15]。今天，除了毒品、野生動物和人口販運之外，勐拉還將建造一座 66 兆瓦的水電站大壩[16]。隨著一家中國公司建立永邦區塊鏈經濟特區的報告，「實驗數位經濟，行使高度自治權，並擁有獨立的行政、立法和司法權力」，具備「電子公民」制度和自己的加密貨幣——永邦幣[17]。儘管勐拉官員在官方說法中正式否認，但水電設施的存在確實持續幫助比特幣礦場降溫。

VI 雲端和礦物

今日新自由主義經濟與數位雲端的構成，又帶著我們來到圖表中的另一個垂直軸，該軸線仰賴的是大量由地表下所提取的稀土元素，即從對流層的「雲端」延伸到地殼深處的「礦物」。這些奇怪的組合在贊米亞附近再次發生，根據 Bertil Lintner 的報導，在撣邦佤族控制的地區（該地區從事大量鴉片——海洛因和甲基苯丙胺貿易），「有目擊者報告說，北部克欽獨立軍（Kachin Independence Army，KIA）控制的地區有兩個稀土礦場，而阿佤山區域可能還有更多，雖然這些報導未經證實」[18]。

藉由雲端和礦物的視野來檢視人類歷史，意味著開啟這類非人元素和

14. 亞歷山卓・理帕，〈贊米亞 2.0：在緬甸和寮國的兩個賭場城鎮的政治疏遠性和新自由主義的連接性〉。摘自 https://allegralaboratory.net/zomia-2-0-political-remoteness-and-neoliberal-connectivity-in-two-casino-towns-in-myanmar-and-laos/
應注意的是，趙偉否認了毒品資金與他的博弈帝國之間的關係。參見：江迅、袁瑋婧〈獨家專訪：金三角經濟特區管委會主席趙偉〉（2019.1.13）摘自 http://www.mingpaocanada.com/van/htm/News/20190113/tcad1_r.htm

15. 亞歷山卓・理帕（2016-11-15），〈贊米亞 2.0：在緬甸和寮國的兩個賭場城鎮的政治疏遠性和新自由的連接性〉

16. 葛雷格里・彭岱特（2016-02-28），〈緬甸啟動 66 兆瓦的勐瓦水電站計畫〉，摘自 www.hydroreview.com/2016/03/28/myanmar-moves-forward-with-66-mw-maingwa-hydroelectric-project/#gref

17. 楠倫（2019-02-20），〈勐拉官方否認中國公司可以建立自治數位經濟區〉，摘自 https://www.irrawaddy.com/news/burma/mongla-official-denies-chinese-firm-permitted-set-autonomous-digital-economic-zone.html

18. 柏提爾・林納（2019-09-06），〈緬甸的佤邦握有戰爭與和平的關鍵〉，摘自 www.asiatimes.com/2019/09/article/myanmars-wa-hold-the-key-to-war-and-peace/
美國地質調查局的數據顯示，緬甸是世界上最大的稀土礦產生產國之一，僅次於中國、澳洲和美國。2018 年生產了 5,000 公噸。稀土礦物質被用於各種設備中，從智慧型手機到電動汽車引擎和衛星。參見：林信男，〈若中國發動稀土戰 美國還有這 6 個替代來源〉（2019.5.30），摘自 news.cnyes.com/news/id/4328873

贊米亞地區陡峭的地勢，以及雨季時豐沛的降雨量提供了水力發電廠良好的條件，廉價的電力也吸引了比特幣礦場的進駐。這也引導我們到了圖表的另一個垂直軸，蘇祿海與雲端之間的水循環關係。比特幣挖礦的過程需仰賴大量電力，以提供大量主機的持續運算，比特幣礦場展示了一種新型態的水循環過程。儲存於海洋的水經過蒸發，凝結成雲端，接著再降水於贊米亞地區，這些水量通過水力發電產生的電力，提供比特幣礦場足夠的「算力」，再「蒸發」成為數位的雲端。在這個水循環 2.0 當中，我們看到了水分子所構成的雲端，實質轉化成為了數位雲端，重新分配政治經濟的技術與自然循環間的相互囓合。

數位雲端不只是虛擬的世界，同時也仰賴大量物質的基礎建設，例如各類型稀有礦，或是維持全球通信運作的海底電纜與衛星。目前全球有 380 條海底電纜，鋪設長度超過 120 萬公里，不管是 Google 或是 Facebook 的影像與通話 99% 都是透過光纖海底電纜傳送。藝術家林育榮（Charles Lim）的作品〈初始 3.9：現況的沈默拍擊〉（2016）呈現了一條鄰近新加坡海域的海底電纜，這些貼著海床的電纜支撐著資訊社會，網路訊號在這裡是以物質的方式存在，還曾經因為地震的緣故造成電纜受損，跨國之間的網路通訊因而中斷。就像是贊米亞山區的水力發電場所產生的比特幣礦，又一次我們在海底電纜的例子中，看到水循環的不同階段在數位世界裡扮演不同的角色，電子訊號通過電纜，穿梭在深海當中。林育榮曾經是代表新加坡參加奧運的職業帆船選手，特別關注於新加坡海域的議題，在〈海況六〉（2015）這件作品中，海況可解釋為海的狀態，也可指涉「國家的海」，他關注到一個國家如何對待或利用周遭水域。海洋不只是具備發電、運輸和油氣開採的功能，同時也存在許多看不見的權力博弈層面。新加坡的近海是處於嚴格控管之下的，有時海洋疆界就像陸地領土一般穩固，在當代的技術條件之下，國家主權實質進入海洋，新加坡是全球三大石油冶煉中心之一，而這些石油就儲存在原先是七個小島組成的人工島底部，這是東南亞第一個地下儲油岩洞，巨大的地下儲油庫影像，呈現了一個政治力量與自然力量緊繃的張力。

對於岩石不同的思考方式，能夠在王思順的創作方法中更清晰的理解。2015 年時，王思順開車從中國穿越亞歐大陸到達法國，沿途他對石頭產生了濃厚的興趣，而開始了他至今仍持續進行的《啟示》系列（2015– 持續），這些世界各地所搜集的石頭構成了作品，有的另外經過翻模或是數位再製，但其形象都是石頭原初的樣貌，這些形象是通過億萬年的時間所形成的，在地質的運動當中被擠壓破壞，最終所形成的造型。這些石頭就像是有自己的生命歷程，甚至是遠遠比人類的起源還久遠。王思順談到自己的創作方式就像莊子〈齊物論〉當中所呈現的宇宙觀，人是自然界當中的一份子，或是一個材料而已。這種中國古代對「自然」的想法，並非是建立在人為與自然這樣的二分，而是指事物本身自然如此。

在當代的技術之下，各種傳感器的作用讓我們能夠面對石頭當中的分子結構，這也帶來一種更微觀的非人視野，在江凱群的〈豐田玉庭園〉（2019）作品中，透過與科學家的合作，演繹玉石的分子化學作用。在臺灣花蓮的斷層帶所產生的閃玉很早就在東南亞流通，兩千多年前的菲律賓北部、呂宋島南部、越南南部及泰國南部的遺址都曾發現臺灣閃玉的廢料。花蓮近年來則是因開採成本過高與淺層礦脈枯竭，而停止開採。他從過去製作馬賽克作品的經驗，對不同石頭的理解，轉而深入到人所難以感知的分子結構。閃玉屬於矽酸鹽類礦石，原先是在 600 萬年前的造山運動中，經過變質作用所產生的，從蛇紋岩取得了鎂，從黑色片岩取得了矽酸鹽，從附近大理岩取得了鈣，透過高壓變質的環境才產生。這個作品以人為的加速過程演繹了原本歷經百萬年結晶過程，展場中所陳列的玻璃罐裝的是矽酸鈉液體，透過與多種金屬鹽類固體反應長晶，形成與閃玉相似的化學組成，這些漂浮在透明液體當中的綠色晶體，再現了微觀的地質事件。

非人類時間尺度的角色敘事——從板塊運動的緩慢地質時間，到人類的壽命長度，再到一朵飄蕩雲朵的轉瞬即逝。

在中國賞石以靜寓動的傳統中，有著對多個時間尺度的同時感知，在此脈絡中岩石也被稱為「雲根」，這樣的情感抒發來自於「水與岩石碰撞的霧氣圍繞（亂石驚濤捲起千堆雪），以及聚集在山峰周圍（山身嵐氣合蒼頂）或是籠罩在懸崖和山脊頂部的蒸氣（水氣成嵐連山脊）。一些最受中國人喜愛的岩石就像雲朵一樣，在山水畫中，描繪山脈時常不伴隨著雲，因為他們自己看起來就像是積雲。」[19]

賞石同時也包含了人的時間映射，《淵鑑類函》這本18世紀的中國百科全書中，有關石頭的條目寫到：「土精為石。石，氣之核也。氣之生石，猶人之精絡之生爪牙也。地以名山為輔佐，石為之骨。」[20] 觀石就是在幽思自我存在的短暫，正如觀山水之景讓人得以將人體內部風景的流動視覺化。

除此之外，岩石還可以講述許多故事，如同岩石可以用很多種方式講故事。最好的中國岩石，正如哲學家葛里翰·帕克斯（Graham Parkes）所言，「聽起來也會和看起來一樣令人印象深刻：在敲擊時，應該發出『清晰的音調』（讓人想起中國宮廷音樂中使用的石鐘）。」岩石作為地球「生命中心」的一份子，它的身世「在與我們不同的時間序列中展開，但同時也受制於萬物的無常性。」[22] 這種時間和歷史的擴展概念似乎也符合我們這個時代的需要——當前人類對地球的影響不僅達到了地質尺度，而且速度正在加快。我們開始從思考人與非人的糾葛，在這次展覽的籌備過程中引發的其中一項核心問題是：**如何在這些關注點中，重新思考亞洲未曾完成的解殖計畫？**

VII （去）殖民和（去）同時性

今天，當我們聽到「現代性」一詞時，仍會想到關於進步、文明和發展等觀念，即便我們已知道事實上它們代表「持續的開發、剝削他人及耗盡地球資源。」[23] 對於社會學家羅蘭多·瓦茲奎斯（Rolando Vázquez）

19. 葛里翰·帕克斯，〈日本枯山水庭園中岩石的角色〉，《寓禪於石－日本枯山水庭園》，芝加哥大學出版社（2005），89頁。

20. 葛里翰·帕克斯，〈岩石的意識－對東亞的理解和含義〉，《守心：新千禧的泛心論》，David Skrbina 編，John Benjamin Publishing Company（2009），328頁。

21. 葛里翰·帕克斯，〈日本枯山水庭園中岩石的角色〉，《寓禪於石－日本枯山水庭園》，芝加哥大學出版社（2005），100頁。

22. 葛里翰·帕克斯，〈岩石的意識－對東亞的理解和含義〉，《守心：新千禧的泛心論》，David Skrbina 編，John Benjamin Publishing Company 出版（2009），338頁。

23. 羅蘭多·瓦茲奎斯，〈博物館，解殖性和當代的終結〉，《新的未來－社會加速時期的藝術創新》，Thijs Lijster 編，Valiz 出版（2018），185-188頁。

1895 年日本以武力帶著近代權力與知識入境臺灣，重新編造殖民地的文化守則和生活秩序，臺灣森林的主導權落入新起的工業國手中。在殖民者眼中，殖民地森林是欠缺近代知識尺度與利用不完熟的領域，因此如何將其權力工具與知識力量介入殖民地森林，達到深切控制，其中就包含著科學的政治性。當時臺灣總督府民政長官後藤新平（Shinpei Goto）就訴求增進「科學性的生活」，伴隨大規模的調查研究與統計事業，透過這樣的統治手段，試圖實現科學的、物質的幸福。然而於此同時，原先島上人民與山林的傳統關係建立在非現代知識系統的風俗禁忌領域，則被視為未開化的狀態。殖民者重新書寫被殖者森林歷史的動機，並非意在學習被殖者的森林看法，反而是因其知識構築歷史書寫的正當性，凸顯傳統在地居民近代知識的薄弱。從這個角度看，現代進程中的森林史不斷將傳統的森林風俗認識排除在外，逐漸趨於扁平與單一。

在這個脈絡底下，丁昶文以 1920 年代在臺灣的日本星製藥株式會社為著力點，切入帝國想像與熱帶疾病交錯的關聯。製藥廠在日本是以生產奎寧、嗎啡及鴉片崛起，爾後在臺東設置了金雞納造林事業地，生產用以對抗瘧疾的奎寧。在作品〈處女地〉（2019）中，並不單以殖民現代性作為主題，而是透過製藥廠的第二代社長星一所出版的科幻小說《三十年後》為範本，當時的社長無心投入家族事業，專注於科幻小說的書寫，這個轉折成為這件作品一個特殊的視點，以反烏托邦科幻的形式叩問現代性單一的時空觀。

2018 年的夏天，有一支青年足球隊受困於贊米亞山區清萊美賽鎮的睡美人洞，他們的困境成為重塑泰國的時刻，並將其展示給全世界，這個事件成為寇拉克里·阿讓諾度才 & 亞歷克斯·格沃伊奇（與男孩子）（korakrit Arunanondchai & Alex Gvojic (with boychild)）作品〈在一個滿是怪人的房間裡沒有歷史 5〉（2018）的主題。在贊米亞山區的廣大森林中有許多口述故事和神話，這是一個無歷史的區域，有許多異人所未被書寫的故事，而受困山洞的事件就像是當代的另一則新傳說。影像一部分呈現了劇場表演，表演者的肢體動作近似泰國萬物有靈論傳統當中的蛇神那伽，那伽是泉水、井水和河流的保護神，祂們能夠造雨，通往祂們居住的地宮的入口常被認為位於井、湖和河流的底部。暴雨過後大量的雨水流入地下河道，堵住了睡美人洞的入口，就像是那伽對這片山林的控制。藝術家同時也處理了不同角色在這片山林的交會，泰國的靈媒、僧侶和幽靈在那裡和科學家、美軍以及跨國企業並肩作戰，像是一個多重的時空觀疊合，最後這些新的傳說可能會變成好萊塢的劇本，也可能會進入廟宇之中，或是留存在口耳相傳之間，這些故事會隨著時間的推移而變異。

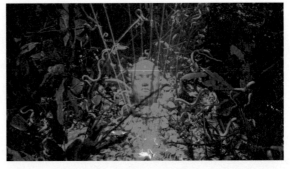

寇拉克里·阿讓諾度才 & 亞歷克斯·格沃伊奇（與男孩子）
〈在一個滿是怪人的房間裡沒有歷史 5〉
2018，三頻道錄像、裝置（各式貝殼、樹枝、塵土、雷射豎琴、造霧機、阿讓諾度才祖父雙手的樹脂鑄型、男孩子頭部的樹脂鑄型、LED 燈、丹寧布料枕頭、兔子造型絨毛玩偶），30 分 44 秒，尺寸依場地而異
由藝術家與 CLEARING 紐約／布魯塞爾、Carlos ／ Ishikawa 倫敦及 BANGKOK CITYCITY GALLERY 曼谷提供
由日內瓦當代藝術中心為 2018 年移動影像雙年展委託製作

來說，殖民性是現代性中隱藏維度；而伴隨著對美國、亞洲、非洲和大洋洲的土地、人類生活和非人要素等前所未有的殖民佔用，是對再現的掌控，透過對知識、認識論和敍事的控制，否定其他（非歐洲）世界的意義。京都學派的創始者日本哲學家西田幾多郎（Kitaro Nishida）在1943年時，已清楚地看到這一點：

> 由於科學、技術和經濟的發展，今天每個國家的人（國家民族）已進入一個單一而緊密壓縮的全球空間，解決方案無非是讓每個國家喚醒自己的世界歷史使命，讓每個國家能同時完全忠實於自我，同時又超越自我，並創造一個由群體構成的單一世界[24]。

伴隨這樣的空間壓縮，隨之而生的是全球時間在單一時間制度下產生大幅度的同步，其他「區域」的時間形式被驅逐拋棄，被「當代性」所取代——此一「時序以新穎（內在性、未來性、當代性）的原則先行於其他相互連結的時間性」，正如瓦茲奎斯所述：

> 「存有」透過時間歧視獲得自身定義，「存有」作為自身屬性，是透過將他者視為傳統的、過時的、落後的、陳舊的摹本來定義，當代性……在時間中規範了我們的經驗，引領我們沒入空洞存在的遺忘之中，將我們限制於被簡化成現時性的當下表象。它建立了空洞的現實，同時確立其世界的狡詐、經驗之局限，經驗變得近乎淺薄且虛空[25]。

VIII 政治與空無

在我們圖表發展的初期階段，一個暫時命名為「主體」的佔位符碼被放置在圖表中心，我們想像的是一個平地的現代民族國家主體，從圖表中心沿著各軸線開展，但這個主體之前和之後又存在著什麼呢？如哲學家阿蘭‧巴迪歐（Alain Badiou）所述，主體是「真理在事件發生後的變化，或者真理本身這個有限點，在穿越或經歷其自身無限存在的結果。」[26]既非結果亦非源始，主體僅僅是過程的局部狀態，是空無的一個實例，「存有的合適名稱」依據巴迪歐的說法，即是「空無，是非人且非主觀的。」[27]就像世界上的萬物一樣，「主體」即是空無的組合。

對「空無」的位置，我們也曾經考慮其他可能的名稱，例如，京都學派的哲學家，西田幾多郎轉化禪宗概念所提出的「絕對無」（Zettai Mu），

24. 引自克里斯多夫‧戈托－瓊斯，《日本的政治哲學：西田、京都學派與共榮》，Routledge 出版（2005），97 頁。另見本書細膩且客觀的評論西田幾多郎的影響一以及與日本軍國主義的距離。

25. 羅蘭多‧瓦茲奎斯，〈博物館，解殖性和當代的終結〉，《新的未來－社會加速時期的藝術創新》，Thijs Lijster 編，Valiz 出版（2018），192 頁。

26. 阿蘭‧巴迪歐，〈最後無緣的主體〉，《主體之後誰會到來？》，Eduardo Cadava, Peter Connor, Jean-Luc Nancy 編，Routledge 出版（1991），94 頁。

27. 阿蘭‧巴迪歐，《存在與事件》，Oliver Feltham 譯，London: Continuum 出版（2006），345 頁。

李禹煥在 1970 年代所創作的《關係項》一系列作品中，其中一件作品呈現了被石頭砸碎的玻璃，在李禹煥的一次訪談中說明：「如果一塊大石剛巧擊中玻璃，玻璃會破裂，這是*毋庸置疑的*。但是如果一位藝術家介入其中的調校功力不強，那麼在這麼一個微小的物理事件之外，還會更有可看性。不過話說回來，如果『砸碎』正好是藝術家本身的企圖，那麼結果就沒什麼意思；如果這是藝術家隨性所致的偶發事件，那也毫無意義，必須有來自藝術家、石頭、玻璃這三者所造成的關係張力才行，只有透過這三個元素，在這三角關係中彼此交叉滲透所產生的裂隙，玻璃本身才能夠第一次地，成為一個藝術物件。」這是由人與物之間所產生的張力，而且各自都保持著原本的狀態，藉此喚起形而上的感知，並與世界運轉所留下的遺痕對峙。

另一件〈關係項〉（2007／2019）作品則是由一塊未經加工的岩石，與後方佇立著一面弧形鋼板構成。這系列作品《關係項》創作於 1970 年代，外觀上容易讓人聯想到同時期歐美的極限主義，但如果我們深入探究藝術家與物之間的關係，可以發現背後包含著東方的哲學觀。這種面對岩石的方式，我們可以回溯到日式庭園的枯山水形式，當一個設計師接受委託時，往往耗費數個月的時間尋找適當的石頭，放置在庭園中的石頭必須是未經加工的，石頭與砂的構成，使人在觀賞時，也能想像出石塊深埋在地下的部分，似乎庭園當中的石頭只是巨大山頭的尖端，從而產生極強的縱深感，能夠「於點景石之中，感知大地的力量」，這種枯山水形式也常被日本僧侶作為輔助冥想的工具。這樣的場所精神，我們也可以參照京都學派的西田幾多郎所描述的「絕對無的場所」，是一種宗教式的「無」的體驗，包含了日常生活經驗中的「全體體驗」，人與世界的關係先於人與對象的關係。李禹煥關注於這些物件與其周遭相互往來而形成的能量，既帶我們回返古老的東方哲學，也帶我們反思當前人類中心主義的問題。

李禹煥，〈關係項〉
1969/2019，鐵（170×140×1 公分）、玻璃（170×140×1 公分）、石（40×30×25 公分）
新加坡 Pierre Lorinet、東京 SCAI THE BATHHOUSE 提供

或者由他的學生西谷啟治（Nishitani Keiji）提出的佛教概念「空」（śūnyatā）。畢竟，虛無或虛空的概念，是某些亞洲偉大思想體系的根基[28]。另外，值得一提的是零和其運算的數學概念，是由印度教數學家婆羅摩笈多（Brahmagupta）於公元前 628 年首次定義，正如宇宙學家約翰・戴維・巴羅（John D. Barrow）告訴我們的，印度文化中零的概念「擁有複雜的聯繫，可能從中產生不可預測的連結，不必對其進行邏輯分析以確定它們在形式邏輯結構上的連貫性，就此意義上來說，印度的發展在自由聯想中是近乎現代的。」[29]「空」（sunya）或空無（void）是一個未知的數量、空的空間，也同時蘊藏無限潛力。

然而，正是這種意義上的自由度——或是可塑性，使這個空無的概念，容易在亞洲受到政治性（錯誤）挪用和（錯誤）決策的影響，並帶來嚴峻後果，我們只需看看在第二次世界大戰期間京都學派哲學家的（不幸）經歷，當時西田的同事和學生——帶著他「絕對無」這一基本概念的變體，被有意識或無意識的納入軍國主義的論述中，在四個京都學派學者以「世界史與日本的立場」為名所舉行的圓桌會議中，哲學家高坂正顯（Kosaka Masaaki）宣告：

> 隨著東西方的世界正在破裂，而歷史主義仍然受困於阻礙重重的道路上，這種新力量背後的絕對基礎正在開始顯現，我認為，這個更深層的、全新的基礎，應該被稱為「絕對無」（Zettai Mu）[30]。

西田透過禪宗所領悟的「絕對無」概念，是克服「東方」和「西方」的方法，此概念超越了對理性解釋的需求或「非彼即此」的簡化邏輯，既是主觀也是客觀的，在毫無根基的基礎上樹立一個新體系來「克服現代性」。要剖析京都學派哲學家在戰時的意圖、策略和效果，實是超出了本文的範圍，但它無疑是具有深刻的矛盾之處，借用巴羅（Barrow）的語句來形容，這與「自由聯想」這個具有高可塑性的概念有關，現今已有證據顯示京都學派的重要成員曾避免讓日本走上戰爭一途——這主要與美日的衝突有關（他們知道日本無法獲勝），他們在日本侵略亞洲的立場上，遠比亞洲主義者希望將亞洲從殖民地中解放並假設日本在亞洲

28. 在格奧爾格・威廉・弗里德里希・黑格爾的道家講座中，他提到：「我們仍然有他的［老子的］主要著作；在維也納可以買到，我自己也見過。他們經常引用一段特別的段落：「無，名天地之始；有，名萬物之母。……」對中國人來說，最高的層次、事物的起源，是虛無、空虛、完全未定、抽象的全體，這也被稱為道……」。《黑格爾關於哲學史的講座》，第 1 卷，Elizabeth Haldane 編譯，Routledge 出版（1974），125 頁。

29. 約翰・巴羅，《無之書：萬物由何而生》，Vintage Books 出版（2002），第 36-37 頁。這反映在零的印度詞彙的多樣性，其中包括：Abhra（大氣層）、Akâsha（以太）、Ambara（大氣層）、Ananta（空間的巨大）、Antariksha（大氣層）、Bindu（點）、Gagana（天堂的樹冠）、Jaladharapatha（海上航行）、Kha（太空）、Nabha（天空、大氣）、Pûrna（完整）、Randhra（洞）、Sunya（虛空）、Vindu（點）、Vishnupada（毗濕奴的腳）、Vyant（天空）、Vyoman（天空或太空）。

30. 從 1941 年 11 月 26 日，在高坂正顯、西谷啟治、高山岩男和鈴木成高的圓桌討論中。大衛・威廉斯，《日本抗戰時期的哲學思想——讀京都學派關於『世界史與日本的立場』的談話紀要全文注本》，Routledge 出版（2014），149 頁。這是發表於具影響力的期刊《中央公論》（Central Review）上，三個圓桌討論中的第一個。這些旨在引導對戰爭產生輿論的公眾活動，是伴隨著一系列與日本帝國海軍避戰派的海軍大將，（前首相）米內光政參與的秘密講座和研討會。最初他們致力於防止戰爭爆發。但是，當戰爭無法避免時，他們決定下一步是推翻日本首相東條英機（日本帝國陸軍中將）的內閣。這些「秘密」演講彙編在大島筆記中。這些是 2000 年由哲學家大橋良介在 1989 年去世的哲學家大島康正的家中發現的。

朴贊景，〈京都學派〉
2017，雙頻道圖像投影、書（大衛·威廉姆斯著《日本戰時抵抗活動的哲學思想：閱讀與評論，京都學派「世界歷史觀點與日本」》），尺寸依場地而異
藝術家提供

「悠悠哉天壤，遼遼哉古今。五尺小軀，難測大空。何瑞修哲學，何權威之有。萬般真相，一言蔽日，『不可解』。我悶懷此恨，終決意至死。既立巖頭，胸臆安篤，始知：大悲觀等同大樂觀。」這是 1903 年日本中學生藤村操在華嚴瀑布投水自殺前，在旁邊的樹上所留下的〈巖頭之感〉。對當時日本的知識份子造成極大的衝擊，之後陸續有百餘名的青年在此投水自殺。朴贊景的作品〈京都學派〉（2017）呈現了這個華嚴瀑布的影像，同時也呈現了一篇一篇的二戰時期神風特攻隊隊員臨行前的遺書：「明天，一名自由與自由主義的信徒將會離開這個世界。他遠去的身影或許看起來孤獨，但我保證，他內心充滿了滿足之感。」（上原良司寫於 1945 年 5 月 10 日）

這些隊員的年齡皆不滿 20 歲，這是兩個不同時空下，直面死亡的場景。朴贊景在華嚴瀑布的影像當中，還穿插著一場二戰期間日本京都學派哲學家圓桌論壇的對話——高山岩男（Iwao Koyama）：「是的，我們若是能夠帶著世界史，從日本精神最高的岩石跳進華嚴瀑布，那會是一件好事。」在死亡的論述上，京都學派參照自海德格的哲學體系，同時融合東方的宗教哲學，海德格的人是「向死存有的」（Being-towards-death）概念與佛學的「生死」觀結合，並不是要征服死亡，而是要從生和死之中解脫出來。這也是京都哲學的絕對無概念的一環，不是單純的不死，而是一種不生不死的空無狀態。在政治上，京都哲學企圖建立一種無中心世界的客觀性，宗教式的自我否定日本發展成帝國主義的可能，同時又能打破歐洲、美國主導的世界秩序，對他們來說，太平洋戰爭是日本對亞洲國家的解放戰爭，更是東洋道德與西洋道德的直接對決，最終這種道德的崇高與戰爭和死亡產生了致命的吻合。

其他地區具有「道德領導能力」，來的更加矛盾[31]；禪宗佛教、民族主義、亞洲主義和軍國主義這種奇怪又荒謬的結合在 20 世紀初的日本並不罕見[32]，禪宗學者鈴木大拙貞太郎（Suzuki Daisetsu Teitaro）（後來以 D.T. 鈴木為西方所知），是西田幾多郎的熟識，也是京都學派圈有所來往，他本人即宣稱：

> 有一個暴力的國家（中國），只要它阻礙我們的貿易並侵犯我們的權利，就是直接阻斷全人類的進步。我國以宗教信仰之名，拒絕屈服於此，而因此不可避免地拿起了武器，我們純粹是為了至公至義，是在嚴懲不公的國家，沒有其他企圖，這是一場信仰之戰[33]。

日本在 20 世紀中葉的亞洲主義下產生的虛無和暴力的致命交織，正如佛教學者羅伯特·沙爾夫（Robert H. Sharf）所觀察到的，是在中國禪宗（佛教）遇到鎌倉時代的武士文化後所誕生，它體現於「只有在日本才能完全理解亞洲的靈性」的這個概念[34]。然而，若我們暫且不論其中超脫世界的修辭，禪宗和其他形式的思想並無二致，也受歷史背景的影響和時代的誘惑[35]。

IX 叛徒和空無

在現今地緣政治急遽變化、技術革命不斷推進和全球性生態危機之際，我們似乎陷入了一種與過往不同的空無。現有的道德和政治座標不再具有參考價值──「左派」和「右派」的政治光譜比起過往顯得更無意義，共產主義黨派反而成為自由市場中大發利市的領頭羊，同時各類政客

31. 香港哲學家許煜表示：「對於西谷［啟治］來說，問題是：絕對無是否適合現代性，從而建構一個不受西方現代性限制的新世界歷史？……西谷的回答引導出一個以全面戰爭為策略來克服現代性的提議，這一提議被作為第二次世界大戰之前京都學派哲學家的口號。我稱之為形而上學的法西斯主義，是對現代性的問題有錯誤的判斷所引起……」。許煜，《論中國的技術問題》，Urbanomic 出版（2008），43 頁。
在同一本書中，他提出透過「宇宙技術」的視角來重新構想現代性問題，他將它定義為「藉由技術活動來統一宇宙秩序和道德秩序。」，而哲學的任務是「尋求並確認兩者的有機統一」。（19-20 頁）。他著手描述中國的宇宙技術與西方的非道德精華之一。用他的話說：「在中國宇宙學中，人們發現除了視覺、聽覺和觸覺之外的感覺。它被稱為感應，其字面意思是『感覺』和『回應』，通常〔……〕被理解為『關聯思維』。」在李約瑟之後，我更喜歡稱之為共鳴。它產生了一種「道德情感」，進而產生了一種「道德義務」（從社會和政治角度而言），這不僅是主觀沉思的產物，而且還源於天與人之間的共鳴（天人感應），因為天堂是道德的基礎（法天而立道）。（27 頁）。許煜所描述的中國宇宙技術的「道德」底蘊，使我們想起了第二次世界大戰期間，許多日本知識分子和（激進分子）所享有的「道德」領導權。我們想建議宇宙的「道德制高點」與空無的「無底之底」的交織已經（並將繼續使）東亞地緣政治發生致命的混合。

32. 也許人類學家愛德華多·威維羅斯·德·卡斯特羅對圖皮南巴哲學的分析，為我們提出了一個不同的（令人耳目一新的「非道德」）宇宙技術框架作為對比。在圖皮南巴食人族的詞人主義中，威維羅斯·德·卡斯特羅將其形容為「過度社交」，源於他們對敵人的「認同」需求，「透過他人的自決，以及其不斷改變的狀態」。圖皮南巴的哲學「沒有按照信仰的類別來界定，這種文化秩序並非以自動排除其他秩序為基礎，而且這個社會並非存在於與改變的內在關係的框架之外。我的意思是，圖皮南巴哲學肯定了本質上本體論的不完整；社會性的不完整；以及一般來說，人性。換句話說，這是一種內在性和同一性被外在性和差異性所包圍的秩序，其中，變化和關係優先於存在和實體。對於這種宇宙學，他者在變成問題（對歐洲入侵者而言）之前，是一個解決方案」。愛德華多·威維羅斯·德·卡斯特羅，《印地安靈魂的不穩定性：16 世紀巴西天主教徒和食人族的遭遇》，Gregory Morton 譯，Prickly Paradigm Press 出版（2011），47 頁。

33. 引自克里斯多福·艾夫斯，〈帝國禪及西出哲學當中的倫理陷阱〉，《粗暴的覺悟：禪、京都學派及國家主義問題》，詹姆斯·海西格及約翰·馬拉爾多合編，夏威夷大學出版社，17 頁。日本投降後，鈴木大拙貞太郎在美國廣泛教書，影響了很多人，最著名的應該是前衛作曲家約翰·凱吉。

34. 引述自羅伯特·沙爾夫，誰人的禪宗？再訪禪的國家主義，《粗暴的覺悟：禪、京都學派及國家主義問題》，詹姆斯·海西格及約翰·馬拉爾多合編，夏威夷大學出版社，48 頁。

35. 正如沙爾夫所說：「那些要經營寺院、訓練弟子，要侍奉上帝和君王的人，不能在面對棘手的道德和政治問題時，將自己裹在『絕對無』的外衣中」。羅伯特·沙爾夫，誰人的禪宗？再訪禪的國家主義，《粗暴的覺悟：禪、京都學派及國家主義問題》，詹姆斯·海西格及約翰·馬拉爾多合編，夏威夷大學出版社，51 頁。

我向你保證，我會帶領軍隊，與你一同向印度前進

租列伊哈，喬杜里〈排演自由印度臨時政府廣播電台〉
2018，錄像、聲音、混合媒材，40 分 12 秒
藝術家提供
由柏林雙年展委託與共同製作，歌德學院支持

蘇巴斯·錢德拉·鮑斯（Subhas Chandra Bose）是印度的民族主義者，他是爭取印度獨
立的激進派，在二戰期間他選擇與德國納粹合作，成立印度國民軍。接著又參與由日本
所主導的大東亞會議，在日本的支持下建立臨時政府並就任最高司令官。他在個人的政
治生涯的不同階段，分別化身成齊亞丁先生（Mr. Ziauddin）、奧蘭多·馬佐塔先生（Mr.
Orlando Mazzotta）、松田先生（Mr. Matsuda）、T 先生、涅特吉先生（Netaji），據說
最後鮑斯是在 1945 年在臺灣的松山機場因飛機失事喪生，當時他正準備前往東京。鮑斯
的一連串的政治行動是難以用二戰後的盟軍觀點去理解的，這也凸顯了亞洲在殖民歷史、
民族國家以及冷戰框架之間層層難解的關係。當時他在柏林的自由印度電台製作了一系列
廣播節目，而這些歷史檔案材料成為藝術家租列伊哈·喬杜里（Zuleikha Chaudhari）的
切入點，她建構了一個廣播電台錄音室的場景，並且由幾位不同的演員重演這些廣播片
段。鮑斯個人複雜的多面性，在劇場式的演出中，分裂成不同的表演者，這個過程並不是
為了為歷史平反，而是一種想像式的重建工作，影像呈現的是彩排的過程，包括了演員在
其中的思考、誤差或是失敗，就像是民族主義在當時的兩難處境，在演員與演出角色之間，
我們看到了這種遲疑、反省又跨步向前的狀態。

毫無顧忌又常態性地顛覆他們原本標舉的原則信念，在這樣反常的情勢下，叛徒的角色成為當前時代的代表。

而現今的叛徒面貌是分歧且多元的，他／她可能以叛逃者、強硬派、潛伏臥底、內應、特務、破壞者、背叛者、陰謀者、吹哨者、甚至是評論者等身份出現[36]，但是背叛也具有傳染性，現在，我們比過往任何時候，都更常目睹國家在無情追捕無論是「恐怖分子」、「毒品走私販」或「抗議份子」等敵人時，透過其暴力的反制行動而背離了憲法，使自身成為叛徒，「秘密戰術和行徑」正如媒體理論家伊娃·霍恩（Eva Horn）所述，「成為社會行為各面向的基礎〔……〕角色扮演、偽裝和變節，變成現代人在社交和情慾生存方面的部份技能。」[37]

但叛徒——就其最深刻的意義來說，「是人性展示下的政治版圖，有著模糊、抽象和缺乏透明度等特色，同時是社會和敵對雙方的危機」[38]。政治結構不再定義為：

> 「朋友和敵人之間劃分明確的界線……叛國、變節、不受控是反常行為的縮影，打破規則，意圖為不同形式的擁護和另類的政治選擇創造空間，當忠誠已悲劇性地成為不可能的選項，由此引發的政治危機中，叛徒或變節者同時是這類政治危機的受害者和解決方案，叛徒成了放棄自己的國家、意識形態、宗教或科學社群的人。」[39]

不管是在個人的群體中，抑或道德層面上，提出批評並採取行動需要跨越界線並打破階級，但是這個過程是否有其界限？如果有，這些限制是誰設置的？是根據什麼標準？有沒有什麼方法，可以確保我們不會太輕率又過於快速的栽入空無之中？在這種情況下，重返、重新思考及重新定義亞洲思想體系中的空無或許有所幫助，這也將展覽的思考帶往下一個問題：**如何以具創造性又符合倫理的方法思考「空無」，又該如何在「空無」中進行這樣的思考？**

36. 哲學家尚·保羅·沙特（Jean-Paul Sartre）也通過定義將知識分子的狀況描述為叛徒之一。用沙特的話來說，知識分子生活在「永久叛逆的狀態中，而他能真正實現『本真』的最重要途徑就是意識到這一點，並選擇叛逆。」東尼·賈德，《未竟的往昔：法國知識份子，1944–1956》，紐約大學出版社（2011），51頁。

37. 伊娃·霍恩，《秘密戰爭 – 叛國，間諜和現代小說》，傑佛瑞·溫斯羅普·楊譯，西北大學出版社（2013），40頁。

38. 伊娃·霍恩，《秘密戰爭 – 叛國，間諜和現代小說》，傑佛瑞·溫斯羅普·楊譯，西北大學出版社（2013），64頁。

39. 伊娃·霍恩，《秘密戰爭 – 叛國，間諜和現代小說》，傑佛瑞·溫斯羅普·楊譯，西北大學出版社（2013），69頁。

如同異人一般，叛徒是一個相對的概念，不容於既有的意識形態框架，對這樣模糊不清的角色進一步思考，可以反思的問題是這些框架由誰制定？如何產生的？出生於臺灣日治時期的音樂家江文也就經歷了這種劇烈衝突，1930 年代他開始在日本樂壇發展，二戰過後轉而在中國任教，卻因為親日的背景而被視為文化漢奸，1957 年又因過去的作品〈臺灣舞曲〉曾在德國得獎，被認為與右派法西斯有關聯，而被打成右派，他流轉於東亞國境之間，飽受政治敵視與苦難。在他的音樂特性中，臺灣、日本或是中國似乎都不是音樂立基的所在，這樣的態度可以在他研究古代音樂的文章中進一步理解，在他所著的《古代中國正樂考》中，多方證明孔子為傑出音樂家，更將祭孔古樂重新改作為現代管弦樂〈孔廟大成樂章〉，大同的思想與音樂的特性相連，而國族就不再是江文也要考慮的對象。他的成名作品是以臺灣為背景的〈白鷺的幻想〉，而最後一首曲子則是〈阿里山的歌聲〉，來自非人的驅力超越了國族的框架，在經歷政治災難後，最後他在離世時寫下這句話：「繼續奮鬥，用盡最後一卡熱量，然後倒下去，把自己交給大地就是了。〔……〕我一直認為那個美麗的『白鷺之島』的血液是無比優秀的，我抱著它而生，終將死去。」藝術家王虹凱的作品〈這不是國境音樂〉（2019）就以江文也的音樂軌跡作為對話的對象，據說江文也曾經為 1935 年的臺中大地震譜寫了一首〈賑災歌〉，但並未留下任何樂譜或錄音。這件作品就以尋找這首遺失的曲子作為起點，學習江文也音樂當中的宇宙與鄉土性。這個計畫是由一連串的工作坊所構成，透過與地球科學家的合作，在回訪不同地點與遺跡時，導入了現代地質探測技術，閱讀地表所覆蓋的斷層線。這個過程不只是透過江文也的生命經驗叩問國族的意識形態框架，同時也推進某種超越人類時空觀的框架。

王虹凱，〈這不是國境音樂〉
2019，工作坊、多媒體裝置，尺寸依場地而異
藝術家提供
2019 亞洲藝術雙年展委託新作
本計畫由國立臺灣美術館、臺中國家歌劇院以及國立中央大學地震災害鏈風險評估及管理研究中心協助製作

X 無盡之底和奇特的陌生人

這個問題在道家歷史悠久的思想體系中曾以不同形式出現多次，例如在魏晉時期（公元前 220 至 420 年）的「玄學」中，虛無被認為同時具備新生的可能性（自由）和虛無主義（放縱）的特質，政治科學家約翰・瑞普（John Rapp）在撰寫無政府主義與道教之間的關係時，認為此概念代表從「道」到以「無」或「無名」為關鍵字的轉變過程，區別在於從「萬物與我為一」演變為「無的存有」，瑞普將其延伸為從無政府主義轉變到虛無主義的過程[40]。

這種關於「相互依存之整體」的想法，又可與提摩西・莫頓（Timothy Morton）「生態思想」中的「網絡」概念連結，進而描述為「眾多糾纏的陌生人之間的相互連繫」[41]，用莫頓的話來說：

> 在「無底之底」，主體是一個無限的空無。當我遇到奇特的陌生人時，我凝視著空間深處，遠比可以用儀器測量的物理空間更廣闊且更深刻，另一個人那令人不安的深度是內在自由的根本結果，我們不該認為這個網絡「比我們更大」，天地之間萬物並生，生態思想的確是廣大遼闊，但奇特的陌生人就在我們身邊，他們就是我們，內在空間就在於此，「比呼吸更近，也比手和腳更近。」[42]

對陌生人好客是許多文化的古老格言，我們遵循這個精神，不僅歡迎帶來消息的陌生人和來自「外界」的「新」，也因為這個「外部」始終都存在於我們「內部」最深處的摺縫之中，與陌生人的相遇是一種疏離的經驗，此一經驗讓我們與內在的陌生人產生聯繫、交流，這個奇特的陌生人可能會為我們帶來禮物，即本體論和認知上的謙卑──「我們」不再居於自我繪製的圖表中心位置，不再是歷史的中心主體，這有時可能看起來像是背叛，需要違背我們所接受的觀點、社會的風氣、國家的法律，甚至可能是人類自身的意願，然而，也許我們從這種空無或掏空中能有所獲得──如此切斷連結、去同步化，首先帶來自由，接著是充滿可能性的新世界，在其中我們可以建立新的同盟、新的連結和新的關係，擴大自身世界的深度，產生新的力量──使其活躍，也就是說，我們要認可、要站在生成的那一方、在來者的身邊、推陳出新、去創造[43]。

40. 參見約翰・瑞普，《道教與無政府主義－評古今中國的國家自主性》，Continuum（2012），31-32 頁。瑞普建議：「關於科學技術進步的問題，我們可以再次求助於李約瑟，他認為道家是『反封建』勢力的代表，並批評使用科技來建立新的壓迫統治形式。同時，在他們的思想範圍內，保持了對所有權威反對的『原始科學』元素，並且希望在沒有前提條件的情況下觀察宇宙，正如我們在莊子〈內篇・齊物論〉第二所看到的那樣」。

41. 提摩西・莫頓，《生態思維》，哈佛大學出版社（2012），15 頁。

42. 提摩西・莫頓，《生態思維》，哈佛大學出版社（2012），78 頁。

我們一直發展延伸的圖表既不是理論模型也不是故事腳本，是我們製作的工具，好創造出可以讓藝術家、思想家和共創者的作品、思想和存在所棲息和活化的舞台（展覽），倘若我們無法為亞洲當前面臨的許多緊迫問題提供答案，我們仍希望能夠重新架構部份的問題，用新的關係鏈結來擴大詮釋的範圍，從而拓展回應的可能性。

43. 在這裡，我們要加上「選擇」。我們是從哲學家吉爾‧德勒茲的觀點（透過弗里德里希‧威廉‧尼采的發言）來說這句話：「活躍是被視為選擇的產物。通過力的活動和意志的確定同時進行雙重選擇。但是怎樣進行選擇呢？選擇的原則是什麼？尼采回答：「永恆回歸。〔……〕我們注意到，永恆回歸，作為一種物理理論，是推測合成的新公式。作為一種倫理思想，永恆回歸是實踐綜合的新表述：無論你的意願是什麼，它也將以永恆回歸的方式來實現。如果，您會首先問自己：我會願意無數次的這樣做嗎？這應該是你最堅實的核心。」吉爾‧德勒茲，《尼采與哲學》，Hugh Tomlinson 譯，Continuum 出版（1992 年重印），68 頁。
德勒茲-尼采還提醒我們：「因此，力不是意志所需要的，而是相反，意志中所要的。而『想要或尋求力』只是全力意志的最低程度，是力的消極形式，是在事物狀態中反動力佔上風時所假定的幌子。尼采哲學最原始的特徵之一就是『什麼是』問題的轉變…？改為『哪個是…』例如。對於任何給定的命題，他都會問『哪個人有能力說出來？』。在這裡，我們必須擺脫所有『個人主義者』的提法。那一個……不是指一個人，而是一個事件，即一個命題或現像中處於各種關係中的力，以及決定這些力（力量）的遺傳關係。那個永遠是狄俄尼索斯的人，是狄俄尼索斯的面具或假裝，是一道閃電。關係以『肯定』和『否定』等類型的動態品質來表達自己」吉爾‧德勒茲，《尼采與哲學》的〈序言〉，Hugh Tomlinson 譯，Continuum 出版（1992 年重印），xi 頁。

by ——— HO Tzu-Nyen

I The Marebito and the Stranger

The "stranger" in the title of the exhibition is inspired by the ancient Japanese word *marebito*. The word *mare* means "rare", while *bito* means both "person" and "spirit". The ethnologist and folklorist Shinobu Orikuchi described the *marebito* as a rare guest, a supernatural being from beyond the horizon or from beyond distant mountain ranges, and who might visit a village during special occasions like festivals or foundational events such as the building of a house. Encountering such an otherworldly being is bound to be an uncanny experience, one that wavers between hospitality and hostility, welcome and alienation.[1] However, if responded to in the appropriate way—with rituals, offerings and festivities—the *marebito* would bestow gifts of spiritual knowledge and wisdom.

We use the term "stranger" as an extension of the *marebito*, to refer to many "others". Not only spirits and gods, but also aliens, shamans, foreign merchants, immigrants, minorities, colonists, smugglers, partisans, spies and traitors—the stranger is a medium, through which another world may be communicated. Through encounters with strangers, we may perhaps confront the outlines of ourselves, the borders of our society or even the boundaries of our species. This is the stranger's gift, and some gifts are not easy to receive.

II Zomia and the Sulu Sea

For the "mountain" and the "sea" of our title, we had "Zomia" and the "Sulu Sea" in mind. Zomia is, as the anthropologist James C. Scott explains:

> a term for highlander common to several related Tibeto-Burman languages spoken in the India-Bangladesh-Burma border area. More precisely, *Zo* is a relational term meaning "remote" and hence carries the connotation of living in the hills; *Mi* means "people". As is the case elsewhere in Southeast Asia *Mi-zo* or *Zo-mi* designated a remote hill people, while at the same time the ethnic label applies to a geographical niche.[2]

1. See Ishii Satoshi for a summary of the historical and conceptual interconnections between theorisation of strangers in the "Western" academic tradition and the Japanese terms of *marebito*, *ijin*, and *gaijin* in relation to what Ishii called "the Japanese Welcome–Nonwelcome Ambivalence Syndrome". For Ishii, these insights and frames of reference can further research on interracial, interethnic, and intercultural issues in Japan, and various parts of the world. Ishii Satoshi, "The Japanese Welcome-Nonwelcome Ambivalence Syndrome toward Marebito—Its Implications for Intercultural Communication Research", in *Japan Review*, No. 13 (2001), p. 146

2. James C. Scott. *The Art of Not Being Governed: An Anarchist History of Upland Southeast Asia*, Yale University Press (2009), pp. 14–16

來自山與海的異人

by ——— HSU Chia-Wei

The scientific discoveries of today have superseded the assumptions of traditional physics regarding absolute space and time and a clear distinction between motion and solid matter, rendering the objective methods of Newton/the modern paradigm obsolete. That is to say, new science has reimagined reality. Yet what we now mistakenly consider as objective truth may itself be overturned in a few years. Park Chan-kyong's *Chun-sang-yeol-cha-bun-ya-jido* (2015) can be understood as a meditation on the relativity of cosmological understandings across different points in space and time. In the video, we see a huge observatory dome slowly opening, looking out at the vast universe and opening a channel between us and the unknown world. In the 17th century, Galileo's new revelations about the universe triggered a vehement backlash from the Vatican, causing a schism between science and faith. In this work, the artist has spliced together images from telescopes—the vision of contemporary science—with astronomical charts drawn up in 1395 by Korea's Joseon Dynasty. The cosmologies of these two different eras embody different ways of imagining reality, bridging the dichotomy between science and faith. At the end of the film, black-and-white images of South Korea in the late 19th century appear, including sequences related to Korean shamanism. Just like the contemporary telescope, Korean shamanism can be understood as another way to open a path to the unknown.

Relying on shamanistic visions, the works of Tcheu Siong use embroidery to manifest the spirit beings of an ethnic minority people. When she first moved from the mountains to the city, the artist made many small-sized works of embroidery to secure her livelihood. But now her works have grown increasingly larger in size. These images come from the interpretations of dreams performed by the artist's husband Phasao Lao, a shaman of the Hmong people who identifies these figures from the spiritual pantheon for his wife. Such large-scale works are not for human viewing. For Tcheu Siong, they engage in dialogue with the spirits that envelop her life, protecting her family and her home. This work can be grasped as a conversation with outsiders and a guide to the unique worldview that lies behind it.

Tcheu Siong
Star Spirit 1
2016, embroidery and applique on cotton, 353x108 cm (One of 8 works on view in the exhibition)
Courtesy of the artist and Project Space · Pha Tad Ke

According to James C. Scott, the region of Zomia has for centuries been the site of a dialectical relationship between lowland empires founded upon sedentary agriculture and the highland tribes that practice transitory agriculture. These highlanders have avoided the emergence of state structures from within through their capacity for nomadism, which is complemented by their preference for slash-and-burn agriculture. At the same time, they are beyond the reach of the armies of lowland empires, who run out of breath at high altitudes. However, this model of a stateless Zomia seems obsolete today, in an age of satellites and drones. Yet one cannot help wonder why the nation states surrounding Zomia are still unable to effectively control this mountainous area. A look at the recent histories of non-state military forces in the region may help us to better understand the evolution of the relations of Zomia to its surrounding nation states. For example, the Burmese warlord turned drug lord Khun Sa rose to power in the 1960s by commanding what were originally isolated Kuomintang forces, becoming a key player in the anti-communist resistance and gaining control over a large swath of land in the Shan and Wa states of Myanmar.

Scott used Zomia to describe a broad, elevated region stretching from the highlands of central Vietnam to northeastern India at 300 meters or more above sea level. Zomia's high altitudes and rugged terrain form a natural barrier, making it difficult for the surrounding low-lying states to govern, thus becoming a sanctuary for partisan fighters of forgotten wars, drug traffickers, ethnic minorities and other fugitives escaping the reach of "flatland" nation states.

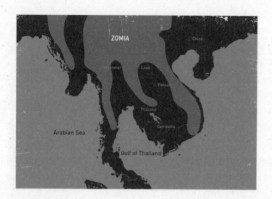 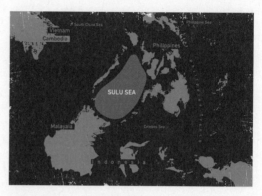

The Sulu Sea is a marginal sea between the Pacific Ocean and the South China Sea, bracketed by Borneo in the south and the complex Philippine archipelago in the north. "Tri-bordered" by the Philippines, Indonesia and Malaysia, the Sulu Sea is notoriously difficult to police. Historically rich in maritime commerce, these waters have, since the colonial era, been infamous for slave raiding and piracy. To the European colonisers, piracy and slave raiding were manifestations of cultural anomie and backwardness that must be stamped out if civilisation—and business—were to enter the region. But the historian James Francis Warren tells us that these activities should be viewed "as an extension of jihad, with political, not simply economic motives".[3]

In the last decades, the Sulu Sea has become one of the main stages for the activities of Philippine-based Jihadist militants such as the Abu Sayyaf Group (ASG), who carried out a series of high profile seaborne kidnappings and attacks on numerous diving resorts.[4] These waters have also served as a gateway for terrorist groups travelling from one part of Southeast Asia to another. Members of the Jamaah Islamiyah (JI), a Southeast Asian militant extremist Islamist rebel group with cells in Indonesia, Singapore, Malaysia and the Philippines, use this route to travel to training camps in the Philippines.[5]

3. James Francis Warren. *The Sulu Zone 1768–1898—The Dynamics of External Trade, Slavery, and Ethnicity in the Transformation of a Southeast Asian Maritime State*, 2nd Edition, NUS Press (2007), p. xxi

4. Meghan Curran. "The Deadly Evolution of Abu Sayyaf and the Sea" (2019/05/24). Retrieved from https://www.maritime-executive.com/editorials/the-deadly-evolution-of-abu-sayyaf-and-the-sea

5. Febrica Senia. "Securing the Sulu-Sulawesi Seas from Maritime Terrorism: A Troublesome Cooperation?" in *Perspectives on Terrorism*, Vol. 8, No. 3 (June 2014), pp. 64–83

來自山與海的異人

Kun Sa's career embodied the complex entanglements of ethnic fissures in the Zomia area, the ideological conflicts of the Cold War and the so-called underground economy of opium and heroin industry "Golden Triangle" which is deeply entwined with the political economies of Thailand, Laos and Myanmar. Although the laws of these nation states prohibited such trade, the actual day-to-day operations of this business not only crossed national borders, but also blurred the line between the lawful and the unlawful.

The self-understanding of empires and countries built upon agricultural heartlands often exhibits a privileging of the land over the sea. The Ming Dynasty ban on seafaring in the 14th century forced coastal peoples who survived on maritime trade into desperate action. Coupled with a huge rise in the number of impoverished peasants, the coasts of China became rife with piracy, and laid the grounds for a relationship of confrontation between the inland empire and the pirate culture of the South China Sea. The artist Ming Wong's work *Tales of the Bamboo Spaceship* (2019) centers on the Red Boat opera troupe, which plied the waters of Southeast Asia in the late Qing and early Ming Dynasties. The membership of this Canfonese opera troupe included those who fled the persecution of the empire, notably Shaolin monks trained in martial arts. In those days, opera and martial arts companies often fomented the movement to "overthrow the Qing and restore the Ming," becoming a vehicle of anti-imperial revolution, and the ocean was their base.

The work *ChronoLOGICal* (2018) by Roslisham Ismail (a.k.a Ise) is both a vision of history written from below (as opposed to one written from above) and a version of history intimately connected with the ocean. Firmly anchored upon his home province of Kelantan in Malaysia, he sets off from a mythological perspective before turning the relationship between land and sea on its head. His mixed media installation presents an enormous, dizzying system, and running through the middle of it is the myth of the Great Flood. The archipelagoes scattered across the seas of Southeast Asia are thought to be the remains of the continent of Mu that was lost 15,000 years ago. The ancient people of Mu violated the law and were punished with a deluge. The continent of Mu once occupied most of the South Pacific, stretching 8,000 kilometers from east to west, and it sank to the bottom of the sea after the flood. Some residents of the lost continent survived and later became the Malayo-Polynesians. In December 2014, Kelantan suffered the worst flood in its history, and many saw it as the Second Punishment from heaven. Unlike the traditional narrative of empire, Ise's story presents a perspective that begins in the ocean before it moves to the land.

Yee I-Lann's photographic work *Sulu Stories* (2005) is also set amidst the ocean and it manifests a special sense of space. Just like the archipelagoes left behind from the lost continent of Mu, the image alludes to intermediary "holey spaces", such as small coastal islands, coral reefs and bays, that exist within the "smooth space" of the ocean. These spaces are the hideouts of pirates. They conceal stories and provide multiple channels through which to enter the story of the Sulu Sea.

For some, these activities are the latest incarnations of the "Moro Jihad" that began as early as the 16th century against the Spanish colonisers.[6]

Religious, political and anti-colonial intents aside, the historian Eric Tagliacozzo tells us that maritime violence, slaving and attacks on commercial shipping "can often be much more accurately understood within the context of local political and economic systems, providing the necessary status and surplus that made whole societies run".[7] Just as piracy in the Sulu area during the 18th and 19th century can be co-related to disruptions of indigenous trade patterns by the new colonial networks, slave raiding grew to meet manpower demands generated by the highly profitable trade in opium, guns and tea with the geopolitical core areas of Europe and China.

III The Inside and the Outside

To understand the dynamics of Zomia and the Sulu Sea requires a mode of history-without-borders, where the flow of commodities, both legal and illegal, are not only entangled with questions of ethnicity, culture, and state formation, but implicated with the system of world commerce. To do this, James Francis Warren proposed a conceptual re-framing of the Sulu Sea as the "Sulu Zone"—an "inherently unstable" and "generally dynamic" spatial system, which is not "enduring", "self-maintaining" or "autonomous".[8]

Perhaps we can visualise the Sulu Zone as an entity with fuzzy outlines and an inherently unstable make-up. It is hard to know where it begins and ends, and its components undergo perpetual metamorphosis. Consider for example, how the huge influx of captured slaves into the Sulu Zone in the 19th century irrevocably altered the very cultural and ethnic matrix of its core. [D]istinction of ethnicity and culture blurred and were broken down; thousands of 'outsiders' were being incorporated into the lower reaches of a rapidly expanding Islamic trading society".[9] Nevertheless, and contrary to Warren, we think that the Sulu Zone possesses a degree of autonomy. It endures not by the persistence of its components over time, but it nevertheless retains a certain structural consistency over time. It persists through how it absorbs and processes its "inputs"—the "inside" of the Sulu Zone is defined by its communication with its "outside".

6.The collective term "Moro" refers to the 13 Islamised ethnolinguistic groups of Mindanao, Sulu and Palawan. According to Sheik Abu Zahir, the Moro Jihad has to date unfolded in three phases: "First, beginning in the 16th century as part of the Moro Jihad against the Spanish invasion (1521–1898), followed by the second phase against American colonisers (1898–1946) and the current phase which began around 1970, against the Philippine Crusade". See Sheik Abu Zahir, "The Moro Jihad—Continuous Struggle for Islamic Independence in Southern Philippines", first published in the 23rd issue of *Nida'ul Islam – The Call of Islam Magazine* (April–May 1998). Retrieved from https://fas.org/irp/world/para/docs/ph1.htm

7.Eric Tagliacozzo, *Secret Trades, Porous Borders – Smuggling and States Along a Southeast Asian Frontier, 1865–1915*, Yale University Press (2005), p. 109

8.Warren. *The Sulu Zone,* pp. xxvii to xxviii.

9.Warren. *The Sulu Zone,* p. xxxv.

來自山與海的異人

"The story culminates with the famous scene of the young man's hara-kiri, and the cloudy white syrup flowing up from his belly. The syrup turns the sea into a dull white color, causing white-crested waves on the shore." These words come from Yuichiro Tamura's work *Milky Bay* (2016), which connects the legendary life of Yukio Mishima with imagery of the ocean. The film adds, "Good things always come from the sea." In 1853, the United States' "gunboat diplomacy" forced Japan to open its borders, and these gunboats were commonly referred to by the Japanese as "Black Ships" (kurofune). Then in 1945, the US military occupied the ports of Yokohama. The artist blends together different myths, fictions and fragments of history, moving from the bodybuilding culture introduced by the US military, to Mishima's fascination with the muscularity of Greek sculpture, to an actual historical case of human body parts found in the bay of Yokohama. At moments these scenes flow past us like an ocean current, but at moments they solidify into chunks that resonate. The concept of bodybuilding, as observed in the work, "bodybuilding is based on training each muscle separately. This muscle today, and the other muscle tomorrow…This dismembered thinking about the body. This fragmentary manner of thought." Perhaps the logic of this work can be imagined to be a constant oscillation between the individual muscles and the body as a whole.

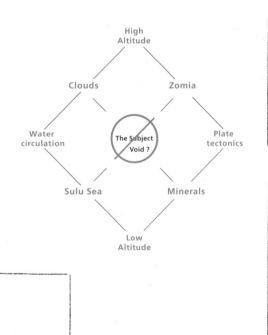

This special quality of being a sculpture in motion can also be found in the works of Chiu Chen-Hung. Coincidentally, the image of a "Black Ship" (*kurofune*) also appears in his *Shattered Romance* (2019). In the exhibition space, a set of huge black sails hangs upside down. They are modeled on the carrack, a three- or four-masted ocean-going sailing ship used in the so-called Age of Discovery, as well as a species of bat discovered by French explorer Dumont d'Urville. The seemingly soft fabric of these sails is derived from hard fibers formed from the nephrite jade found in Hualian. The masts are made from four different kinds of wood, including teak, a major commercial wood of the 17th century, as well as the Douglas fir, which must pass through the high temperatures of a forest fire before their seeds become fertile. The shimmering fragments at the tip of the mast are meteorites gathered by the artist's grandfather. Each of these materials is engaged in its own process of change, and ultimately they are woven together. Just like a line in Yuichiro's work, they are "a joint creation of the artist and time, a temporal sculpture named fragment."

For us, the Zomia and the Sulu Sea make up two ends of a vertical axis of altitudinal difference, while a horizontal axis is constituted by the circulation of water on one side, and plate tectonics, on the other. The two axes in turn pull at the foundations of flatland empires. To imagine what such a force field might look like, we created a diagram that gradually became something of a blueprint for this exhibition.

For us, "Zomia" and the "Sulu Sea" are not merely tropes for the intersection of geography and politics, altitudes and anarchism. The Zomia highlands and the low-lying Sulu Sea are not simply other to, outside of, or in opposition, or in opposition to the law and order of flatland nation states. Instead, the "informal" and "illegal" activities of these outlying zones are woven into the very political-economic cores of the modern nation states around them. We only need to follow the trail of opium and heroin that drifts across the Sulu Sea, and courses through the veins of Zomia.[10]

IV Poppy and the Political-Economy

The Shan State opium-heroin industry of Southeast Asia is located in an area within Zomia, "tri-bordered" by Thailand, Laos and Burma—the "Golden Triangle". While the laws of these nation-states prohibit this trade, the actual day-to-day operations of this business traverses not only national borders, but blurs the very line between the legal and the illegal.

On the ground—as Chao-tzang Yawnghwe tells us—the production, processing, storage and transportation of opium and heroin is controlled as much by stateless, unofficial militias, as it is by officials of recognised states such as Thai, Burmese, Chinese, Laotian army officers, garrison commanders, police officers and custom-officers. And the financing and exporting of opium and heroin in turn involves another constellation of actors. These are the "legitimate businessmen, shopkeepers, jade and gem dealers, restaurant owners, bank managers, commodity brokers, hotel owners, active in respectable trade business associations, religious or social organisations, rotary clubs, chambers of commerce".[11] Responsible not only for binding Burma together economically and politically, these economic-commercial actors also plug Burma's economy into the wider, regional economies of "China", "Thailand", "Laos", "Malaysia", "Hong Kong", "Taiwan", the "Philippines" and beyond, to overseas circuits of finance and capital. The names of these countries—following the example of Yawnghwe, are put within quotation marks, because "in terms of the opium/contraband-based, informal/underground, or 'illegal' world of trade and investment, borders are basically without the meaning conventionally attached to them".[12]

10. When John Herbert was appointed to head the British East India Company trading station at Balambangan, an island adjacent to North Borneo within the domain of the Sulu Sultanate, he wrote to his superiors: "I cannot but strenuously recommend [...] the provision of a very large supply of opium which may well be considered as a necessary of life; all the manufactures on the west of India will not have half the attraction that this single article will have, it will operate on every other sort of goods, wanting that alone the undertaking will wear a dreary prospect". Quoted from Warren, *The Sulu Zone*, p. 19

11. Chao-tzang Yawnghwe. "The Political Economy of the Opium Trade", in *Journal of Contemporary Asia*, Volume 23, Issue 3 (1993), pp. 312–313

12. Yawnghwe. "The Political Economy of the Opium Trade", p. 309

Sawangwongse Yawnghwe
The Opium Parallax
2019, oil on linen, 224×400 cm
Courtesy of the artist
Commissioned by the *2019 Asian Art Biennial* (Taiwan) and realised
with the support of Rijksakademie van beeldende kunsten

In 1947, General Aung San, acting as the leader of the interim government of Burma, signed the *Panglong Agreement* with the leaders of the Shan, Kachin and Chin peoples, declaring that Burma was collectively owned by all ethnic groups. After the nation of Burma was founded in 1948, U Nu, an ethnic Burman, became prime minister, while Ne Win, a Hakka Chinese, commanded the army and Sao Shwe Thaik, a Shan, served as the first president. However, with the assassination of Aung San, the *Panglong Agreement* became an unfulfilled dream. To this day, ethnic conflict and turmoil continues unabated in Burma (now known as Myanmar). In 1962 Ne Win led a coup, and President Sao Shwe Thaik was arrested and imprisoned. This very same Sao Shwe Thaik was the grandfather of the artist Sawangwongse Yawnghwe. At that time the artist's father, Chao-tzang Yawnghwe, joined the Shan State Army, an underground insurgent group waging war against the military government in the highlands along with other ethnic minorities. But with the advent of the Cold War, ethnic fissures became entangled with both the politics of the Communist Party of Burma and the opium industry in the Shan State, giving rise to a complex and multilayered conflict. Eventually, the Yawnghwe family fled to Canada.

In his paintings, Sawangwongse Yawnghwe depicts his family history and the geopolitics that underlie it. *The Opium Parallax* (2019) offers a glimpse at the network of relationships formed around the drug trade in Zomia. It is a speculative diagram that embodies the imbroglio of colonization, nationalism, ethnic conflicts, the Cold War framework and neoliberalism—without any clear lines of demarcation.

V Golden Triangle 2.0 and Zomia 2.0

Today, the drug trade of the Golden Triangle has been "updated" from an agricultural to synthetic model focused on the production of methamphetamines ("crystal meth" and "yaba"). Cheaply produced in labs and no longer beholden to the vagaries of climate as poppy was, we are looking at a new Golden Triangle 2.0. The circulation of methamphetamines received a major shot in the arm with China's *One Belt One Road* initiative. As reported by Joshua Berlinger in CNN, this "massive infrastructure development project intended to connect global, predominantly developing economies", made it easier for meth traffickers to move their products from the Shan State to the rest of Southeast Asia, China, Hong Kong, Taiwan, Japan, South Korea, New Zealand and Australia.[13]

Profits from the meth trade was reported to be laundered through the King Romains Casino owned by Chinese businessman Zhao Wei, who has a 99-year lease with the Laotian government to operate the Golden Triangle Special Economic Zone (SEZ). In 2000, Zhao Wei opened a casino in the town of Mong La, located in an autonomous strip of land on the Chinese-Burmese border known as Special Region No. 4. Created in the aftermath of the 1989 ceasefire between the two states, Special Region No. 4 has since been governed by a Shan-Chinese named Lin Ming-Xian. Initially built on drug money, casinos began appearing in Mong La in the 1990s, and since the 2000s, Lin also began investing in the growing online gambling industry.[14]

The social anthropologist Alessandro Rippa proposed to understand Mong La, alongside the Golden Triangle Special Economic Zone, not as the "last remains" of Scott's lawless Zomia, but as zones penetrated by businesses that aim to "reach the same goal: escape state power". Rippa refers to this "update" as Zomia 2.0, characterised as much by political remoteness as by neoliberal connectivity.[15] Today, alongside drugs, wildlife and human trafficking, a 66 megawatt hydroelectric dam will be implemented in Mong La.[16] This is accompanied by reports of plans by a Chinese company to set up the Yongbang Blockchain Special Economic Zone, an "experimental digital

13. Joshua Berlinger. "Asia's Meth Boom—How a War on Drugs Went Continent-wide" (2018/11/02). Retrieved from https://edition.cnn.com/2018/11/02/asia/asia-methamphetamine-golden-triangle-intl/index.html

14. Alessandro Rippa. "Zomia 2.0: Political Remoteness and Neoliberal Connectivity in Two Casino Towns in Myanmar and Laos" (2016/11/15). Retrieved from https://allegralaboratory.net/zomia-2-0-political-remoteness-and-neoliberal-connectivity-in-two-casino-towns-in-myanmar-and-laos/.

It should be noted that Zhao Wei has denied the connection between drug money and his casino empire. See Jiang Xun and Yuan Weijing. "Exclusive Interview with Zhao Wei, Chairman of the Management Committee of the Golden Triangle Special Economic Zone (2019/01/13). Retrieved from http://www.mingpaocanada.com/van/htm/News/20190113/tcad1_r.htm

15. Rippa. "Zomia 2.0"

16. Gregory Poindexter. "Myanmar moves forward with 66-MW Maingwa hydroelectric" (2016/02/28). Retrieved from https://www.hydroreview.com/2016/03/28/myanmar-moves-forward-with-66-mw-maingwa-hydroelectric-project/#gref

The poppy flower, once processed and refined, becomes heroin. In the 1980s the Golden Triangle was responsible for 80% of the world's heroin output. Today, the area's fields are no longer planted with poppies. They have been replaced by cottage-industry labs producing methamphetamines. Its ingredients can be derived from household products available in stores and processed chemically in a kitchen or living room. Given to soldiers as a stimulant in World War II, meth is now used by many workers in the jadeite mines of Myanmar, sustaining the world's biggest place of export for jade. According to a report from the United Nations Office on Drugs and Crime, in the first three quarters of 2018 the quantity of methamphetamines that were found and seized amounted to 116 tons. It should also be noted that Taiwan-based transnational smuggling rings play a major role in the transport process.

In Thailand many legends depict the mountains of Zomia as a mysterious zone filled with black magic. According to Thai artist duo jiandyin (Jiradej Meemalai and Pornpilai Meemalai), the drug's anesthetic and aphrodisiac effects on the nervous system are a contemporary form of black magic. In this context jiandyin (Jiradej Meemalai and Pornpilai Meemalai)'s *Friction Current: Magic Mountain Project* (2019) is an art action that begins by following the trails of the two substances, Burmese jade and meth, using them as threads by which to weave together an image of the geopolitics of Zomia. They worked with Thai police to collect urine samples containing traces of methamphetamines, which were obtained via anti-drug campaigns along the Thai border. Then, using legal channels, they shipped the urine to Taiwan, placing it in a fountain. The urine in the fountain causes a jade sphere to spin. This inventive installation manifests the covert yet material path of flow from Zomia to Taiwan.

The drug trade is a key component of the underground economy in Zomia. Today, a new element has been added to the mix—the blockchain economy. Liu Chuang's work *Bitcoin Mining and Field Recordings of Ethnic Minorities* (2018) addresses the transformations in Zomia brought about by contemporary digital technology. The video takes us on a grand journey, from a cable engineering project of the late Qing Dynasty, to the relationship between hydropower projects and bitcoin mining in southwestern China, to Andrei Tarkovsky's 1972 science fiction film *Solaris*. Another focal point in the video is the political nature of sound. In Zhou-dynasty China, a discourse on what constituted proper rituals (and music) caused a narrative of national consciousness to germinate, while the narratives of ethnic minorities were relegated to the status of unorthodox noise. For Liu, this process is analogous to the contemporary differentiation between state-led monetary systems and decentralized digital currencies, and further reflected in the relations between anthropocentric language systems and the imagined vocal communications of extraterrestrials. Finally, the video ends by cutting back and forth between images of the Queen of Naboo from *Star Wars* (directed by George Lucas in 1999) and historical photos of ethnic minorities. In our science fiction universes, the ways by which we imagine alien worlds seem to be derived from our projections of 'others' on earth. In Liu's speculative history of technology, we are simultaneously led through a series of technologies of control aligned with the ideology of nationalism and a different history of technologies used for deterritorialization and escape from the reach of the nation state.

economy exercising a high degree of autonomy, and vested with independent executive, legislative and judicial power", with an "e-citizen" system and its own cryptocurrency—the Yongbang coin.[17] Although officially denied by Mong La officials, the presence of hydropower benefits the constant cooling required by Bitcoin mines.

VI Clouds and Minerals

This updated mesh between stateless zones, neoliberal economy and digital technology brings us to the other vertical axis in our diagram, which stretches from "Clouds" in the earth's troposphere to "Minerals" beneath the earth's surface. But we also had in mind the digital cloud enabled by rare earth elements extracted from the ground. Once again, these strange couplings take place in the vicinity of Zomia. As reported by Bertil Lintner, in the Wa-controlled areas of the Shan State (which is heavily involved in the opium-heroin and methamphetamine trade), there have been eye-witnesses who "report seeing two rare earth mines in areas controlled by the KIA (Kachin Independence Army) in the north, and there could be more in the Wa Hills, although the reports are unconfirmed".[18]

To view human histories against the horizon of clouds and minerals is to open up these narratives to the roles of non-human elements and non-human scales of time—from the slow geological time of tectonic plate movements, to the lifespan of a human being, to the fleetingness of a passing cloud.

The simultaneous perception of multiple time-scales is inherent in the tradition of Chinese lithophilia, where rocks have been called the "roots of the clouds", an expression derived from "the mists that surround the collision of water with rock, and from the vapours that gather around the peaks of mountains or enshroud the tops of cliffs and ridges. Some of the rocks most admired by the Chinese resemble clouds, and in landscape painting mountains are often depicted not so much accompanied by clouds as themselves looking like heaps of cumulus".[19]

17.Nan Lwin. "Mongla Official Denies Chinese Firm Permitted to Set Up Autonomous Digital Economic Zone" (2019/02/20). Retrieved from https://www.irrawaddy.com/news/burma/mongla-official-denies-chinese-firm-permitted-set-autonomous-digital-economic-zone.html

18.Bertil Lintner. "Myanmar's Wa hold the key to war and peace" (2019/09/06). Retrieved from https://www.asiatimes.com/2019/09/article/myanmars-wa-hold-the-key-to-war-and-peace/

Data from the United States Geological Survey indicates that Burma (Myanmar) is one of the world's largest producers of rare earth minerals, behind only China, Australia and the USA. In 2018 it produced 5,000 metric tons. Rare earth minerals are used in an extremely broad array of devices, from smartphones to electric vehicle engines and satellites. See, Lin Hsin-Nan. "The United States still has these six alternative sources if China launched the rare-earth war" (2019/05/30). Retrieved from https://news.cnyes.com/news/id/4328873

19.Graham Parkes. "The Role of Rock in the Japanese Dry Landscape Garden", in François Berthier, *Reading Zen in the Rocks – The Japanese Dry Landscape Garden*, translated by Graham Parkes, the University of Chicago Press (2005), p. 89

來自山與海的異人

Charles Lim
SEASTATE SIX
2015, video, sound. 8min58sec
Courtesy of the artist

Zomia's high altitude and abundant rainfall during the wet season provide good conditions for the development of hydroelectric power plants. And cheap electricity attracts Bitcoin mines. This leads us to the second, vertical axis of our curatorial diagram, which concerns the water-cycle, the sea and the cloud. The Bitcoin mining process requires a large volume of electricity to enable a large number of host computers to run around the clock. Thus a new kind of water cycle can be seen. The water stored up in the ocean evaporates, then condenses into clouds, before falling back to the land as rain. This water volume, converted into electricity through hydropower generation in turn provides sufficient "computing power" to sustain a Bitcoin mine, where it "evaporates" again into a digital cloud. In this water cycle 2.0, clouds constituted by water molecules substantively transform into clouds of a digital nature—a new intermeshing of natural cycles with technology that reconfigures the political economy.

The digital cloud is not entirely virtual. Instead, it relies on a massive, material infrastructure that requires, for example, a variety of rare earth minerals and physical networks of submarine cables and satellites that keep global telecommunications operating. Currently, 380 submarine cables have been laid around the world, spanning a cumulative distance of 1.2 million kilometers. Be it Google or Facebook, 99% of the images and communications we send and receive pass through underwater optical fiber cables. *Alpha 3.9: silent clap of the status quo* (2016) by Charles Lim scrutinizes a submarine cable off the shores of Singapore. These cables lying on the seabed enable our so-called information society to function. In recent years, we have witnessed how they have been affected by tectonic plate movements. Earthquakes have damaged these cables and disrupted transnational internet transmissions. Just like the Bitcoin mines facilitated by the hydroelectric plants in the mountainous regions of Zomia, these submarine cables once again demonstrate the interaction of nature with the digital world.

A former competitive sailor who once represented Singapore at the Olympics, Lim's artistic practice is characterized by a profound engagement with the sea. This is apparent in his work *SEASTATE SIX* (2015), which can be interpreted as the relation between a "state" and the "sea," "a state of the sea" or "the state of the sea." We are reminded that the ocean is not only used for power generation, transportation, and oil and gas extraction, but it is also the site of numerous power games. Singapore is one of the world's top three oil refining centers, and is home to Southeast Asia's first underground (and undersea) rock cavern for the storage of crude oil, built on an artificial island formed from what was originally seven islets through a violent process of explosions and excavations.

In *The Classical Contents of the Mirror of Profound Depths*, an 18th century Chinese encyclopedia, the entry on stones reads: "The essential energy of earth forms rock [...]. Rocks are kernels of energy; the generation of rock from energy is like the body's arterial system producing nails and teeth. [...] The earth has the famous mountains as its support [...] rocks are its bones".[20] To contemplate a rock is to meditate on the fleetingness of one's own existence, just as contemplation of an external landscape allows one to visualise the flows within the inner landscape of one's body.

There are many stories that a rock can tell, just as there are many ways that rocks can tell stories. The best Chinese rocks, as the philosopher Graham Parkes tells us, "sound as well as look impressive: when tapped, it should give forth 'a clear tone' (reminiscent of the stone chimes used in Chinese court music)".[21] As participants in the "great central life" of the earth, rocks have a life that "unfolds in time sequences that are different from ours, yet which is also subject to the impermanence that characterises all things".[22] Such an expanded notion of time and history seems fitting for our moment—one of ecological catastrophe at a planetary level, because human influence on the earth has not only reached geological proportions, but does so in accelerated time. Thinking of this intertwining of the human and non-human has led to one of our central questions while preparing for this exhibition: **How can the unfinished project of Asian decolonisation be rethought through these entanglements?**

VII (De)Colonisation and (De)Synchronisation

Today, notions of progress, civilisation and development still linger when we hear the word "modernity", despite the fact that we know today it is "sustained on exploitation, dispossession of others, and on the depletion of Earth".[23] For the sociologist Rolando Vázquez, coloniality is the hidden dimension of modernity. And accompanying this historically unprecedented colonial appropriation of land, human life and non-human elements in America, Asia, Africa and Oceania was a control of representation. Through the regulation of knowledge, epistemologies and narratives, other (non-European) worlds

20.Graham Parkes. "The Awareness of Rock—East-Asian understandings and implications", in *Mind that Abides: Panpsychism in the New Millennium*, edited by David Skrbina, John Benjamin Publishing Company (2009), p. 328

21.Parkes. "The Role of Rock in the Japanese Dry Landscape Garden", p. 100

22.Parkes. "The Awareness of Rock", p. 338

23. Rolando Vázquez. "The Museum, Decoloniality and the End of the Contemporary" in *The Future of the New—Artistic Innovation In Times Of Social Acceleration*, edited by Thijs Lijster, Publisher Valiz (2018), pp. 185–188

來自山與海的異人

A different way of thinking about stones is also expressed in the creative method of Wang Si-Shun. In 2015 Wang drove a car across the Eurasian continent to France. Along the way he became keenly interested in rocks, and so began his *Apocalypse* (2015-ongoing) series, which he continues to today. These stones collected from all over the world comprise artworks. Others have been molded or digitally reproduced, but their images are all the original appearances of the rocks. These images have formed over hundreds of millions of years, having been compressed and broken in the course of geological movements. These rocks seem to have their own life history; their origins are far more ancient than humankind. According to Wang, his creative method intimates that people are only a part of the world or a kind of material, a viewpoint reflecting the cosmology of Zhuangzi in *On the Equality of Things* (4th century B.C.E.). This ancient Chinese perspective on nature is not built on a dichotomy between humanity and nature, but an understanding that all things are the way they naturally are.

With today's technology, the use of various kinds of sensors allows us to perceive the molecular structure of stones. This has initiated a more microscopic, non-anthropic vision. In *Fengtian Jade Garden* (2019), Chiang Kai-Chun collaborated with scientists to deduce the molecular chemical reactions that produce jade. The nephrite jade produced in the fault zones of Hualian in Taiwan has long been in circulation in Southeast Asia. Discarded objects made of Taiwanese jade dating back more than 2,000 years have been discovered in archaeological sites in the northern Philippines, southern Luzon Island, southern Vietnam and southern Thailand. Jade mining has only ceased recently in Hualian, due to high costs and the exhaustion of shallow veins. Based on his past experience of making mosaic artworks, Chiang became knowledgable about different kinds of stones, eventually gaining an understanding of their imperceptible molecular structures. Nephrite jade is a silicate mineral, which took shape in orogenic movements 6 million years ago, as magnesium derived from serpentinite, sodium silicate from black schist, and calcium from the region's marble underwent metamorphism in a high-pressure environment. This work acts out the process of crystallization that took place over millions of years through a procedure that takes place on a human time scale. The glass jars displayed in the exhibition space hold liquid sodium silicate, which reacts with various metallic salt solids to crystallize and form a chemical composition similar to nephrite jade. These green crystals floating in a transparent liquid reenact a microscopic geological event.

When Japan entered Taiwan with military force in 1895, it brought modern power and information with it, creating a new cultural and social order for its colony. Power over Taiwan's forests also fell into the hands of this emerging industrial nation. In the eyes of the colonizers, the colonial forests were an uncomprehended realm lacking the measurement and use of modern information. Their efforts to interject their instruments of power and the force of their knowledge into the forests they colonized, to achieve thorough control, imbued their science with a political nature. Shinpei Goto, Civil Affairs Director of the Governor-General's Office at the time, called for the local populace to increase their level of "scientific living," in concert with large-scale surveys and statistical projects. Through such methods of governance, he attempted to realize scientific, material happiness. Yet at the same time, the traditional relationships that originally existed on the island between the people and the forests, built on non-modern systems of knowledge and taboos, was viewed as being in an undeveloped state. When the colonizers rewrote the history of the forests that had belonged to the colonized, their motivation was not to learn the views the colonized held of the forest, but instead to employ information to construct a historical narrative that legitimized themselves, emphasizing the weakness of the traditional knowledge of the local residents. From this perspective, the process of modernizing forests has constantly excluded traditional forest customs and knowledge, and has thus gradually become flat and monodimensional.

of meaning were negated. In 1943, the Japanese philosopher Kitaro Nishida—founder of the Kyoto School had already seen this clearly:

> As a result of scientific, technological, and economic development, today each national people (kokkaminzoku) have entered into a single compact global space. The solution is nothing other than for each nation to awaken to its world-historical mission and for each to transcend itself while remaining completely true to itself, and to create a single world-of-worlds. [24]

This compacting of space was in turn accompanied by a mass synchronisation of global time under a single temporal regime. Other "regional" forms of times were banished, and replaced everywhere by "contemporaneity"—a "chronology in which the principle of novelty (immanence, futurity, contemporaneity) is privileged over relational temporalities". The "now", as Vázquez wrote:

> attains its definition through temporal discrimination. The "now" as a property of the self is defined through seeing the other as traditional, as passé, as backward, as a belated copy. Contemporaneity [...] rules over our experience in time and leads us into the oblivion of empty presence, confining us to the surface of a present that is reduced to presence. It establishes the empty present and the concurrent affirmation of the world as artifice, as the confinement of experience. Experience becomes akin to superficiality and emptiness. [25]

VIII Politics and the Void

In the early stages of our diagram's development, a placeholder tentatively named the "Subject" occupied the center of our working diagram. We had in mind the subject of a flatland, modern nation-state stretched apart on all sides by the various axes of the diagram. But what came before, and after the subject? The philosopher Alain Badiou described the subject as "what a truth transits, or this finite point through which, in its infinite being, truth itself passes or transits".[26] Neither a result nor an origin, the subject is merely the local status of the procedure, an instance of the void. The "proper name of being", Badiou tells us, is "the void, is inhuman and a-subjective".[27] The "subject"—like all the beings of every world—are compositions of the void.

24. Quoted from Christopher Goto-Jones. *Political Philosophy in Japan – Nishida, the Kyoto School and Co-Prosperity*, Routledge (2005), p. 97. See this book for a nuanced and balanced evaluation of Kitaro Nishida's implications—and distance from Japanese militarism.

25. Rolando Vázquez. "The Museum, Decoloniality and the End of the Contemporary", p. 192

26. Alain Badiou. "On a Finally Objectless Subject" in *Who Comes After the Subject?*, edited by Eduardo Cadava, Peter Connor and Jean-Luc Nancy, Routledge (1991), p. 94

27. Alain Badiou. *Being and Event*, translated by Oliver Feltham, London: Continuum (2006), p. 345

來自山與海的異人

In this context, Ting Chaong-Wen ponders the entangled connections between the imperial imagination and tropical diseases, by examining the Hoshi Pharmaceutical Company of Japan, which was active in Taiwan in the 1920s. It rose to prominence in Japan producing quinine, morphine and opium, and later established a timber plantation in Taidong to grow cinchona trees, used to produce the anti-malarial drug quinine. The work *Virgin Land* (2019) not only addresses the themes of colonialism and modernity, but also takes as a model the science fiction novel *Thirty Years Later*, published by Hajime Hoshi, the company's second-generation president. Hoshi was uninterested in the family business and devoted himself to writing science fiction instead. This book serves as a backdrop for the work, which seeks to enact a science fiction dystopia, invoking not only a different space, but also another time, in order to question the dominant narrative of modernism and its accompanying myth of progress.

In the summer of 2018, a junior football team became trapped in Tham Luang cave near the town of Mae Sai in Thailand's Chiang Rai Province. Their predicament became a moment of renewal for Thailand, on display for the whole world to see. This incident is the theme of Korakrit Arunanondchai & Alex Gvojic (with boychild)'s work *No History in a Room Filled with People with Funny Names 5* (2018). In the wide forests of the Zomia highlands, there are many oral stories and myths. This is a place without history, where the stories of many strangers have never been written, and this event of being trapped in a cave has the ring of a modern-day legend. Some of the work's images present a stage performance. The performers' bodily movements are suggestive of the mythical serpents called Nāgas in Thai animist tradition. The Nāgas are guardian deities of fountains, wells and rivers. They can bring rain, and the entrances leading to the subterranean palaces where they live are often believed to be located at the bottom of wells, lakes or rivers. After heavy rains a large volume of rainwater flowed into the underground river, blocking the exit to Tham Luang cave, as if a Nāgas were exercising control over this stretch of woods. During this crisis, Thai psychics, monks and phantoms assembled alongside scientists, American soldiers and multinational CEOs in a common effort to save the football team. And for this artist, this becomes a confluence of multiple spacetime configurations. This new legend may ultimately become a Hollywood script, it may enter the temples, or it may continue being passed from listener to listener, mutating over time.

Ting Chaong-Wen
Virgin Land
2019, tempered glass floor, ultraviolet light tube, neon lamp, raw material of cinchona tree, tonic water, multi-channel video. Dimensions variable
Courtesy of the artist
Commissioned by *2019 Asian Art Biennial* (Taiwan)

One of Lee Ufan's works from his *Relatum* series, which he created throughout the 1970s, consists of a pane of glass that has been cracked by a rock. The artist once explained in an interview: "If a heavy stone happens to hit glass, the glass breaks. That happens as a matter of course. But if an artist's ability to act as a mediator is weak, there will be more to see than a trivial physical accident. Then again, if the breakage conforms too closely to the intention of the artist, the result will be dull. It will also be devoid of interest if the mediation of the artist is haphazard. Something has to come out of the relationship of tension represented by the artist, the glass, the stone. It is only when a fissure results from the cross-permeation of the three elements in this triangular relationship that, for the first time, the glass becomes an object of art." This tension between people and objects, in which both retain their original states, awakens metaphysical perception and stands in opposition to the dross left over from the workings of the world.

In the place of the "void", we might well have suggested other names—for example, the Zen inflected concept of *Zettai Mu* (absolute nothingness) proposed by Kitaro Nishida, or the Buddhistic *śūnyatā* (emptiness) put forth by his student Nishitani Keiji. After all, concepts of nothingness or emptiness lie at the foundations of some of Asia's great thought systems.[28] It is also worthwhile to recall that the mathematical notion of zero and its operations were first defined by the Hindu mathematician Brahmagupta in 628 B.C.E. The Indian conception of zero, as the cosmologist John D. Barrow tells us, "possesses a nexus of complexity from which unpredictable associations could emerge without having to be subjected to a searching logical analysis to ascertain their coherence within a formal logical structure. In this sense the Indian development looks almost modern in its liberal free associations".[29] The sunya or the void is an unknown quantity, an empty space, also a place of infinite potentiality.

Yet it is this very liberality of meanings, this malleability, that has made the concept of the void in Asia so vulnerable to political (mis)appropriations and (mis)steps with grave consequences. One has only to look at the (mis) adventures of the Kyoto School of philosophers during the World War II when the colleagues and students of Nishida—armed with variations of his foundational concept of "absolute nothingness", were consciously or unconsciously implicated in the discourse of militarism. In a roundtable discussions by four scholars of the Kyoto School titled "The Standpoint of World History and Japan", the philosopher Kosaka Masaaki declared:

> While the worlds of East and West are cracking, while historicism remains trapped in its obstructed path, the absolute foundation that lies behind such a new force is beginning to show itself. I think that this deeper foundation, in all its newness, should be called "absolute nothingness"(Zettai Mu/ 絕對無).[30]

28. In the philosopher Georg Wilhelm Friedrich Hegel's lecture of Taoism, he mentioned: "We still have his [Lao Tzu's] principal writings; they are available in Vienna and I have seen them myself. One special passage is frequently quoted from them: 'The nameless Tao is the beginning of Heaven and Earth; with a name Tao is the Mother of the Universe (All Things) [...] To the Chinese what is highest, the origin of things, is nothingness, emptiness, the altogether undetermined, the abstract universal, and this is also called Tao [...]'". FW Hegel. *Hegel's Lectures on the History of Philosophy Volume 1*, edited and translated by Elizabeth Haldane, Routledge (1974), p. 125

29. John Barrow. *The Book of Nothing – Vacuums, Voids and the Latest Ideas about the Origins of the Universe*, Vintage Books (2002), pp. 36–37. This is reflected in the multiplicity of Indian words for zero, which includes: Abhra (Atmosphere), Akasha (Ether), Ambara (Atmosphere), Ananta (The immensity of space), Antariksha (Atmosphere), Bindu (A point), Gagana (The canopy of heaven), Jaladharapatha (Sea voyage), Kha (Space), Nabha (Sky, atmosphere), Pûrna (Complete), Randhra (Hole), Sunya (Void), Vindu (Point), Vishnupada (Foot of Vishnu), Vyant (Sky), Vyoman (Sky or space).

30. From roundtable discussion on November 26, 1941 between Kosaka Masaaki, Keiji Nishitani, Iwao Koyama, Masaaki Kosaka, and Shigetaka Suzuki. See David Williams, *The Philosophy of Japanese Wartime Resistance—A reading, with commentary, of the complete texts of the Kyoto School discussions of The Standpoint of World History and Japan*, Routledge (2014), p. 149. This was the first of three roundtable discussions published in the influential journal Chūō kōron (中央公論 , Central Review). These public activities meant to steer public opinions about the war were accompanied by a series of secret lectures and seminars with a faction of the Imperial Japanese Navy grouped around (former Prime Minister) Admiral Yonai Mitsumasa. In the beginning, the group was dedicated to preventing the outbreak of war. But when that was no longer possible, they decided that the next course of action required the overthrow of the Cabinet of Prime Minister Tojo Hideki (who was a General in the Imperial Japanese Army). These "secret" lectures are compiled in what has been known as the Oshima Memos. These were discovered in 2000, by the philosopher Ohashi Ryosuke in the house of the philosopher Oshima Yasumasa, who had passed away in 1989.

來自山與海的異人

Another work from the *Relatum* (2017/2019) series is composed of a rock, which has not been altered in any way, and a concave steel plate erected behind it. The external appearance of this series suggests associations with the European minimalism of the same era. Yet if we take a deeper look at the relationship between the artist and physical objects, we will discover they are informed by Eastern philosophy. We can trace this way of understanding rocks back to the rock gardens in Japanese-style courtyards. When a designer receives a commission, they often spend months searching for just the right stones. The rocks placed in the courtyard must be completely unaltered by human tools. The garden is composed entirely of stones and sand, so that when people admire it, they can also imagine the parts of the rocks buried under the surface of the garden, as if they are merely the tips of enormous boulders. This potent sense of depth enables one to "sense the power of the earth from a single decorative stone." Such rock gardens have often been used by Japanese monks as tools to aid meditation. Such a genius loci is reflected in the concept of a "place of absolute nothingness" postulated by the Kyoto School philosopher Kitaro Nishida, a religious experience of the void, which encompasses a "total experience" in daily life, in which the relationship between a human and the world precedes the relationship with perceived objects. Lee Ufan is attentive to the energy formed by the interaction of these objects and their surroundings, harking back to ancient Eastern philosophy and also leading us to ruminate on the state of affairs in age of the Anthropocene.

"How immense the universe is! How eternal history is! I wanted to measure its immensity with this tiny five-foot body. What authority has Horatio's philosophy? The true nature of all creation lies in one word – 'unfathomable.' With this regret, I am determined to die. Standing on a rock on the top of a waterfall, I have no anxiety. I recognize for the first time: Great pessimism is nothing but great optimism." This was the poem "Thoughts on the Precipice," written in 1903 by the Japanese middle school student Fujimura Misao, before he leaped to his death into the Kegon Falls. It had a huge impact on Japan's intellectuals of that time. Later, more than a hundred youths committed suicide there. Park Chan-Kyong's work *Kyoto School* (2017) presents images of Kegon Falls, alongside a series of farewell letters written by World War II kamikaze squad members before they set off on their missions: "Tomorrow, a believer in freedom and liberty will leave this world. His figure may look lonely as it goes into the distance, but I guarantee, his heart is full of contentment." (Written by Uehara Ryoji, May 10, 1945.)

Park Chan-Kyong
Kyoto School
2017, two-channel photography projection, and book
(*The Philosophy of Japanese Wartime Resistance: A Reading, with Commentary, of the Complete Texts of the Kyoto School Discussions of The Standpoint of World History and Japan* by David Williams).
Dimensions variable
Courtesy of the artist

The concept of "absolute nothingness" intuited by Nishida through Zen discipline, was a means to overcome the "East" and the "West". Posited as a concept that transcended the need for rational explanation and the reductive logic of "either/or", it was at once subjective and objective, a groundless ground on which a new edifice that could "overcome modernity" was to be erected. While it is beyond the scope of this essay to unpack the wartime intentions, strategies and effects of the Kyoto School, Nishida's use of the concept of nothingness was undoubtedly characterised by profound inconsistencies that had something to do with—to borrow a phrase from Barrow—the "liberal free associations" of a malleable void. Today, evidence exists that pointed to attempts by significant members of the Kyoto School to steer Japan away from the war—but largely only in relation to the conflict with the United States (which they knew they would not win). Their positions on Japanese aggressions in Asia were a far more ambivalent mixture of Pan-Asianist desires to free Asia from colonisation and an assumption of the Japanese right of "moral leadership" over the rest of Asia.[31] This strange, monstrous coupling of Zen Buddhism, nationalism, Pan-Asianism and militarism was not uncommon at the turn of 20th Century Japan.[32] The Zen scholar Suzuki Daisetsu Teitaro (later known to the West as D. T. Suzuki), a close friend of Kitaro Nishida and part of the extended circle of the Kyoto School, could find it in himself to proclaim:

> There is a violent country [China], and insofar as it obstructs our
> commerce and infringes upon our rights, it directly interrupts the
> progress of all humankind. In the name of religion, our country refuses

31. According to the Hong Kong philosopher Yuk Hui: "For Nishitani [Keiji], the question was: Can absolute nothingness appropriate modernity and hence construct a new world history that is not limited by Western modernity? [...] Nishitani's answer leads to a proposal for a total war as a strategy to overcome modernity, something that was taken up as the slogan of the Kyoto school philosophers prior to the Second World War. This is what I term a metaphysical fascism, which arises from a misdiagnosis of the question of modernity [...]". Yuk Hui. *The Question Concerning Technology in China*, Urbanomic (2008), p. 43

In this same book, Yuk proposes to reframe the question of modernity through the lens of "cosmotechnics", which he defined as "the unification between the cosmic order and the moral order through technical activities"; the task of philosophy is that "of seeking and affirming the organic unity of the two" (pp. 19–20). He proceeds to describe the cosmotechnics of China against the amoral, extractive one of the West. In his words: "The work in Chinese cosmology, one finds a sense other than vision, hearing, and touch. It is called *Ganying* (感應) literally meaning 'feeling' and 'response', and is often [...] understood as 'correlative thinking'; I prefer to call it resonance, following Joseph Needham. It yields a 'moral sentiment' and further, a 'moral obligation' (in social and political terms) which is not solely the product of subjective contemplation, but rather emerges from the resonance between the Heaven and the human, since the Heaven is the ground of the moral", p. 27

The "moral" undertone of the Chinese cosmotechnics described by Yuk reminds us somewhat of the right of "moral" leadership that so many Japanese intellectuals (and militants) assumed during WWII. And we would like to suggest that this intertwining of a cosmic "moral high ground" and the "groundless ground" of the void has made (and continues to make) for a deadly concoction in East Asian geopolitics.

32. Perhaps the anthropologist Eduardo Viveiros de Castro's analysis of the Tupinambá philosophy presents us with a different (and refreshingly "non-moralistic") cosmotechnical framework as a point of contrast. Of the Tupinambá's cannibalism of their enemies, Viveiros de Castro, described it as "an excess of sociability", emanating from their need for "identification" with enemies, "its self-determination through the Other, its condition of perpetual alteration". The philosophy of the Tupinambá was "not framed in terms of the category of belief, that this cultural order did not base itself on the automatic exclusion of other orders, and that this society did not exist outside of an immanent relation with alterity. What I am saying is that Tupinamba philosophy affirmed an essential ontological incompleteness: the incompleteness of sociality; and, in general, of humanity. It was, in other words, an order where interiority and identity were encompassed by exteriority and difference, where becoming and relationship prevailed over being and substance. For this type of cosmology, others are a solution, before being-as they were for the European invaders—a problem." Eduardo Viveiros de Castro. *The Inconstancy of the Indian Soul: The Encounter of Catholics and Cannibals in 16 century Brazil*, translated by Gregory Morton, Prickly Paradigm Press (2011), p. 47

These pilot were not yet 20 years old. These are two scenes from two different eras of young men facing death. Interspersed among Park Chan-Kyong's images of Kegon Falls is a round-table discussion of the World War II-era Kyoto School of philosophy—Iwao Koyama: "Yes, if we could carry world history and leap from the heights of the Japanese spirit into Kegon Falls, that would be a good thing." In their theory on death, the Kyoto School made reference to Heidegger's philosophical system, while also blending in Eastern religious philosophy. They married Heidegger's concept of Being-toward-death with the Buddhist view that we should not try to overcome death, but rather find release from life and death. This was a crucial element in the Kyoto School's view of Absolute Nothingness, which was not simply non-death, but a state of nonbeing, neither alive nor dead.

In terms of politics, the Kyoto School attempted to build an objective philosophy of a world with no center, advocating religious self-abnegation so that Japan could develop into an empire and also break the world order dominated by Europe and America. For them, the Pacific War was a war of liberation for the nations of Asia, and it was a direct confrontation between Oriental morality and Occidental morality. Ultimately, the loftiness of this morality fatally coincided with war and death.

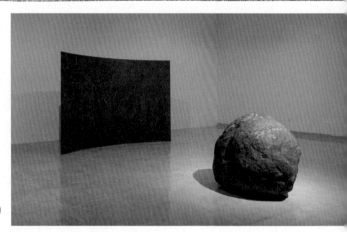

Lee Ufan
Relatum
2007/2019, iron (180×274×40 cm) and stone (73×73×72 cm)
Courtesy of SCAI THE BATHHOUSE, Tokyo

to submit itself to this. For this reason, unavoidably we have taken up arms. For the sake of justice and justice alone, we are simply chastising the country that represents injustice, and there is nothing else we seek. This is a religious action.[33]

This deadly intertwining of nothingness and violence—within a particular strain of Japanese mid-twentieth century Pan-Asianism—was, as the Buddhist scholar Robert H. Sharf observed, born out of the meeting of Chinese Ch'an [Buddhism] with the samurai culture of the Kamakura period. It manifested itself in the notion that only in Japan was Asian spirituality fully realised.[34] Yet if we lay aside its world transcending rhetoric, Zen was, no more or less than any other forms of thought, shaped by its historical context and drawn by the temptations of its time.[35]

IX The Traitor and the Void

Today, at a time of great geopolitical shifts, incessant technological revolutions and an ecological crisis on a planetary scale, we seem to be entering a void of a different kind. Existing ethical and political coordinates no longer seem to guide us—the political spectrum of the "left" and the "right" makes less sense than ever. Communist parties lead the way in making the most out of the free market, while on the ground, politicians of all stripes brazenly and routinely subvert whatever constitutions they are meant to uphold. In these moments of profound irregularity, the figure of the traitor emerges as the exemplary figure of our times.

The traitor's appearance today is manifold and multivalent. He or she can appear as defector, partisan, sleeper, mole, agent, saboteur, renegade, conspirator, whistle-blower or even critic.[36] But treachery is also contagious. Today, more than ever, we witness how the State, in its relentless pursuit of its enemies— be their "terrorist", "drug-traffickers" or "protestors", betrays the constitution through the violence of their responses and render themselves traitors. "Clandestine tactics and conduct", as media theorist Eva Horn wrote, "underlie

33.Quoted from Christopher Ives. "Ethical Pitfalls in Imperial Zen and Nishida Philosophy", in *Rude Awakenings – Zen, the Kyoto School, & the Question of Nationalism*, edited by James Heisig & John Maraldo, University of Hawaii Press (1995), p. 17. After the Japanese surrender, D. T. Suzuki would teach extensively in the US, where he influenced many, including, perhaps most famously, the avant-garde composer John Cage.

34.Robert H Sharf. "Whose Zen? Zen Nationalism Revisited", in *Rude Awakenings – Zen, the Kyoto School, & the Question of Nationalism*, edited by James Heisig & John Maraldo, University of Hawaii Press (1995), p. 48

35.As Sharf puts it, "those with a monastery to run, disciples to train, gods and emperors to appease, could not, when confronted with difficult moral and political questions, afford to shroud themselves in the cloak of "absolute nothingness". Sharf. "Whose Zen?", p. 51

36.The philosopher Jean-Paul Sartre described the condition of the intellectual as one of treason by definition. In Sartre's words, the intellectual lives in a "permanently traitorous condition, and the nearest he can come to 'authenticity' is by realising this and by choosing his treason". See Tony Judt. Past Imperfect French Intellectuals, 1944–1956, New York University Press (2011), p. 51

來自山與海的異人

Zuleikha Chaudhari
Rehearsing Azaad Hind Radio
2018, video, sound, mixed media. 40min12sec
Courtesy of the artist
Commissioned and co-produced by *Berlin Biennale for Contemporary Art*, with the support of the Goethe-Institute

Subhas Chandra Bose was an Indian nationalist and radical who fought for Indian independence. Aligning himself with Nazi Germany during World War II, he founded the Indian National Army and later took part in the Greater East Asia Conference led by Japan. With Japan's support he formed the Provisional Government of Free India, serving as its head of state. At different stages in his political career, he changed his personal identity to Mr. Ziauddin, Mr. Orlando Mazzotta, Mr. Matsuda, Mr. T, and Mr. Netaji. He is said to have perished in an airplane crash at Songshan Airport in Taipei in 1945 as he was preparing to travel to Tokyo. From the viewpoint of the Allied Forces in World War II, Bose's series of political actions were incomprehensible. This highlights the intractable connections among Asia's colonial history, nationalist governments, and the Cold War framework.

At one point Bose produced a series of programs for Free India Radio (Azaad Hind Radio), and these historic recordings became the starting point for the work of artist Zuleikha Chaudhari. She constructed the scene of a radio recording studio and reenacted radio segments with the help of different actors. When acted out on stage, the many complicated aspects of Bose's personality split into different characters. This process was not an act of historical revision, but a work of imaginative reconstruction. Her film presents the dress rehearsal process, including the actors' musings, mistakes and failures. Much like the dilemmas faced by nationalism at that time, we see that both the actors and the characters they play exist in a state of hesitation and reflection before moving forward.

every aspect of social behaviour [...]. Role-playing, disguise, and betrayal are part of the modern individual's social and erotic survival techniques".[37]

But the "Traitor", understood in the strongest sense, "is the human manifestation of a political landscape marked by obscurity, abstraction, and lack of transparency, a crisis of both community and enmity".[38] In a political structure no longer defined

> by clear-cut front lines between friends and enemies [...,] treason, apostasy, going rogue, are the epitome of irregular conduct, a breaking of rules intent on opening up a space for different forms of allegiance and alternate political choices. The traitor or apostate is both the victim of and the solution to a political crisis that consists in the tragic impossibility of allegiance. The traitor is the one who leaves his or her nation, ideology, religion, or scientific community behind.[39]

To critique and to act upon one's critique requires a crossing of lines, and the breaking of ranks, either with one's own community, or a moral schema. But is there a limit to this process? And if so, who sets these limits, and according to which criteria? Is there any way by which we can ensure that we are not plunged headlong and too quickly into the Void? At moments like this, it might be useful to return, rethink and repurpose the Void in certain Asian thought systems. This brings us to the next question we had in the formulating this exhibition: **How can we think creatively and ethically of the void, and in the void?**

X Bottomless Bottoms and Strange Strangers

Variations of this question seemed to have been posed through the long march of Taoist inflected thought through time. For example, in the "Dark Learning" (*xuanxue*) of the Wei-Jin period (220 to 420 B.C.E.), nothingness was thought of as both a space of emergent possibilities (liberty) and nihilism (libertinage). The political scientist John Rapp, writing about the relationship between anarchism and Taoism, described this as a shift of emphasis from *tao* (path or way) to *wu* (nothing or nothingness) or *wuming* (the nameless) as the key term. The difference is one of saying 'everything exists as an interdependent whole of which we are a part' to those saying that 'nothing exists', which Rapp further co-related as a shift from anarchism to nihilism.[40]

37. Eva Horn. *The Secret War – Treason, Espionage, and Modern Fiction*, translated by Geoffrey Winthrop-Young, Northwest University Press (2013), p. 40

38. Horn. *The Secret War*, p. 64

39. Horn. *The Secret War*, p. 69

40. See John A Rapp. *Daoism and Anarchism – Critiques of State Autonomy in Ancient and Modern China*, Continuum (2012), pp. 31–32. Rapp suggests: "As for the question of science and technological progress, here again we can turn to Needham, who sees the Taoists as representatives of 'anti-feudal' forces and who criticised the use of technology to build up new forms of oppressive rule while at the same time maintaining within their thought a 'proto-scientific' element of opposition to all authority and a desire to observe the universe without preconditions, as we saw above in the satirical version of a cybernetic view of the human body in the second, inner chapter of the Chuang Tzu."

來自山與海的異人

Like the notion of a stranger, a traitor is a relative concept. It is someone who does not fit within the existing ideological framework. When we ponder such ambiguous roles, the questions we might consider that: Who made these frameworks? And how were they made? Koh Bunya (Jiang Wenye), a musician born in Taiwan during the Japanese colonial era, experienced just such an intense clash of identity. In the 1930s, he began to make a name for himself in the Japanese music world. After World War II, he moved to China to teach, but because of his former friendliness toward Japan, he was labeled a cultural traitor. Likewise, because he had previously won an award in Germany for his composition *Taiwanese Dance*, he was associated with fascists and considered right-wing. Crossing national borders in East Asia, he met with political hostility and suffering.

The special nature of his music seemed to be anchored to neither Taiwan nor Japan nor China. His attitude can be more fully understood from an article he wrote on dynastic-era music. In *A Study of Formal Music of Ancient China*, he presented evidence that Confucius was an accomplished musician, and his *Movement for the Main Hall of the Confucius Temple*, was a modern orchestral composition adapting traditional music honoring Confucius. The Confucian utopian concept of the "Great Togetherness" was ingrained in his music, and national identity was an idea Koh had ceased to consider.

His most famous piece, *Egret Fantasia*, was set in Taiwan, and his final composition was *Song of Alishan*. His drive, which arose from being an outcast, transcended the confines of nationality. After experiencing political misfortune, the last thing he wrote before passing away were these words: "Keep struggling. Use up your last drop of energy, and then collapse. Give yourself back to the great earth...I have always believed that the blood of that beautiful *island of the egrets* was incomparably admirable. I was born embracing it, and so shall I die."

Wang Hong-Kai
This is no country music
2019, workshop, multi-media installation. Dimensions variable
Courtesy of the artist
Commissioned by *2019 Asian Art Biennial* (Taiwan). With the support of National
Taiwan Museum of Fine Art, National Taichung Theatre and Earthquake-Disaster
& Risk Evaluation and Management, National Central University

This thought of the "interdependent whole" brings us to the "mesh" of Timothy Morton's "ecological thought", described as one of "interconnectedness between a multitude of entangled strange strangers".[41] In Morton's words:

> At the "bottomless bottom", subjectivity is an infinite void. When I encounter the strange stranger, I gaze into depths of space, far more vast and profound than physical space that can be measured with instruments. The disturbing depth of another person is a radical consequence of inner freedom. It's a mistake to think that the mesh is "bigger than us". Everything is intimate with everything else. The ecological thought is vast, but strange strangers are right next to us. They are us. Inner space is right here, "nearer than breathing, closer than hands and feet".[42]

Hospitality to strangers is an age-old adage of many cultures. We follow this not only because we can welcome the strangers who bring us news, and the "new" from the "outside", but also because this "outside" is always already there, in the deepest folds of our "inside". To encounter strangers is be estranged. And to be estranged is to put in touch with and to communicate with the stranger inside us. This strange stranger may offer us a gift, and this might be the gift of ontological and epistemic humility—the notion that "we" are not the centre of a diagram of our own making, that we are no longer the central subject of history. Sometimes, this may amount to what seems like treachery—the need to go against the grain of received opinions, the mores of our society, the laws of our state and even what might seem like the will of our species. But perhaps what we may gain from this voiding or emptying out, this de-linking and de-synchronisation, is first, a freedom, and second, a new world of possibilities in which we can enter new alliances . To participate in strange couplings and engender new relationships that will increase the thickness of our world and enable new powers—to become active, which is also to say, to affirm, to be on the side of becoming, on the side of those to come. To emerge, to create.[43]

41. Timothy Morton. *The Ecological Thought*, Harvard University Press (2012), p. 15

42. Morton. *The Ecological Thought,* p. 78

43. And here, we will like to add "to select". We mean this in the sense of the philosopher Gilles Deleuze (speaking through Friedrich Wilhelm Nietzsche): "a becoming-active can only be thought as the product of a selection. A simultaneous double selection by the activity of force and the affirmation of the will. But what can perform the selection? What serves as the selective principle? Nietzsche replies: the eternal return. [...] We have noted that the eternal return, as a physical doctrine, was the new formulation of the speculative synthesis. As an ethical thought the eternal return is the new formulation of the practical synthesis: whatever you will, will it in such a way that you also will its eternal return. 'If, in all that you will you begin by asking yourself: is it certain that I will to do it an infinite number of times? This should be your most solid center of gravity'." See Gilles Deleuze, *Nietzsche and Philosophy* (translated by Hugh Tomlinson), Continuum, (reprinted in 1992), p. 68

來自山與海的異人

This Is No Country Music (2019) by artist Wang Hong-Kai engages in a dialogue with the trajectory of Koh Bunya's music. Koh is said to have composed a piece called *Earthquake Relief Song* for the massive Taichung earthquake of 1935, but no score or recording has survived. Wang's art project takes the search for this lost composition as a point of departure, studying both the cosmic and nativist elements in Koh's music. In a series of workshops held in cooperation with an earth scientist, Wang revisited different locations and historical sites, using modern geological exploration technology to read the fault lines covered over by the earth's surface. This process not only peered through the prism of Koh Bunya's life to question the framework of nationalist ideology, but also advanced a framework that transcends the human perspective of time and space.

The diagram that we have been elaborating is neither a theoretical model nor a storyline. It was a tool we made in order that we can make a stage (an exhibition) to be inhabited, and activated by the works, thoughts and presences of artists, thinkers and collaborators. If we are unable to provide answers for the many pressing questions Asia is facing now, we hope that we are able to reframe some of these questions, to widen the outline of interpretation with new chains of relations, and thus expand the possibilities of response.

Deleuze–Nietzsche also reminds us: "Power is therefore not what the will wants, but on the contrary, the one that wants in the will. And 'to want or seek power' is only the lowest degree of the will to power, its negative form, the guise it assumes when reactive forces prevail in the state of things. One of the most original characteristics of Nietzsche's philosophy is the transformation of the question 'what is…?' into 'which one is…?' For example, for any given proposition he asks 'which one is capable of uttering it?' Here we must rid ourselves of all 'personalist' references. The one that…does not refer to an individual, to a person, but rather to an event, that is, to the forces in their various relationships in a proposition or a phenomenon, and to the genetic relationship which determines these forces (power). 'The one that' is always Dionysus, a mask or a guise of Dionysus, a flash of lightning. relationship expresses itself in the dynamic qualities of types such as 'affirmation' and 'negation'." See Deleuze, *Nietzsche and Philosophy*, p. xi

在文本之外

協同研究

——

林怡秀

在本屆亞洲藝術雙年展「來自山與海的異人」規劃前期，兩位具有藝術家身份的策展人即對「展覽」的形貌進行非典型的想像，在做為展覽藍圖的矩形圖表中，最初的展覽概念由「異人」（strangers）所指涉的「他者」開始，將山與海的空間關係拉伸到贊米亞（Zomia）與蘇祿海（Sulu Sea）兩處指涉地理棲位與域外政治的座標，經由無法以單一國族概念劃定的區域進一步討論亞洲地區地緣政治的問題，以及在此之中、那些不容於主流歷史與意識型態的異人（如流亡者、少數民族、孤軍、海盜、叛徒等），接著再透過雲端與礦物非人視角，進行超越人類尺度的時空回看，通過靈、人工智慧、神怪、外星人等非人，描繪出人、物與科技之間複雜的關係樣態。這兩條交錯的軸線使這個原本繪於平面上的圖表，在某種程度上被轉化為如壇城（Mandala）般涵括了非線性時間、空間與本質的立體結構。策展人表示：「這個圖表既不是理論模型也不是故事線，它是我們製造出來的工具，是一個讓藝術家、研究者和合作者的作品與想法能夠棲息的舞台。」

而在這樣的研究方法下，他們進一步提出：「在作品的觀看與展示之間是否有其他可能？」這個提問形成了展場設計時，在參展藝術家作品之外加入旁側「註腳」（Footnotes）的想法，策展人試圖在展場中延伸出不同的對話可能。這項溢於作品之外的計畫，策展人在策劃前期即邀請筆者以協同研究者身份共同參與、對此概念展開討論，並邀請藝術家黃思農加入，與筆者分別以聲響、文字的方式介入展覽敘事，黃思農藉由「漫遊者劇場」（Flâneur series）的聲音敘事、虛構文本，介入策展概念的矩形圖表，從「聽覺」及「行走」的身體感知，創造了自外於展覽作品脈絡的敘事，藉以改變觀眾與藝術品之間的觀看／展示關係，筆者則以外部編輯的概念，重新延展藝術家作品中提及的各種線索，「再寫」與「並置」不同文本，使觀眾得以自行在觀看過程中，架構出外於官方說法的作品想像。

註腳・文本外的閱讀

將殘篇斷語從原有的上下文中撕裂開來，以嶄新的方式重新安置，從而引語可以相互闡釋，在自由無礙的狀況中證明它們存在的理由。[1]

在展場內置入註腳、或將展間內容轉換為檔案室的類似想法，亦曾於 2018 年光州雙年展「想像的疆界」（Imagined Borders）七個子題之一的「返回」（Returns）展區中出現。在這個子題展區中，策展人鄭大衛（David Teh）以「走入雜誌」（walk-in magazine）的概念展示了 1995 年以來大量關於光州雙年展的相關檔案（展場設計為藝術家何子彥）。而在 2012 年由安森・法蘭克（Anselm Franke）所策劃的台北雙年展「現代怪獸／想像的死而復生」（Modern Monsters ／ Death and Life of Fiction）裡，則可觀察到策展人藉由展櫃的系統性設計，及展示與參展藝術家作品內容有關的外部檔案，在視覺整合與創作議題上進行對話。

註腳展出現場

由此回到「來自山與海的異人」的規劃，聲響與閱讀兩種形式的註腳置入，一方面提供作品的延伸背景、回應藝術家在特定脈絡下的相關思考，使觀眾更能理解作品創作的脈絡，另一方面也與美術館建築空間原有的限制有關，策展人許家維對此表示：「國美館內部的空間很分散，以美術街展區為例，過去的做法多半是搭建假牆，將形狀畸零的建築空間隔成白盒子，但在面對當代的裝置性作品時便需要重新考慮空間的問題。我們這次決定將假牆拆開、露出建築原本的樣貌，但也因為如此，我們需要某種在展場中不斷出現的元素去串起各個空間，這個動作同時也是在引導觀眾『如何閱讀空間』這件事。」何子彥認為：「亞雙展的中型規模有助於開創性的實驗，不只在於主題的探索上，也包括一個展覽如何被設計，而註腳的規劃就是這樣的嘗試成果。」相較於前述其他展覽的做法，許家維與何子彥進一步拓展了註腳在字面上的原始功能，改以平行於展覽及展場設計的尺度進行規劃，最後以四個獨立展覽室呈現圖文閱讀，而在聲音的設計上，兩位策展人的想法是試圖取代美術館本身原有的語音導覽系統，以黃思農自 2016 年開始發展「漫遊者劇場」的創作方法，藉由一連串虛構的聲音敘事引導（或改變）觀眾在展場中的身體移動與觀看。

展場規劃由前述的矩形圖表所指涉的內容展開，以四個相互關聯的章節概念呈現並分類此次參展的 30 組藝術家作品：第一展區（Zone 1）及第二展區（Zone 2）體現了人的歷史與山、海、雲、礦之間的交匯，第三展區（Zone 3）涵括人與物的變形與轉換，第四展區（Zone 4）則鎖定於超越既有認同框架之人。而穿插在展場中的四個「註腳」空間，在書寫的前期研究中也以四組對應藝術家作品的關鍵詞群進行發想（贊米亞、自然與工業物件、比特幣、罌粟、物派；蘇祿海、陸地與海洋政權、薩滿、南太平洋故事、裕廊島；物的變異、鐘與大砲、閃玉、淘金熱；地震、邊境、叛徒、神風特攻隊、奎寧），由此回應策展人的作品分區，藉由多則與作品有關、但不直接對其內容進行描述的研究筆記與延伸資料構成整體的書寫內容。

在註腳對作品背景脈絡的延伸文字中，原本由策展矩形圖表所繪出、相對抽象的時空方位，在此也進一步套疊到真實地圖上的環太平洋火山帶（Ring of Fire）、金三角（Golden Triangle）、19 世紀中葉以來的東南亞海上貿易與政治活動、兩次世界大戰以來所影響的各類版圖等位置，策展論述中所關注的「再次思考亞洲未曾完成的解殖計畫」，在這些資料交織出的時空背景裡也顯得更為清晰。除了文字內容涉及的歷史事實之外，若從本次註腳區的圖片來源進行觀察，無論是大量來自美國海軍歷史及遺產司令部（Naval History and Heritage Command）、大英／紐約

1. 漢娜·阿倫特，〈瓦爾特·本雅明：1892-1940〉，《啟迪：本雅明文選》，三聯書店（2008），65 頁。

公共圖書館資源、日本在 1945 年之前對臺灣地質與熱帶植物的現代化觀測研究內容等，皆可瞥見過去在戰爭與殖民時期，帝國之眼對亞洲的觀看視線，以及地區之間因戰火、貿易與政治等因素而相互串連的隱微關係。

聲音劇場．隱匿的事件

> 如果抽象的「理性」（Vernunft）觀念回溯到動詞「感覺、視聽」（Vernehmen）的原意——那麼，可以想像的是，一個來自上層領域的詞可以回覆它的感性基礎，或者反過來說，一個概念能轉化成一個隱喻，條件是「隱喻取其原有的、非寓言的含義『移置』（transfer）。」這是因為一個隱喻建立了一種可直接感受、無需詮釋的關係。〔……〕自荷馬（Homer）以降，隱喻就一直乘載著傳達認知的詩性因素，它建立了在物理上天壤之遙事物間的感應。〔……〕隱喻是世界渾然一體得以詩意地呈現的途徑。[2]

在展場內實體的註腳空間之外，藝術家黃思農的聲音導覽作品〈第一個夢〉的內容也由策展概念的矩形圖表出發，由此延伸出關於「山、海、異人、夢境」的四段音景敘事。〈第一個夢〉整體劇本的最初構思，來自黃思農一位香港友人告訴他的真實故事，他改編了這則故事發生的時間與畫面內容，假想一個發生在今年十月（與亞雙展同時），位於越南山區森林中的噪音藝術季。這場幾乎還沒正式開始就被軍方控制的荒謬活動，構成了這個作品的聲音敘事起點、引導觀眾自展場服務台逐步穿越美術街的〈異鄉樂人〉段落。這則指涉當下時間的敘事，最後收束在角色所在的位置：香港。在背景音景與角色的獨白中，觀眾所在的環境將從美術館展場直接連結到今年年初至今騷動未歇的反送中事件。

談及這次的劇本構思，黃思農表示：「其實回過頭來，這個作品是關於如何思考『疏離』這件事，去製造一個為了讓觀眾感到疏離的導覽。這些是從我自己看展的經驗而來，有時候，作品的語境與我而言似乎不是這麼重要，作品反而可能是觸發觀者想到個人記憶的某種媒介。」這組具有明確時空感的〈異鄉樂人〉之後，黃思農再由此延伸出描述 20 世紀初贊米亞地區先知運動，從過去時間看向未來的〈先知〉；近未來一座島

註腳展出現場

2. 漢娜・阿倫特（Hannah Arendt），〈瓦爾特・本雅明：1892-1940〉，《啟迪：本雅明文選》，三聯書店（2008），33 頁。

〈第一個夢〉手稿筆記（攝影：黃思農）

嶼上能目及千里的異能者，可以看到未來時間的〈島嶼少年〉兩個故事段落。這三段聲音敍事以當下、過去、未來的時空設定書寫劇本內容，對此，黃思農談到：「三段敍事的時間彼此互相指涉，構成了一組循環時間而非線性的時間，這個文本策略結合了策展人的矩形圖表，去拉出一組潛藏的虛構文本。」

在與另一位編劇陳雅柔合寫的文本中，他們藉由可以望向未來時間的〈島嶼少年〉段落回看展覽的時空，以部分銜接藝術家作品內容的虛構敍事回應現場。但同時，他們也適度地避免直接將作品的視覺性描述放入劇本旁白內，而是以敍事文本的內容去交織出觀眾所見的畫面。〈先知〉的內容則是較為後設的對應，黃思農在故事中虛構出另一個與贊米亞有關的展覽與一位正要去與策展人開會的展覽顧問，並擷取異端基督教、苗族、高地少數民族神話、死海古卷（Dead Sea Scrolls）等內容，揉合成另一個半虛構的東方文化環境。在〈先知〉段落中，黃思農引用了斯賓格勒（Oswald Spengler）在歐洲歷史中辨認出阿拉伯文化時，曾經使用「贋形體」這個礦物學名詞來稱呼這個現象的過程，劇中角色說到：「這個詞的原意是說某個礦物層中的結晶體，由於地質原因消失，留下來的空間塑造了填補這個空間的新材料，使這些新結晶具有舊的外型，斯賓格勒於是進一步延伸，就像新的阿拉伯文化填進古典文化留下的空隙，不得不以古典文化表述自己，但實質上卻是一種新文化，是『文化的贋形體』。」在此，「文化的贋形體」其實也隱隱指向此次亞洲藝術雙年展的整個內容主題，以及亞洲之眾如何在前者留下的結構裡進行自我的創造性描述。

在此次受邀製作的聲音導覽作品裡，黃思農更在意的是展場與觀眾動線的狀態。相對於過去傳統的環境劇場或視覺藝術所強調的展示性與對空間的佔領，漫遊者劇場所構築出的內容反而在環境中匿藏，因為聲音不具形體，除非你戴上耳機，否則無人知道正有一場事件在空間裡發生。這樣的演出並不是以演員的表演去佔據空間，而是企圖改變人們早已習慣的觀看方式，藉由與言語及聲音的置換，原本隱藏在文本之外的不可見者，得以被賦予可被感受的形象，進而被體驗、化出可觸的肉身。

做為聲音導覽最後一段，〈島嶼少年〉由205展覽室帶領觀眾往左方動線移動，在穿越一樓展覽室後緩步走出館外。此時，我們透過這位能目及千里的少年之眼，回到最初從美術館服務台步入展場時，所感受到的那個融解於城市燈火的時刻：「我也看過好大一群人撐著傘，站在高架道路上，可是沒有下雨。對面有另一群人穿著制服，拿著盾牌一步步向他們逼近。有人踩到別人的腳跌倒了，身邊穿著短褲的女孩子把他扶起來。我不太明白為什麼一個小小的寶特瓶會帶我看到這個時刻，不明白裡面的水為何不是拿來喝而是沖洗眼睛。周圍是好高、高到離譜的密密麻麻的大樓，這些人還不知道才沒過幾十年，這些巨大的建築就會一一倒下，已經沒有人在那邊。」島嶼少年說。

Outside the Text

Research Collaborator ———— Lin Yi-Hsiu

During the planning phase of the *2019 Asian Art Biennial: The Strangers from beyond the Mountain and the Sea*, the two curators, who are artists by profession, began to imagine this 'exhibition' in an atypical manner—by drafting a diamond-shaped diagram to serve as the exhibition's blueprint. In it, they placed their initial curatorial concept: 'strangers'. Then, as an extension of the spatial relationship between the mountains and the sea, they placed two coordinates that signify geographical niches and extraterritorial politics: Zomia and the Sulu Sea. Through these regions that cannot be demarcated by the concept of a single nationality, they initiated a closer look at the geopolitical issues of Asia, as well as the outsiders who live there and do not fit within mainstream history and ideology (exiles, ethnic minorities, isolated forces, pirates or traitors). Then, through the vantage point of non-human elements—clouds and minerals—they considered time and space beyond the human scale, channeling non-human entities such as ghosts, artificial intelligence, gods, monsters, and extra-terrestrials to depict the complex state of relations among people, objects and technology. To a certain extent, these two crossing axes transform this diagram, originally drawn on a flat surface, into a three-dimensional structure encompassing non-linear time, space and essence, like a Mandala. The curators state: 'The diagram is neither a theoretical model nor a storyline. It is a tool we made in order that we can make a stage to be inhabited, and activated by the works, thoughts and presences of artists, thinkers and collaborators.'

With this method of inquiry, they asked further: 'Are there other possibilities that lie in between viewing and displaying a work?' This question suggested an idea: to design the exhibition with 'Footnotes' placed alongside the artworks, thus introducing new opportunities for dialogue within the exhibition space. In the early stages of the curatorial process, the curators invited the writer to take part in the capacity of assistant researcher and engage in discussion about this concept, so that this plan could overflow beyond the borders of the works. They also asked the artist Snow Huang to take part, so that he and the writer could interject new perspectives into the exhibition narrative, in the form of sound and words, respectively. Snow Huang added the sound narratives and fictional texts of his *Flâneur series* to the diamond-shaped diagram, using the bodily perceptions gained from listening and walking to create a narrative external to the context of the exhibition. By altering the relationship of viewing/display between the visitor and the artworks, the writer employed the concept of external editing to create new extensions of the various threads presented in the artists' works, rewriting and juxtaposing different texts, so that in the process

of viewing, visitors could imagine the artworks in their own way, outside the framework of the official story.

Footnotes installation view

Footnotes: Extra-Textual Readings

The main work consisted in tearing fragments out of their context and arranging them afresh in such a way that they illustrated one another and were able to prove their raison d'etre in a free-floating state.[1]

The idea of placing footnotes in exhibition spaces, similar to transforming a gallery into an archive room, appeared in *Returns*, one of seven exhibitions that made up the *2018 Gwangju Biennale: Imagined Borders*. In that exhibition the curator David Teh used the concept of a "walk-in magazine" to display the many articles about the *Gwangju Biennale* that had been published since 1995 (the artist Ho Tzu-Nyen contributed to the design of the exhibition space). And in the *2012 Taipei Biennial: Modern Monsters / Death and Life of Fiction*, the curator Anselm Franke systematically designed display cases to present an external archive related to the content of the participating artists' works, thus engaging in dialogue with the exhibition's overarching visuals and creative themes.

This brings us back to the planning of *The Strangers from beyond the Mountain and the Sea*. Inserting two forms of footnotes, sound and text, provides elaboration on the backgrounds of the works and responds to the artists' own thoughts in a specific setting, so that the audience can better understand the milieu of the artworks. Moreover, it is related to the inherent spatial limitations of the museum's architecture. Curator Hsu Chia-Wei notes: 'The space inside the National Taiwan Museum of Fine Arts is very scattered. In the museum's Gallery Street, for example, it has usually been the practice in the past to build partition walls, dividing this nearly shapeless architectural space into white boxes. But with the introduction of contemporary installations, the problem of space needs to be reconsidered. We decided to remove the partition walls and reveal the original appearance of the building. But this necessitated an element in the exhibition space that would provide continuity. Doing this also gives visitors direction on "how to read the space"'. Ho Tzu-Nyen believes: "The moderate scale of the *Asian Art Biennial* favours adventurous experiments, not just in terms of the theme that can be explored, but also in terms of how the exhibition is designed. Developing footnotes is the result of one such experiment.'

1. Hannah Arendt 'Walter Benjamin: 1892-1940', *Illuminations: Essays and Reflections*, tr. by Henry Zohn (HMH, 1968), p. 47

Compared with the other exhibitions mentioned above, Hsu Chia-Wei and Ho Tzu-Nyen took the idea of footnotes literally, deploying them in their original function. They designed the scale of the footnotes in parallel with the exhibition and the galleries, ultimately presenting the prints for reading in four separate rooms. For the design of the sound, the idea of the two curators was to replace the museum's original audio guide system. In 2016, Snow Huang began to conceptualise his *Flâneur series*, using a series of fictional sound narratives to guide (or alter) the visitor's bodily movements and viewing behaviour in the exhibition space.

The exhibition spaces were planned to unfold in reference to the aforementioned diamond-shaped diagram, categorizing the 30 sets of works in the exhibition according to the concept of four interrelated chapters. The first area (Zone 1) and the second area (Zone 2)were to present the convergence of human history with mountains, seas, clouds and minerals. The third area (Zone 3) considered the mutation and transformation of both humans and objects, and the fourth area (Zone 4) centred on people who have transcended their existing framework of identity. Woven into the entire exhibition were 'Footnote' spaces. In the early stages of their writing, they were conceptualised according to

clusters of key words, which responded to the works and corresponded to the curators' division of the works (Zomia, natural and industrial objects, Bitcoin, poppies, Mono-ha; Sulu Sea, land and sea hegemony, shamanism, tales of the South Pacific, Jurong Island; the metamorphosis of matter, clocks and cannons, nephrite, gold rushes; earthquakes, borders, traitors, kamikaze squads, quinine). The overall content of the footnotes developed from numerous research notes and elaborative materials related to the works but not directly describing their contents.

In these footnotes expounding on the context of the artworks, the relatively abstract time/space coordinates originally sketched out in the curators' diagram were overlaid with coordinates from real-world maps, such as the Ring of Fire, the Golden Triangle, maritime and political activities in Southeast Asia since the mid-19th century, and the various domains of influence since World War I and World War II. In the spatial-temporal background formed by the interweaving of this information, the issue of 'rethinking the unfinished project of Asian decolonization' that stands as a key note of concern in the curatorial statement comes into clearer focus. In addition to the historical facts that the texts reference, the images contained in the footnotes—whether they are obtained from the archives of the Naval History and Heritage Command, the British Library, the New York Public Library, or Japan's pre-1945 studies of Taiwan's geology and tropical plants as part of their modernization program—all reveal subtle interconnected relationships

arising from war and colonialization, connecting such elements as the imperial view of Asia, inter-regional strife, trade and politics.

Sound Theatre, Concealed Events

If the abstract concept Vernunft (reason) is traced back to its origin in the verb vernehmen (to perceive, to hear), it may be thought that a word from the sphere of the superstructure has been given back its sensual substructure, or, conversely, that a concept has been transformed into a metaphor—provided that 'metaphor' is understood in its original, nonallegorical sense of metapherein (to transfer). For a metaphor establishes a connection which is sensually perceived in its immediacy and requires no interpretation...Since Homer the metaphor has borne that element of the poetic which conveys cognition; its use establishes the correspondences between physically most remote things...Metaphors are the means by which the oneness of the world is poetically brought about.[2]

In addition to the physical footnote spaces in the galleries, artist Snow Huang's sound audio guide *The First Dream* is also based on the diamond-shaped diagram's expression of the curatorial concept, presenting four soundscape narratives regarding 'mountains, sea, strangers and dreams.'

The initial concept for the overall script of *The First Dream* came from a true story told to Huang by a friend from Hong Kong. He changed its time and setting, imagining that it takes place at a noise art festival in the mountain forests of Vietnam in October of this year (the same time as the *Asian Art Biennial*). When the festival has barely got started, it is brought under control by the army. This absurd event comprises the plot of *The Stranger*, the first segment of the sound narrative, which guides visitors step by step from the service desk through the Gallery Street. It references the narrative taking place in the current moment but ends in the place where the main character lives: Hong Kong. The background soundscape and the character's monologue directly link the environment of the art museum where the visitor is located to the protests against China's intervention in Hong Kong's

Footnotes installation view

2. Ibid., pp. 13-14

autonomy that have been raging non-stop since the beging of 2019.When speaking of the inspiration for the script, Snow Huang says: 'Actually, looking back, this work is about how to think about alienation, to produce an audio tour that makes the visitor sense alienation. This comes from my own experiences looking at exhibitions. Sometimes, the linguistic framing of the artworks doesn't seem all that important to me. The art may in fact serve as a vehicle that triggers a personal memory of in audience'.

Following *The Stranger*, which is clearly grounded in time and place, Huang broadens out with two story segments. *The Prophet* stands in the past and gazes toward the future, depicting a prophetic movement of the early 20th century in the region of Zomia. In *A Young Islander*, a person with psychic powers living on an island in the near future can see distant places and future times. The temporal settings of these three sonic narratives— the present, past and future—form the content of the script. Huang remarks: 'The three narratives reference one another in terms of time. They form a system of cyclical time and non-linear time. This textual strategy integrates the curators' diagram to tease out a latent fictional text.'
Through this segment on an *A Young*

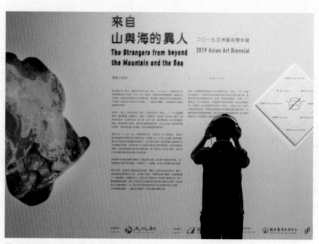

The First Dream installation view

Islander who can see into the future, Huang and his scriptwriting collaborator Yarou Chen look back in time on the exhibition, with a fictional narrative partly connected to the content of the artists' works. Yet they are also careful to avoid directly inserting descriptions of the artworks' visuals into the script narration, which would interweave the content of their narrative with the visuals the visitors see.

The content of *The Prophet* relies more heavily on meta correspondence. In the story, Huang fabricates a different exhibition that also has to do with Zomia and an exhibition consultant who is about to have a meeting with the curator. Drawing on the myths of heretical Christians, the Hmong, and highland minorities, as well as the Dead Sea Scrolls, he concocts a semi-fictitious Eastern cultural environment. In *The Prophet* Huang cites the concept of 'pseudomorphosis', a term from mineralogy that Oswald Spengler used when identifying elements of Arabic culture in European history. The main character in the script says: 'The original meaning of this term is that crystals in a certain stratum of mineral disappear for geological

reasons, leaving behind a space that is filled in by a new material, and causing the new crystals to take on the external shape of the old. Spengler extended this a step further. The new Arabic culture moved in and filled the gaps left behind by classical culture, but it could not help using classical culture to express itself, even though it was essentially a new culture. This is "cultural pseudomorphosis"'. Here, "cultural pseudomorphosis" subtly signifies the content and themes of the entire *2019 Asian Art Biennial*, and how the peoples of Asia have engaged in original modes of self-depiction within the structures left behind by their predecessors.

In the sound audio guide he was invited to produce, Snow Huang remained conscious of the state of the space and the visitors' line of motion. Unlike conventional environmental theatre or visual art of the past, which emphasised the act of display and the occupation of a space, *Flâneur series* provides content that is hidden in the environment. This is because sound is intangible. Unless you put on the headphones, you will never know that an event is taking place in the space. This form of acting does not involve actors occupying a place, but attempts to change people's habitual ways of viewing. As language and sounds trade places, unseen things that once lay hidden outside the text are given palpable images. They can be experienced and transformed into tangible bodies.

The final segment of the sound audio guide, *A Young Islander*, leads the visitor out of Gallery 205 along a line of motion to the left. After passing through a gallery on the ground floor, we slow our steps and exit the museum. At this moment, we see through the eyes of that youth who can see thousands of miles. We return to that moment when we first left the service desk and started walking through the exhibition and felt we were melting into the lights of the city: 'I saw a huge crowd of people," the island youth says, "They were standing on an overhead expressway holding umbrellas. But it wasn't raining. Standing opposite them was a different group of people dressed in uniforms, holding shields and pressing in on them step by step. Someone stepped on someone else's foot and fell over. A girl in shorts standing nearby helped lift him up. I don't really understand why a little bottle will lead me to see this moment. I don't understand why the water inside isn't for drinking, but for washing people's eyes. Everywhere around them are tall buildings, ridiculously tall. These people don't know that in just a few decades, these giant buildings will all fall down, and no one will be there.'

The First Dream installation view

藝術家與作品簡介
Artists' Biographies and
Works Descriptions

參展藝術家

李禹煥
LEE Ufan

1938 年出生於韓國，是引領藝術流派「物派」的主要藝術家及論述者，其創作呼應人類對自然的欣賞和理解，並以藝術手法轉化人造及工業製造物，藝術家刻意採用內斂的創作手法，將個人表現減到最低限，還原物質的原始面貌，進而產生某種具衍生性又生動的空白，這樣的「留白」（yohaku）手法（即運用空白的空間及餘裕），使李禹煥的作品得以誘發出展覽空間中的動態氛圍及靜謐感。

李禹煥的作品廣泛典藏於各大世界級美術館，如巴黎龐畢度中心、東京國立近代美術館、紐約古根漢美術館、倫敦泰德美術館、首爾國立現當代美術館、香港 M+ 博物館等，李禹煥現居、工作於法國巴黎及日本鎌倉。

Lee Ufan was born in 1938 in Korea. He lives and works in Paris and Kamakura, Japan, and is a leading practitioner and theorist of "Mono-ha", or "School of Things". "Mono-ha" is an art movement from the 1960s where artists explored materials and their properties in response to Japan's ruthless industrialisation and development. Lee's art centres on the appreciation of nature and the artistic evolution of manmade creations when they are opened up to industrial manufacturing processes.

Lee deliberately restrains his gestures in his work and cuts personal expression to a minimum by leaving the material untouched, which in turn produces a sense of emptiness that is generative and vivid. Often described as an "art of *yohaku*" (meaning empty spaces and margins), his work draws out a resilient tension and tranquillity which occupies the exhibition space.

His work is in the permanent collections of Centre Pompidou, Paris; National Museum of Modern Art, Tokyo; Solomon R. Guggenheim Museum, New York; Tate Collection, London; National Museum of Contemporary Art, Seoul; M+ Museum, Hong Kong; and many other institutions and private collections. He now lives and works in Paris and Kamakura.

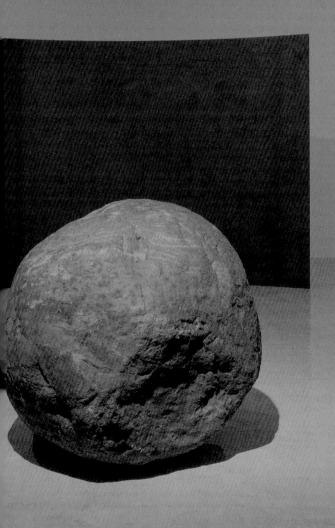

〈關係項〉
2007 ／ 2019，鐵（180×274×40 公分）、石頭（73×73×72 公分）
東京 SCAI THE BATHHOUSE 提供

—

Relatum
2007/2019, iron (180×274×40 cm) and stone (73×73×72 cm)
Courtesy of SCAI THE BATHHOUSE, Tokyo

〈關係項〉

〈關係項〉（2007／2019）為一空間構成，藝術家將自然狀態下的石頭與工廠壓製生產的鋼鐵板並置，後者所含的礦砂及礦物成份亦是石頭的構成元素，李禹煥認為鋼鐵是一種「高度概念化的物質團塊」——是極為沈重、堅實的物質，若沒有經過加工，就沒有其他的用途或內涵，此作誘發二種物質間的寧靜對話並探索他們與空間及自身脈絡的關係。

Relatum

Relatum (2007/2009) is a work of spatial composition that juxtaposes a natural stone in an "as-is" state, against a factory-rolled steel plate made from ores and minerals—both of which are elements contained in stone. Lee considers steel "a highly conceptual lump of matter": it is an extremely heavy and solid material which serves no function without undergoing further processing. The work initiates a silent dialogue between these two materials, and their relationship with the space and the very contexts they inhabit.

〈關係項〉

以哲學名詞「關係項」為名，指涉物件及事件之間存在的關係，這件作品讓人聯想到藝術家 1968 年創作的一件沒有紀錄的行為作品，當時李禹煥在公共空間中置放玻璃片，再用石頭將玻璃一片片敲破，這件原先創作於 1969 年的〈關係項〉以玻璃、鐵及石頭構築而成，思考藝術家創作的主要題旨，即創作和原始之間的過渡狀態。

Relatum

This work takes its title from a philosophical term, "relatum", which denotes objects and events where there is a relation. *Relatum* is comprised of glass, iron and stone, and evokes the artist's undocumented 1968 performance, during which he laid out panels of glass in a public space that were broken, one-by-one, with a stone. Originally produced in 1969, *Relatum* manifests the artist's primary concern, that is the transitional conditions of making and unmaking.

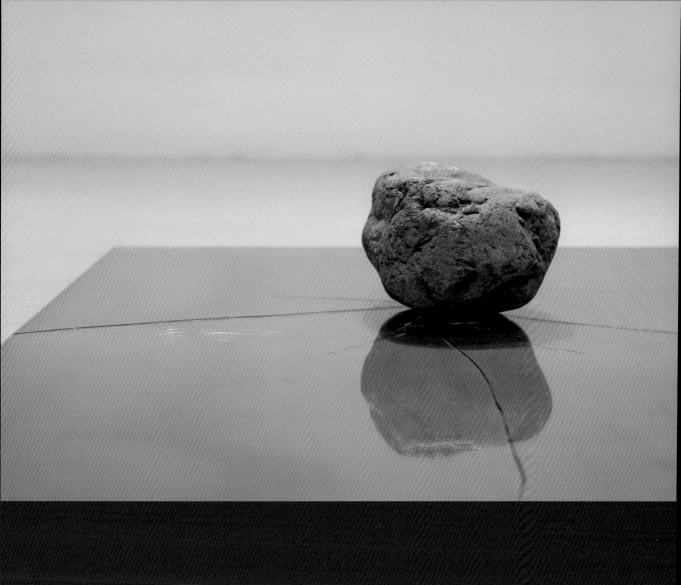

〈關係項〉

1969／2019，鐵（170×140×1 公分）、玻璃（170×140×1 公分）、石（40×30×25 公分）

新加坡 Pierre Lorinet、東京 SCAI THE BATHHOUSE 提供

—

Relatum

1969/2019, iron (170×140×1 cm), glass (170×140×1 cm) and stone (40×30×25 cm)

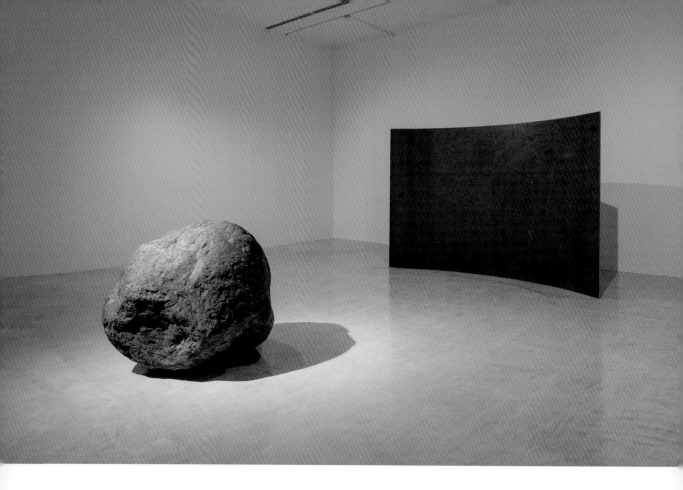

〈關係項〉

2007 ／ 2019，鐵（180×274×40 公分）、石頭（73×73×72 公分）

東京 SCAI THE BATHHOUSE 提供

———

Relatum

2007/2019, iron (180×274×40 cm) and stone (73×73×72 cm)

Courtesy of SCAI THE BATHHOUSE, Tokyo

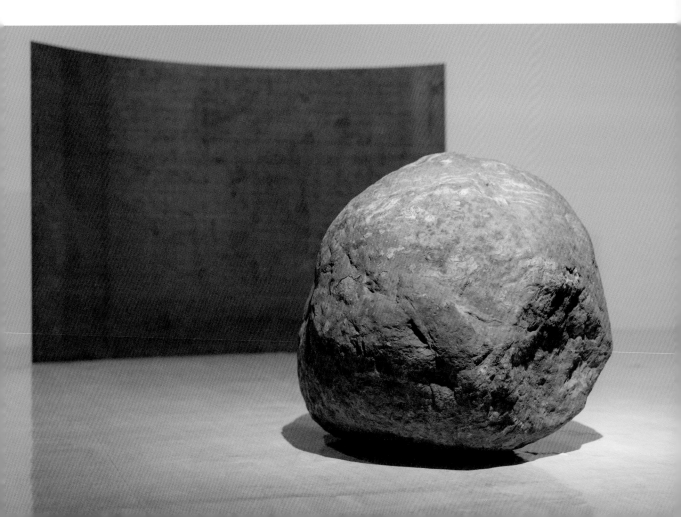

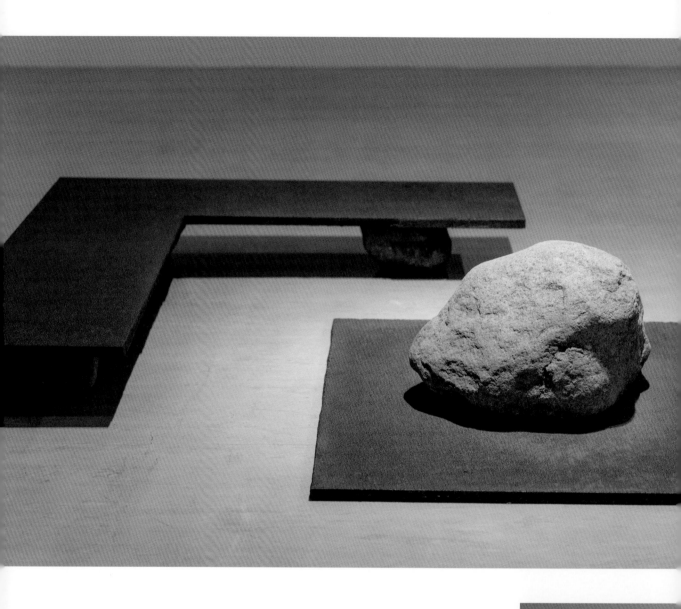

〈關係項〉

年代不詳，鐵板（110×99.5×3 公分／ 140.5×160.2×3 公分）、石頭（高 42 公分）、

圓周約 161 公分（1 個），（高 21 公分）、圓周約 42 公分（3 個）

白石畫廊提供

—

Relatum

Unknown, iron plate (110×99.5×3cm/140.5×160.2×3cm)and stone (H 42cm, dia.

161cm×1/H 21cm, dia. 42cm×3)

Courtesy of Whitestone Gallery

〈關係項〉

受到成長環境和教育環境的雙重影響，李禹煥將藝術創作和哲學思考的過程相融合，認為藝術作品的終極概念在於「相遇」，即作品、觀賞者、當下空間之間的聯繫都是一次「相遇」的動態過程。不論作品的媒介如何，他始終認為比起形式元素，布局和質地是更值得關注的根本——因為作品材質與周圍環境存在著一種無形的「共振式連接」。他的作品雖大多擁有一種強有力的圖像，但觀者似乎容易被牽引進入這個大的「引力場」，瞬間喚起寧靜之感。作品大多使用未經加工的自然材料，避免人為加工的痕跡，組合手法極度單純，通過表現層面極端弱化的方式來突出自然世界「原本」的存在方式。

Relatum

Under the dual influences of the environment Lee Ufan grew up with and the education he received, his work is an amalgamation of artistic creation and philosophical thinking. For the artist, the ultimate concept of an artwork is to "encounter", referencing the dynamic process that forms connections between the artwork, its spectator, and their surrounding space.

Lee considers the arrangement and texture of a work to be fundamentally worth more of our attention than its form, because there exists an invisible, yet "resonant connection" between the artwork's material and its surrounding environment. Although most of Lee's works reveal a powerful image, spectators are more likely to be drawn into their expansive "gravitational fields" which immerses them in a sense of serenity.

Lee mainly uses unprocessed natural materials to create his work. By avoiding the mark of the man and adopting extremely pure approaches to art-making, his work unveils nature's "original" way of existence through highly minimal forms of expression.

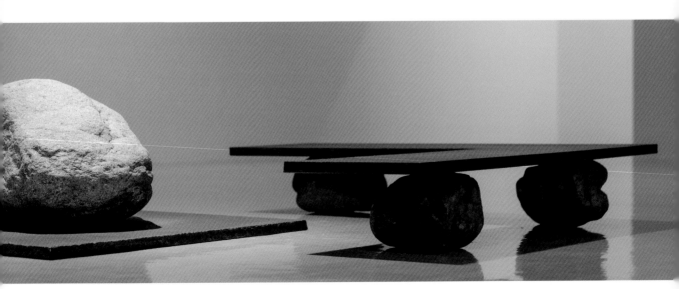

劉窗
LIU Chuang

1978 年生於中國湖北，於 2001 年畢業於湖北美術學院，目前居住和工作在上海。其作品多以現成品、裝置、錄像或表演呈現，透過社會介入、制度批判，進而審視社會的現況，探討當下城市的生活體驗。這些作品往往具有冷峻的幽默、細微的詩意和感性、冷靜的洞察力。他的作品在世界諸多美術館、雙年展展出。代表個展包括：天線空間與喬空間聯合個展（上海，2019）；魔金石空間個展（北京，2015）；Kunsthall Stavanger 畫廊（挪威，2014）；Salon94 畫廊 Freemans 空間（紐約，2014）。代表性聯展包括：路易威登基金會（巴黎，2016）；Para Site（香港，2016）；第 10 屆上海雙年展「社會工廠」（上海，2014）；第 10 屆光州雙年展「燒毀房子」（光州，2014）；坦帕美術館（坦帕，2014）；盧貝爾家族收藏，（邁阿密，2013）；尤倫斯當代藝術中心（北京，2013）；白教堂畫廊（倫敦，2012）；民生現代美術館（上海，2011）；阿涅利美術館（都靈，2010）；新當代藝術博物館（紐約，2009）；阿斯楚普‧費恩利現代藝術館（奧斯陸，2007）等。

Liu Chuang was born in 1978 in the Hubei province, China, and is currently working as an artist based in Shanghai. In 2001, he graduated from the Hubei Institute of Fine Arts.

The bulk of Liu's work includes ready-made pieces, installations, videos and/or performances, all of which are integrated with critiques of society and its systems. His art examines and explores current social situations and urban life. Liu's works are often a mixture of crisp humour, delicately poetic and sentimental qualities, and cool observations.

Liu's work has been showcased in fine art museums and art biennales across the world. Notable solo exhibitions include, Qiao Space and Antenne Space (Shanghai, 2019); Magician Space (Beijing, 2015); Kunsthall Stavanger (Norway, 2014); and Salon94 Freemans (New York, 2014). He has also participated in group exhibitions at a number of venues, including Foundation Louis Vuitton (Paris, 2016); Para Site (Hong Kong, 2016); *Social Factory: 10th Shanghai Biennale* (Shanghai, 2014); *Burning Down the House: 10th Gwangju Biennale* (Gwangju, 2014); Tampa Museum of Art (Tampa, 2014); Rubell Family Collection (Miami, 2013); UCCA Centre for Contemporary Art (Beijing, 2013); Whitechapel Gallery (London, 2012); Mincing Art Museum (Shanghai, 2011); Pinacoteca Giovanni e Marella Agnelli (Turin, 2010); New Museum of Contemporary Art (New York, 2009); and Astrup Fearnley Museum of Modern Art (Oslo, 2007).

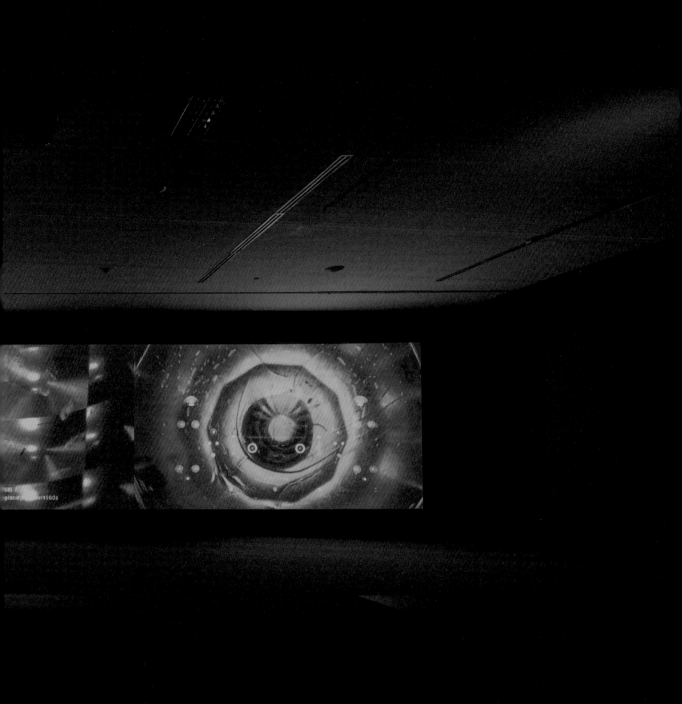

〈比特幣礦與少數民族田野錄音〉
2018，三頻道錄像、4k、5.1 聲道，40 分
藝術家和上海天線空間提供
全球都市國際藝術雙年展委任製作，由毛繼鴻藝術基金會支持

———

Bitcoin Mining and Field Recordings of Ethnic Minorities
2018, three-channel video, 4k, 5.1 sound. 40min
Courtesy of the artist and Antenna Space, Shanghai
Commissioned for Cosmopolis #1.5: Enlarged Intelligence, with the support of the Mao Jihong Arts Foundation

〈比特幣礦與少數民族田野錄音〉

20 世紀初的東亞，在眾多民族的喧嘩中，滿族統治下的清帝國將要崩潰了，做為帝國最後的遺產，一個完備的電報網絡在古代驛站的基礎上被建立，這個現代化的信息網絡一方面將清帝國廣大的疆域連接起來，另一方面則從內部加速了清帝國崩塌的過程。這部影片從這些蛛絲馬跡出發，將兩種看似無關的事物放在一起：比特幣礦和少數民族田野錄音。這兩者的基礎設施根源和現代國家的歷史有著千絲萬縷的關係，一個是文化的技術，借助現代的錄音和影像技術，博物館和檔案館構建了現代國家的知識體系，一個是基於互聯網的虛擬貨幣技術，試圖從中心化的國家貨幣體系中逃逸——這和少數民族的禮物經濟有相似的特點。

影片不僅用無人機在比特幣礦的密集區進行田野式的掃描，還引用了一些早期的攝影檔案，以及兩部有名的科幻電影：史蒂芬・史匹伯的《第三類接觸》（1977）和安德烈・塔可夫斯基導演的《飛向太空》（1972），這部作品分析了其中的一些外星人角色來源，其實都取材於贊米亞地區各個少數民族的人類學檔案。在比特幣採礦的現場紀錄中，地質表層的能源被視為是地球的物質記憶，抽象的虛擬貨幣被視為一種試圖逃逸現代民族國家的方法——這些觀點最終共同建構了另一個「他者」，一個位在地球外部的人 外星人。

Bitcoin Mining and Field Recordings of Ethnic Minorities

Liu Chuang's film, *Bitcoin Mining and Field Recordings of Ethnic Minorities*, interweaves the infrastructural building of early information networks into a singular narrative with seemingly-unrelated subjects: bitcoin mining and field recordings of ethnic minorities. The origins of these two infrastructures are intimately connected to the history of the modern nation state: the first is related to a culture's technology, and utilises modern recording and photographic technologies, museums, and archives in order to construct modern nations' knowledge systems. The second is a form of virtual currency that exists on the internet and seeks to circumvent and escape centralised national financial systems—qualities that it shares with the "gift" economy of ethnic minorities.

The film scans concentrated areas of bitcoin mines with drones as a part of its field study; it also cites early archival footages, along with two renowned science-fiction films: Steven Spielberg's *Close Encounters of the Third Kind* (1977), and Andrei Tarkovsky's *Solaris* (1972). The archival footage analyses the alien characters in these films, arriving at the conclusion that they were drawn from anthropological documentation of various ethnic minorities in the Zomia region. In Bitcoin Mining and Field Recordings, the energy residing at the geological surface is regarded as the material memory of the earth, whereas the abstraction of virtual currency is seen as an attempt to escape the reach of the modern nation state—together, these perspectives culminate in the construction of yet another "Other", one that is external to the earth, an "alien".

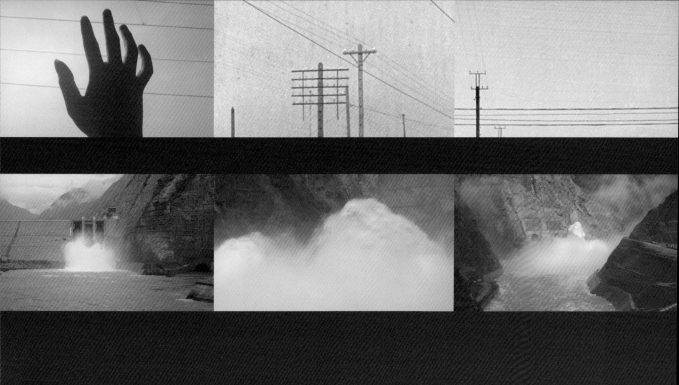

〈比特幣礦與少數民族田野錄音〉
2018，三頻道錄像、4k、5.1 聲道，40 分
藝術家和上海天線空間提供
全球都市國際藝術雙年展委任製作，由毛繼鴻藝術基金會支持

—

Bitcoin Mining and Field Recordings of Ethnic Minorities
2018, three-channel video, 4k, 5.1 sound, 40min

〈比特幣礦與少數民族田野錄音〉
2018，三頻道錄像、4k、5.1 聲道，40 分
藝術家和上海天線空間提供
全球都市國際藝術雙年展委任製作，由毛繼鴻藝術基金會支持

———

Bitcoin Mining and Field Recordings of Ethnic Minorities
2018, three-channel video, 4k, 5.1 sound. 40min
Courtesy of the artist and Antenna Space, Shanghai
Commissioned for Cosmopolis #1.5: Enlarged Intelligence,
with the support of the Mao Jihong Arts Foundation

薩望翁・雍維
Sawangwongse YAWNGHWE

1971 年出生於緬甸撣邦，為撣族良瑞王室後裔。其祖父蘇瑞泰，是緬甸在 1948 年從英國殖民獨立後緬甸聯邦（1948–1962）的第一任總統，並於 1962 年奈溫將軍發動軍事政變後死於監獄。雍維與家人被驅逐出境後流亡至泰國，而後再度逃往加拿大並於當地接受教育，現居、創作於荷蘭。

雍維的繪畫和裝置作品，與其家族史、緬甸近代史及政治事件高度相關。家族照片為其作品提供了圖像語言之基礎，通過對國家事件的探索，其創作揭示出現有的檔案並非是一個國家的全部真相。雍維亦透過地圖網絡的方式，呈現出海洛因與安非他命等毒品、革命軍、少數族裔、礦業與石油、軍事武裝與政府屠殺等各種衝突，試圖從複雜政治局勢中梳理出秩序。

雍維獲邀參與過諸多大型國際展覽，包括第九屆亞太當代藝術三年展（澳洲，2018）、第十二屆光州雙年展（韓國，2018）、達卡藝術高峰會（孟加拉，2018）、巴勒斯坦雙年展（耶路撒冷，2016）、施泰爾馬克之秋藝術節（奧地利，2016）、第 12 屆非洲當代藝術雙年展（塞內加爾，2016）、印度藝術博覽會（印度，2016）等。

Sawangwongse Yawnghwe was born in 1971 in the Shan State of Burma, and is a descendent of the Shan royal family. His grandfather, Sao Shwe Thaik, was the first president of the Union of Burma (1948–1962) after the country gained independence from Britain in 1948. Shwe Thaik died in prison following the 1962 military coup by General Ne Win. Since then, Yawnghwe's family has been driven into exile. They had settled in Thailand before escaping to Canada, where Yawnghwe grew up and received a formal education. He now lives and works in the Netherlands.

Yawnghwe's painting and installation practice engages politics with reference to his family history as well as current and historical events in his country. Family photographs also provide the basis for a pictorial language through which he explores events in the country, suggesting that existing and available archives cannot reveal a nation's entire truth. In addition, Yawnghwe's work of maps charts the conflicts between revolutionary armies, minority ethnicities, drugs (such as heroin and amphetamines), mining and gas pipelines, the armament of generals, as well as state genocide against its minorities. He intends to bring discernible order to a complex political situation.

Yawnghwe has exhibited internationally, including the 9th *Asia Pacific Triennial of Contemporary Art* (Australia, 2018); 12th *Gwangju Biennale Exhibition* (Korea, 2018); *Dhaka Art Summit* (Bangladesh,

2018), *Qalandiya International — Jerusalem Show VIII* (Jerusalem, Israel 2016); *Steirischer Herbst* in (Austria, 2016); *Dak'Art 2016: The 12th Biennale of Contemporary African Art* (Senegal, 2016); and the *Indian Art Fair* (India, 2016).

〈鴉片視差〉
2019，油彩、麻布，224×400 公分
藝術家提供
2019 亞洲藝術雙年展委託新作，作品由荷蘭皇家視覺藝術學院贊助製作

—

The Opium Parallax
2019, oil on linen, 224×400 cm
Courtesy of the artist

Commissioned by the *2019 Asian Art Biennial* (Taiwan) and realised with the support of Rijksakademie van beeldende kunsten

〈鴉片視差〉〈附註〉

在薩望翁・雍維的繪畫實踐中，撣邦（緬甸）的歷史與政治分析與他個人的家族歷史相互交織。透過作品〈鴉片視差〉與〈附註〉，他潛進了撣邦海洛因——鴉片萃取物——的兩面性，它不僅穿越國界，同時也模糊了合法與非法之間的界線。

「在上述情況下，撣邦軍，尤其是人稱『金三角海洛因之王』的坤沙所擁的軍隊，無非只是屬於一個非正式但精密複雜的監管制度。該制度在不同程度上既能助長非正式的無國界經濟商業世界，又能從中得益。以鴉片為主的投資、交易、利潤複合企業所在的跨國區域，並不受任何一個涉足政治與軍事的人物控制。由於關係是非正式的，是用「不規則」且非正式的方式管制，而且由於當權者之間權勢和結盟的平衡動盪不定，所以並沒有任何一個涉足經濟與商業的人物可以主宰這個區域，至少無法持久。它們的唯一最高指導原則，就是製造利潤並將其最大化。在這個世界裡，旗幟或意識形態的顏色，都不如財富的顏色來的重要。」
——節錄自曹張・良瑞，〈鴉片貿易的政治經濟學：對撣邦的影響〉（2003）

The Opium Parallax, Footnotes

In Sawangwongse Yawnghwe's painterly practice, historical and political analyses of Shan State in Burma are intertwined with personal and familial histories. In *The Opium Parallax* and the accompanying *Footnotes*, Yawnghwe dives into the two-sidedness of the Shan State's heroin-opium trade, which traverses not only national borders but blurs the very line between the legal and the illegal.

Within the context of the above, it is evident that the Shan armies and, in particular, the army of Khunsa, singled out by the outside world as the 'heroin king' of the Golden Triangle, are but parts of an informal but sophisticated and complex, regulatory system which both facilitate and benefit from, in varying degrees, the informal economic-commercial world without borders. No one single political military actor controls the transnational physical terrain of the area in which the opium-based complex of investments, trade and profit is situated. Also, because relationships are informal and "regulated" in irregular and informal patterns and because the balance of power and coalitions among the powers-that-be are unstable and shifting, so no single economic-commercial actor can dominate the field, not for long at any rate. However, clusters and entrepreneurial groups which operate with only one goal in mind, i.e., making and maxImising profit. It is a world where the colour of flags or ideology is not as important as the colour of wealth.
—Excerpt from The Political Economy of the Opium Trade: Implications for Shan State (2003), by Chao Tzang Yawnghwe

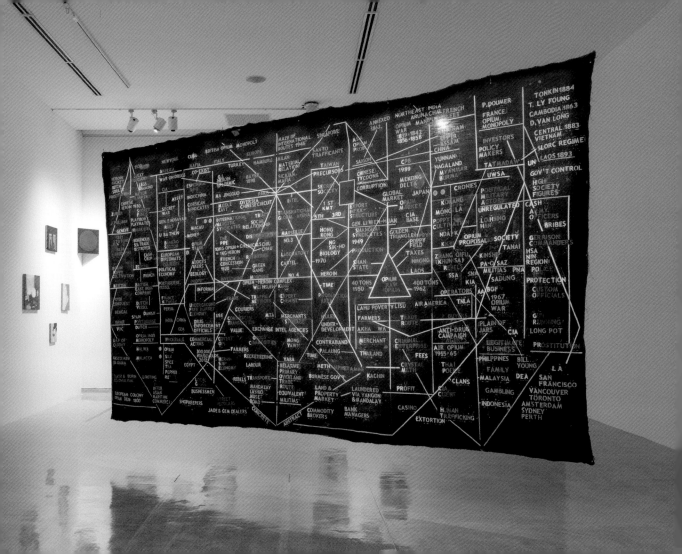

a

b

| a | b | c |

c

a 〈香港警局〉
2019，油彩、麻布，30×35 公分
藝術家提供
2019 亞洲藝術雙年展委託新作
作品由荷蘭皇家視覺藝術學院贊助製作

HK Police Office
2019, oil on linen. 30×35 cm
Courtesy of the artist
Commissioned by the *2019 Asian Art Biennial* (Taiwan) and realised with the support of Rijksakademie van beeldende kunsten

b 〈白龍〉
2019，油彩、麻布，23×30 公分
藝術家提供
2019 亞洲藝術雙年展委託新作
作品由荷蘭皇家視覺藝術學院贊助製作

White Dragon
2019, oil on linen. 23×30 cm
Courtesy of the artist
Commissioned by the *2019 Asian Art Biennial* (Taiwan) and realised with the support of Rijksakademie van beeldende kunsten

c 〈3 號海洛因〉

2019，油彩、麻布，24×29 公分

藝術家提供

2019 亞洲藝術雙年展委託新作

作品由荷蘭皇家視覺藝術學院贊助製作

———

No.3 heroin

2019, oil on linen. 24×29 cm

Courtesy of the artist

Commissioned by the 2019 Asian Art Biennial (Taiwan) and realised with the support of Rijksakademie van beeldende kunsten

jiandyin （紀拉德‧明瑪萊＆朋琵萊‧明瑪萊）

jiandyin (Jiradej MEEMALAI and Pornpilai MEEMALAI)

泰國跨領域藝術策展雙人團隊 jiandyin 成立於 2002 年，二人現居並工作於泰國拉差汶里府。jiandyin 持續透過藝術調研、田野訪查，結合各類來源、證據交織而成的系譜層次和跨領域、跨媒材的形式和物質，以共作及社會參與型式發展藝術創作，jiandyin 專注於創造的空間／平臺或情境，涉及地方和空間脈絡與歷史，可用以分析人與社會之間關係，藉由挖掘複雜且具曖昧性的普世和特殊議題，他們探索政治衝突和它們對邊緣族群的影響，而這些邊緣族群也往往是民族國家的悖論。

jiandyin 近期個展包含 2017 年在泰國清邁觀景藝廊舉行的「肖像『對話的檔案：觀看與存在』」、泰國卡特爾藝術空間的「黃金的本體論：魔幻之山」；近年參與的雙年展及群展有臺中國立臺灣美術館的「2019 亞洲藝術雙年展：來自山與海的異人」；2018 年在臺北舉行的「關渡雙年展：給亞洲的七個提問」；泰國甲米的「泰國國際雙年展：邊界幻境」；為「重新發電：第九屆上海雙年展」創作，於上海當代藝術館展出的「中山公園計劃」；分別在佛統府的泰國藝術大學藝術實驗室及德國柏林北境藝廊和 M 藝廊展出的「異國風情 2013」。

jiandyin 於 2011 年成立 Baan Noorg 非營利協作藝文空間，為拉差汶里府的在地社區的當代藝術文化發展和國際連結，策劃提供當代藝文展演、駐村計劃、策展和跨領域交流、成人教育計劃等活動。

jiandyin is a Thai duo of interdisciplinary artists and curators, comprising of Jiradej Meemalai and Pornpilai Meemalai, who have been collaborating since 2002. For almost a decade, jiandyin have been developing a body of work with an approach that combines artistic research; field work; genealogically-layered references to multiple sources and evidences; as well as forms and matters that engage with a wide range of disciplines and mediums—all of which are brought together through collaboration and social engagement.

jiandyin are interested in creating a space, platform or situation through which they can analyse relationships between humanity and society, especially in relation to a place or space's context and history. Their work delves into complex, ambiguous, and universal yet specific issues regarding political conflict and its effects on marginalised communities—the perpetual paradox of the nation-state.

jiandyin are founders of Baan Noorg Collaborative Arts and Culture in 2011, a not-to-profit artist initiative that runs contemporary art and cultural, artist-in-residency, curatorial, interdisciplinary exchange and post-education programmes for Nongpho community's contemporary art and culture development and global networks.

jiandyin have participated in a number of solo-exhibitions including *Portrait [Archives of Dialogue: Seeing and Being]* at Gallery Seescape, Chiang Mai, Thailand, and *The Ontology of Gold: Magic*

Mountains at Cartel Artspace, Bangkok, Thailand, in 2017.

They have also exhibited at a number of group shows including *Kuandu Biennale: Seven Questions for Asia* at Kuandu Museum of Fine Arts in Taipei, Taiwan (2018); *Thailand Biennale Krabi: Edge of the Wonderland* in Krabi, Thailand (2018); *Re-Activation 9th Shanghai Biennale* at the Zhongshan Park Project in the Shanghai Power Station of Art, Shanghai China; *The Exotika at Silpakorn* Art Lab, Nakhon Pathom, Thailand (2013); and at the Galerie Nord and Galerie M in Berlin, Germany.

〈磨擦流動：魔幻之山計畫〉
2019，單頻道錄像、鈉鋁矽酸鹽粉末、C10H15N 人類尿液、冷藏櫃、玉石、大理石球體噴泉
防水接觸式麥克風、錄音介面、控制器、擴音喇叭、畫作、紀錄文件、1990 年中國人民幣百元紙鈔、壁畫
藝術家提供，2019 亞洲藝術雙年展委託新作

Friction Current: Magic Mountain Project
2019, mixed media installation with single-channel video, NaAlSi2O6 powder, C10H15N human urine, jadeite sphere
water fountain, refrigerated cabinet, immersion sturgeon waterproof contact microphone, USB audio interface,
controller, sound speakers, paintings, documentation, 100 Yuan-1990 China banknote, mural paint
Courtesy of the artist. Commissioned by the *2019 Asian Art Biennial* (Taiwan)

〈磨擦流動：魔幻之山計畫〉

你我皆是恆古山河的異人。──jiandyin

贊米亞的魔幻山地有著複雜起伏的地形，對當地的高原民族來說不僅是戰略性資源，也是一種護身保障，以距離形構空間，進而將國家控制的力量隔絕在群山之外，在綿延的神秘山谷中有陡峭山脈、難以抵達的曠野，這樣複雜的地理環境最早形成於前寒武紀時期，一直持續到第三紀時期喜馬拉雅山脈拔起而起，產生東南亞的大陸板塊才逐漸趨緩。在贊米亞高原民族有關宇宙的傳說中，山脈是有皺摺的土地，以特別的線縫，將區域及大陸編織在一起。從現代科學的角度來看，這些土地是在地質時間中通過板塊構造而形成，其中涉及了壓力、溫度與動力學。這些過程已經展開，且持續至今。

要了解地質演化，可以研究實驗室密閉空間或實驗中所觀察到的現象，用以推演地質形成的原初場景，然而，埋藏在地底的玉石也是前寒武紀時代的地質證據，這種珍貴而具高度經濟價值的寶石又被稱為「天上之石」；另一方面，以化學方式生成、擁有同等價值的結晶則是現代社會新陳代謝作用系統的流動證據，二者皆揭示了力量和利益形成的關係所產生的顯著影響。

〈磨擦流動：魔幻之山計畫〉是 jiandyin 的一項藝術研究計畫，關注於贊米亞區域與週邊現代民族國家之間的社會和政治張力、相對速度、磨擦和洋流的相互作用。這項計畫以二種地質見證為基礎，首先是運用變質岩與化學元素（鈉鋁矽酸鹽，$NaAlSi_2O_6$）反應後形成的硬玉，第二是藉由尿液樣本中所含的化學物質甲基苯丙胺（$C_{10}H_{15}N$）。這兩種物質在贊米亞地區的流通不僅跨越民族國家的邊界，也跨越合法與非法的邊界，從而涉及了歷史、社會政治、經濟和文化交織的隱喻。

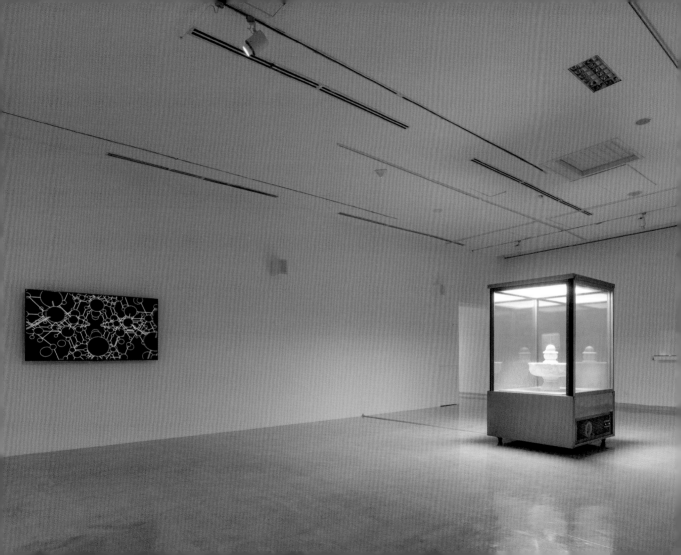

Friction Current: Magic Mountain Project

We are strangers of the same old mountain, the same old river. ——— jiandyin

The magic mountains of Zomia are a terrain of complex topographical reliefs which act as a strategic resource or talisman for the highland people — they create space in the form of distance, which is a tool for avoiding the control of state powers that cannot surmount Zomia's remoteness. The steep mountain ranges and faraway plains amidst mysterious valleys were formed in the Precambrian era. Its development continued into the Tertiary era, during which the Himalayas emerged and gave birth to the Southeast Asian continent.

In the cosmic folklore of Zomia's highland peoples, mountains are considered to be "wrinkled lands", sewn together by special threads which weave together region and continent. In the perspective of modern science, these lands were formed as a result of tectonic plates shifting in geologic time, involving the dynamics of pressure, temperature and enormous frictions. The process has unfolded across eons and continues to the present day.

If we seek to understand the geological evolution of these primitive witnesses, the phenomenon can be studied in the closed space or via a laboratory experiment. It is undeniable that the mountains' origins in the Precambrian era is an important discovery—this evidence has resulted in the discovery of rocks from the earth's basement, in particular jadeite, a type of precious and highly valuable gem that is also known as "Heavenly Rocks".

However, jadeite is not necessarily confined to this prehistoric age—in fact, there is contemporary evidence that these gems occurred through the chemical reaction of a separate but equally-valuable crystal. This reality might signify the current condition of our social system's metabolism.

Both of these pieces of evidence are significant, effecting the relationship between power and benefit.

Friction Current: Magic Mountain Project is an artistic research project by jiandyin that focuses on the phenomenon of forces caused by the interplay of social and political resistance, relative motions, as well as the frictions and currents between modern nation states and the stateless Zomia highland peoples.

The work takes Zomia's two types of "witnesses" as its starting point: the first being jadeite formed by metamorphic rocks, which has reacted with a chemical formulation, $NaAlSi_2O_6$; the second being urine samples which contain the chemicals $C_{10}H_{15}N$ (methamphetamine). The circulation of these two substances in and out of Zomia suggests a crossing of not only national borders, but also those lines between the legal and illegal. Their movement functions as a metaphor for the intertwining of the historical, the socio-political, the economic and the cultural.

〈磨擦流動：魔幻之山計畫〉
2019，單頻道錄像、鈉鋁矽酸鹽粉末、C10H15N 人類尿液、冷藏櫃、玉石、大理石球體噴泉
防水接觸式麥克風、錄音介面、控制器、擴音喇叭、畫作、紀錄文件、1990 年中國人民幣百元紙鈔、壁畫
藝術家提供，2019 亞洲藝術雙年展委託新作

———

Friction Current: Magic Mountain Project

2019, mixed media installation with single-channel video, NaAlSi2O6 powder, C10H15N human urine, jadeite sphere
water fountain, refrigerated cabinet, immersion sturgeon waterproof contact microphone, USB audio interface,
controller, sound speakers, paintings, documentation, 100 Yuan-1990 China banknote, mural paint
Courtesy of the artist. Commissioned by the *2019 Asian Art Biennial* (Taiwan)

攝影師｜利安・摩根	Cinematographer｜Liam MORGAN
3D 動畫｜沙威提利・帕姆卡蒙	3D Motion Graphic｜Sawitree PREMKAMON
聲音工程｜張暉明、黃偉	Sound Engineer｜CHANG Huei-Ming, HUANG Wei
藝術家助理｜阿威卡、撒姆古撒面、阿庇奇・蒲恩米威瑟	Artist assistants｜Awika SAMUKRSAMAN, Atsushi BOONMEEWISET
地質學顧問｜坦・帕蓬・桑帕－烏多姆	Geology Advise｜Thampaphon SUNPA-UDOM
場務器材及燈光設備｜VS 電影基金	Grip and Lighting Equipment｜VS Film Fund

寇拉克里·阿讓諾度才
Korakrit ARUNANONDCHAI

1986 年出生於泰國，現於曼谷以及紐約工作生活。身兼視覺藝術家、導演、說書人，寇拉克里將自己多元的手法應用於訴說交織於文化移植與融合的故事。他的作品將小說與詩詞結合，並且將親友與同事的生活經驗結合當地傳說，傳達多元主題，提供觀者多元體驗。寇拉克里不僅個人創作，還熱衷於與其他藝術家合作，並在過去與許多藝術家共同創作錄像、表演與音樂。寇拉克里的第一部錄像作品是《2012-2555》系列，聚焦於時代的死亡、重生以及虛構性質。該件作品於 2014 年在紐約市 P.S.1 當代藝術中心展出。寇拉克里與雙胞胎兄弟與表演藝術家寇拉帕·阿讓諾度才、男孩子與藝術家亞歷克斯·格沃伊奇一同創作了一場結合錄像裝置的現場演出，做為 P.S.1 當代藝術中心週日集會（Sunday Session）的一部份。2015 年，寇拉克里於巴黎東京宮展出影片〈在滿是怪人的房間裡，用歷史作畫 3〉。2018 年初，寇拉克里成為「鬼魅基金會（Ghost Foundation）」的創辦人之一，該基金會為非營利組織，致力於支持泰國一系列名為〈鬼魅〉的錄像與表演藝術作品，並為 2018 年 10 月 11-28 日「鬼魅基金會」創始系列「鬼魅：2561」的策展人。

Born in 1986 in Thailand, Korakrit Arunanondchai is a visual artist, filmmaker and storyteller based in Bangkok and New York. He employs his versatile practice to tell stories embedded with themes of cultural displacement and hybridity. His body of work merges fiction with poetry, thus creating for audiences a synesthetic experience that is engaged with a multitude of subjects primarily based on the lives of family, friends, and colleagues as well as local myths.

Eschewing the pose of a solitary artist, Korakrit is an avid collaborator, and has worked with an extensive list of people on videos, performances and music. *2012–2555*, the first video in a series of work, was derived from ideas of death, rebirth and the fictionalisation of time. It showed at MoMA PS1 in New York City (2014). Korakrit also produced a live performance that would accompany the video installation as part of MoMA PS1's Sunday Sessions programme. The performance was created in collaboration with his twin brother Korapat Arunanondchai, filmmaker Alex Gvojic, and the Californian performance artist, boychild.

In 2015, Korakrit exhibited *PAINTING WITH HISTORY IN A ROOM FILLED WITH PEOPLE WITH FUNNY NAMES 3* at the Palais de Tokyo, Paris. In early 2018, Korakrit co-founded the Ghost Foundation, a non-profit organisation that aims to support a video and performance art series in Thailand entitled *GHOST*. He curated its inaugural series, *Ghost:2561*, which was shown in Bangkok, Thailand between 11-28 October 2018.

亞歷克斯・格沃伊奇
Alex GVOJIC

1984 年出生於美國，現於紐約生活與工作。亞歷克斯・格沃伊奇是一名在紐約創作的環境設計師與電影導演，創作融合錄像、燈光與電影的「超寫實」場景，營造令觀眾感到既熟悉又陌生的世界。格沃伊奇的作品藉由物理空間的轉換探索眼見與相信之間的關聯，並於過去展示於柏林雙年展、東京宮、移動影像雙年展、倫敦當代藝術學會、PS1 當代藝術中心、尤倫斯當代藝術中心、華沙現代藝術博物館，以及阿姆斯特丹市立博物館。格沃伊奇合作過的藝術家包括寇拉克里・阿讓諾度才、萊恩・特里卡丁、DIS 藝術小組、Xavier Cha，以及法蒂瑪・阿里・卡蒂里，一同創造與觀眾互動的新型平台。

Alex Gvojic was born in 1984 in the USA, where he currently lives and works as a New York-based environmental designer and cinematographer. His work focuses on creating "hyper-real" environments that blend videos, lighting, and cinematic tropes in order to create worlds that suspend disbelief. Gvojic explores the relationship between seeing and believing by transmuting these physical spaces into places that feel both familiar and foreign.

His work has been exhibited, at the Berlin Biennale, the Palais de Tokyo, the Biennale de l'Image en Mouvement, ICA London, MoMA PS1, UCCA, MOMA Warsaw, and the Stedelijk Museum. He has collaborated with a number of artists, including Korakrit Arunanondchai, Ryan Trecartin, DIS, Xavier Cha, and Fatima Al Qadiri, to create new platforms for audience engagement.

〈在一個滿是怪人的房間裡沒有歷史 5〉
2018，三頻道錄像、裝置（各式貝殼、樹枝、塵土、雷射醫琴、造霧機、寇拉克里祖父雙手的樹脂鑄型、男孩子頭部的樹脂鑄型、LED 燈、丹寧布料枕頭、兔子造型絨毛玩偶），30 分 44 秒，尺寸依場地而異
由藝術家與 C L E A R I N G 紐約／布魯塞爾、Carlos ／ Ishikawa 倫敦及 BANGKOK CITYCITY GALLERY 曼谷提供
由日內瓦當代藝術中心為 2018 年移動影像雙年展委託製作

No History in a Room Filled with People with Funny Names 5
2018, three-channel video, installation (mixed seashells, tree branches, dirt, laser harp, hazer, resin cast of Korakrit's grandfather's hands, resin cast of boychild's head, LED lights, denim fabric pillows, rabbit plush toys) 30min44sec, Dimensions variable
Courtesy of the artists, C L E A R I N G New York / Brussels, Carlos / Ishikawa London, BANGKOK CITYCITY GALLERY Bangkok
Commissioned by Centre d'Art Contemporain Genève for *Biennale of Moving Image 2018*

〈在一個滿是怪人的房間裡沒有歷史 5〉

在寇拉克里・阿讓諾度才的《在一個滿是怪人的房間裡沒有歷史》系列中，藝術家嘗試以肉體作為媒介的說故事方式，來揭示出現實的破碎本質，其中也反映出泰國傳統思維、自然環境、科技發展、政治與文化之間的關係。本次展出的作品〈在一個滿是怪人的房間裡沒有歷史 5〉，是他與亞歷克斯・格沃伊奇的共同創作，影片主要描述 2018 年夏天，泰國清萊一組少年足球隊與他們的教練受困於山洞內的事件，藉由作品，藝術家重新叩問當時在軍方與媒體的操作下，各個角色如何在全世界的注目中展開他們的每一步。而在另一個銀幕中，則播放過去六年來阿讓諾度才、格沃伊奇與男孩子的表演合作。在這開放的故事空間裡，男孩子扮演的角色近似於泰國萬物有靈論傳統中的蛇神那伽——一種關於當下的饋贈；可供經驗但從未被存留之物。

No History in a Room Filled with People with Funny Names 5

In Korakrit Arunanondchai's series, entitled, … *in a Room Filled with People with Funny Names*, the artist attempts to reveal the shattered nature of reality through a form of storytelling mediated by the physicality of the body. The work simultaneously reflects upon the relationship between traditionally "Thai" modes of thought, the natural environment, technological development, politics and culture.

The work on view in this exhibition, *No History in a Room Filled with People with Funny Names 5*, is a collaboration between Korakrit and Alex Gvojic. It depicts the accidental entrapment of a group of teenage soccer players and their coach in a cave in Chiang Rai, Thailand, during the summer of 2018. Through the work, the artists revisit and question how each person's role in the event was shaped by the military and media, particularly in relation to how the story's developments were closely watched by the entire world.

Also on view on a separate screen is an edited selection of collaborative performances of Korakrit, Gvojic and boychild from the last six years. boychild takes on the role of the Nāga, a mythical creature from Thai animist tradition. In the undefined open space of storytelling, boychild's performance creates a kind of present within a present—something that can be experienced but never preserved.

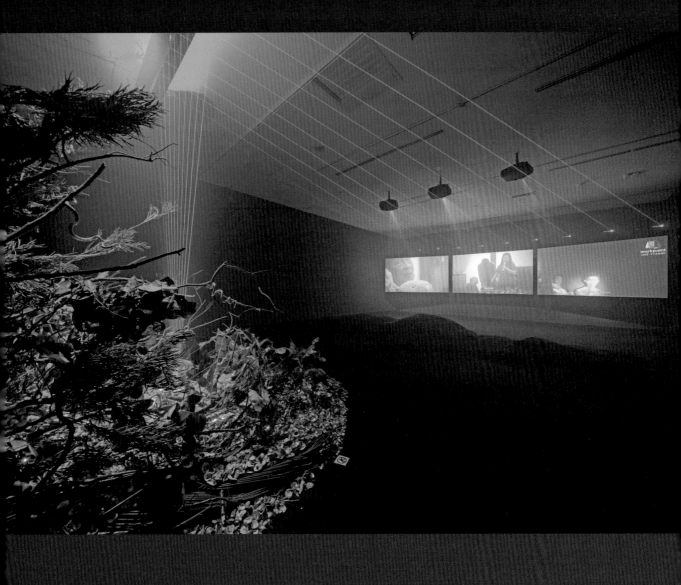

〈在一個滿是怪人的房間裡沒有歷史 5〉
2018，三頻道錄像、裝置（各式貝殼、樹枝、塵土、雷射豎琴、造霧機、寇拉克里祖父雙手的樹脂鑄型、男孩子頭部的樹脂
鑄型、LED 燈、丹寧布料枕頭、兔子造型絨毛玩偶），30 分 44 秒，尺寸依場地而異
由藝術家與 C L E A R I N G 紐約／布魯塞爾、 Carlos ╱ Ishikawa 倫敦及 BANGKOK CITYCITY GALLERY 曼谷提供
由日內瓦當代藝術中心為 2018 年移動影像雙年展委託製作

No History in a Room Filled with People with Funny Names 5
2018, three-channel video, installation (mixed seashells, tree branches, dirt, laser harp, hazer, resin cast of Korakrit's grandfather's hands, resin cast of
boychild's head, LED lights, denim fabric pillows, rabbit plush toys) 30min44sec, Dimensions variable
Courtesy of the artists, C L E A R I N G New York / Brussels, Carlos / Ishikawa London, BANGKOK CITYCITY GALLERY Bangkok
Commissioned by Centre d'Art Contemporain Genève for *Biennale of Moving Image 2018*

will be a place indescribable with the words we have

for a mystical time to appear once again

〈在一個滿是怪人的房間裡沒有歷史 5〉
2018，三頻道錄像、裝置（各式貝殼、樹枝、塵土、雷射豎琴、造霧機、阿讓諾度才祖父雙手的樹脂鑄型、男孩子頭部的樹脂鑄型、LED 燈、
丹寧布料枕頭、兔子造型絨毛玩偶），30 分 44 秒，尺寸依場地而異
由藝術家與 C L E A R I N G 紐約 / 布魯塞爾、 Carlos/Ishikawa 倫敦及 BANGKOK CITYCITY GALLERY 曼谷提供
由日內瓦當代藝術中心為 2018 年移動影像雙年展委託製作

━━

No History in a Room Filled with People with Funny Names 5
2018, three-channel video, installation (mixed seashells, tree branches, dirt, laser harp, hazer, resin cast of Korakrit's grandfather's hands, resin cast
of boychild's head, LED lights, denim fabric pillows, rabbit plush toys). 30min44sec, Dimensions variable
Courtesy of the artists, C L E A R I N G New York / Brussels, Carlos / Ishikawa London, BANGKOK CITYCITY GALLERY Bangkok
Commissioned by Centre d'Art Contemporain Genève for *Biennale of Moving Image 2018*

the voices of the ghosts are often heard through spirit mediums

攝影｜亞歷克斯・格沃伊奇、寇拉克里・阿讓諾度才、羅利・莫勒瑞、
永康同・寧孟康、瓊・王
聲音設計與混音｜亞倫・大衛・羅斯
音樂｜迪・理查德〈最後的憐憫〉
程式設計｜麥可・波文（Nitemind 公司）
曼谷製作團隊｜沙查達・思理坦萬悟迪、匹賽・汪薩添才、
阿克拉・宏勒、那隆・喜守法比、譚那衛・米撒、齊薩康・丁圖泰、
那澎・康蘇文、那他・薩朵
研究與製作｜諾・契達
靜態攝影｜尼可・塞西
其他演出者｜男孩子、寇拉克里・阿讓諾度才、提巴亞彎納・尼提朋、
瓦拉奇・尼提朋、恩典教會（泰國清萊美塞）、
娜娜托育中心（泰國清萊美塞）、威馬遜歷史博物館（泰國烏隆塔尼）、
差樂拆・鎚喜批帕、白廟、蘇姍・布朗博士

Camera | Alex GVOJIC, Korakrit ARUNANONDCHAI, Rory MULHERE,
Yukontorn MINGMONGKON, Jon WANG
Sound Design and Mixing | Aaron David ROSS
Music Contribution | "Final Mercy" by DJ RICHARD
Programming | Michael POTVIN (Nitemind)
Bangkok Production Team | Suchada SIRITHANAWUDDHI, Pises
WONGSATHIANCHAI, Akerat HOMLAOR, Narong SRISOPHAB,
Tanawit MISA, Krissakorn THINTHUPTHAI, Naporn KONGSUAN, Nata SATO
Research and Production | Nok CHIDA
Still Photography | Nick SETHI
With | boychild, Korakrit ARUNANONDCHAI, Tippayavarna NITIBHON,
Varachit NITIBHON, Grace Church (Mae Sai, Chiang Rai, Thailand),
Nana Childcare and Foster Home (Mae Sai, Chiang Rai, Thailand),
Ramasun Camp History Museum (Udon Thani, Thailand),
Charlermchai KOSITPIPAT and Wat Rong Khun (White Temple), Dr. Susan BROWN

〈在一個滿是怪人的房間裡沒有歷史 5〉
2018，三頻道錄像、裝置（各式貝殼、樹枝、塵土、雷射醫琴、造霧機、阿讓諾度才祖父雙手的樹脂鑄型、男孩子頭部的樹脂鑄型、LED 燈、
丹寧布料枕頭、兔子造型絨毛玩偶），30 分 44 秒，尺寸依場地而異
由藝術家與 C L E A R I N G 紐約 / 布魯塞爾、 Carlos/Ishikawa 倫敦及 BANGKOK CITYCITY GALLERY 曼谷提供
由日內瓦當代藝術中心為 2018 年移動影像雙年展委託製作

No History in a Room Filled with People with Funny Names 5
2018, three-channel video, installation (mixed seashells, tree branches, dirt, laser harp, hazer, resin cast of Korakrit's grandfather's hands, resin cast
of boychild's head, LED lights, denim fabric pillows, rabbit plush toys). 30min44sec, Dimensions variable
Courtesy of the artists, C L E A R I N G New York / Brussels, Carlos / Ishikawa London, BANGKOK CITYCITY GALLERY Bangkok
Commissioned by Centre d'Art Contemporain Genève for *Biennale of Moving Image 2018*

註腳 FOOTNOTES

第一展區　　　　Zone 1

#贊米亞 #自然與工業 #比特幣 #金三角 #罌粟 #坤沙 #物派

Zomia # Nature and Industry # Bitcoin # Golden Triangle # Poppy # Khun Sa # Mono-ha

四川是中國水電資源最為豐沛的省份之一，由於大量修建水電站，當地水電長期處於過剩狀態。比特幣採礦需要耗費大量電力，這些過剩水電就成為採礦者的目標。四川甘孜康定的大渡河，是當年中共長征躲避被剿匪的一段路途，面對數位時代的來臨，這條河流因水電豐沛價格低廉，遂成為比特幣挖礦者的首選之地，在其流域的水電站內，隱藏著許多為就近向水電站購電的比特幣礦場，甚至發展出可隨季節遷移、如候鳥般的貨櫃版礦場。四川自此成為世界著名的比特幣礦場，全球 70% 的比特幣產自中國，而其中約有 7 成的礦場在四川大渡河，曾有報導指出，世界上每挖出 100 枚比特幣，就都有 5 枚產自這裡。

▲ 大渡河〈圖片來源：維基共享資源媒體庫〉
Dadu River. (Image source: Wikimedia Commons, the free media repository)

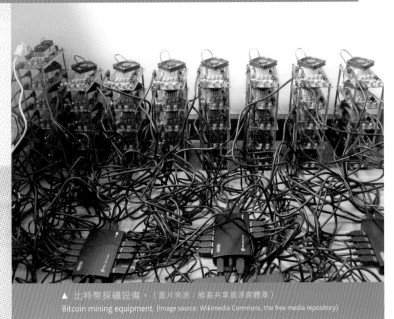

▲ 比特幣採礦設備。〈圖片來源：維基共享資源媒體庫〉
Bitcoin mining equipment. (Image source: Wikimedia Commons, the free media repository)

Sichuan is one of the provinces with the most abundant hydropower resources in China. Due to the mass construction of hydropower stations, the local hydropower has been in a long-term state of excess. Bitcoin mining requires large amounts of electricity, and the excess hydropower in Sichuan has become a target for miners. Dadu River of Kangding, Garze used to be the route of the Chinese communists' Long March when hiding from attacks. With the dawning of the digital age, the river's abundant, low-costing hydropower made it a prime location for Bitcoin miners. Hidden within the hydropower stations situated in the river basin are various Bitcoin mines, located near power stations so that purchasing electricity would be convenient. These mines have even invented a migration system, relocating according to the seasons, moving their mining containers like migratory birds. Sichuan has since become a world-famous location for Bitcoin mining, with 70% of the world's Bitcoins produced in China, among which almost 70% of the mines are located near Dadu River, Sichuan. A news report stated that with every hundred pieces of Bitcoin, five is produced near Dadu River, Sichuan.

▲ 贊米亞（Zomia）區域大致與圖面紅色區塊的東南亞地塊（Southeast Asian Massif）範圍重疊。（圖片來源：Journal of Global History）

The area of Zomia mostly overlaps with the red area of the Southeast Asian Massif. (Image source : *Journal of Global History* (2010) 5, pp. 187-214*. London School of Economics and Political Science 2010)

贊米亞（Zomia）是 2009 年美國學者詹姆士·史考特（James C. Scott）在《不受統治的藝術：東南亞高地無政府主義的歷史》（The Art of Not Being Governed: An Anarchist History of Upland Southeast Asia）一書中所提出的地域名詞。指的是西起印度以北、東至越南北部的東南亞高地區域，涵蓋包括越南、柬埔寨、寮國、泰國和緬甸的部分地區，以及中國的四個省份。贊米亞是一個概念上的相應範圍與政治結構，所以並不會出現在任何官方地圖上。史考特認為，2000 年以來這個地理範圍內的人群由一波波逃離低地邦國、帝國治理、現代國家概念（包括泰、緬、印和中國政體）的群體組成。居住於此人們並非被各種文明計劃淘汰的人，也不是社會發展演化下的邊緣人，而是選擇與文明中心及國家保持距離而逃往高地的人。他們的生活、社會結構、文化，甚至無文字狀態，都是選擇逃避統治的結果。

The name 'Zomia' is a regional term mentioned in *The Art of Not Being Governed: An Anarchist History of Upland Southeast Asia* by American academic James C. Scott in 2009. Zomia refers to the highlands of Southeast Asia, starting from the north of India in the west and stretching to the north of Vietnam in the east, covering places including Vietnam, Cambodia, Laos, Thailand, parts of Myanmar, and four provinces of China. Zomia is a concept that overlaps with certain geographical extents and political structures, therefore is not shown in any official maps. Scott believes that for 2,000 years, the geographical area of Zomia has been composed of a group of people escaping from the Low Countries, imperial rule, and the concept of modern nations (including the government of Thailand, Myanmar, India, and China). The people living in Zomia are not outcasts of civilizations, nor are they marginal people amid social advancement; in fact, they are people who have moved to the highlands, choosing to maintain a distance with the centres of civilization and nations. The lifestyle, social structure, culture, and even illiteracy of these people are all results of choosing to flee from being governed.

◀ 鴉片的原料植物：罌粟。（圖片來源：紐約公共圖書館手稿及檔案處，1751）
The source of opium: poppy.
(Image source: Manuscripts and Archives Division, The New York Public Library, 1751. © The New York Public Library. 2019)

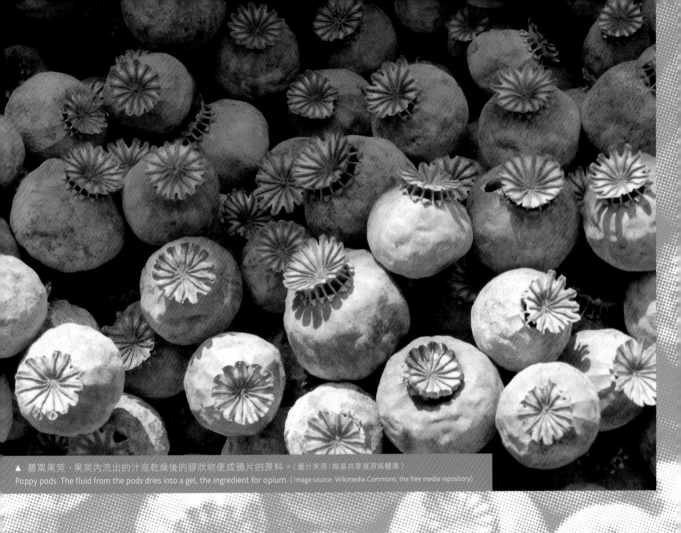

▲ 罌粟果莢，果莢內流出的汁液乾燥後的膠狀物便成鴉片的原料。（圖片來源：維基共享資源媒體庫）
Poppy pods. The fluid from the pods dries into a gel, the ingredient for opium. (Image source: Wikimedia Commons, the free media repository)

金三角指由緬甸、寮國、泰國交界，總面積約 15-20 萬平方公里的地區，因氣候乾燥、雨季短且集中而適合栽種罌粟，昔日由當地軍閥、毒梟等製造鴉片、海洛因等毒品而惡名昭彰，為世界三大毒品源之一，也曾是世界上最大的鴉片、海洛因產地。其中最知名的毒梟之一即是人稱「金三角海洛因之王」的坤沙（Khun Sa）。軍閥坤沙在 1980 年代末金三角毒品貿易最高峰時，幾乎控制了金三角地區毒品貿易的 80%。1993 年坤沙宣布成立撣邦共和國，自任總統，但在當時，組織內部已開始瀕臨瓦解，1996 年 1 月 12 日坤沙向緬政府軍投降。

The Golden Triangle is at the borders of Thailand, Laos, and Myanmar, covering over a total of 150,000 to 200,000 square kilometres. The dry climate and concentrated, short rainy seasons make it an ideal location for planting poppy. In the past, the area was notoriously controlled by local warlords and drug lords, who used the place to produce narcotics such as opium and heroin, making it one of the top three production sites of narcotics and the largest production place for opium and heroin. The most famous drug lord was Khun Sa, also known as the Heroin King of the Golden Triangle. By the late-1980s, at the height of the drug trade in the Golden Triangle, the warlord Khun Sa had controlled up to 80% of the drug trade in the area. In 1993, Khun Sa announced the establishment of the Shan State with himself as the president. However, the organization had started collapsing from within, and on January 12th, 1996, Khun Sa surrendered to the Burmese government army.

羅斯里胥安姆・伊斯梅爾（伊謝）
Roslisham ISMAIL (a.k.a Ise)

1972 年生於馬來西亞吉蘭丹的哥打巴魯，目前生活與工作地點為哥打巴魯與吉隆坡。跨領域藝術家，作品包括裝置、影像藝術以及參與式作品，靈感往往來自漫畫與塗鴉等流行文化，試圖透過作品將不同的表達模式與區域以及文化的架空歷史產生連結。

伊謝過去的個展經歷包括紐約的自助洗衣企劃（2016）、曼谷大學畫廊（2014）、吉隆坡美水路（2010）、吉隆坡日本交流基金會畫廊（2008）、雪梨澳洲最高委員會 4A 畫廊（2007）、印尼日惹的 Kedai Kebun 論壇（2007）以及雪梨的亞澳藝術中心（2016）。參與群展如吉隆坡 ILHAM 畫廊的「當今北大年」展覽（2018）、吉隆坡 ILHAM 畫廊「烹飪計畫」（2018）、泰國清邁 MAIIAM 當代美術館（2017）、馬來西亞國家美術館「逃離大海」（2017）、曼谷文花藝術中心「聯絡方式」（2017）、東京森美術館「太陽雨」（2017）、歌德學院新加坡國際藝術節（2016）、巴黎東京宮（2015）、新加坡當代藝術中心（2015）、伊斯坦堡 Arter 博物館（2014）、柏林 OPENHAUS ZK/U 藝術與都市學中心（2014）、國立臺灣美術館亞洲藝術雙年展（2013）等。伊謝是 Parkingproject 的創始人，該藝術空間位於藝術家於吉隆坡的住所；伊謝也是馬來西亞藝術刊物 sentAp! 的創辦人之一。

Roslisham Ismail, better known as Ise, was born in 1972 in the city of Kota Bharu, in Kelantan, Malaysia. He was a multidisciplinary artist whose works include installations, video art and participatory projects. Ise's practice explored the links between forms of pop cultural expression—such as comics and graffiti—and representations of alternative histories of places and cultures.

Ise was the founder of Parkingproject, an artists space based in his apartment in Kuala Lumpur, and a co-founder of the Malaysian art publication sentAp! (KELANTAN KL). He passed away in June 2019.

Ise's work has been the subject of solo exhibitions at The Laundromat Project, New York (2016); Bangkok University Gallery (2014); Jalan Mesui, Kuala Lumpur (2010); Japan Foundation Kuala Lumpur Gallery (2008); Australia High Commission, Gallery 4A, Sydney (2007); Kedai Kebun Forum, Yogyakarta, Indonesia (2007); and Asia-Australia Art Centre, Sydney (2006).

His work has also been presented in group exhibitions and venues, including *Pattani Semasa* at ILHAM Gallery, Kuala Lumpur (2018); *Nasi Gunung Cooking Performance* project, ILHAM Gallery, Kuala Lumpur (2018); MAIIAM, Contemporary Art Museum, Chiang Mai, Thailand (2017); *Escape from SEA* at the National Art Gallery Malaysia(2017); *Mode of Liaison*, Bangkok Art and Culture Centre (2017); *Sunshower*, Mori Art Museum, Tokyo (2017); the Goethe-Institut, as part of the Singapore International Festival of Arts

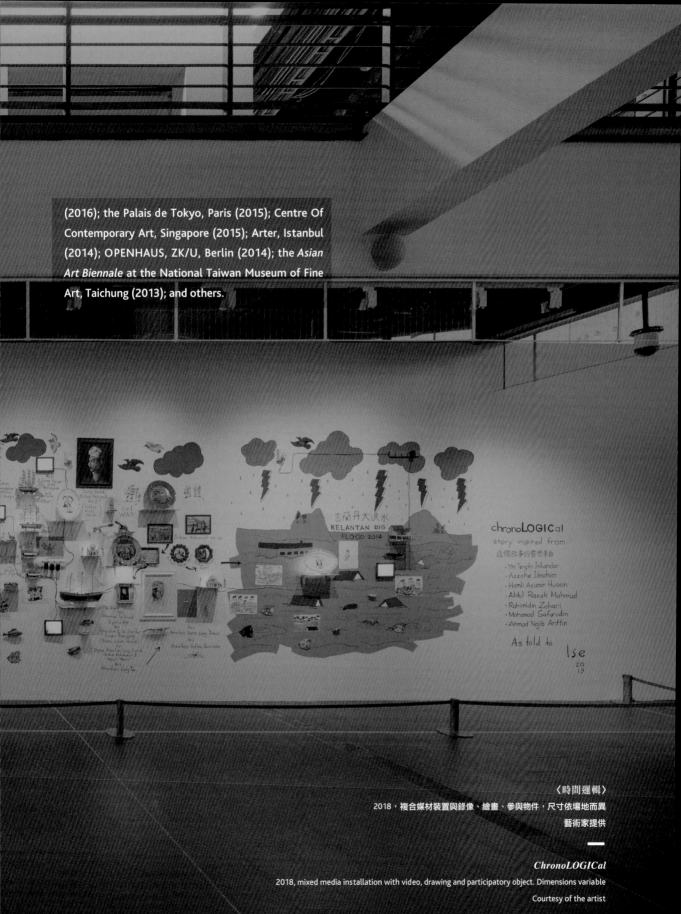

(2016); the Palais de Tokyo, Paris (2015); Centre Of Contemporary Art, Singapore (2015); Arter, Istanbul (2014); OPENHAUS, ZK/U, Berlin (2014); the *Asian Art Biennale* at the National Taiwan Museum of Fine Art, Taichung (2013); and others.

〈時間邏輯〉
2018，複合媒材裝置與錄像、繪畫、參與物件，尺寸依場地而異
藝術家提供

—

ChronoLOGICal
2018, mixed media installation with video, drawing and participatory object. Dimensions variable
Courtesy of the artist

〈時間邏輯〉

在錄像、繪畫、裝置以及參與式企劃當中，羅斯里胥安姆・伊斯梅爾（伊謝）運用流行文化的語彙，試圖拆解地域複雜的架空歷史以及文化根源。在〈時間邏輯〉（2019）中，伊謝繪測自己的文化血緣，呈現位於馬來半島東北方的吉蘭丹王國（葉門移民的後代）的私人歷史。

阿拉伯文化進入到馬來群島最早開始於西元九世紀，當時阿拉伯商人從葉門的哈德拉毛越過印度洋，開始影響馬來群島。這種旅居式的航海群體同時駐足東非與印度次大陸，從摩洛哥到毛里塔尼亞，甚至擴及歐洲與中國。他們在此從事商業、學術活動、外交，最終甚至參與地方政治，並透過通婚在群體中取得地方勢力。伊謝在這件裝置中，運用由當地親友、鄉間教師與長者、領袖與史學家錄製的口述歷史，形塑微型紀念物、歷史事件動畫以及文本戲劇。伊謝透過個人的回憶及具體化的行動提醒觀眾，一個時代的繪測從來都沒有邏輯、不是線性發展，並且充滿未知，參雜了古老傳說、神話、童話故事；這些都是超越教條規範與學術研究的歷史迴聲。

ChronoLOGICal

Through a combination of video, drawing, installation and participatory projects, Roslisham Ismail (a.k.a Ise) employs expressions of popular vernacular with an eye toward unpacking a place's complex, and often alternative, cultural roots. In *chronoLOGICal* (2019), lse maps his cultural ancestry and offers a personal history of the Kingdom of Kelantan (whose residents are descendants of Yemeni migrants), located in the north-eastern corner of the Malaysia peninsular.

The Arab world arrived in the Malay Archipelago in the ninth century, when trading merchants crossed the Indian Ocean from the Hadramawt region of Yemen. The traders engaged in commerce, scholarship and diplomacy when they were in the Archipelago, and would eventually enter the domain of local politics. Marriage between the Arab traders and the local community would eventually lead to the former gaining particular influence.

In the exhibited installation, Ise relies on recordings of oral histories from his local communities—including friends, family, rural teachers, village elders, imams and historians—to create a hand-drawn composition of miniature souvenirs, animations of historical accounts and textual dramas. These works in combination illustrate and narrate the various conflicts and claims on this largely Islamic territory located between the ancient kingdoms of Siam and the Malaccan Sultanate. Ise's work is a constant reminder that the mapping of time can never be logical, linear and certain. In fact, such endeavours have the unintended consequences of reinforcing old lore, mythical legends and childhood tales—histories that are determined by voices that echo far beyond the centralised tomes of doctrine and academia.

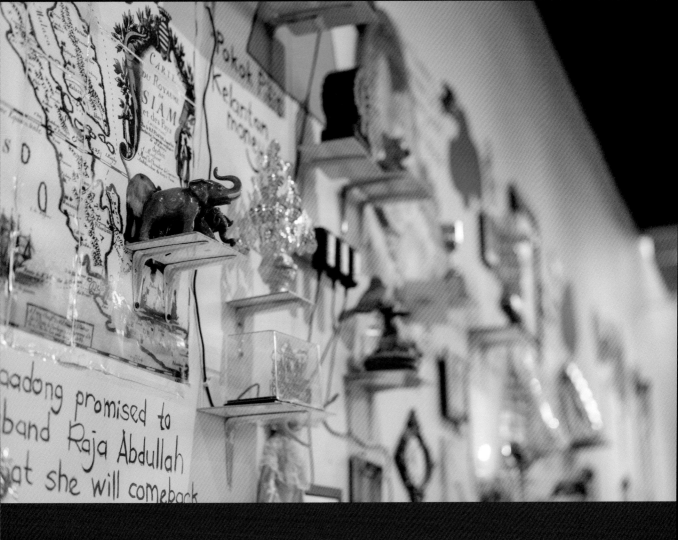

〈時間邏輯〉
2018，複合媒材裝置與錄像、繪畫、參與物件，尺寸依場地而異
藝術家提供

—

ChronoLOGICal
2018, mixed media installation with video, drawing and participatory object. Dimensions variable

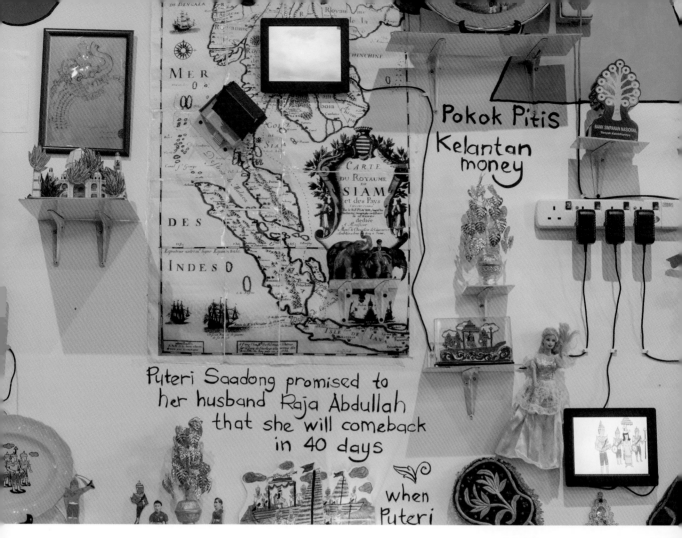

Pokok Pitis
Kelantan
money

Puteri Saadong promised to her husband Raja Abdullah that she will comeback in 40 days

when Puteri

〈時間邏輯〉
2018，複合媒材裝置與錄像、繪畫、參與物件，尺寸依場地而異
藝術家提供

ChronoLOGICal

2018, mixed media installation with video, drawing and participatory object. Dimensions variable
Courtesy of the artist

作品布展協助∣阿扎哈・易卜拉欣、
莫哈末・里扎爾・曼薩丁（切克里）、
馬茲蘭・穆罕默德、安瓦里・阿扎里、
祖爾庫納、阿扎米（鮑伯）

Installed by Parkingproject team∣
Azzaha Ibrahim, Mohd Rizal Mansordin (Chekri),
Mazlan Muhamad, Anwar Azhari, Zulkurnain,
Azami (Bob)

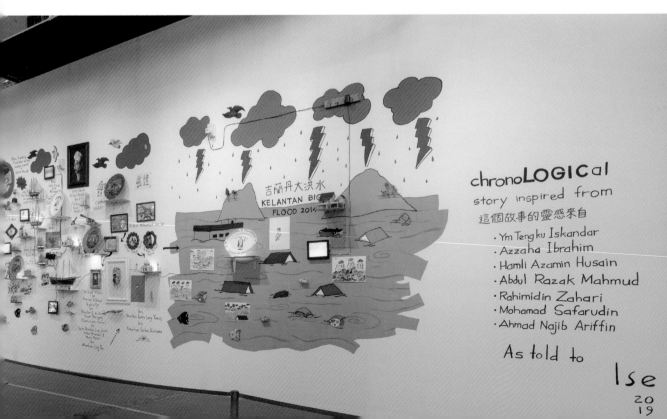

CHIU Chen-Hung

1983 年生於臺灣花蓮，2008 年畢業於國立臺灣藝術大學造形藝術研究所。目前居住和工作在花蓮。就像是進行一場考古探險般，他的創作多以裝置、雕塑的方式呈現，他擅於挖掘生存時空曾經存在的身影與軌跡，並透過抽象的手法重新演繹那些被合理化及設計過的邏輯規則，將它們生動地重塑，藉此發展出一套巨大的記憶修補術。代表個展包括「趨光」（貝塔寧藝術中心，柏林，2019）、「時間的灰燼」（伊日藝術計劃，臺北，2017）、「九色鹿」（關渡美術館，臺北，2015）。代表聯展包括「南方以南」（大武海濱公園，臺東，2018）、「破碎的神聖」（臺北當代藝術館，臺北，2017）、臺灣美術雙年展「一座島嶼的可能性」（國立臺灣美術館，臺中，2016）、大臺北當代藝術雙年展「去相合」（國立臺灣藝術大學，臺北，2016）、「巴黎／柏林／馬德里國際影像藝術節」（法國 La Gaîté Lyrique 數位影像中心）、柏林世界文化之家、西班牙索菲雅皇后美術館、「利物浦雙年展：城市聯盟」（利物浦 LJMU 大樓，2012）、「理解的尺度－臺泰當代藝術展」（曼谷藝術文化中心，曼谷，2012）。

Chiu Chen-Hung was born in 1983 in Hualien, Taiwan, where he is currently based. He graduated from the Graduate School of Plastic Arts at National Taiwan University of Arts in 2008. Chiu's work mainly encompasses art installations and sculptures that are archaeological explorations that seek to unveil the states and trajectories of existence. Through his practice, he attempts to redefine rationalised and designed rules of logic, exercising a kind of vast memory restoration by presenting these "rules" in new ways.

Chiu has exhibited widely across the world. His notable solo exhibitions include *Photoaxis* at Kunstlerhaus Bethanien, Berlin (2019); *The Dust of Time* at YIRI ARTS, Taipei, 2017; and *A Deer of Nine Colors* at Kuandu Museum of Fine Arts (Taipei, 2015). Chiu's work has also been featured in group exhibitions, including *The Hidden South* at DaWu Waterfront Park (Taitung, 2018); *Shattered Sanctity* exhibition at the Museum of Contemporary Art (Taipei, 2017); the *Taiwan Biennial: The Possibility of an Island at* National Taiwan Museum of Fine Arts (Taichung, 2016); the *Greater Taipei Biennial of Contemporary Arts: De-coincidence* at the National Taiwan University of Arts (Taipei, 2016); *Rencontres Internationales* at La Gaîté Lyrique (France), Haus der Kulturen der Welt Berlin (Germany), and Reina Sofia National Museum (Madrid, Spain, 2015); *Liverpool Biennial City-States* at LJMU Copperas Hills (Liverpool, 2012); and *THAITAI：A measure of Understanding* (Bangkok Art and Culture Centre, 2012).

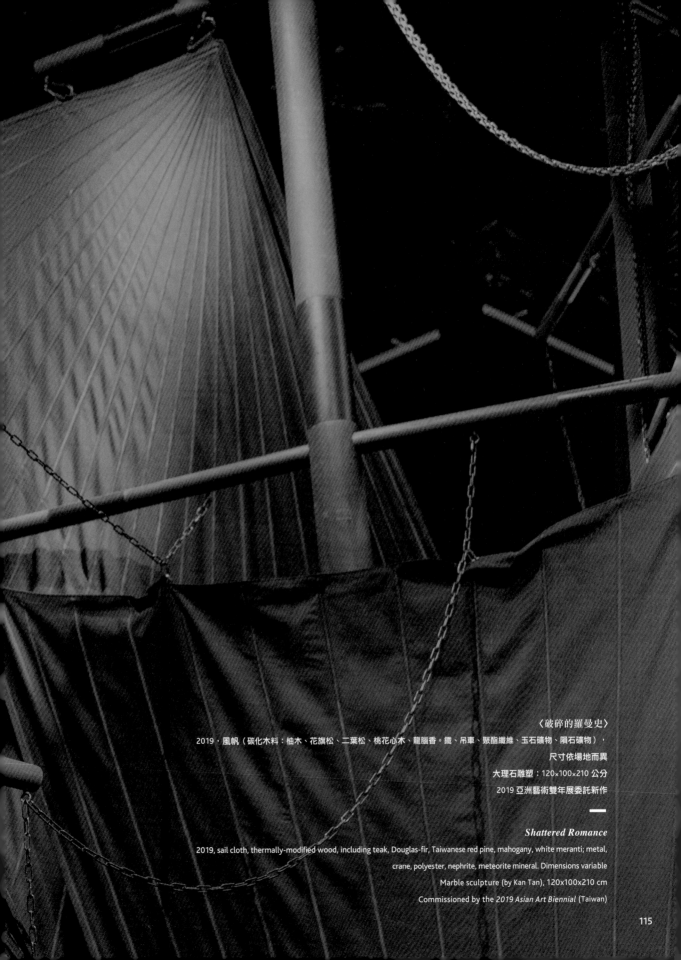

〈破碎的羅曼史〉
2019，風帆（碳化木料：柚木、花旗松、二葉松、桃花心木、龍腦香。鐵、吊車、聚酯纖維、玉石礦物、隕石礦物），
尺寸依場地而異
大理石雕塑：120×100×210 公分
2019 亞洲藝術雙年展委託新作

—

Shattered Romance

2019, sail cloth, thermally-modified wood, including teak, Douglas-fir, Taiwanese red pine, mahogany, white meranti; metal,
crane, polyester, nephrite, meteorite mineral. Dimensions variable
Marble sculpture (by Kan Tan), 120x100x210 cm
Commissioned by the *2019 Asian Art Biennial* (Taiwan)

〈破碎的羅曼史〉

本計畫試著以歷史、礦物與自然元素之間的流動狀態，做為一種另類的美學觀察。受到1819年探險家迪蒙‧迪維爾（Dumont d'Urville）航行的啟發，這件作品透過不同物體與事件的組合，將海洋探險與洋流、文化政治之間的關係聯繫在一起，例如米洛島維納斯雕像的發掘，以及1960年代太空競賽等特殊事件做為參照的軸線，試圖提出不同於過去以人類為中心的宇宙觀，轉而尋求一種物質的內在活力與創造性，並轉化在造形的邏輯中。

這個創作計畫試著與多樣性的材料來進行對話。透過一艘由碳化木料、金屬共構，搭配玉石及隕石礦物而製成的克拉克式帆船（三桅或四桅帆船），和借展作品（〈海風〉，2006）的奇異組合，展開人類航海探索的歷史與洋流活動的交錯關係。透過遊走在歷史和自然活動之間，這件作品開展出不同時空之間的無聲對話。在這過程中鬆動原本對立的邊界，如同人工與自然、生與死、欲望與現實、未知與理性、原生與外來、有機與合成、破碎與完整。藝術如何在這災難性變化的時代中，重新建構材料的主體性、感知意識、甚至秩序，本創作計畫試圖提供一種潛在路徑，書寫出一篇破碎的羅曼史。

大理石雕塑〈海風〉（2006）由藝術家甘丹（甘朝陽）製作及提供。

Shattered Romance

In this project, Chiu attempts to portray the fluidity of history, minerals, and natural elements as an alternative method of aesthetic observation. Inspired by the 1819 voyage of the explorer Dumont d'Urville, this work ties together ideas of oceanic exploration, sea currents and cultural politics, through an assemblage of disparate objects and events. Tales of colonial seafaring are further overlaid with trace memories of the Venus de Milo sculpture and the 1960s Space Race. *Shattered Romance* is imagined by the artist as an adventure into the unknown, as well as an embodiment of a form of history where humans no longer occupy a privileged centre. Instead, this work proceeds by pursuing the inner energy and creative potential of diverse materials, engaging them in dialogue, and seeking to embody them through the logic of their internal designs.

Shattered Romance's interweaving of the history of human exploration and the activity of ocean current is manifested in the strange combination of a borrowed sculpture by Kan Tan (*Wind from the Sea*, 2006), a jade and meteorite carrack (a three—or four—masted ship), and a sculpture made of thermally-modified wood and metal. Altogether, the works restlessly oscillate between the historical and the natural, a silent dialogue between different times and spaces.

The process of combining these elements has loosened the borders of what had previously been opposed: the artificial and the natural, life and death, desire and reality, the unknown and reason, the native and the foreign, the organic and the synthetic, the broken and the complete. How does art, in a time of catastrophic change, manage to reconstruct autonomy, perceived consciousness and order? This project aims to present an underlying route for writing a shattered romance.

Wind from the Sea (2006) by Kan Tan (Kan Chao-Yang) and courtesy of the artist.

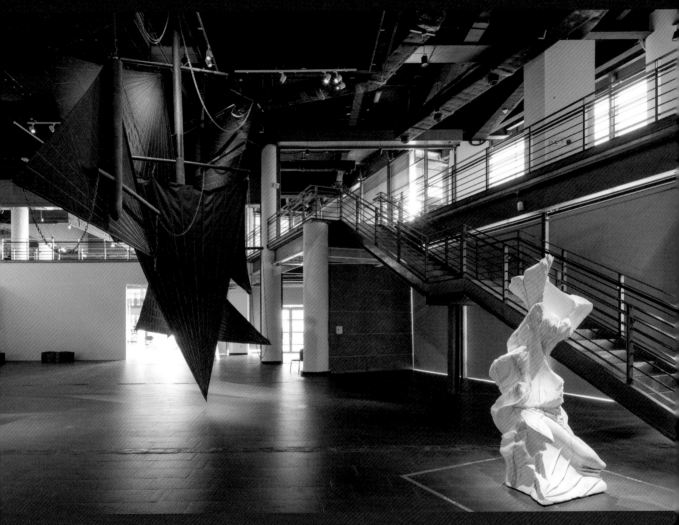

〈破碎的羅曼史〉
2019，風帆（碳化木料：柚木、花旗松、二葉松、桃花心木、龍腦香。鐵、吊車、聚酯纖維、玉石礦物、隕石礦物），
尺寸依場地而異
大理石雕塑：120×100×210 公分
2019 亞洲藝術雙年展委託新作

—

Shattered Romance
2019, sail cloth, thermally-modified wood, including teak, Douglas-fir, Taiwanese red pine, mahogany, white meranti; metal,
crane, polyester, nephrite, meteorite mineral. Dimensions variable
Marble sculpture (by Kan Tan), 120x100x210 cm
Commissioned by the *2019 Asian Art Biennial* (Taiwan)

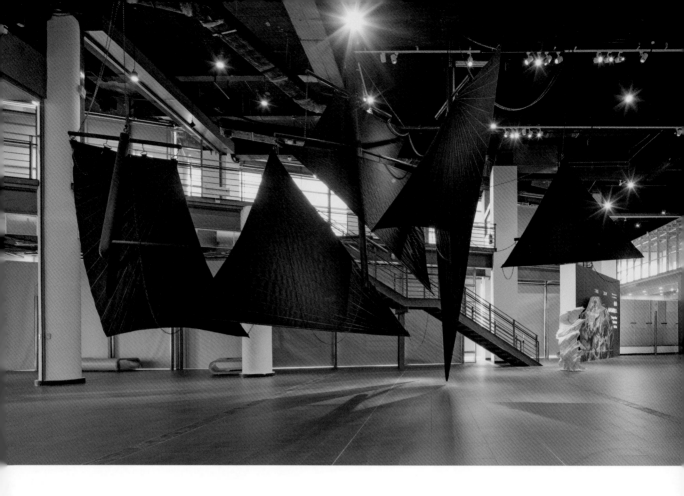

〈破碎的羅曼史〉

2019，風帆（碳化木料：柚木、花旗松、二葉松、桃花心木、龍腦香。鐵、吊車、聚酯纖維、玉石礦物、隕石礦物），
尺寸依場地而異

大理石雕塑：120×100×210 公分

2019 亞洲藝術雙年展委託新作

———

Shattered Romance

2019, sail cloth, thermally-modified wood, including teak, Douglas-fir, Taiwanese red pine, mahogany, white meranti; metal,

crane, polyester, nephrite, meteorite mineral. Dimensions variable

Marble sculpture (by Kan Tan), 120x100x210 cm

Commissioned by the *2019 Asian Art Biennial* (Taiwan)

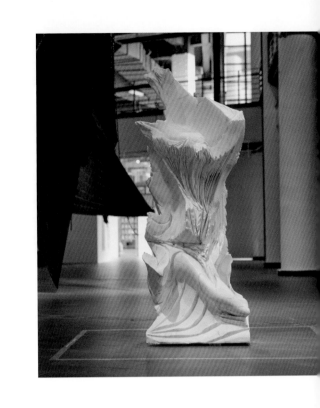

黃漢明
Ming WONG

1971 年出生於新加坡。黃漢明透過錄像、裝置及表演創作重新演繹世界電影及流行文化,建構電影語言、社會結構、身分認同及自我內省的多元層次,企圖以非完美的轉譯及執行方式,讓同一名演員(大多時候由藝術家本人)演出故事中的不同角色,運用人的展演性詮釋「真實」、「原創」及「他者」等概念,黃漢明的創作專注於文化、性別、身分認同是如何被建講、複製及傳播,也關注這些過程與再現政治的內在關聯性,藝術家雖非專業演員訓練出身,其藝術實踐卻在電影的深刻影響下,不斷與展演、性別及衍異等概念對話,近年的創作多為跨領域實踐,融入表演和裝置來體現自身對全球文化產物的探究。

黃漢明近期展覽包括韓國釜山雙年展人、塞內加爾達喀爾雙年展、孟加拉達卡藝術峰會、香港 Para Site 藝術空間、柏林 Savvy 當代藝術中心和巴黎國家舞蹈中心等。也曾多次參與各大藝術盛會,包含雪梨雙年展(2010、2016)、亞太三年展(2015)、上海雙年展(2014)、里昂雙年展(2013)、利物浦雙年展(2012)、光州雙年展(2010)及紐約 Performa 藝術節(2011),更曾在 2009 年代表新加坡參加第 53 屆威尼斯雙年展,以個展形式展出作品〈一世模仿〉並獲頒評審團特別提名(Special Mention)。

Ming Wong was born in 1971 in Singapore. Through his videos, installations and performances, he builds layers of cinematic language, social structure, identity and introspection through his re-telling of world cinema and popular culture. With imperfect translations and re-enactments, he casts an actor (often himself) as every character in a story. Wong attempts to unravel ideas of "authenticity", "originality" and the "other", with reference to acts of human performativity. He looks into how culture, gender and identity are constructed, reproduced and circulated, as well as how it all feeds into the politics of representation.

Though untrained as an actor, he has embarked on an artistic practice that is at once highly influenced by cinema and is in constant dialogue with issues of performativity, gender, and difference. Wong's recent projects have become more interdisciplinary, incorporating performance and installation to flesh out his exploration of cultural artefacts from around the world.

In 2018, his work was shown at the *Busan Biennale*, South Korea; *Dakar Biennale*, Senegal; *Dhaka Art Summit*, Bangladesh; Para Site, Hong Kong; SAVVY Contemporary, Berlin; and Centre National de la Danse, Paris. He participated in both the 2010 and 2016 *Sydney Biennale*. Other exhibitions include: *Asia Pacific Triennial* (2015); *Shanghai Biennale* (2014); *Lyon Biennale* (2013); *Liverpool Biennial* (2012); *Gwangju Biennale* (2010); and *Performa 11*, New York (2011). In 2009, Wong represented Singapore at the 53rd *Venice Biennale*, showcasing a solo presentation, *Life of Imitation*, which was awarded a special mention.

妳已經認識我了

efugee

〈竹製飛船的故事〉
2019，有聲單頻道高畫質錄像，15 分 35 秒
藝術家提供

Tales of the Bamboo Spaceship
2019, single channel HD video with audio. 15min35sec
Courtesy of the artist

〈竹製飛船的故事〉

此作品是一件正在進行中的計畫，黃漢明試圖連結粵劇和科幻文學這二種截然不同的文化形式。在最新的敘事中，呈現了過去五年來他對粵劇由舞台表演到登上 20 世紀大螢幕的歷史過程研究，黃漢明藉由此作思索傳統中國南方藝術的其他可能性，一方面透過科幻觀點向前推進，摸索根植於語言及文化記憶中的社群另類未來，另一方面回望過去，探討這類藝術在 19 世紀以海洋為主要場景的傳統神話中，在沿海地帶發展的根源。

Tales of the Bamboo Spaceship

Tales of the Bamboo Spaceship is an ongoing project in which Ming Wong attempts to connect two seemingly distinct cultural forms of Cantonese Opera, and science fiction literature. In its latest iteration (the 2019 version), the artist presents a narrative structure drawn from the last five years of his research into the history of Cantonese opera's transition from stage to screen during the 20th century. Wong extends the speculative possibilities of this traditional Southern Chinese art form both forwards— through the lens of science fiction, towards alternative futurities for communities tied by language and cultural memory—as well as backwards, to the opera's coastal roots in the 19th century and the tradition's mythology surrounding its history of suppression and survival.

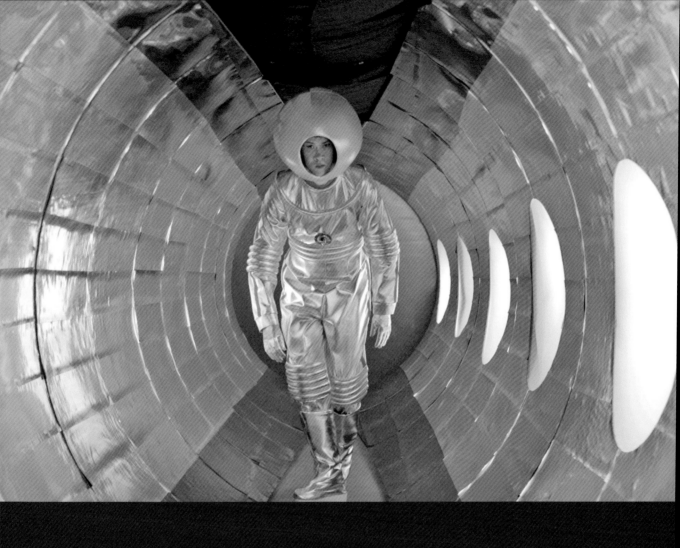

〈竹製飛船的故事〉
2019，有聲單頻道高畫質錄像，15 分 35 秒
藝術家提供

—

Tales of the Bamboo Spaceship
2019, single channel HD video with audio. 15min35sec

〈竹製飛船的故事〉
2019，有聲單頻道高畫質錄像，15 分 35 秒
藝術家提供

——

Tales of the Bamboo Spaceship
2019, single channel HD video with audio. 15min35sec
Courtesy of the artist

〈血腥瑪麗－南海之歌〉

羅傑斯及海默史坦合作的音樂劇〈南太平洋〉1949 年在百老匯初次登場後，1958 年被改編翻拍成電影，登上大銀幕，劇情是依據詹姆士 A. 米契納 1947 年出版的普立茲得獎作品〈南太平洋故事集〉，該作描繪二次大戰期間在太平洋上發生的戰事歷史。

在音樂劇中，〈巴利哈依〉這首歌曲是由劇中那位被稱為「血腥瑪莉」的在地女族長所演唱，這個擁有北越東京人（Tonkinese）血統的角色是創作者自殖民時期太平洋島國移民歷史中汲取靈感所建構出來的人物，隨法國殖民者來到島上。

「血腥瑪莉」令人生厭的形象及名字，令人聯想到過往那段血腥殘暴又危機四伏的航海歷史，也喚起純潔女性為求生存而不得不屈服於暴力之下的眾多故事，「瑪莉」這大眾化的名字套用在無數面容模糊的外來女性身上，使其真實的原生自我無聲消音，這樣一種可憎的母性角色令人又愛又恨，猶如辛辣味鹹的刺激調酒能振奮精神，卻又消滅不了那揮之不去的殖民宿醉。

在這件作品中，藝術家納入 16 位血腥瑪莉的形象，多為在網路上找到的業餘和高中音樂劇演出，藝術家將這些形象與自身的詮釋和電影中的原版演出交織疊合，以這張運用各種「血腥瑪莉」織構的網，揭示由非裔、亞裔、太平洋島民等族裔融合而成的選角光譜，其中更包含不同外型、「非傳統樣貌」的種族他者，呼籲在 21 世紀的今天，應該要有一座不同以往且以包容、他者性、新主體性為號召的「獨特之島」，向過去那些開拓新領域的人致敬。

Bloody Marys—Song of the South Seas

Rodgers and Hammerstein's stage musical *South Pacific*, opened on Broadway in 1949 and was turned into a film in 1958. The plot was based on James A. Michener's Pulitzer Prize-winning 1947 book, *Tales of the South Pacific*, about the Pacific campaign in World War II. In the film, *Bali Ha* is the siren song delivered by the native matriarch "Bloody Mary": a Tonkinese (North Vietnamese) character concocted by her creators out of the colonial swamp of migrants in the Pacific Islands, transplanted there by the French.

The repugnant image and name of Bloody Mary connotes at once histories of brutal and hazardous journeys across the seas, and virginities surrendered in violent struggles to survive. The default pet name "Mary", given to the hordes of faceless foreign females, silences their true identities. Bloody Mary is a damned maternal figure one loves to hate—a salty, spicy pick-me-up for sure, but no cure for a colonial hangover.

In *Bloody Marys—Song of the South Seas*, sixteen Bloody Marys—mostly taken from amateur and high school musical productions—are woven together, and interlaced with the film's original "Bloody Mary" song and the artist's own rendition of it. This mesh of Marys—revealing a casting spectrum which includes "Black", "Asian", "Pacific Islander", "unconventional looking" or other forms of physical and racial Otherness. The work calls out for a new "special island" for the 21st century, an island of inclusion, alterity and new subjectivity on the horizon, a tribute to those individuals who have broken the ground ahead of us.

林育榮
Charles LIM

新加坡藝術家林育榮的《海況》計劃，透過海洋可見與不可見的多元視角，檢視民族國家的政治生態及生物物理輪廓，林育榮曾經是專業航海人士，他運用包含攝影、影片、錄像等媒材，探索海洋環境及歷史，《海況》曾在新加坡、法國、荷蘭等國的知名藝術機構展出，也曾受邀至上海、大阪、雪梨、冰島、愛爾蘭等地的雙年展及日本愛知三年展展出，林育榮更在 2015 年代表新加坡參加第 56 屆威尼斯雙年展。

Charles Lim's *SEA STATE* project examines the political and bio-physical contours of the nation-state, through the visible and invisible lenses of the sea. A former professional sailor, Lim works across several mediums including photography, film and video, drawing on extensive research into maritime environments and histories. *SEA STATE* has been exhibited at leading institutions in Singapore, France and the Netherlands, as well as at biennales in Shanghai, Osaka and Sydney, the *EVA International*, Ireland and the *Aichi Triennale*, Japan. In 2015, Lim represented Singapore at the *56th Venice Biennale*.

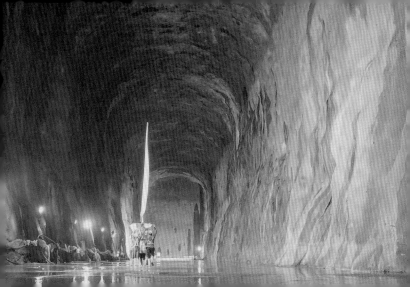

〈海況六〉

無論海平面上或海平面下，新加坡都持續在擴張中。

裕廊島地下儲油庫是東南亞第一個地下液態碳氫化合物儲存設施，這座地下儲油庫位於裕廊島榕樹凹地地底下 130 公尺處，提供新加坡在裕廊島上運作的石化工業基礎用油，該島建立於 1980 年代，原有的數座小島經填海造地、連結開拓，成為與新加坡本島相連的人工島。2015 年儲油設施正式進入第一階段運作時，可存放 147 萬立方公尺的儲油槽，大約為 600 座奧運標準泳池的容量，而第一階段自海底挖出的石頭則約有 180 萬立方公尺，可填滿 1400 座奧運標準泳池。林育榮的《海況》透過那些可見、不可見且與海洋有關的觀點，檢視民族國家的政治和生物物理輪廓，曾擔任專業船員的林育榮，其創作藉由攝影、電影、錄像等不同媒材，對海洋環境和歷史展開廣泛研究。《海況》做為能夠同時觀測氣候及生態狀態的前線，讓觀眾得以看到先前想像不到的境域。此作首次展出於 2015 年的威尼斯雙年展。

SEASTATE SIX

Singapore continues to grow, both above and under the sea.

The Jurong Rock Caverns are Southeast Asia's first underground liquid hydrocarbon storage facility. Located at depths of 130 metres beneath the Banyan Basin on Jurong Island, the Caverns will eventually provide infrastructural support to the petrochemical industry that operates on Singapore's Jurong Island, a cluster of islets that have been reclaimed into a single major island which was connected to the mainland in the 1980s. Phase 1 became fully operational in 2015, and is capable of holding some 1.47 million cubic metres of oil storage tanks. This is about the size of 600 Olympic swimming pools. The volume of undersea rocks excavated from Phase 1 equals 1.8 million cubic metres, which is enough to fill 1,400 Olympic swimming pools. Charles Lim's *SEA STATE* project examines the political and biophysical contours of the nation state, through the visible and invisible lenses of the sea. A former professional sailor, Lim works across several media including photography, film and video, drawing on extensive research into maritime environments and histories.

The exhibited work exists as the frontier of a climatic and ecological complex, taking us to places that were, until recently, only a thing of oneiric theory (related to dreaming). This work was first exhibited at the Singapore Pavilion of the *Venice Biennale* in 2015.

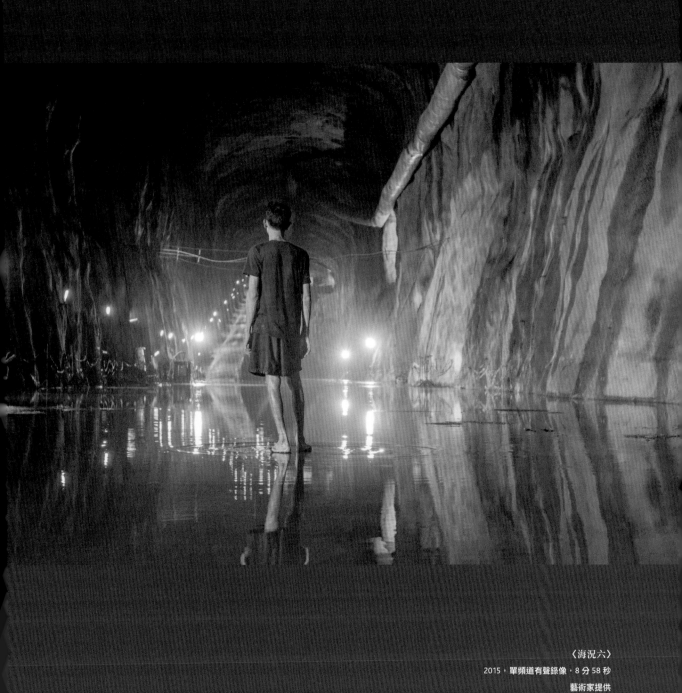

〈海況六〉
2015，單頻道有聲錄像，8 分 58 秒
藝術家提供

—

SEASTATE SIX
2015, video, sound. 8min58sec
Courtesy of the artist

〈海況六〉
2015，單頻道有聲錄像，8 分 58 秒
藝術家提供

SEASTATE SIX
2015, video, sound. 8min58sec
Courtesy of the artist

〈初始 3.9：現況的沉默拍擊〉

大海在文化想像中總是被描繪成無法被佔有的，這個概念在我們常用的「公海」一詞中顯露無遺，海不受任何單一國家所掌控，聯合國海洋法公約第112條即指出：「所有國家均有權在公海海底鋪設海底電纜。」全球99%的國家所使用的電信網路通訊都仰賴設置於海床上的電纜，而在負責這些相關工作的電纜公司資料庫中，存有大量掌握這些電纜網絡設備狀態的「檢視影像」。林育榮藉此展示人工基礎設施如何受到經濟擴張政治的驅動，如何改變海洋環境，並挑戰海洋文化所代表的位置。

Alpha 3.9: silent clap of the status quo

Within our cultural imagination, the sea has been endlessly depicted as "uninhabitable"—a notion commonly expressed by the phrase "high seas"—a zone that is thought to be free from the control of any individual nation or state. Article 112 of the United Nations Convention on the Law of the Sea states that, "All States are entitled to lay submarine cables on bed of high seas". As a result, 99% of the world's internet and international communications networks run through cables laid at the bottom of oceans and seas.

Deep within the archives of the various parties involved in these endeavours sits a collection of "inspection videos", which monitor the cables covering the length of these networks. Lim utilises these videos in his work to showcase how artificial infrastructures—often driven by the politics of economic expansion—transform the maritime environment, and to challenge the cultural idea of the sea as "uninhabitable".

〈初始 3.9：現況的沉默拍擊〉
2016，單頻道錄像，2 時 26 分 30 秒
藝術家及東協海底電纜公司（ASEAN Cableship）提供

于一蘭
YEE I-Lann

1971 年生於亞庇，現工作居住於馬來西亞沙巴州的亞庇。其主要以攝影媒材為基礎的創作觸及東南亞群島動盪不安的歷史，透過作品探討殖民主義與新殖民主義、權力和歷史記憶對社會經驗的影響，並特別著眼於「人民的歷史」所形成的反敘事。她將歷史參照、大眾文化、文獻、日常物件揉匯成複雜且層次交疊的視覺語彙，近幾年則開始與沙巴州依海維生和依土地維生的族群，以及當地的原民巫師共同合作。她與夥伴喬依·基德（Joe Kidd）創立了「電鍋資料庫：東南亞搖滾珍寶」（The Ricecooker Archives: Southeast Asian Rock 'n' Roll Treasury），也參與馬來西亞電影產業的美術指導相關工作。

2019 年間的近期參展經驗包括外灘美術館（上海）；Para Site 藝術空間（香港）；A+ Works of Art 畫廊（吉隆坡）；高雄市立美術館（高雄）；敦沙卡蘭博物館及彩船節（仙本那）；亞洲電影資料館（新加坡）；北園購物中心（達拉斯）。其他參展經驗包括銀川雙年展（2016）、雅加達雙年展（2015）、大邱攝影雙年展（2014 及 2010）、亞洲藝術雙年展（2011）、福岡亞洲藝術三年展（2009）、堂島河流雙年展（2009）、新加坡雙年展（2006）、第 3 屆亞太當代藝術三年展（1999）。

Yee I-Lann was born in 1971 in Kota Kinabalu, in the Malaysian Borneo state of Sabah, where she currently lives and works. Her primarily photomedia-based practice engages with archipelagic Southeast Asia's turbulent history via works that address issues of colonialism and neo-colonialism, power, and the impact of historical memory on the social experience, often with a particular focus on counter-narrative "histories from below". She employs a complex, multi-layered visual vocabulary drawn from historical references, popular culture, archives, and everyday objects. She has, in recent years, started working collaboratively with Southeast Asia-based and land-based communities, as well as indigenous mediums in Sabah. She is a co-founding associate of "The Ricecooker Archives: a Southeast Asian Rock 'n' Roll Treasury" alongside her partner Joe Kidd, and has worked as a production designer in the Malaysian film industry.

In 2019, her work has been shown at Rockbund Art Museum, Shanghai; Para Site, Hong Kong; A+ Works of Art, Kuala Lumpur; Kaohsiung Museum of Fine Arts, Taiwan; Tun Sakaran Museum and The Lepa Regatta, both of which are in Sabah state; Asian Film Archive; and NorthPark Centre. She has participated in *Yinchuan Biennale* (2016); *Jakarta Biennale* (2015); *Daegu Photo Biennale* (2014 and 2010); *Asian Art Biennial* (2011); *Fukuoka Asian Art Triennale* (2009); *Dojima River Biennale* (2009); *Singapore Biennale* (2006); *The 3rd Asia-Pacific Arts Triennial* (1999).

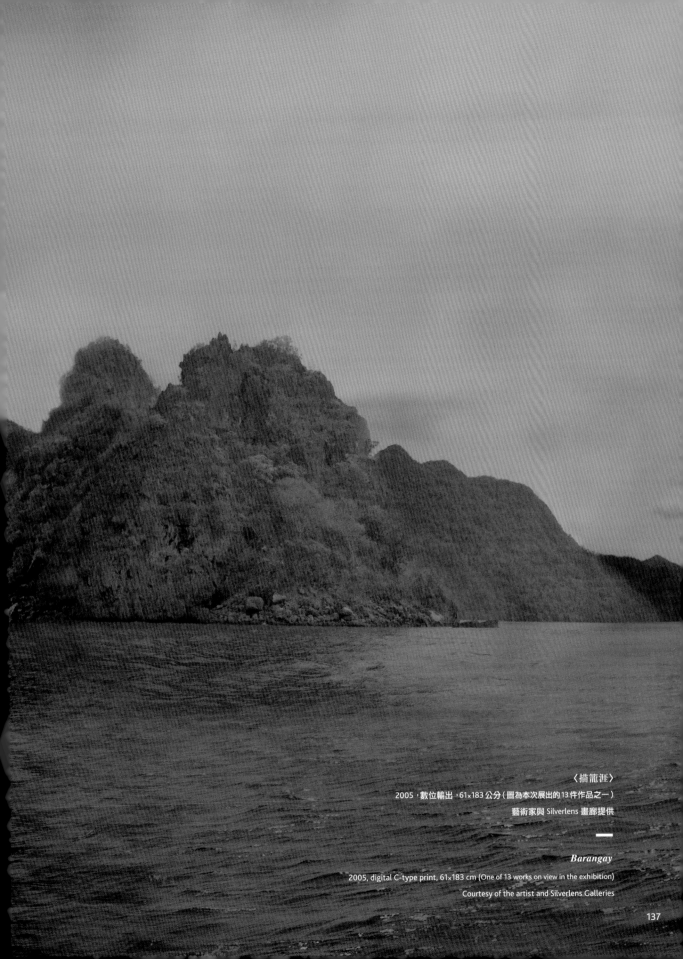

〈描籠涯〉
2005，數位輸出，61×183 公分（圖為本次展出的 13 件作品之一）
藝術家與 Silverlens 畫廊提供

—

Barangay
2005, digital C-type print, 61×183 cm (One of 13 works on view in the exhibition)
Courtesy of the artist and Silverlens Galleries

《蘇祿海的故事》

于一蘭對蘇祿最早的記憶，是關於一隻龍的故事，牠住在沙巴的京那巴魯的山裡，最愛玩的東西是一顆珍珠，那是一個牡蠣吞入一滴月亮的眼淚後所生成的絕美大珍珠。于一蘭啟程前往實地拍攝那裡的風景、天空，和島嶼。旅行時，她同時是故事的圖書館員、收藏家、分揀員，也是運用那些資料館的研究員，帶著沉重的包袱，去找某種稟性、風波、廟宇、樣板，用來訴說蘇祿。它是一片魔海，被政治和偏見的思潮隔離在世界之外 30 餘年，守護著它的，是往麥加那一方朝拜的「在海流上生活的人」的陶蘇格族，和「海上吉普賽人」的巴瑤族這兩個古老民族。他們落海生根，在海上生老病死。千年以來，海帶來了帝國和從世界各個角落來的商人，但乘風破浪的蘇祿人守住了疆界。于一蘭所聽聞過的數百則故事經常以這片海為背景，多得是令人可望而不可及的題材：海盜、奴隸、鴉片、M16 步槍、牧師、戰爭、綁架、Tau Tau 人形木雕、颱風、海難、惡靈、蘇丹。

Sulu Stories

Yee I-Lann's first memory related to Sulu was a story about the dragon that lived on Mount Kinabalu in Sabah and had a favourite plaything, a giant pearl from the Sulu Sea. An oyster had swallowed a tear from the moon, thus producing a pearl of extraordinary size and beauty. Yee would journey to the Sulu Sea, and photograph the physical vistas, the sea, the sky, the islands.

It is a haunted sea, barred to the world for over thirty years by the currents of politics and prejudice and guarded by the ancient "Tausug People of the Current" and the "Bajau Sea People" that turn to pray to the horizon of Mecca. The sea is their life, the land a graveyard. For a millennia, the sea brought with it empires and traders from every corner of the world, and yet the peoples of Sulu continue to ride the currents and hold their frontiers. The sea is the constant backdrop to the hundreds of stories the artist has encountered, the subjects tantalising: pirates, slaves, opium, M16s, priests, wars, kidnappings, Tau Taus, typhoons, shipwrecks, Boogeymen and Sultans.

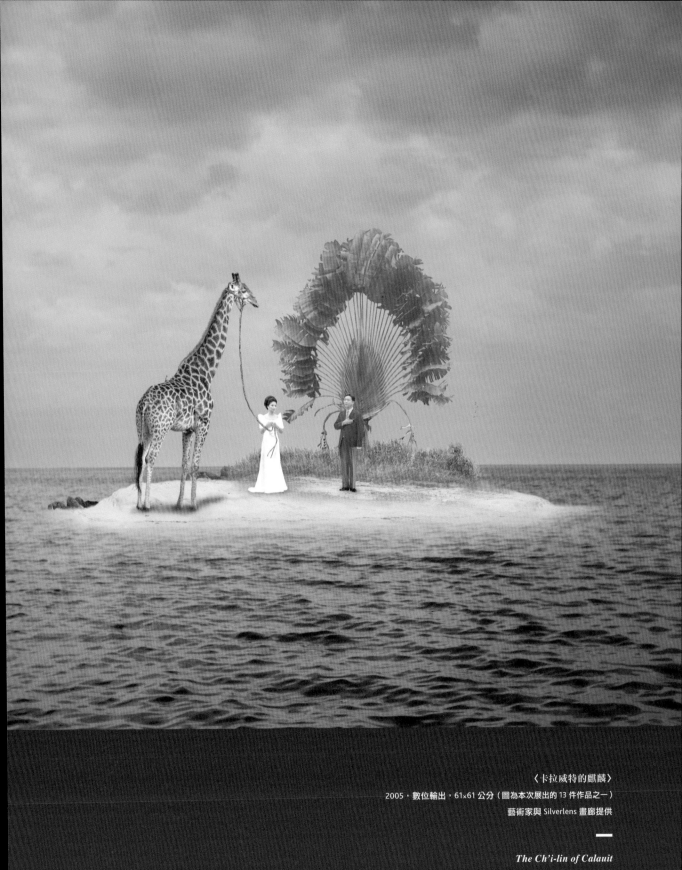

〈卡拉威特的麒麟〉
2005，數位輸出，61×61 公分（圖為本次展出的 13 件作品之一）
藝術家與 Silverlens 畫廊提供

The Ch'i-lin of Calauit
2005, digital C-type print, 61×61 cm (One of 13 works on view in the exhibition)
Courtesy of the artist and Silverlens Galleries

b 〈巢〉
2005，數位輸出，61×61 公分（圖為本次展出的 13 件作品之一）
藝術家與 Silverlens 畫廊提供

———

Sarang

2005, digital C-type print, 61×61 cm (One of 13 works on view in the exhibition)
Courtesy of the artist and Silverlens Galleries

a 〈地圖〉
2005，數位輸出，61×122 公分（圖為本次展出的 13 件作品之一）
藝術家與 Silverlens 畫廊提供

———

Map

2005, digital C-type print, 61×122 cm (One of 13 works on view in the exhibition)
Courtesy of the artist and Silverlens Galleries

c 〈紗籠〉
2005，數位輸出，61×61 公分（圖為本次展出的 13 件作品之一）
藝術家與 Silverlens 畫廊提供

———

Sarung

2005, digital C-type print, 61×61 cm (One of 13 works on view in the exhibition)
Courtesy of the artist and Silverlens Galleries

a

b

c

田村友一郎
Yuichiro TAMURA

1977 年生於富山縣，現工作居住於日本京都。東京藝術大學大學院映像研究所博士，日本大學藝術學部攝影科學士，柏林藝術大學空間實驗研究所客座研究員（2013–2014）。其裝置作品多半結合錄像、攝影、行為等形式。田村友一郎除了向熟悉當代藝術的觀眾傳達訊息之外，更以其不受限於錄像或視覺藝術等傳統分類、獨特思維方式的作品，與觀眾激發出跳脫傳統的對話。

田村友一郎近期展覽包括：紐西蘭戈維特－布魯斯特藝廊的個展「乳白山」；京都市立藝術大學藝術中心的個展「吶喊」；東京國立新美術館、廣島市立當代美術館、森美術館、2018 年釜山雙年展、2018 年亞太藝術獎、2017 年日產藝術獎、柏林世界文化之家和橫濱美術館的聯展等。

Born in Toyoma prefecture in 1977, the artist currently lives and works in Kyoto, Japan. Tamura holds a doctoral degree from the Graduate School of Film and New Media, Tokyo University of the Arts, and a Bachelor's degree of Photography from Nihon University. He was a guest researcher for the Institut für Raumexperimente at the Berlin University of the Arts (2013-2014). The artist mostly produces installations with video, photography and performance. He not only addresses contemporary art world audiences, but also triggers an unconventional way of communication with the general public, through the works that utilise his unique form of reflection, which is unconstrained by the conventional division of disciplines and categories such as video or visual arts.

His recent exhibitions have included the solo shows *Milky Mountain* at Govett-Brewster Art Gallery, New Zealand; *Hell Scream* at Kyoto City University of Arts Art Gallery @KCUA and the group shows at National Art Center, Tokyo, Hiroshima City Museum of Contemporary Art, Mori Art Museum, *Busan Biennale 2018*, Signature Art Prize 2018, Nissan Art Award 2017, Haus der Kulturen der Welt, Berlin and Yokohama Museum of Art.

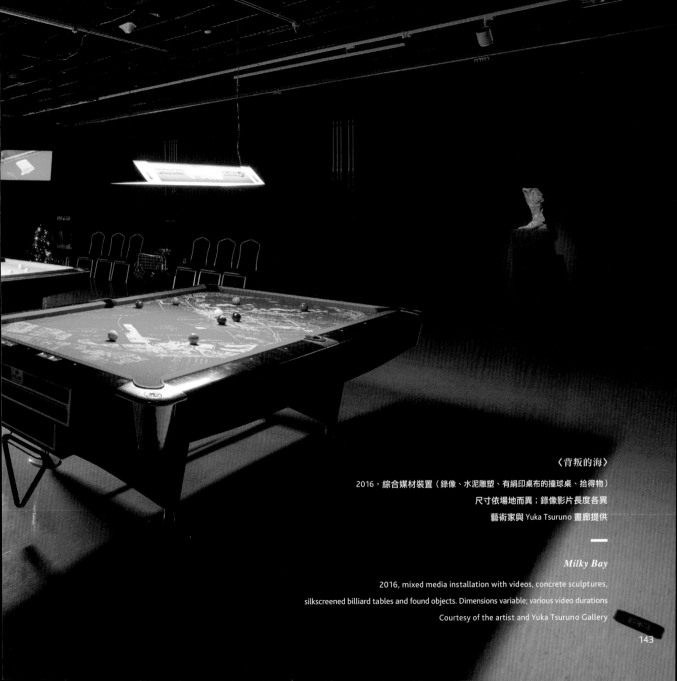

〈背叛的海〉

2016，綜合媒材裝置（錄像、水泥雕塑、有絹印桌布的撞球桌、拾得物）

尺寸依場地而異；錄像影片長度各異

藝術家與 Yuka Tsuruno 畫廊提供

———

Milky Bay

2016, mixed media installation with videos, concrete sculptures,
silkscreened billiard tables and found objects. Dimensions variable; various video durations
Courtesy of the artist and Yuka Tsuruno Gallery

〈背叛的海〉

此作品是一件沒有「現場演員」的戲劇作品，由一位虛構的故事講述者擔任旁白，令人聯想到日籍作家、詩人、劇作家三島由紀夫。1945 年，美軍不分青紅皂白地對橫濱市區展開空襲行動，據稱造成約一萬人死亡。戰爭結束後，橫濱落入了盟軍的控制，市區街道都被冠上美式名稱。〈背叛的海〉由一連串的歷史片段構成，包括洗滌於橫濱的身體記憶，以及一位青年憶述那些大搖大擺地走在橫濱街頭的美國大兵，被他們精實的軀體深深吸引。1951 年的聖誕節，三島由紀夫從橫濱港出發前往希臘，他在當地享受的陽光及所見的胴體對他產生深刻的影響，返回日本後，三島在 1955 年開始進行重訓，但他的性取向則始終隱晦不明。〈背叛的海〉創作靈感來自三島由紀夫 1963 年以橫濱為背景的小説《午後的曳航》。在作品中，種種閃爍的連結一如撞球擊中另一個撞球，隨著聯想與共鳴相乘，我們被賦予了一種帶有強烈心理學觀點的廣闊視野。

Milky Bay

A dramatic piece without "live actors", *Milky Bay* is narrated by a fictional storyteller reminiscent of Yukio Mishima, the Japanese author, poet and playwright. In 1945, the U.S. Army indiscriminately bombed Yokohama's city centre, reportedly killing approximately 10,000 people. After the war, Yokohama fell under the control of the Allied Forces and the streets became known by American-style names. *Milky Bay* is composed of a series of historical fragments including recollections of washed up body parts in Yokohama, and reminiscences of a young man attracted by the muscled bodies of American soldiers swaggering through the streets of Yokohama. On Christmas Day 1951, Mishima set off from Yokohama Port to Greece, where the Mediterranean sun and the bodies he encountered had a significant influence on him. After returning to Japan, Mishima started weight training in 1955; his sexual orientation remained obscure. *Milky Bay* is inspired by and contains elements of Mishima's 1963 novel, *The Sailor Who Fell From Grace with the Sea*, which was set in Yokohama. In *Milky Bay*, flashes of connections come together like the striking of one billiard ball against another. As associations and resonances multiply, we are given a vision of history that is both wide-ranging and intensely psychological.

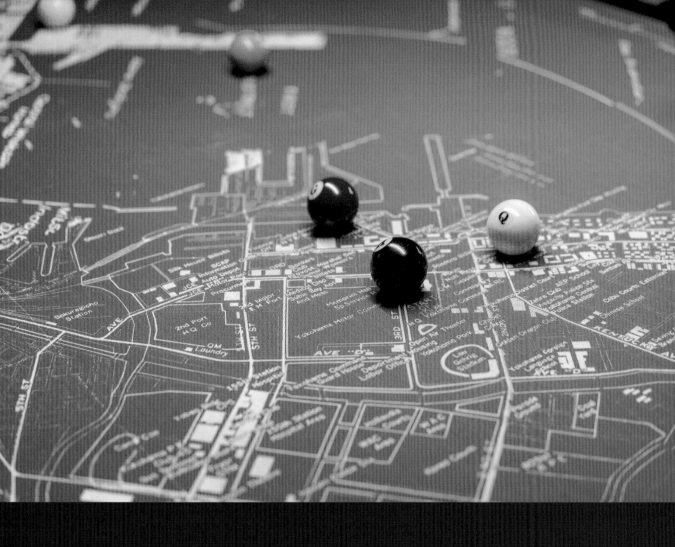

〈背叛的海〉

2016，綜合媒材裝置（錄像、水泥雕塑、有絹印桌布的撞球桌、拾得物）

尺寸依場地而異；錄像影片長度各異

藝術家與 Yuka Tsuruno 畫廊提供

—

Milky Bay

〈背叛的海〉

2016，綜合媒材裝置（錄像、水泥雕塑、有絹印桌布的撞球桌、拾得物）
尺寸依場地而異；錄像影片長度各異
藝術家與 Yuka Tsuruno 畫廊提供

———

Milky Bay

2016, mixed media installation with videos, concrete sculptures,
silkscreened billiard tables and found objects. Dimensions variable; various video durations
Courtesy of the artist and Yuka Tsuruno Gallery

〈背叛的海〉

2016，綜合媒材裝置（錄像、水泥雕塑、有絹印桌布的撞球桌、拾得物）

尺寸依場地而異；錄像影片長度各異

藝術家與 Yuka Tsuruno 畫廊提供

Milky Bay

2016, mixed media installation with videos, concrete sculptures,

silkscreened billiard tables and found objects. Dimensions variable; various video durations

Courtesy of the artist and Yuka Tsuruno Gallery

郭鳳怡
GUO Fengyi

1942 年生於中國西安，是一位自學成才的藝術家，在生命後半段才開始從事藝術創作。原本在橡膠廠工作的她，39 歲時因受關節炎所困只好提前退休。後來為了減輕疾病引發的痛苦，她開始研究易經和研習氣功，讓雙手功能不至於就此荒廢。在練習氣功時，郭鳳怡會以一種她稱為「遙視」的方法，「看見」一些特定的景象。之後，她將其繪於紙上，創作出許多尺幅或大或小的作品，而她的身心靈也在這番藝術生成的過程，達到祥和與協調的境界，相當類似超現實主義思想下的自動性繪畫。

Guo Fengyi was born in 1942 in Xi'an, China. As a self-trained artist, Guo did not begin her artistic career until the latter portion of her life. Instead, she worked at a rubber factory until age 39, after which a case of severe arthritis forced her into early retirement.

Guo began studying *I-Ching* and practising qigong in an effort to alleviate the pain. Guo Fengyi would use a method called "to see from a distance", to observe some specific "visions". Afterwards, she would give those visions a form through drawing.

Guo then started attempting to capture the figures she saw in her hallucinations on both small and large scrolls. Guo was able to connect her mind and body through this art-making practice which bears much resemblance to the Surrealist practice of automatic drawing.

郭鳳怡作品展出現場
Installation view

郭鳳怡筆下的角色繁複細密，無論是神祇神獸或衣著華麗的人類，都具備既擬人又超脫塵世的特質。她以嚴謹的細節和鮮豔的色彩繪述的奇幻題材，往往和她對中國最古老的文獻《易經》這本占卜之書的研究有關，另外也會觸及中國傳統的思想體系，如宇宙觀、占卜、人體穴位圖、三皇五帝、河圖洛書、帝葬等。特異不羈地將各種知識領域編織在一起，建構出一種強大的自我賦權形式，這位深耕於生命哲學和病理醫療的藝術家所創作出的繪畫，是宇宙圖式，是療癒良方，也是藝術。

Guo's work often depicts elaborately-drawn characters, such as mythological figures and ornately dressed humans, which embody both human and otherworldly qualities. The fantastic themes in her artwork, delineated with minute details and vibrant colours, are often related to the artist's study of the *I-Ching*, the most ancient book of divination in China.

Guo's work also references other systems of thought in Chinese tradition, such as cosmologies, acupoint chart, the *Three Sovereigns and the Five Emperors* concepts, the *He Tu (Yellow River Map),* the *Luo Shu (Lo Shu Square),* imperial burial rituals, and so on. The artist's unique and eccentric weaving of these diverse fields of knowledge constitutes a striking form of self-empowerment. Guo was all at once a philosopher, healer, and artist, who created drawings that function as cosmic diagrams, healing devices, and also, art.

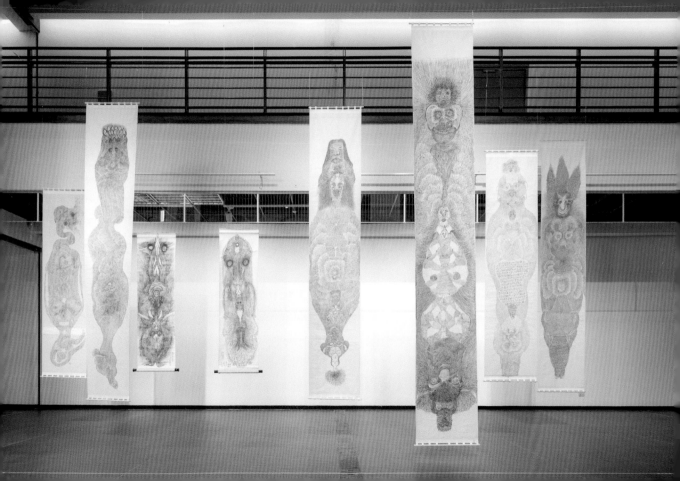

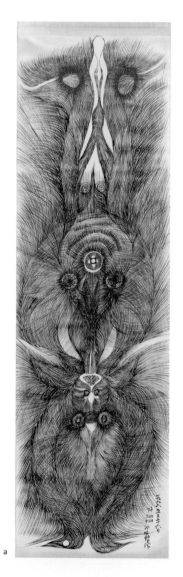

a

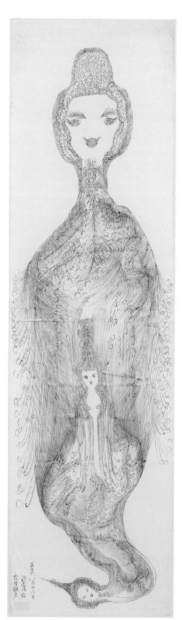

b

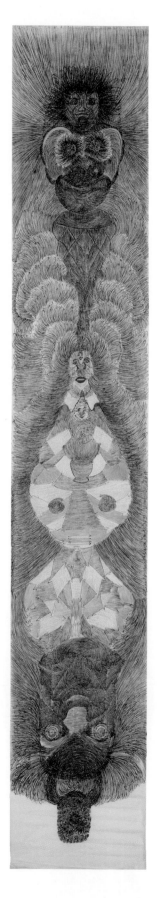

c

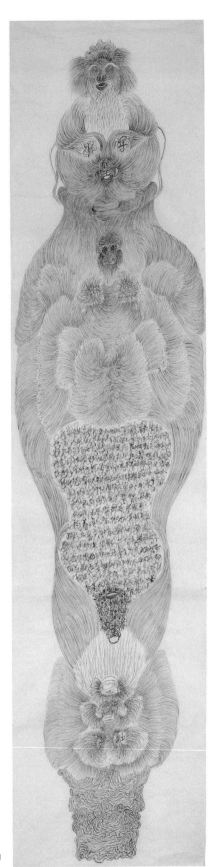

d

a　〈氣功圖〉
1992，水墨、宣紙、原始立軸，152×44 公分（圖為本次展出的 9 件作品之一）
長征空間提供

Qigong Diagram
1992, ink on ricepaper, original hanging scroll. 152×44 cm. (One of 9 works on view in the exhibition)
Courtesy of Long March Space

b　〈敦煌飛天〉
1996，水墨、宣紙，195×55.5 公分（圖為本次展出的 9 件作品之一）
長征空間提供

Flying Apsaras of Dunhuang
1996, ink on ricepaper. 195×55.5 cm. (One of 9 works on view in the exhibition)
Courtesy of Long March Space

c　〈少典〉
2006，彩墨、宣紙，456×70 公分（圖為本次展出的 9 件作品之一）
長征空間提供

Shaodian (Father of Yellow Emperor)
2006, coloured ink on ricepaper. 456×70 cm. (One of 9 works on view in the exhibition)
Courtesy of Long March Space

d　〈孔聖人〉
2007，彩墨、宣紙，299×69 公分（圖為本次展出的 9 件作品之一）
長征空間提供

Confucius
2007, coloured ink on ricepaper. 299×69 cm. (One of 9 works on view in the exhibition)
Courtesy of Long March Space

澤・春
Tcheu SIONG

1968 年生於寮國。現工作居住於寮國龍坡邦。她説自己作品裡的角色是來自夢和幻想，即清醒與作夢的中間狀態。她相信夢是通往另一個世界的路，那是她服從的世界，因為那個世界能解釋我們生活的這個世界。她的創作是在探索她自己、她的想像、她的世界、她的童年、她的魔鬼、她的渴望之間的連結。她藉著剪刀和繩線，依其所願，為神靈鬼魂賦形，讓它們成為「滋養」她的世界的一部分。

近年展覽包括：第 9 屆亞太當代藝術三年展（昆士蘭美術館，2018）、海拔老撾－萬象（貓畫廊，2018）、新加坡雙年展「鏡子地圖集」（2016）、靈之作：澤・春作品展（查普曼藝廊威拉德廳，2016）、靈之作：澤・春（康考迪亞大學，H・威廉姆斯藝廊，2016）、澤・春新作展（龍坡邦計畫空間，2012）、澤・春－剪刀背後的精靈（龍坡邦計畫空間，2010）。

Tcheu Siong was born in 1968, and now lives and works in the city of Luang Prabang, Laos.

She describes the characters in her artworks as emerging from dreams and visions, the zones between consciousness and dreaming. She believes that dreams are paths to another world, a world that she obeys because it elucidates this one. Her artworks explore the connections between a woman, her imagination, her world, her childhood, her demons, and her aspirations. With her scissors, thread and ties, she makes these spirits, gods and ghosts conform to her will, making them part of the world which "nourishes" her.

She has recently shown works at a number of selected exhibitions, including *APT9* at the Queensland Art Gallery (2018); *Elevations Laos-Vientiane* at I:Cat Gallery (2018); *Singapore Biennale*: *An Atlas of Mirrors* (2016); *Spirit Works*: *The Art of Tcheu Siong* at Chapman Gallery, Kansas (2016); *Spirit Works: Tcheu Siong* at H. Williams Gallery, Concordia University, Montreal (2016); *Tcheu Siong*, *New Works* at Project Space Luang Prabang (2012); and *Tcheu Siong—The Genie Behind the Scissors* at Project Space Luang Prabang (2010).

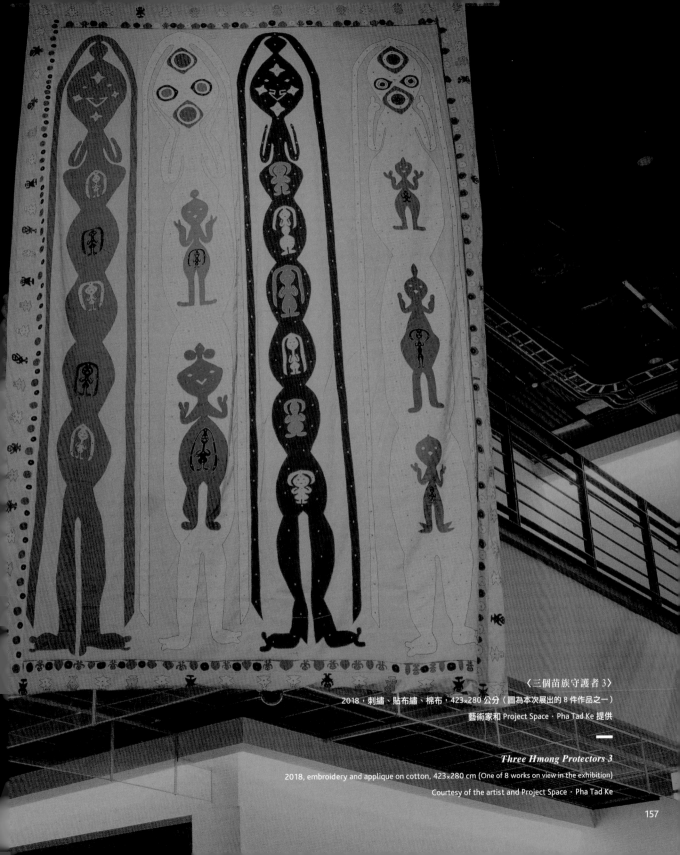

〈三個苗族守護者 3〉
2018，刺繡、貼布繡、棉布，423×280 公分（圖為本次展出的 8 件作品之一）
藝術家和 Project Space，Pha Tad Ke 提供

Three Hmong Protectors 3
2018, embroidery and applique on cotton, 423×280 cm (One of 8 works on view in the exhibition)
Courtesy of the artist and Project Space · Pha Tad Ke

澤·春是白苗人，苗族曾是經常四處遷徙的寮國山區少數民族，現今，這些高地人已被併入寮國平地的經濟文化區。重新安置偏鄉族群之所以勢在必行，是為了施行社會福利與文化融合之便，但此舉必然也會驚擾庇佑人民安身立命的土地的守護靈。遷移的時候，祂們有跟著一塊兒走嗎？祂們是怎麼適應城市的生活？已在城市安定下來的春，還是像個外來者嗎？她的中心落在哪？她做了許多夢，作品中的角色來自夢境、經由她薩滿丈夫的詮釋，通過她的剪刀與布料表現出來。對藝術家而言，夢是另一個世界來的聲音，它們為人的生命理出頭緒、指引方向，但夢的寓意未必好懂，我們需要解夢。

Tcheu Siong is a member of the ethnic minority group, the White Hmong, that has experienced frequent displacements. These highland people have now become integrated into the economic and cultural spaces of the Lao lowlands. This displacement of remote ethnic groups is encouraged by the Lao state for the sake of social welfare and cultural assimilation, but, surely, these movement have also created disturbances among the guiding spirits who are the guardians of the territory occupied by the White Hmong.

Do these spirits come along on the journey? How have they become urbanised? Does Tcheu Siong now live as an outsider? Where is her centre? She dreams a lot, and it is from this world of dreams that her characters emerged, first interpreted by her Shaman husband, and later manifested quite simply, through her scissors and cloth. For the artist, dreams are a voice from another world, they give order and direction to one's life, but they are not clear and we need to decipher them.

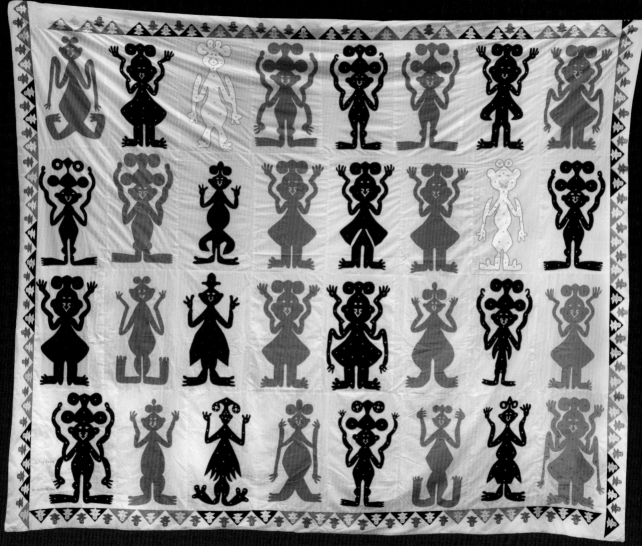

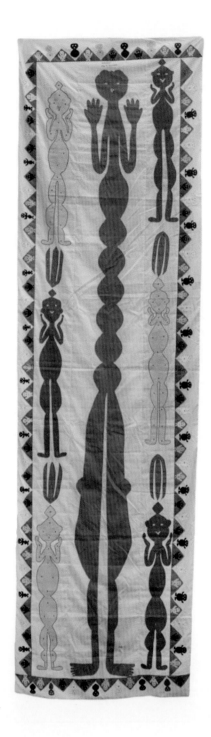

〈三個苗族守護者 1〉

2018，刺繡、貼布繡、棉布，448x130 公分（圖為本次展出的 8 件作品之一）

藝術家和 Project Space · Pha Tad Ke 提供

—

Three Hmong Protectors 1

2018, embroidery and applique on cotton, 448x130 cm (One of 8 works on view in the exhibition)

Courtesy of the artist and Project Space · Pha Tad Ke

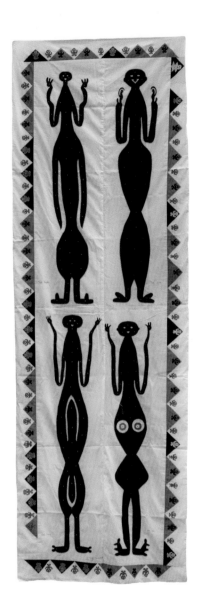

〈四兄弟〉
2018，刺繡、貼布繡、棉布，391x130 公分
（圖為本次展出的 8 件作品之一）
藝術家和 Project Space・Pha Tad Ke 提供

—

Four Brothers
2018, embroidery and applique on cotton, 391x130 cm
(One of 8 works on view in the exhibition)
Courtesy of the artist and Project Space・Pha Tad Ke

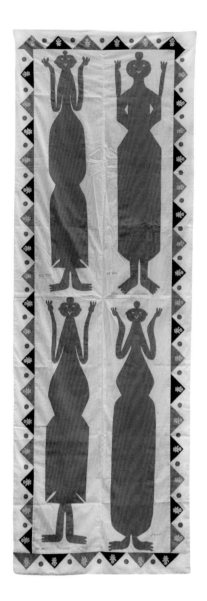

〈四姊妹〉
2018，刺繡、貼布繡、棉布，385x130 公分
（圖為本次展出的 8 件作品之一）
藝術家和 Project Space・Pha Tad Ke 提供

—

Four Sisters
2018, embroidery and applique on cotton, 386x130 cm
(One of 8 works on view in the exhibition)
Courtesy of the artist and Project Space・Pha Tad Ke

打開－當代藝術工作站 × Lifepatch

成立於 2001 年的「打開－當代藝術工作站」,是藝術家匯聚的團體與藝術空間。關注藝術與公眾之間多樣的交涉模式,建立讓更多熱愛藝術文化與熱忱的創作者能夠聚集、談話、勞動、生發新事物或者游擊戰的樞紐,一處文化生產的「工作站」。

近年「打開－當代藝術工作站」在東南亞地區交流深耕,促成具有持續性與協作性的藝術計畫,以多樣的路徑去實驗和理解這個對我們來說日益擴大,熟悉亦陌生的文化場域。重要計畫如「理解的尺度:臺泰當代藝術交流」(2012–2014),「CO- Temporary 臺灣－東南亞藝文交流暨論壇」(2016),與印尼團體 Lifepatch 合作的「CO-Temporary #2:伊圖阿巴的島」(2017)以及「邊境旅行 PETAMU Project」(2018)等。

Founded in 2001, OCAC (Open Contemporary Art Center) is a collective and artist-run space that focus on initial nexus between art and society. facilitate the space as a garage and laboratory, in which accommodate artists and creative ones creating dialogue, sharing their joy of labor, initiating movement and journey.

In recent years, OCAC has been travel around the region in Southeast Asia, engaging series collaborative projects, Making noises in the flat repeated art world. Important projects of OCAC include *ThaiTai: A Measure of Understanding* (2012 -2014); *CO- Temporary: Southeast Asia—Taiwan Forum and Exchange Program on Arts and Culture* (2016); the collaborative project with Lifepatch, *CO- Temporary #2: Itu Apa Island (2017)*; and *PETAMU Project* (2018).

OCAC (Open Contemporary Art Center) × Lifepatch

成立於 2012 年的 Lifepatch，是關注藝術、科學與科技之間跨領域創作的公民倡議社群。透過邀集成員及活動參與者實現共同研究、集體探索與發展週遭環境中的科技、自然和人文資源。以「DIY」和「DIWO」（與他人協作）的精神，在人與人的互動、個人和群體之間，激發各種新形式和創造力。

Lifepatch 的使命是有效地激發人文與自然資源的潛力，建構在地和國際合作的橋樑，並提供所有人開放的研究資源並共享獲得的成果。其創立成員來自各領域，擁有正式教育或非正規的學習背景，於印尼日惹設立空間。Lifepatch 的空間不僅是成員居住的所在，亦作為朋友聚集，舉行各種工作坊、實驗室、工作室與展演活動的公共空間。

Founded in 2012, Lifepatch is a community-based citizen initiatives that promotes cross-disciplinary creative work in art, science and technology. Lifepatch invites members and anyone involved in their activities to research, explore and develop the presence of technology, natural resources, and human resources in the surrounding area. Unfolding the spirits of Do It Yourself (DIY) and Do It With Others (DIWO), the practice of Lifepatch encourages new forms and creativities from interactions between people as well as individuals and communities.

The mission of Lifepatch is to be useful in developing the potential of human resources and natural resources, building bridges of domestic and international collaboration, providing open access for everyone to research sources and the results of development that have been carried out. Lifepatch members come from various disciplinary backgrounds with both formal and informal education. They have a house in Yogyakarta as a living space, also a hub for friends together, a place for several events, such as workshops, performances, exhibitions, lab and studio, etc.

〈島嶼集市〉
2019，現地製作裝置、工作坊活動，尺寸依場地而異
藝術家提供，2019 亞洲藝術雙年展委託新作

———

Deposits of the Island
2019, site-specific installation, workshop and activities. Dimensions variable
Courtesy of the artists. Commissioned by the *2019 Asian Art Biennial* (Taiwan)

〈島嶼集市〉

打開－當代藝術工作站與印尼團體 Lifepatch 的合作始於 2017 年的計畫「CO-Temporary：伊圖阿巴的島」。計畫集結來自臺、印兩地的藝術家於 Lifepatch 位在印尼日惹尚未啟用的新基地，共同生活並齊力建造這個空間未來可能的樣貌。在本次「2019 年亞洲藝術雙年展：來自山與海的異人」中，這群來自不同背景的人們再次聚集在一起，於臺灣各地駐地創作。描繪過去與現在人與人匯聚的場所，探索臺灣特定地點中人與自然、信息與物件、移動性與在地性之間的循環系統。

本次的共同創作「島嶼集市」，旨在創造美術館中一處相遇與交換的場所，邀請觀眾一起成為旅行中的貿易者，以聲音與遊戲描繪隱藏的故事，解析金瓜石礦藏層層積累的物質、時間與記憶的寶藏；進入東南亞移工匯聚的臺中東協廣場，從身體按摩的觸摸、感受為介面，開啟身體的維度的田野調查與對話；我們亦將帶領觀眾一同伸出神靈之手，認識臺／印的作（植）物、香料、草藥與酒精的習俗、歷史與文化，及其在當代的變遷。

〈島嶼集市〉在雙年展的展覽期間，以「DIY」與「DIWO」（Do-It-With-Others）的精神，根據不同主題分別進行多次的工作坊與活動，調節著主與客的分界，擁抱人之間交匯所帶來可能性：「伸出神靈之手：印尼 Jamu 草藥飲與分子料理實驗工作坊」、「歐普洛斯吧－實驗靈飲」、「進入身體維度」等。

Deposits of the Island

The collaborative process between OCAC (Open Contemporary Art Center) and Lifepatch began with the project *CO-Temporary#2: Itu Apa Island* in 2017. The project accommodated artists from both Taiwan and Indonesia at Lifepatch's new not-yet-launched venue, where members of both groups collectively lived and sculpted. In *The Strangers from beyond the Mountain and the Sea*, OCAC and Lifepatch once again assembled and visited multiple places around Taiwan in order to engage with places where people gather, while also exploring the circulation between the man-made and the natural, information and objects, moving experience and locality.

The collaborative work, *Deposits of the Island*, aims to build a place of encounter and exchange. It invites audience to become the agents in this journey, using sound and playful games as a medium to evoke hidden stories and a means by which to "extract" the layers of historical, geographical and memory in Jinguashi. It also dives into the bodily memories of migrant workers gathering around ASEAN Plaza and aims to initiate dialogues through the touch of massage. With this work, OCAC and Lifepatch aim to lead the audience through the "hand of the deities"—to learn the spices, herbs and liquor from Taiwan and Indonesia, and further explore their customs, histories, cultures and transformative impacts in the contemporary world.

During the exhibition period, Deposits of the Island applies the spirit of "DIY" (do-it-yourself) and "DIWO" (do-it-with-others) in hosting workshops and other events in accordance with varied themes. Those activities accommodate the boundary of host and guest, to welcome the possibilities brought from gathering people. The events indicated.

〈島嶼集市：成為旅途的中介者〉
邀請觀眾成為旅途的中介者，聆聽藏在傘下的各種聲音，隱藏的故事。

———

Deposits of the Island: Being an Agent of Journey
Inviting audience to become the agents of journey, discover hidden stories by following 8 sound umbrella.

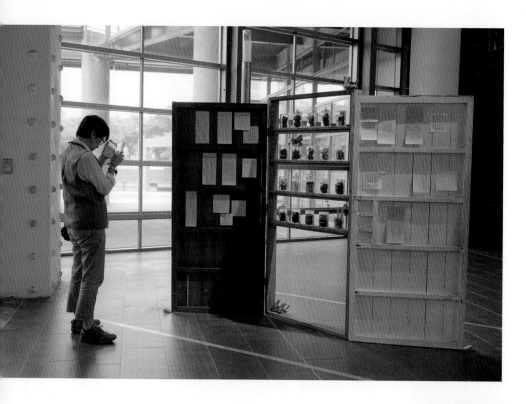

〈島嶼集市：伸出神靈之手〉
這件裝置以金瓜石礦工老屋中的門板製作成展示架，呈現印尼傳統草藥飲的材料及配方。

———

Deposits of the Island: Extend Hand of the Deities
The installation made out of old miner's house in Jinguashi, presents traditional Jamu meterial and ingredients.

〈島嶼集市：進入身體的維度〉
五張按摩床描繪出在臺灣的印尼移工的心靈圖示，並在每個週日舉辦釋放壓力工作坊。

——

Deposits of the Island: Step Into Body Altitude
Five Massage bed mapped the inner space of migrant workers in Taiwan, following with
the stress release workshop every Sunday.

〈島嶼集市：於寶藏中解謎〉
篩釋與探索。此件互動裝置鼓勵觀眾從中尋找屬於自己的寶藏。

——

Deposits of the Island: Dissolves in Treasury and Gold
Panning and seeking. This installation encourage audiences to look for their own treasury.

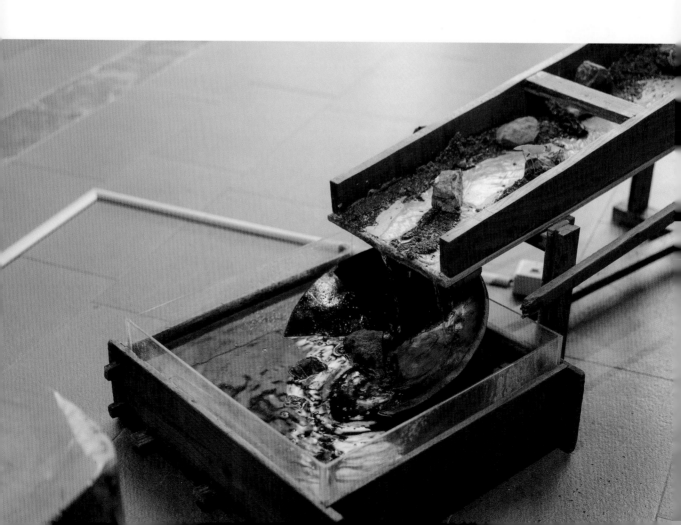

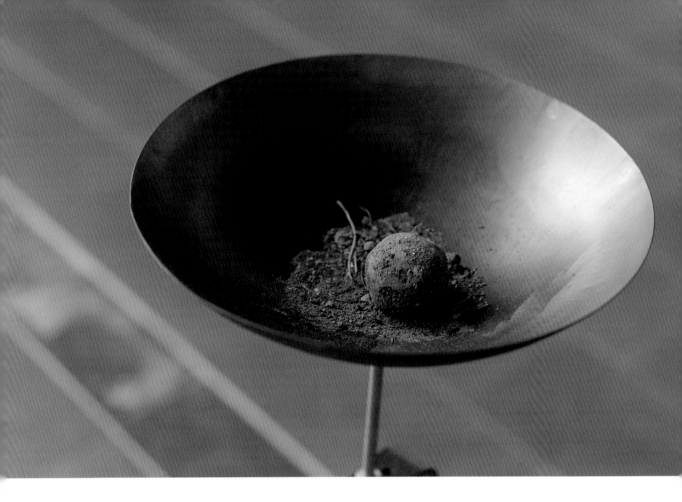

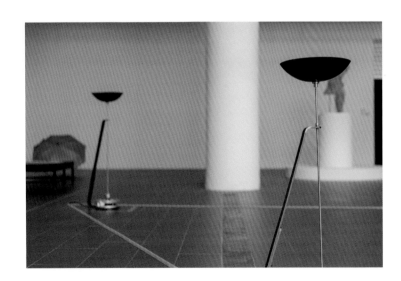

〈島嶼集市：融合〉
三座動力雕塑，如淘金般的旋轉運動。

—

Deposits of the Island: Fusion
Three moving sculptures mimic the gold panning gesture.

〈島嶼集市：歐普洛斯吧－實驗靈飲〉
一座關注臺印兩地酒精與非酒精飲料，作（植）物、香料、草藥之間靈性結合的實驗酒吧。
影片長度 4 分 38 秒

—

Deposits of the Island: Oplos Bar—Experimental Spirit Drink
An experimental bar mix the sprits between Taiwan and Indonesia
in plants, spices and herbs.
Video 4min38sec

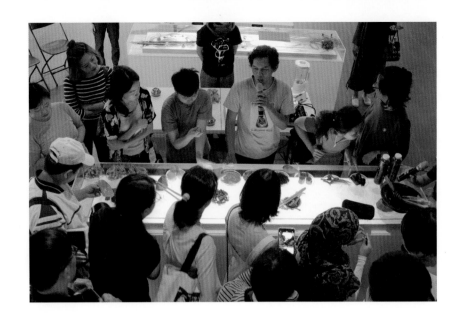

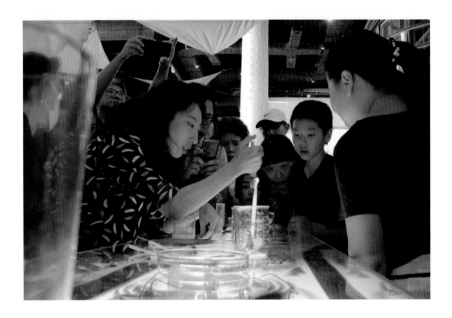

〈島嶼集市：伸出神靈之手－印尼 Jamu 草藥飲與分子料理實驗工作坊〉

Deposits of the Island: Extend the Hand of the Deities: Indonesian Jamu and Molecular Gastronomy Workshop

〈島嶼集市：狂熱的地主〉
加入這個以金瓜石為範本的大富翁遊戲，發掘地方性從過去到現在的轉變。
影片長度 4 分

—

Deposits of the Island: Delarious LandLord
Play the Monopoly made in the context of Jonguashi. Exploring the identity
changes of the area from the past to present.
Video 4min

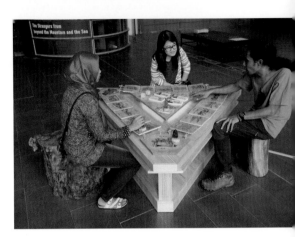

註腳 FOOTNOTES

第二展區　　　Zone 2

蘇祿海 # 陸地與海洋政權 # 薩滿 # 迪蒙・迪維爾 # 南太平洋故事 # 裕廊島
Sulu Sea　# Land and Ocean Regime　# Shaman　# Dumont d'Urville　# The Tales of the South Pacific　# Jurong Island

蘇祿海（Sulu Sea）位於西南太平洋海域，周圍被菲律賓的蘇祿群島、巴拉望島、棉蘭老島以及馬來西亞的沙巴地區圍繞，連接南海和蘇拉威西海。面積約 348,000 平方公里，平均深度約 1,570 公尺。因為該海域地理複雜，周圍連結的島嶼眾多且靠近國際航道，大約從 19 世紀 40 年代開始，蘇祿海盜便持續在棉蘭老島附近活動，這些海盜到 20 世紀初曾因西班牙割讓菲律賓給美國，在美軍大規模的和平運動過程中被有效打擊。但由於戰時的安全漏洞，與軍用剩餘引擎、槍枝的廣泛供應，二戰後蘇祿海盜又再度出現，而這些新一代的海盜大多是早期海盜的後裔。海盜至今仍是蘇祿海上的一大問題，這些海盜主要針對小型船隻，包括漁船、客船和運輸船進行攻擊，有時也會劫持人質要求贖金，甚至連同船隻一併帶走出售，根據 2018 年隸屬於菲國政府國際商會組織的「國際海事局」報告顯示，在蘇祿海被綁架的人數已創 10 年新高，因為持續存在的問題導致收入損失，目前許多國際公司也開始擱置他們在該地區的貨運活動。

The Sulu Sea is in the southwestern region of the Pacific, surrounded by the Sulu Archipelago, Palawan, Mindanao of the Philippines, the Malaysian state, Sabah, and connected to the South China Sea and the Celebes Sea. The Sulu Sea is approximately 348,000 square kilometres with an average depth of 1,570 meters. Due to its geographical complexity, the large number of islands and its vicinity to international sea routes, Sulu pirates have been active near Mindanao since the 40s of the 19th century. The pirates were effectively suppressed in the early 20th century when Spain ceded the Philippines to the US, whose troops embarked on a large-scale pacification campaign against piracy. However, taking advantage of the safety loopholes during the wartime and making use of engines and weaponry left by the militaries, the Sulu pirates re-emerged after World War II. Most of the new-generation pirates are descendants of the pirates from the earlier time. Piracy is still a major problem in the Sulu Sea. The pirates have targeted smaller vessels, including fishing boats, passenger ships and cargo ships, sometimes taking hostages for ransom and even hijacking the ships for sale. According to a 2018 report issued by the International Maritime Bureau, a division of the "International Chamber of Commerce (ICC)" of the Philippines, the number of hostages taken by the Sulu pirates has reached a new high in the past decade. Due to the income loss caused by this persisting problem, many international companies have begun halting sea freight services in the region.

1944 年 12 月，輕型巡洋艦與蘇祿海上的日落。（圖片來源：海軍歷史及遺產司令部）
light cruiser and the sunset on the Sulu Sea in December 1944. (Image source: NH 89349 'Sunset on the Sulu sea', al History and Heritage Command, Washington, DC)

馬來西亞與菲律賓之間蘇祿海的內部波浪。（圖片來源：美國國家航空暨太空總署）
ulu Sea waves between Malaysia and the Philippines. (Image source: Jeff Schmaltz, MODIS Rapid Response Team, NASA/GSFC)

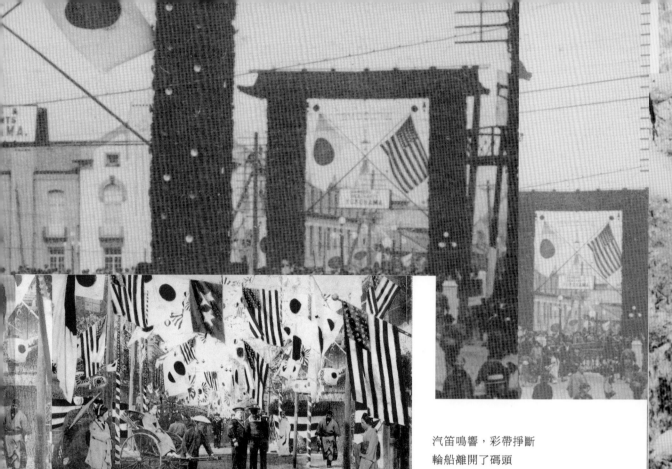

▲ 這張發行自日本的明信片，畫面為美國大白艦隊（Great White Fleet）於 1908 年 10 月抵達橫濱時，當地對其到來的熱烈歡迎。（圖片來源：海軍歷史及遺產司令部）
A Japanese postcard depicts the fervent welcome that the American Great White Fleet received when it first arrived in Yokohama in October 1908. (Image source: NH 106116-KN Yokohama, Japan, Naval History and Heritage Command, Washington, DC)

汽笛鳴響，彩帶掙斷
輪船離開了碼頭
我生來就是大海的男人
面對遠去的港灣
悄悄、悄悄地舉手揮舞，心潮起伏

—— 三島由紀夫《午後的曳航》

The whistle wails and streamers tear.
Our ship slips away from the pier.
Now the sea's my home, I decided that
But even I must shed a tear
As I wave, boys, as I wave so sad
At the harbour town where my heart was glad.

—— Yukio Mishima, *The Sailor Who Fell from Grace with the Sea*

▲ 1908 年 10 月在日本出版的明信片，用以紀念大白艦隊的來訪。（圖片來源：海軍歷史及遺產司令部）
A Japanese postcard issued in October 1908 to commemorate the visit of the Great White Fleet. (Image source: NH 106118 Yokohama, Japan, Naval History and Heritage Command, Washington, DC)

▲ 1970 年 1 月 16 日，從 4,700 英尺處拍攝的寮國胡志明小道鳥瞰圖。畫面顯示了三輛偽裝卡車，以及繞過炸彈坑的道路。
（圖片來源：海軍歷史及遺產司令部）
An aerial image of the Ho Chi Minh Trail in Laos taken at a height of 4,700 meters on January 16, 1970. It shows three trucks in camoflouge and a road meandering through blast holes. (Image source: USN 1144308 Ho Chi Minh Trail, National Archives, Naval History and Heritage Command, Washington, DC)

對他們來說，夢同時又有一種對我們而言所沒有的意義。他們首先把夢看成是一種實在的知覺，這知覺是如此切實可靠，與清醒時的知覺一樣。但除此以外，在他們看來夢又主要是對未來的預見，是與精靈、靈魂、神的交往，是確定個人與其守護神的聯繫，甚至是發現祂的手段。他們完全相信在夢裡見到那一切的真實性。

── 列維－布留爾，《原始思維》

For them, dreams also possess a kind of meaning that we do not see. They first see dreams as an actual perception, which is utterly reliable and the same as the perception one has when awake. Moreover, they see dreams as predictions of the future, a form of communication with spirits, souls and the divine power, a way to ascertain an individual's connection with his guardian spirit, or even the means to find it. They have complete faith in the authenticity of what they see in dreams.

── Lucien Lévy-Bruhl, *Primitive Mentality*

吉拉德・拉特曼
Gilad RATMAN

1975 年出生於以色列海法，先後於耶路撒冷貝札雷藝術設計學院（藝術學士）及紐約哥倫比亞大學（藝術創作碩士）就讀。拉特曼以其錄像及裝置作品在藝術領域廣受肯定，試圖透過創作把他認為難以成立的人類行為記錄下來，並邀請觀眾細細探討他編撰的虛實參半的情境。

拉特曼於全球各地美術館及畫廊的展出經驗豐富，個展經歷包括 TRAFO 當代藝術中心（斯塞新，2015）、以色列博物館（耶路撒冷，2015）、巴塞羅那當代藝術館（布宜諾斯艾利斯，2014）、威尼斯雙年展以色列國家館（威尼斯，2013）等。聯展經歷包括第 7 屆 Contour 國際影像雙年展（梅赫倫，2015）、特拉維夫美術館（特拉維夫，2015）、猶太博物館（紐約，2014）、PRO ARTE 文化藝術基金會（聖彼得堡，2014）等。作品永久典藏單位包括當代藝術館，芝加哥、以色列博物館，耶路撒冷、特拉維夫美術館，特拉維夫、海法美術館，海法、美國大學博物館，華盛頓特區等。

Gilad Ratman was born in 1975 in Haifa, Israel, where he studied at the Bezalel Academy for Art and Design (BFA). He later pursued his Masters of Fine Arts at Columbia University in New York, USA. Ratman is known for his artistic video works and installations, which aim to deal with aspects of collective human behavior emerging within complex control systems. Audiences are invited to deeply explore the scenarios offered up by Ratman, which lie conspicuously somewhere between fiction and reality.

Ratman has exhibited in museums and galleries all over the world. His solo exhibitions have been held in a number of venues, including TRAFO Centre for Contemporary Art (Szczecin, 2015); Israel Museum (Jerusalem, 2015); MACBA, Museum of Contemporary Art in Buenos Aires (2014); as well as in the Israeli Pavilion at the *Venice Biennale* (Venice, 2013). Ratman has also participated in numerous group exhibitions, including *Contour 2015, 7th Biennale of Moving Image* (Mechelen, 2015); Tel Aviv Museum of Art (Tel Aviv, 2015); The Jewish Museum (NY, 2014); and PRO ARTE Foundation (St. Petersburg, 2014). Some of Ratman's work is held in the permanent collections of the Museum of Contemporary Art, Chicago; The Israel Museum, Jerusalem; Tel Aviv Museum of Art, Tel Aviv; Haifa Museum of Art, Haifa; American University Museum, Washington DC, among others.

〈工作坊〉
2013，三頻道錄像裝置，8 分 1 秒
藝術家提供

The Workshop
2013, three-channel video installation. 8min1sec
Courtesy of the artist

〈工作坊〉

〈工作坊〉是一件有聲多頻道錄像裝置。錄像內容是一部虛構的紀錄片，描述一群人從以色列的地底下一路跋涉，前往威尼斯雙年展的以色列國家館。他們穿過地道抵達國家館內部後，開始動手用黏土為自己雕塑一座自刻塑像，再透過從塑像伸出來的麥克風發出聲音。所製造的聲音由一名專業的音訊工程師用一台巨大的混音器編成有旋律的曲調，滲透空間每個角落。我們可以將這件作品理解為人類主體如何創造新的逃逸路線、穿越邊界並重新塑造自己的隱喻。

The Workshop

The Workshop is a multi-channel audio-video installation. The video depicts a fictional documentation of a group of people travelling underground from Israel to the Israeli Pavilion at the *Venice Biennale*. After they arrive at the pavilion via an underground tunnel, each participant sculpts her or his self-portrait in clay and produces sounds through microphones protruding from the sculptures. The sounds are transformed by a professional sound engineer on a massive audio mixer into an acoustic and melodic arrangement that permeates the entire space. The work can be understood as a parable of how human subjects can create new routes of escape, traverse borders and re-make themselves.

〈工作坊〉
2013，三頻道錄像裝置，8分1秒
藝術家提供

—

The Workshop
2013, three-channel video installation. 8min1sec

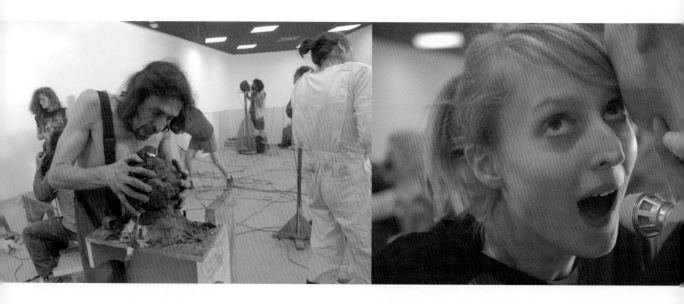

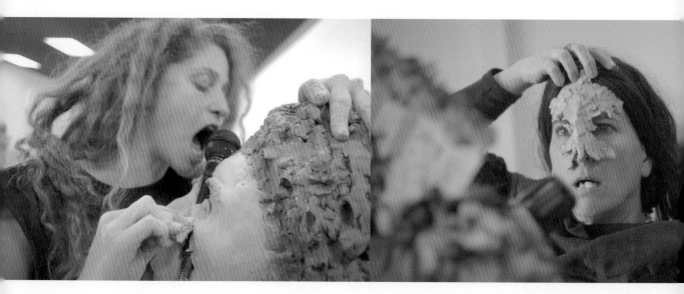

〈工作坊〉
2013，三頻道錄像裝置，8 分 1 秒
藝術家提供

———

The Workshop
2013, three-channel video installation. 8min1sec
Courtesy of the artist

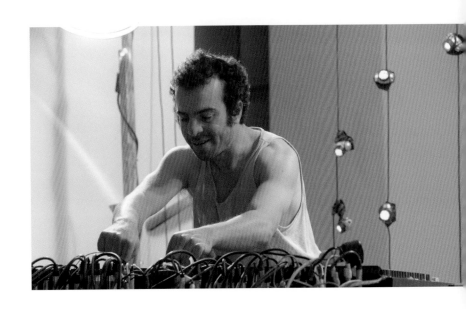

製作人｜埃亞・維克斯勒

攝影指導｜艾西・歐倫

第二攝影師｜阿夫阿罕・勒維

聲音設計創作｜丹尼爾・麥爾

助理導演｜瓦爾・亞夫尼斯基

選角｜露絲・帕提爾

服裝設計｜哈佳・歐菲爾

裝置設計｜大衛・賈基

參與者｜強納森・伯格曼、艾亞拉・福克斯、艾塔利亞・哥蘭、
伊曼紐・哥斯汀、左哈・葛茲曼、喬漢娜・瓊斯、艾爾達・樂夫、
娜塔莉・列文、歐茲・馬魯爾、塔爾・邁爾森、伊宏納坦・艾夫拉因・帕西、
可倫・帕茲、姬列特・藍姆、夏艾・拉墨特、阿米泰・林恩、
達莉亞・羅比切克、尤瓦・羅比切克、歐裂克・拉多維爾斯基、
伊拉德・羅森、里歐爾・施瓦茲巴特・沙卡爾、羅伊・夏哈爾、伊拉・夏立、
席爾・沙納爾、西拉・夏爾維特、皮歐特・許穆格里亞柯夫、
約塞夫・舒克倫、強納森・席爾瓦、佩沙赫・斯拉伯斯基、吉夫・提恩、
亞歷克斯・懷恩

Producer｜Eyal VEXLER

Director of Photography｜Asi OREN

Second Camera｜Avraham LEVI

Sound Designer and Composer｜Daniel MEIR

Assistant Director｜Val YAVNITZKY

Casting｜Ruth PATIR

Costume designer｜Hagar OPHIR

Installation design｜David CHAKI

Participants｜Jonathan BERGMAN, Ayala FOX, Atalia GOLAN,
Emanuel GOLDSTEIN, Zohar GOTESMAN, Johana JONES, Eldad LEV,
Natalie LEVIN, Oz MALUL, Tal MEIRSON, Yehonatan Efraim PASSY, Keren PAZ,
Tchelet RAM, Shai RAMOT, Amitai RING, Daria ROBICHEK, Yuval ROBICHEK,
Oleg RODOVILSKI, Elad ROSEN, Lior Schwarzbart SHACAR, Reut SHAHAR,
Ira SHALIT, Shir SANAAR, Hila SHARVIT, Pioter SHMUGLIAKOV,
Joseph SHUKRUN, Jonathan SILVER, Pesach SLABOSKY, Zeev TENE, Alex WEIN

希瓦・K
Hiwa K

1975 年出生於北伊拉克的庫爾德斯坦地區，在家鄉蘇萊曼尼亞接受的教育聚焦歐洲文學與哲學，來源為各式翻譯成阿拉伯文的書籍。2002 年移居歐洲之後，希瓦・K 在鹿特丹期間於弗朗明哥大師帕可・佩納（Paco Peña）門下學習音樂，最後落腳於德國。希瓦・K 的作品突破一貫的美學標準，並呈現了另類的白話形式、口述歷史、際遇，以及政治處境。希瓦・K 的創作來源為各種親朋好友的故事、軼事以及日常，並且持續批判藝術教育的系統、藝術的專業化，以及對於藝術家的個人想像。希瓦・K 許多作品都具有高度的群體性以及參與性，並且推崇從日常經驗而非從教條獲得知識。希瓦・K 過去參與過許多聯展，包括特倫特的當代藝術宣言展（2008）、巴黎三年展「激烈的迫近」（Intense Proximity）（2012）、倫敦蛇形畫廊「埃奇威爾路計畫」（2012）、威尼斯雙年展（2015），以及卡薩爾／雅典的第 14 屆卡薩爾文獻展（2017）。近期個展經歷則包括紐約新當代藝術博物館（2018）、比利時根特當代藝術館協會（S.M.A.K.）（2018），以及漢諾威藝術學會（2018）。希瓦・K 於 2016 年獲頒阿諾德・博德獎以及薛陵基金會藝術獎，並於柏林 KW 舉辦個展（2017）。其「芝加哥男孩計畫」持續受到世界各大機構邀約展出。

Hiwa K was born in Kurdistan region of Northern Iraq in 1975, in his hometown of Sulaymaniyah. His informal education was focused on European literature and philosophy, gleaned from whatever books were available in Arabic translations. In 2002, Hiwa K moved to Rotterdam to study music under Flamenco master, Paco Peña. He subsequently settled in Germany, where he now lives and works.

Hiwa K's works escape normative aesthetics, and rather seek to give a possibility of another vibration to vernacular forms, oral histories, modes of encounter and political situations. The references found in his work consist of stories told by family members and friends, found situations, as well as everyday forms that are the products of necessity and a pragmatic attitude. He continuously critiques the art education system and the professionalisation of art practice, as well as the myth of the individual artist. Many of his works have strong dimensions of collectivity and participation, expressing concepts of obtaining knowledge from everyday experience rather than doctrinal learning.

Hiwa K has participated in various group exhibition, such as *Manifesta 7* in Trient, Switzerland (2008); *La Triennale*, *Intense Proximity* in Paris, France (2012); the *Edgware Road Project* at the Serpentine Gallery, London (2012); the *Venice Biennale* (2015); and *documenta14* at Kassel/Athens (2017). His recent solo shows include exhibitions at the New Museum, NYC (2018);

S.M.A.K., Ghent (2018); Kunstverein Hannover (2018); and KW in Berlin (2017). His *Chicago Boys project* is continuously hosted by international institutions. In 2016, Hiwa K received the Arnold Bode Prize and the Schering Stiftung Art Award.

〈鐘計畫〉
2007–2015，雙頻道錄像，彩色有聲，35 分 25 秒（義大利）/25 分 29 秒（伊拉克）
藝術家、米蘭－路卡 Prometeo 畫廊及柏林－馬德里 KOW 畫廊提供

The Bell Project
2007–2015, two channel HD video, colour, sound. 35min25sec (Italy)/ 25min29sec (Iraq)
Courtesy of the artist, Prometeo gallery di Ida Pisani, Milan-Lucca and KOW, Berlin-Madrid

〈鐘計畫〉

這件作品運用時空置換下的戰爭廢棄金屬鑄造一口鐘,連結相隔遙遠的二個地點——伊拉克北方的荒原和義大利的教堂,整個創作過程包含在伊拉克的金屬原料初期製作、透過陸海運送至義大利、在義大利的鑄造廠鑄鐘、將鐘展示於教堂,同時伴隨不同知識生產活動,例如:講座、表演及出版等。

歷史深知各種時空局勢:當戰時銅料取得受限時,教堂的鐘即被熔毀用以製作大砲,這個計劃企圖反轉這個改變,將曾被用以製作軍備和武器的金屬,以一口鐘的形式送返歐洲,這件巨大的雕塑作品因其量體而無法裝置於任何立面,故這口失效的鐘將會置放於鄰近教堂的土地上,化身沉默的物件,無法用於祈禱儀式,亦無法用以示警即將來臨的危險。

庫德族商人 Nazhad 來自蘇萊曼尼南部的聚落,他的人生故事和工作啟發了這項計劃,他年少時候的興趣是熔化金屬,爾今成了他的收入來源,其工作是專業鑄鐵師傅,事業是回收戰場廢棄物,讓他致富的這項事業一即金屬鑄模的全球銷售一具爭議性的地方在於,其物資源料來自兩伊戰爭(1980–1988)和二次波斯灣戰爭(1991、2003)。

他利用地雷、炸彈、子彈、戰用飛機和坦克部件和其他軍事活動殘餘的材料,最後製成金屬塊,當成原料販售到最遠如中國等地區加工再製造,同時展出的影片中,他帶我們參觀其工作和生活的環境,多年下來的實務經驗讓他累積了關於金屬原料、原始武器來源及流通等可觀的知識。

The Bell Project

The Bell Project links two distant places—a wasteland in Northern Iraq, and a church in Italy—by manufacturing a bell from displaced metal wastes, by-products of war. The process of making the project includes the prefabrication of material in Iraq; transportation to Italy by land and sea; the bell casting in an Italian foundry; and the display of the finished product in the church. The work also includes accompanying activities of knowledge production, such as lectures, performances and publications.

In many situations throughout history, access to bronze materials was limited, which led to church bells being melted down to construct cannons. The Bell Project proposes to reverse-engineer this transformation by bringing back to Europe the metal scrapped from arms and weapons found in Iraq, to be remade in the form of a bell. The oversized sculpture, too large to be mounted on a façade, rests on the ground, a silent object which can neither call for prayer nor alert of imminent dangers.

The project was inspired by the personal history and activities of Nazhad, a Kurdish entrepreneur from a settlement south of Sulaymaniyah, Hiwa K's hometown. Nazhad's childhood passion for melting down scrapped metal became a source of income for him, and he embarked on a business and mission is to recycle battlefield wastes as a professional iron-master. The case is controversial, as one could argue that the business of selling metal moulds which have since made him a rich man, would not have been possible without the wars that have plagued the region, that is, the Iraq-Iran War (1980–1988) and both Gulf Wars (1991, 2003).

Nazhad utilises mines, bombs, bullets, parts of military planes and tanks, as well as other remnants of military operations. The final products of this undertaking are metal bricks, which he sells as a material for further production in places as distant as China. In The Bell Project's accompanying video, Nazhad leads the camera through the world of his work and his life, and what unfolds is his practical experience throughout the years, which has accumulated into a significant body of knowledge about the metal itself and the circulation of the original weapons from which the material was obtained.

〈鐘計畫〉
2007–2015，雙頻道錄像，彩色有聲，35 分 25 秒（義大利）/25 分 29 秒（伊拉克）
藝術家、米蘭 – 路卡 Prometeo 畫廊及柏林 – 馬德里 KOW 畫廊提供

━━

The Bell Project
2007–2015, two channel HD video, colour, sound. 35min25sec (Italy)/ 25min29sec (Iraq)
Courtesy of the artist, Prometeo gallery di Ida Pisani, Milan-Lucca and KOW, Berlin-Madrid

江凱群
CHIANG Kai-Chun

2007 年畢業於國立臺北藝術大學美術系，2013 年取得法國國立高等藝術學院碩士文憑（DNSEP），2013-2015 年間，於法國國立菲諾爾當代藝術暨影像中心創作。在巴黎國立 ENSAPC 高等藝術學院和國立菲諾爾影像中心的階段，江凱群開始鑽研實驗電影，數位的像素點和傳統馬賽克是他多年以來的研究主題。2012 年開始，他在約旦以及巴黎學習馬賽克製作。作品曾在臺北市立美術館、關渡美術館、巴黎城市與古蹟建築博物館，以及法國國立菲諾爾影像中心等地展出。受邀請的影展包括瑞士日內瓦動畫影展、英國格拉斯哥短片影展等。曾獲得臺灣文化部以及臺北國際藝術村的甄選到紐約 RU residency 與東京 Tokyo Arts and Space 駐村。

展覽經歷包含：鳳甲美術館「菸葉、地毯、便當、紡織機、穴居人：當代藝術中的工藝及技術敘事」（2017）、關渡美術館「江凱群個展：第三人稱的過客」（2016）、紐約「凝視布魯克林攝影雙個展」（2016）、巴黎「聖瑪麗丹攝影展」（2016）、臺北市立美術館「台北雙年展─當下檔案，未來系譜；雙年展新語」（2016）、臺北美術獎（2017）、北京今日美術館（2018）等。

Chiang Kai-Chun is a multidisciplinary artist, mosaic craftsman, director and photographer based in Taiwan and France. He is a graduate of the School of Fine Arts at the Taipei National University of the Arts, as well as the École Nationale Supérieure d'arts de Paris-Cergy, where he received his master's degree in 2013. After graduating, Chiang began working as an artist at Le Fresnoy-Studio National des Arts Contemporains, where he would remain until 2015.

During his time at the École Nationale Supérieure d'arts de Paris-Cergy (ENSAPC), Chiang started exploring experimental film, a practice which he carried over into his time at Le Fresnoy. His interest in experimental film would later expand into a focus on digital pixels and traditional Mosaic techniques. Chiang began his study of traditional Mosaic techniques in 2012, in both Jordan and Paris.

Chiang's works have been showcased in venues across the world, including the Cité de l'Architecture & du Patrimoine (City of Architecture and Heritage), and Le Fresnoy-Studio National des Arts Contemporains. He has participated in such shows as *Tobacco, Carpet, Lunch Box, Textile Machinery, and Cave Man: the Narratives of Craftsmanship and Technologies in Contemporary Art* at Hong-Gah Museum (2017); *Chiang Kai-Chun Solo Exhibition: Third Person Traveller* at the Kuandu Museum of Fine Arts (2016); *Interpreting Brooklyn, New York* (2016); *the photographic collection at La Samaritaine Photographic in Paris* (2016); *Gestures and Archives of the Present, Genealogies of the Future* at Taipei Fine Arts Museum (2016); as well as showcases at

FP4 PLUS

the 2017 Taipei Art Awards 2017 and the Today Art Museum in Beijing (2018). Chiang has also been invited to various international film festivals, such as International Animation Film Festival in Geneva and the Glasgow Short Film Festival.

In 2016, Chiang was selected by the Taiwan Ministry of Culture and Taipei Artist Village to be the artist-in-residence at the RU residency in New York and Tokyo Arts and Space.

〈豐田玉庭園〉
2019，複合媒材、閃玉、墨玉、臺灣相思木、人造矽酸鹽礦物、聲音、攝影
玻璃箱（150×150×150 公分）、玻璃瓶（20 公升、高 48 公分）
尺寸依場地而異
藝術家提供
2019 亞洲藝術雙年展委託新作

Fengtian Jade Garden
2019, mixed media, nephrite, Serpentine Jade, formosa acacia (Taiwanese acacia), man-made silicate mineral, sound, photograph, glass case (150×150×150 cm), glass bottles (20 liters, height 48 cm)
Dimensions variable
Courtesy of the artist
Commissioned by the *2019 Asian Art Biennial* (Taiwan)

〈豐田玉庭園〉

這件作品的靈感，來自藝術家江凱群在花蓮古厝裡看到的石藝品。它們是藝術家祖父從荖腦溪中拾得的閃玉原石。這些玉石牽引著兒時記憶，以及花蓮縣壽豐鄉以閃玉為脈絡的經濟地方誌。日語中，觀賞石稱作「水石」，翠綠色的閃玉帶有氤氳之氣，而新的結晶人造矽酸鹽於水中亦有另一風貌。閃玉價格昂貴，人造矽酸鹽則非常廉價，兩者的硬度也完全不同。〈豐田玉庭園〉用化學反應形成結晶的技術，以基礎的閃玉結構方程式，作為從個人經驗到閃玉的顧盼。

「閃玉及墨玉」是此次作品〈豐田玉庭園〉的核心素材，此一礦石曾短暫替花蓮豐田村帶來大量財富與繁榮風光。「閃玉礦脈」受到重視須等到 1960 年代初期，臺大地質系譚立平教授等實地考察研究，證實溪谷礦坑中的廢石是價值高昂的「閃玉」。經 1965 年《中央日報》刊載後，豐田地區一夕湧入藉此致富者。由於當時豐田玉的價值不斐，在地的客家居民曾紛紛放下手邊的農具，加入相關產業。這次計畫，江凱群與亞葵蒜 Aquacene（廖啟宏與黃朝偉）合作，以人造矽酸鹽化合物及裝置藝術跨界組合。

Fengtian Jade Garden

Fengtian Jade Garden is inspired by a piece of stone craft Chiang saw in an ancient house in Hualien. The stones were pieces of raw nephrite, also known as jade, that were discovered by his grandfather in the Lao-Nong River. These jade pieces act as reminders of Chiang's childhood memories, as well as witnesses to the local history of jade in the town of Shoufong in Hualien County. The Japanese refer to nephrite as "water stones" due to their green hue—when they hang over the surface of the water, they resemble misty air, unlike new crystals which exude a different kind of charm when placed underwater. Nephrite is expensive, man-made nephrite is very cheap, and the hardness is completely different. *Fengtian Jade Garden* uses techniques from chemistry and traces personal experience and the connection with Nephrite through the basic structure of the mineral.

Fengtien jade lies at the core of the exhibit. The stones were briefly a source of economic prosperity for the eponymous town, which was a legend of Eastern Taiwan's modern mining history. It wasn't until the early 1960s that Fengtien's nephrite deposits were discovered by Tan Li Pin, a professor with National Taiwan University's Department of Geosciences. He proved that the "wasted rocks" in the valley's mines were precious nephrite stones. In 1965, news of the discovery of Fengtien nephrite was published in the *Central Daily News*, causing the humble town to be flooded with fortune hunters virtually overnight.

The work on exhibit incorporates the organised research discoveries of a laboratory, and is a collaboration between Chiang and Acquacene (Liao Chi-Hung and Huang Chao-Wei). The work integrates both man-made nephrite pieces and installation artworks.

〈豐田玉庭園〉
2019，複合媒材、閃玉、墨玉、臺灣相思木、人造矽酸鹽礦物、聲音、攝影
玻璃箱（150×150×150 公分）、玻璃瓶（20 公升、高 48 公分）
尺寸依場地而異
藝術家提供
2019 亞洲藝術雙年展委託新作

Fengtian Jade Garden
2019, mixed media, nephrite, Serpentine Jade, formosa acacia (Taiwanese acacia), man-made silicate mineral,
sound, photograph, glass case (150×150×150 cm), glass bottles (20 liters, height 48 cm)
Dimensions variable
Courtesy of the artist
Commissioned by the *2019 Asian Art Biennial* (Taiwan)

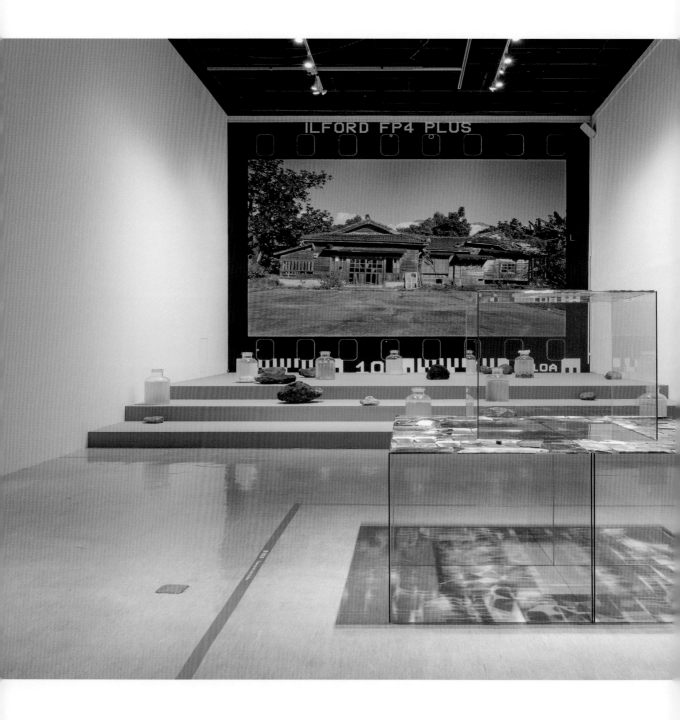

〈豐田玉庭園〉
2019，複合媒材、閃玉、墨玉、臺灣相思木、人造矽酸鹽礦物、聲音、攝影
玻璃箱（150×150×150 公分）、玻璃瓶（20 公升、高 48 公分）
尺寸依場地而異
藝術家提供
2019 亞洲藝術雙年展委託新作

—

Fengtian Jade Garden
2019, mixed media, nephrite, Serpentine Jade, formosa acacia (Taiwanese acacia), man-made silicate mineral,
sound, photograph, glass case (150×150×150 cm), glass bottles (20 liters, height 48 cm)
Dimensions variable
Courtesy of the artist
Commissioned by the *2019 Asian Art Biennial* (Taiwan)

劉玗
LIU Yu

1985 年出生，目前居住及創作於臺北。劉玗的創作生涯從 2014 年開始逐漸發展出一系列紀錄式田野的工作模式。從人類的視點、空間屬性的變化與物在體系中流動的身份，做為勾勒人類演進的過程。從隱匿在社會結構下的族群作為研究主題發展了一系列的作品，這些族群的存在總是可以對照出當下社會或歷史結構中的時間切面，將我們日常熟悉嚴謹的體制、科學方法做一種模糊分界的重組工作。作品參考了多種影像語彙的原形，從文字出版、紀實影像仿電影、類紀錄片的形式，由於大量限地的田調與文獻資料的搜集，也促使她重新編排了這些語言的可能，從空間、歷史、影像、敘事各種零碎的片段，做一相互緊密連結、補敘的整合工程。

Liu Yu was born in 1985, and currently lives and works in Taipei, Taiwan. She embarked on her creative career in 2014, and has since developed a series of methods for conducting field documentation. Liu portrays the trajectory of human evolution, beginning from a human perspective before moving onto changes in spatial attributes and the fluid identity of objects within systems.

Liu has also developed a series of works based on the notion of ethnicity hidden beneath social constructs. The existence of these ethnicities usually corresponds to the society of the time or its historical structure, both of which allow a blurred reorganisation of the familiar, everyday systems, and scientific methods. The works reference many prototypes of a visual vocabulary, and employs various approaches, including textual publications, documentary images that imitate films, and a collection of vast amounts of on-site field research and reference materials. By connecting materials and adding new information, Liu explores the possibilities of rearranging these languages and integrating fragments of these spaces, histories, images, and narratives.

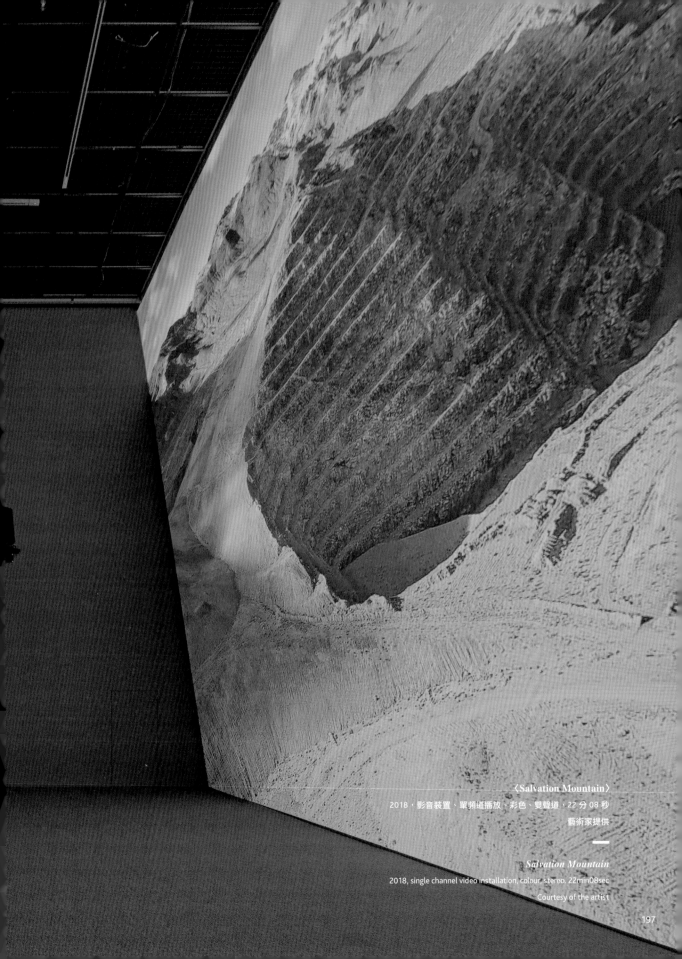

〈Salvation Mountain〉
2018，影音裝置、單頻道播放、彩色、雙聲道，22 分 08 秒
藝術家提供

—

Salvation Mountain
2018, single channel video installation, colour, stereo, 22min08sec
Courtesy of the artist

〈玩石頭的人〉

加州海岸有著舒適的氣候及優渥的生活條件，但同時也是美國流浪人口最多的區域。影片中是劉玗在 Santa Monica 海邊遇見的一位遊民，他在地墊上放置了許多石頭及物件，並不斷的排列重組，希望透過這些石頭指引尋找他的母親。這個常人無法理解的狀態，似乎讓石頭轉變成具有某種超越性的能力之物，也使劉玗開始聯想，人類是如何賦予礦物特定價值？這是一個讓她重新思考美國金礦開採歷史的問題，從流浪者對石頭的信念來比擬人類對礦物的信仰，暗示了這種信仰源自共同起源。這個現象即是美國西岸的歷史縮影，也是劉玗在本次展覽中展出作品〈Salvation Mountain〉的概念源頭。

The Stone Player

The coast of California is blessed with a pleasant climate and comfortable living conditions—however, it also has the largest homeless population in the United States. The video in *The Stone Player* depicts Liu's encounter with a homeless person near the Santa Monica coast. The man places multiple stones and objects on a mat and rearranges them repeatedly, hoping that the stones might provide guidance for him to find his mother. The unusual behaviour seems to imbue the ordinary objects with a transcendent quality, and inspired Liu to ask how and why humans give value to minerals.

These questions led her to a reconsideration of the history of gold mining in the United States. The homeless person's belief in the stones is used as an analogy for humanity's faith in minerals, thus hinting that both this belief and this faith have common origins in a dislocation from reality. This encounter epitomises the artist's experience of her time in the West Coast of the United States, and seeds the beginnings of Liu's other work, *Salvation Mountain*, which is also on show in this exhibition.

〈玩石頭的人〉
2018，影音裝置、單頻道播放、彩色，4 分 22 秒
藝術家提供

—

The Stone Player
2018, single channel video installation, colour. 4min22sec
Courtesy of the artist

199

〈Salvation Mountain〉

〈Salvation Mountain〉透過美國淘金歷史、社會現況與拓荒情節，詮釋人類如何經由挖掘礦物來建造世界及意識形態，在資本制度的建立及經濟的套牢之後，貧窮成為獲得「絕對自由」的最終途徑。影片中藉由三個來自不同時空人物（拓荒者、流浪漢及空拍機）在營火前的一場對話，述説著人類的價值觀如何附著在「挖掘」與「堆積」的抽象概念上，一直到今天虛擬貨幣的生產，人類對於「價值」的想像向來不曾改變，從挖掘「礦物」到生產「廢物」，人類對「物」的信仰演變成我們當下所處的瘋癲世界。

Salvation Mountain

Like *The Stone Player*, *Salvation Mountain* takes as its starting point the history of gold mining in the US, the social status of gold, the mythical tropes surrounding the exploration of virgin lands, and the ways in which humans have constructed their worlds and ideologies in relation to the mineral world.

Salvation Mountain asks: in an age where capitalism and its "economic trap" dominates, is poverty the only way to achieve "absolute freedom"? In the video, three "actors" from different spaces and times—the pioneer, the vagabond, and the drone—engage in conversation in front of a campfire. The dialogue conveys how human values are attached to the abstract concepts of "digging" and "accumulating", before proceeding to the issue of contemporary production of virtual currencies.

For Liu, the human imagining of "value" has remained unchanged throughout these transformations—from digging "minerals" to producing "waste", the human obsession with "objects" has resulted in our current moment of chaos and insanity.

〈Salvation Mountain〉
2018，影音裝置、單頻道播放、彩色、雙聲道，22 分 08 秒
藝術家提供

———

Salvation Mountain
2018, single channel video installation, colour, stereo. 22min08sec
Courtesy of the artist

鐵木爾・斯琴
Timur SI-QIN

1984 年出生於柏林，是德國和中國蒙古混血的藝術家，他成長於柏林，北京和美國西南的印第安人社區，畢業於美國亞利桑那州立大學，現居紐約。在多元文化環境下長大，塑造了他對自然和文化之間關係的獨特的感知能力。鐵木爾・斯琴是後網路時代藝術家中的領軍人物，這一代藝術家借用發達的科技手段來挑戰人類社會和自然界生物法則之間的分離。主要個展包括：魔金石空間（北京，2018、2015）；Spazio Maiocchi（米蘭，2018）；Société 畫廊（柏林，2018、2015、2013、2011）；巴塞爾博覽會香港展會（香港，2018）；孔子學院（柏林，2017）；小組畫廊（洛杉磯，2016）；巴塞爾博覽會「藝創宣言」單元（香港，2016）等，並於 2016 年參加第 9 屆柏林雙年展。

Timur Si-Qin was born in 1984, and is an artist of German and Mongolian-Chinese descent. His early childhood was spent growing up between Berlin, Beijing, and Native Indian community in the American Southwest. Si-Qin's experience growing up in a multicultural environment has helped inform his unique sensitivity towards the relationship between nature and human culture.

Si-Qin currently lives in New York, and has become a leading figure in a post-internet generation of artists who reference new developments in science and technology to challenge the separation between the human world and the biological laws of the natural world.

Si-Qin has exhibited in major solo shows at a number of venues, including Magician Space in Beijing (2015, 2018); Spazio Maiocchi in Milan (2018); Société in Berlin (2011, 2013, 2015, 2017); Art Basel in Hong Kong (2018); Konfuzius Institut in Berlin (2017); Team Gallery in Los Angeles (2016); and Art Basel *Statements* in Basel (2016). He has also participated in the 9th *Berlin Biennale* in 2016.

〈東、南、西、北〉
2018，綜合媒材裝置（雕塑、燈箱、虛擬現實影像），尺寸依場地而異
藝術家與魔金石空間提供

—

East, South, West, North
2018, mixed media installation with sculptures, lightboxes and VR. Dimensions variable
Courtesy of the artist and Magician Space

〈東、南、西、北〉

鐵木爾・斯琴延續發展 21 世紀的「新和平」（New Peace）運動，「新和平」指摘農業社會和宗教中的二元主義遺產對於當代世界的不良影響，並主張反魅物質，以抵抗今天物質世界中諸多問題。「東，南，西，北」四個方向源自神聖循環，做為中亞和美洲地區農業／狩獵時代之前的主要精神觀念，傳達藝術家創作中對我們精神取向的回歸和必要性升級。

藝術家與多樣材料之間的對話，無論是岩石、樹幹、廣告燈牌、數字圖像或是貝殼，不侷限於美學的形式和考量，而是將文化視為一種物質的湧現形式。面對各種邊界的消失、二元主義的崩塌，藝術如何在材料中重建主體性、意識和道德？「新和平」試圖提供一種潛在路徑和個人資源，以便我們在災難性變化的時代中重新定位自己。

East, South, West, North

Timur Si-Qin continues his development of *New Peace*, a project of secular spirituality for the 21st century. *New Peace* identifies the dualistic legacy of agricultural society and religion as maladaptive for our contemporary world, and argues for a re-enchantment with matter as the necessary basis for confronting the material problems of our times. With his work, Si-Qin signals both a return to and a necessary upgrade of our spiritual orientation and dimensionality.

However, the dialogue between the artist and a diverse array of materials—whether it's stones, trees, illuminated advertisements, digital images, or seashells, is not only limited to aesthetic forms and considerations. But on a deeper level, this dialogue also advocates for the independent, open consideration of culture as an emergent manifestation of matter. As various outmoded boundaries wear away, the question of how art should reconstruct subjectivity, consciousness, and morality within the material emerges. *New Peace* is Si-Qin's attempt to provide a potential path and the resources for humanity to re-orient itself in an age of cataclysmic change.

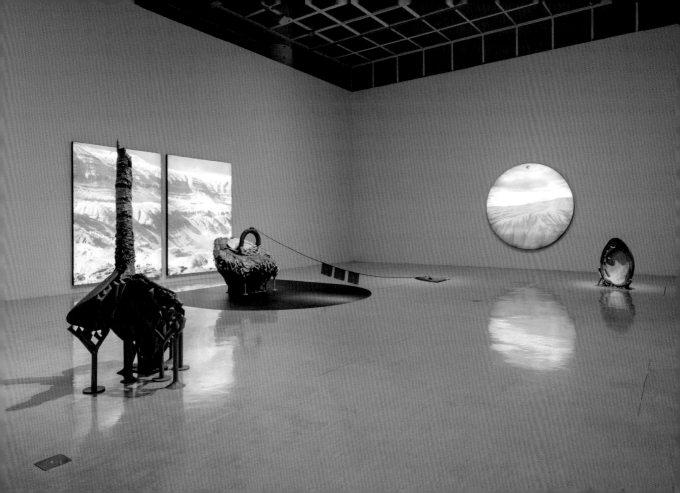

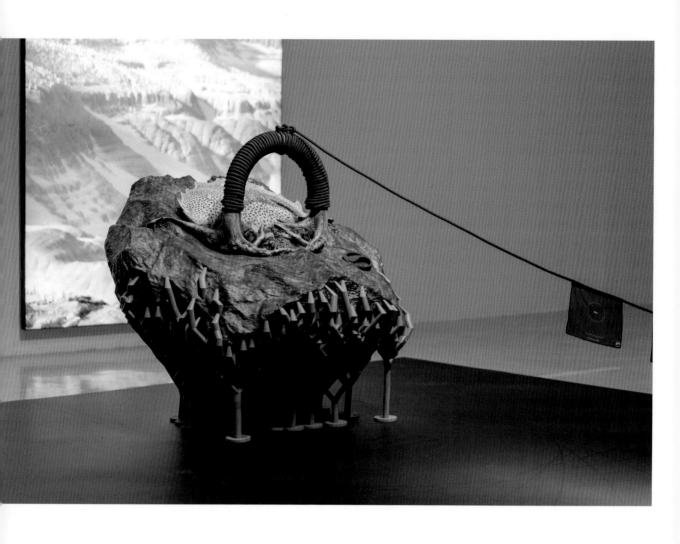

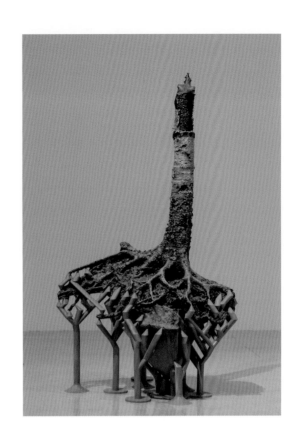

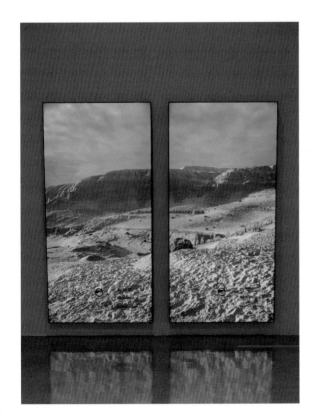

〈東、南、西、北〉
2018，綜合媒材裝置（雕塑、燈箱、虛擬現實影像），尺寸依場地而異
藝術家與魔金石空間提供

———

East, South, West, North
2018, mixed media installation with sculptures, lightboxes and VR. Dimensions variable
Courtesy of the artist and Magician Space

武基爾 · 蘇亞迪
Wukir SURVADI (Senyawa)

印尼日惹音樂團隊 Senyawa 的創作體現印尼傳統音樂的聽覺元素，也持續探索實驗音樂的框架，同時拓展二種音樂傳統的邊界，他們的音樂完美平衡自身前衛影響力及印尼的文化歷史，創造出真正的當代印尼新音樂。他們的音樂創作以魯里·沙巴拉（Rully Shabara）熟練的擴展性聲音技巧為底，綴以樂器創作者武基爾·蘇亞迪（Wukir Suryadi）既現代又原始的狂熱演奏樂音。

Senyawa 曾於許多知名藝術節及獨立地下場所演出，包含澳洲塔斯馬尼亞的 MONA FOMA 音樂藝術節、阿得萊德藝術節與韓國歌手裴日東（Bae Il-Dong）合作表演、瑞典馬爾默夏日舞台音樂節、印尼雅加達沙利哈拉文學季、瑞士巴塞爾藝術博覽會、英國倫敦的 Café Oto、格拉斯哥克雷普堤藝術祭、丹麥哥本哈根爵士樂俱樂部、塞爾維亞貝爾格勒共振藝術節、德國柏林 CTM 藝術節、巴西 RBMA 音樂祭、哥本哈根爵士音樂節、波蘭無聲音樂節、挪威 Clandestino 藝術節、美國舊金山 The Lab 藝術中心、威斯康辛歐克雷爾音樂節、紐約布莉姬特唐納修藝廊、加拿大維多利亞前衛音樂節、紐約先驅事業藝術中心及中國 Oct-Loft 國際爵士音樂節等，Senyawa 於 2018 年澳洲綠屋獎的最佳作曲及音響設計獎，2017 年獲林茲電子藝術節的數位音樂聲音獎。

Jogjakarta's Senyawa embodies the aural elements of traditional Indonesian music, while also exploring the framework of an experimental music practice, pushing the boundaries of both traditions. Their music strikes a perfect balance between their avant-garde influences and cultural heritage to create truly contemporary and new Indonesian music. Their sound is comprised of Rully Shabara's deft, extended vocal techniques which punctuate the frenetic sounds of the modern-primitive instrumentation of Wukir Suryadi, Senyawa's instrument builder.

Senyawa have performed at many notable festivals and underground clubs, such as *MONA FOMA Festival* in Tasmania, Australia; *Adelaide Festival*, with Korean singer Bae Il Dong in Adelaide, Australia; *Malmo Sommarscen Festival* in Sweden; *Salihara Literature Festival* in Jakarta, Indonesia; *Art Basel Switzerland*; Café Oto in London, UK; *Cryptic Festival Glasgow*, UK; Copenhagen Jazz House in Denmark; *Resonate Festival* in Belgrade, Serbia; *CTM Festival* in Berlin, Germany; *RBMA Brazil*; *Copenhagen Jazz Festival* in Denmark; *UNSOUND Festival* Poland; *Clandestino Festival* in Norway; The Lab San Francisco, USA; *Eaux Claires Festival* in Wisconsin, USA; Bridget Donoghue Gallery NYC, USA; *Victoriaville Festival*; Pioneer Works NYC, USA; and *Oct-Loft Jazz Festival* in China. Senyawa won the 2018 Green Room Award for Best Music Composition and Sound Design and the 2017 Ars Electronica Award for Digital Music and Sound.

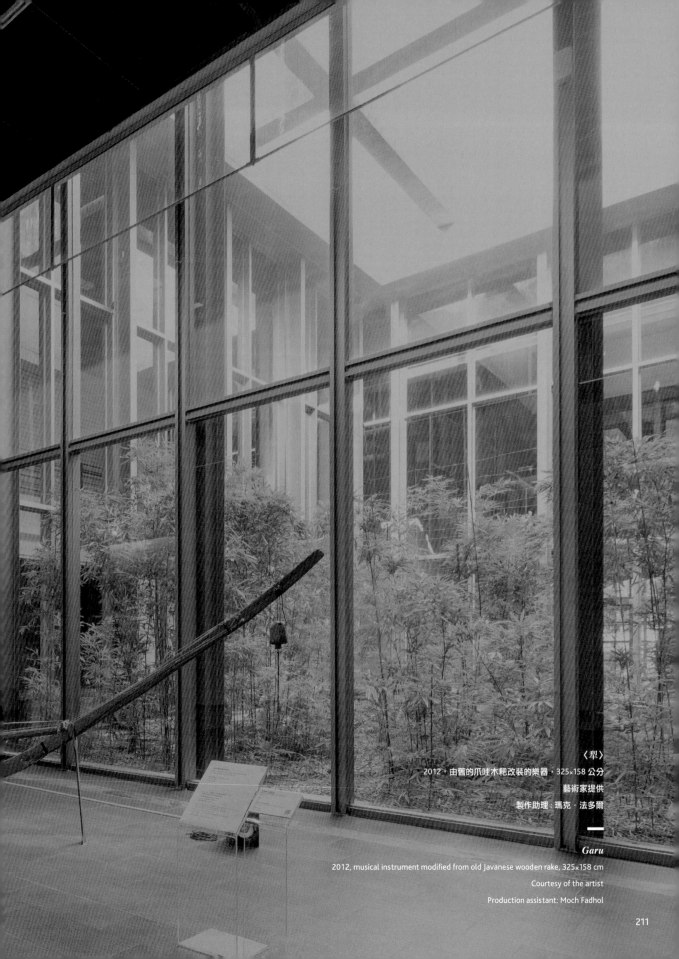

〈犁〉
2012，由舊的爪哇木耙改裝的樂器，325×158 公分
藝術家提供
製作助理：瑪克‧法多爾

Garu
2012, musical instrument modified from old Javanese wooden rake, 325×158 cm
Courtesy of the artist
Production assistant: Moch Fadhol

〈犁〉

武基爾‧蘇亞迪藉由幾種創造性的概念和聲音等迷人方式創造出獨特樂器。如手工打造的「竹矛」(Bamboo Spear)是以厚竹片為主體，掛上可發出打擊聲響的動物皮革帶，再搭上鋼弦，發出的聲音放大時，猶如傳統印尼音樂演奏及電吉他的混種變形。另一方面，此樂器可產生多元樂音，可以一邊敲擊出節奏，另一面則可如弦樂器般拉奏、撥彈出旋律。

這次展覽中，藝術家選擇呈現〈犁〉，一種改良的現有農具，結合弦、聲音、金屬、貝斯和吉他而改製成樂器。武基爾‧蘇亞迪融合了新與舊、在地與國外的技術，與聲樂家盧利‧薩巴拉‧哈曼合作，共同以 Senyawa 樂隊之名登場。跟著 Senyawa、印尼神話和儀式，不同的音樂類型如蜂鳴，實驗搖滾與金屬樂等一層一層疊加，為我們的時代創造新的儀式。

Garu

Wukir Suryadi creates his own musical instruments through several methods that are conceptually inventive and sonically fascinating. For example, there is his handcrafted *Bamboo Spear*, where a thick stem of bamboo is strung up with percussive strips of animal skin alongside steel strings. When played and amplified, its sounds fuse elements of traditional Indonesian instrumentation with a garage guitar distortion. Sonically dynamic, the instrument can, on the one hand, be rhythmically percussive—on the other hand, it can also be melodically bowed and plucked.

For this exhibition, the artist has chosen to present *Garu*, a modification of an existing agricultural tool into a musical instrument—the tool has been transformed it into a string, sound, metal, bass guitar, while its original shape is still respected.

Wukir Suryadi's fusion of old and new technologies, indigenous and foreign, is perfectly matched with his collaborator, vocalist Rully SHABARA Herman, and they come together as the band Senyawa. With Senyawa, Indonesian myths and rituals are layered with the musical genres such as drone, experimental rock, and metal, in an effort to create new rituals for our time.

〈犁〉

2012，由舊的爪哇木耙改裝的樂器，325×158 公分

藝術家提供

製作助理：瑪克・法多爾

Garu

2012, musical instrument modified from old Javanese wooden rake, 325×158 cm

Courtesy of the artist

Production assistant: Moch Fadhol

王思順
WANG Si-Shun

1979 年生於武漢，2008 年畢業於中央美術學院，獲碩士學位。現工作生活於北京。曾受邀參加泰國雙年展、日本越後妻有三年展、銀川雙年展、羅馬尼亞雙年展、俄羅斯烏拉爾當代藝術工業雙年展、英國曼徹斯特亞洲藝術三年展。作品先後展出於香港大館美術館、法國安納西 Salomon 當代藝術基金會、格魯吉亞國家美術館、英國卡斯雕塑基金會、奧地利格拉茲美術館、德國戴姆勒藝術中心、伊斯坦布爾 Borusan Contemporary、尤倫斯藝術中心、中國美術館、義大利路吉‧佩吉當代藝術中心等知名藝術場館。獲 2015 三亞「華宇青年獎」提名獎、2016 ACC（亞洲文化協會）獎。作品被泰康空間、香港 M+ 博物館、德國戴姆勒中心等機構收藏。

Wang Si-Shun was born in Wuhan in 1979, and is currently based in Beijing. In 2008, he graduated from the Central Academy of Fine Arts with a Master's degree. Wang has participated in *Thailand Biennale Krabi*, *Echigo-Tsumari Art Triennale*, *Yinchuan Biennale*, *Art Encounters Biennial*, the *Ural Industrial Biennial* in Russia, and *Asia Triennial Manchester*. His works have been showcased in renowned art institutions and venues, including Tai Kwun in Hong Kong; Fondation Salomon in France; Art Museum of Georgia; The Cass Sculpture Foundation; Kunsthaus Graz in Austria; the Daimler Art Collection in Germany; the Borusan Contemporary in Istanbul; Ullens Centre for Contemporary Art; National Art Museum of China; and Luigi Pecci Contemporary Art Centre.

Wang was nominated for the 2015 Art Sanya Huayu Youth Award, and the 2016 Asian Cultural Council Award. His works are part of the collection of institutions such as Taikang Space; M+ Museum, Hong Kong; and Daimler Art Collection in Germany.

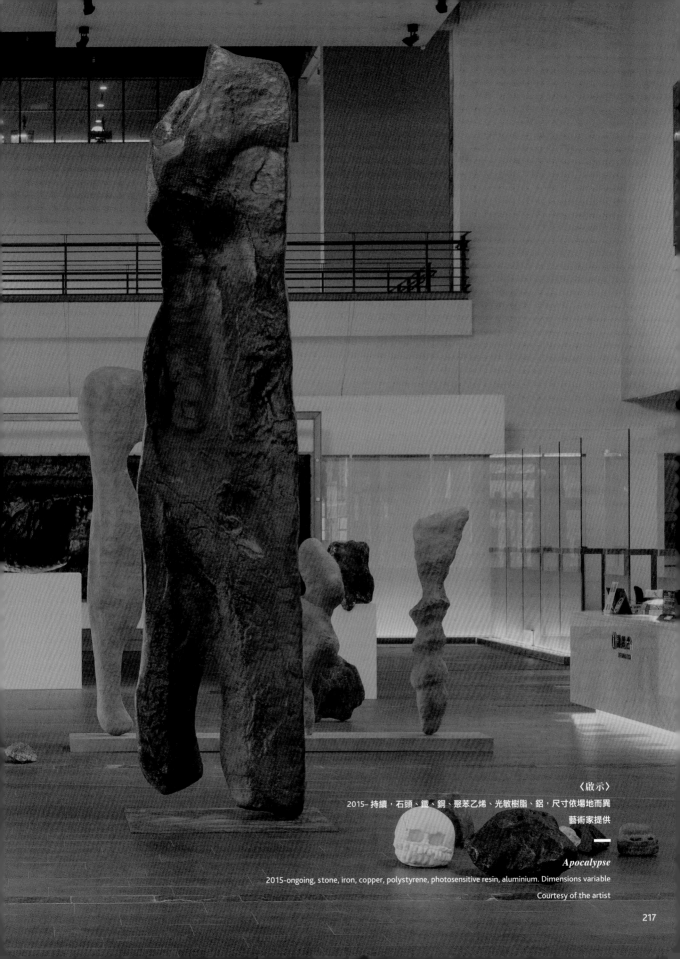

〈啟示〉
2015- 持續，石頭、鐵、銅、聚苯乙烯、光敏樹脂、鋁，尺寸依場地而異
藝術家提供

Apocalypse
2015-ongoing, stone, iron, copper, polystyrene, photosensitive resin, aluminium. Dimensions variable
Courtesy of the artist

〈啟示〉

「神藉由創造，歷史，人的良心，向人類揭示神自己。」

作為創作實踐的一部分，藝術家王思順持續在全世界收集近似人類形象的石頭。迄今為止，他的收藏涵括了俄羅斯、法國、義大利、阿富汗、烏拉圭、埃及、非洲及中國各地。對他而言，這些石頭不僅是人類的形象，更富有個性並飽含內在價值。這些不同大小、形態、顏色和紋理的石頭彷彿是來自不同世界的生命，有著不同的族類和身份、不同的歷史和未來。在此之中，可以召喚諸如神聖、高尚、醜陋、邪惡的意象。它們匯集成互相衝突和交彙的世界。對藝術家來說，是時間和自身塑造出它們，因為他相信它們具有根本的生命力和動力。在這些被石頭所層疊的時間裡，我們的文化經驗、世界觀、藝術史和美學經驗只是其中的一部分。

Apocalypse

"God reveals himself to humans through his creations, through history, and through human conscience."

As part of his practice, Wang Si-Shun has been collecting stones that recall the human figure from all over the world. To date, his collection spans stones from Russia, France, Italy, Afghanistan, Uruguay, Egypt, Africa, and various parts of China. To him, these stones are not simply images of humans, they are beings imbued with personalities and possess intrinsic value. Stones of different sizes, shapes, colours and textures, are akin to people from different worlds, races, identities, pasts and futures. And in them, you can encounter various evocations of the sacred, the noble, the ugly and the evil. Together, they form a world of interactions and conflicts.

Wang believes that these are shaped by time and by themselves, because they possess a fundamental vitality and power. In these stones, eons of time have unfolded, of which our cultural experiences, worldviews, art histories and aesthetics are but one part.

〈啟示〉
2015– 持續，石頭、鐵、銅、聚苯乙烯、光敏樹脂、鋁，尺寸依場地而異（圖片由藝術家提供）
藝術家提供

Apocalypse

2015-ongoing, stone, iron, copper, polystyrene, photosensitive resin, aluminium. Dimensions variable (Photo by Artist)

Courtesy of the artist

黃思農／再拒劇團
Snow HUANG/Against Again Troupe

1981 年出生於香港，為劇場、當代藝術、聲響與音樂的跨域創作者。20 歲時創立再拒劇團並擔任團長至今，歷年曾擔任過多齣劇場編導、劇場及電影作曲者、聲音藝術家、記者、策展人、藝評、樂手、戲劇顧問等多重角色。2007 年發表「微型劇場」宣言回應 1980 年代以降的臺灣小劇場運動，並策劃第一屆「公寓聯展」，在亞洲特有的狹小居住空間舉辦，並以雙年展的方式延續至今。2014 年在策展人鴻鴻邀請下參與並籌劃再拒劇團〈諸神黃昏〉，以無導演的跨域集體創作將臺灣的立院佔領事件，賦予華格納指環四部曲的終局〈諸神黃昏〉當代觀點詮釋，該劇也開啟他這些年在美術館、環境劇場的多齣「聲音劇場」創作，所有的音樂演奏、聲音執行皆成為身體性（physical movement）的劇場表演，圍繞「聲響」開發的各種劇場美學表現成為敘事軸心，該演出獲 WSD 世界劇場設計展聲音設計金獎。近兩年黃思農推出一系列觀眾於城市獨自步行體驗的無人表演「漫遊者劇場」，該計劃結合實存城市地景與虛構偵探文本，以聲檔的方式召喚城市的記憶。近年於美術館參與的「聲音劇場」創作包括：臺北市立美術館「社交場」開幕演出〈Concert of Performance Preview〉（2017）、與何采柔受大臺北當代藝術雙年展「空氣草」邀請共同創作〈254yen〉（2017）……等。

Snow Huang was born in Hong Kong in 1981. His wide-ranging artistic practice engages with theatre, contemporary art, sound and music creations. When he was 20 years old, he founded Against Again Troupe, a group of multi-disciplinary artists, and has since served as its director.

In 2014, curator Hung Hung invited Against Again Troupe to produce and perform *Götterdämmerung*, a production that was created collectively through an interdisciplinary approach that eschewed a designated director. The work reinterprets Wagner's fourth and last opera from a contemporary perspective, within the context of the occupation of Taiwan's Legislative Yuan. This work became the starting point for the various *Sound Theatre* works that Huang has worked on in recent years, and which have been staged in art museums and environmental theatres. In *Sound Theatre*, all musical performance and sound-making exercises adopt a theatrical form of physical movement, whereas diverse theatre aesthetics revolving around the development of "sounds" surface as the core of the work's narratives.

Most recently, Huang launched his *Flâneur series*, which features audiences' solitary walks in an urban setting without any performers. The project comblnes real urban landscapes and fictional detective stories, employing archival sounds to evoke memories of the city.

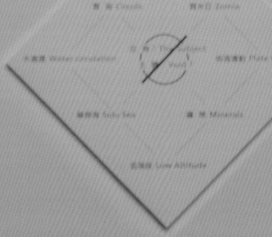

異人　二〇一九亞洲藝術雙年展

2019 Asian Art Biennial

Huang's recent *Sound Theatre* work has been presented in a number of art museums. These works include an opening performance created for the *Arena* exhibition at the Taipei Fine Arts Museum, a piece entitled *Concert of Performance Preview* (2017), as well as a production for *Air Plant: The Greater Taipei Biennial of Contemporary Art*, which was a co-creation with artist Joyce Ho and entitled *254 yen* (2017).

〈第一個夢〉
2019，聲音、導覽機，60 分
藝術家提供
2019 亞洲藝術雙年展委託新作

——

The First Dream
2019, sound, audio devices. 60min
Courtesy of the artist
Commissioned by the *2019 Asian Art Biennial* (Taiwan)

〈第一個夢〉

「沉默對生者提出警示
這裡那裡，緊閉的雙唇」
——〈第一個夢〉(1692)，胡安娜

「漫遊者劇場」是黃思農從 2016 年開始，陸續於臺北萬華、澳門與柏林等地，開啟由觀眾獨自遊走於城市的各個角落凝聽聲檔的無演員劇場計畫，演出藉由虛構聲檔及敘事，將觀眾行走中所見的實存地景「幽靈化」與「疏離化」，進而改變觀者習以為常的城市感知。〈第一個夢〉以聲音導覽的方式將「漫遊者劇場」帶入亞洲藝術雙年展，以四段虛構的聲音敘事，介入觀眾與藝術品之間的觀看／展示關係，故事從 2019 年在越南一場軍方介入的音樂季、20 世紀初贊米亞地區的先知運動，到近未來一位臺灣能目及千里的異能者，他擁有一種觸覺般的視覺，帶我們進入一場又一場無聲的夢境，在過去、當下與未來的移動間，觀看無形的時間，如何作用於我們有形世界和肉身。

The First Dream

"Silence warning the 'living' ones
with here and there a sealed lip".
—First Dream (1692), Sor Juana Inés de la Cruz

Flâneur series is a series of projects that the artist Snow Huang has worked on since 2016. In this series, participants walk on his or her own in a setting without any performers. Throughout their walk, they listen to audio files placed in various corners in a city. The fabricated narratives and sound files turn the cityscape into a spectre-like environment, unsettling participants' accustomed perceptions of reality in the city by estranging them from it.

The First Dream takes the form of an audio guide and its story begins with a music festival involving military troops in Vietnam—the tale then takes listeners to the Millenarian movements in Zomia in early 20th century, before shifting to a young person in Taiwan with the paranormal ability to see "beyond a thousand miles". Huang's tactile vision takes the audience member through a series of silent dreams, revealing how intangible time shapes the tangible world and bodies, as we travel through the past, present and future.

一段因為太陽升起而出現的聲音，或是暗示逐漸明亮的聲音）

麼是有用，什麼是無用呢？

塊被沖上岸的籃球碎片讓我看見八十年前的一場球賽，球員們爭奪一顆球，幾千個

眾歡呼，閃光燈啪擦啪嚓的閃。

也看過一場演唱會，主唱在台上嘶吼，歌迷在台下尖叫、暈厥。那是一支原來是粉紅

色的螢光棒。

這麼多人因為一個小東西狂歡，而我在幾十年、一百年後的現在看到。到底為什麼人

會那麼開心呢？到底為什麼人會這麼在意一件事情？

有一盞頭燈，就　　　　頭上，照亮面前的路又可以空出雙手的東西。挖掘、挖

掘，戴著這顆頭

不知道重複手上的

麼？好多好多張臉。

開始變熱了。

「親愛的……親愛的…

有十二支手指頭的嬰兒

一個礦坑工作，機器

為重要的東西。我手上

來人們才發現這些廢料

兩個夢

第一個夢

太初，一片沉默，只有一些夜行性鳥兒的聲音還被容許出現，彼時沒有天

有地，只有水，水中有一隻雙頭蛇，這蛇也是阿嫫曉白智慧的道，這是他

的奧秘：蛇原初是一條流出伊甸園的河。

河水慢慢凝結成了冰，後來冰塊炸裂成兩片，兩塊冰有輕有重，阿嫫曉

間走了出來，重的沉降變為地，輕的上升變成天，這就是宇宙天地的開

〈第一個夢〉

2019，聲音、導覽機，60 分（圖片由藝術家提供）

藝術家提供

2019 亞洲藝術雙年展委託新作

———

The First Dream

2019, sound, audio devices. 60min (Photo by artist)

Courtesy of the artist

Commissioned by the *2019 Asian Art Biennial* (Taiwan)

〈第一個夢〉
2019，聲音、導覽機，60 分
藝術家提供
2019 亞洲藝術雙年展委託新作

———

The First Dream
2019, sound, audio devices. 60min
Courtesy of the artist
Commissioned by the *2019 Asian Art Biennial* (Taiwan)

長。人們依然熱烈的討論要往哪裡遷移，往更高的地方
，或是移民到新的地球、移民到火星、移民到新的火星。
晃體是數量龐大無法計算的人造碎片。

正在哭泣的我的注意力，而常常唱的一首歌。應該說我想
我只記得她唱歌時的嘴唇，「天／黑／黑／欲／落／」
首沒有旋律的歌還算是歌嗎？模糊的記憶還算是記得嗎？
話的女人重疊，紅紅的嘴唇和她們身上布料的顏色、藍色
遠的畫，像是一片很多顏色的海，我漂浮在海平面上只有
下我一個人。

場景，看著過去的人我好像活過無數遍，我只需要閉上眼
就可以帶我到遠方。

Tin
'o
'o
Mei
Low
Ho

o/ Hi Mei Yo

斷，我沒辦法評斷　　　　和　　　，或是　　　　較重要。
什麼才是歷史上重要的時刻嗎？

我看過一片玻璃，它幾乎是從世界的另一端被運過來，那小片玻璃曾經

編導、聲響設計｜黃思農
戲劇構作、翻譯｜陳佾均
文本｜黃思農、陳雅柔
製作統籌｜羅尹如
作曲｜黃思農、千野秀一、KRITON B.、曾韻方
聲音演員｜黃衍仁、蔡佾玲、陳佾均、王肇陽、蔡志擎
〈異鄉樂人〉故事提供｜許敖山

Concept, Direction and Sound Design | Snow HUANG
Dramaturgy and Translation | Betty CHEN
Text | Snow HUANG, Yarou CHEN
Production Manager | Yinru LO
Composition | Snow HUANG, Shuichi CHINO, Yunfang
TSENG, KRITON B.
Voice Performers | Hin Yan WONG, Yiling TSAI,
Betty CHEN, Chao Yang WANG, Chih Ching TSAI,
The Stranger, an original story from Steve HUI

註腳 FOOTNOTES

第三展區　　　　Zone 3

\# 物的變異 \# 鐘與大砲 \# 閃玉 \# 淘金熱
\#　Variation of Matter　\#　Bells and Cannons　\#　Nephrite　\#　Gold Rush

1848 年 1 月 24 日，詹姆斯‧馬歇爾（James W. Marshall）在加州科洛馬（Coloma）的沙特磨坊（Sutter's Mill）發現金礦，在訊息尚未擴散前，僅有當地人開始投入淘金。1848 年 8 月 19 日，《紐約先驅報》（New York Herald）率先於美國東岸報導加州發現黃金。同年年底，美國總統波爾克（James K. Polk）在國會演說中證實這項消息，加州產金的訊息就此傳開後，美國迎來第一個淘金熱，有近 30 萬人從美國各州與世界各國蜂擁而至，在這 30 萬人中大約有一半航海而來、一半自陸路前來，雖然淘金者多數是美國人，但在這股熱潮下也湧入了數萬個來自拉丁美洲、歐洲、澳洲和亞洲的新移民。為了容納這些突增的人口，加州本地各項產業也在短時間內快速發展。

1850 年代加州淘金熱期間三一河（Trinity River）上的礦工。（圖片來源：橘郡檔案局）
miner working on Trinity River during the California Gold Rush in the 1850s. (Image source: Orange County Archives)

加州淘金熱的起點，沙特磨坊。（圖片來源：維基共享資源媒體庫）
er's Mill, the starting point of the California Gold Rush. (Image source: Wikimedia Commons, the free media repository)

On January 24th, 1848, James W. Marshall discovered the gold mine in Sutter's Mill, Coloma, California. Before the news spread, only the locals went digging gold. On August 19th, 1848, the *New York Herald* first reported about the discovery of California gold mine on the East Coast of the United States. At the end of the year, the US President James K. Polk confirmed this news in an address to Congress, and the news about the California gold mine spread ever since, sending the entire country into a gold mining frenzy. Nearly 300,000 people from all over the country and the world rushed to California, half of which came by boat and the other half via land transport. Although most of the diggers were Americans, tens of thousands of new immigrants from Latin America, Europe, Australia and Asia also joined the gold rush. To accommodate this sudden increase of population, the local industries in California also developed rapidly within a short period of time.

NESBIT & CO., PRINTERS.

教堂的鐘與戰爭用的大砲之間一直存在著某種奇異的關聯，它們兩者由相同的金屬鑄成，也經常在同樣的工廠與工匠手中被製造出來，在戰爭期間，鐘被製造為大砲，當和平來臨時這些武器又重新化做鐘。回顧歷史，早期在火藥技術從中國傳入西方之後，許多教堂製鐘人便成為歐洲第一批製槍商。第一、二次世界大戰期間，由於戰爭工業對金屬供不應求，參與戰事之地向平民徵收金屬、教堂鐘等行為成為普遍現象，多處城鎮的日常鐘聲因戰爭止息，德意志政府則是在 1917 年 3 月頒布法令，使大約 44% 的德國教堂鐘熔為戰爭武器。

There has always been a peculiar connection between church bells and cannons used in wars. They were made of the same metal and often produced by the same factories and craftsmen. During wartime, bells were made into cannons, and when peace returned, cannons were melt for making bells again. Looking back at history, after the technology of making gunpowder was brought to the West from China, many church bell makers became the first group gun makers in Europe. During World War I and World War II, the war industry had high and constant demand for metal. It became a common practice for countries involved in the warfare to commandeer metal and church bells from civilians, causing the daily sounds of bells in many towns and cities to disappear. In March 1917, the German Reich proclaimed a law to commandeer church bells, turning approximately 44% of church bells in Germany into weapons for war.

◀ 1965 年 9 月 23 日《中央日報》第五版。（圖片來源：《中央日報》五十年全文影像資料庫）

Section 5 of the *Central Daily News* on September 23rd, 1965. (Image source: *Central Daily News* 50 years of full-text image database)

「這次翠玉礦的發現，為該礦場帶來極大的困擾，礦場負責人已專程赴臺北向該公司報告，謀求對策，以保礦區權益。豐田附近民眾表示，這些礦石，本是石礦公司採取石綿後放棄的廢物，他們上山挖取並不違法，目前礦商在山中收購的價格，每公斤自六元至十餘元不等，一個鄉民一天之中，載運四、五十斤，獲利三、四百元，而不花一文本錢，難怪大家像淘金一樣，扶老攜幼，相率上山，壽豐鄉民平添了一筆可觀的財富。」

——〈花蓮翠玉礦引起開採潮：壽豐民眾紛往挖取，十餘工廠擬予加工〉，《中央日報》第五版，1965 年 9 月 24 日

'The discovery of the nephrite mine caused a huge problem for the mining company, and the person in charge of the mine has already returned to Taipei to report back to the company and seek countermeasures to ensure their rights. According to the people living near Fengtian, the nephrite rocks were refuse from the mining asbestos. Therefore, digging out these rocks is not an illegal practice. Currently, the mining company purchased the rocks with an average price between six dollars to ten dollars per kilogram. Each person can cart forty to fifty catties per day, making an income of three to four hundred dollars without any cost. It is no wonder that everyone is joining this gold rush, bringing both elders and children into the mountains. The people of Shoufeng have made quite a fortune out of the discovery.'

—— *A Rush of Mining Nephrite Sparked in Hualien: Shoufeng People Joined the Dig, and A Dozen of Factories Are Ready for Processing, Central Daily News*, Section 5, September 24th, 1965.

玉礦廣布全球，其中以閃玉為最，輝玉次之。臺灣僅有閃玉，主要分佈在花蓮豐田（今壽豐鄉）與萬榮一帶。豐田為日治時期移民村，其西側為閃玉礦區所在的荖腦山。在連橫所著的《臺灣通史》〈卷二十八〉中曾記載「相傳玉山之內有玉，然未發現」，臺灣過去雖有產玉的說法，但實際地點無人得知。

大正 6 年（1917）花蓮荖腦山首見石綿礦藏，《臺灣日日新報》亦開始報導石綿礦相關新聞，昭和 12 年（1937）日人砂田鄰太郎在豐田設立「砂田石綿礦業所」，後於昭和 15 年（1940）被「臺灣拓殖株式會社」收購。二戰爆發後，礦區被日本海軍徵用，石綿產量大增，直到 1945 年 5 月遭炸毀而停工，8 月日本宣布投降後，礦區開採也自此停滯多年。戰後，臺灣石綿株式會社幾經易主經營，於 1956 年轉至中國石礦股份有限公司管理，集中開採石綿、蛇紋石、滑石等礦產，在開採時產生的廢石則棄之山谷，這些被當作廢材的閃玉石礦，直到 1950-1960 年代才逐步被證實其經濟價值。

Jade mines are found in many places around the world. Most are nephrite, and jadeite the second. Taiwan only has nephrite, which is mainly found in Fengtian (now Shoufeng Township) and Wanrong in Hualien. Fengtian was an immigrant village during the period of Japanese rule, and to its west was Laonao Mountain where the nephrite mine was found. It is stated in 'Book 28' of Lian Heng's *General History of Taiwan* that 'Jade Mountain is said to produce jade, though none has ever been found'. Although there was rumour that Taiwan had jade mine, but its actual location remained unknown.

In 1917, the asbestos mine in Hualien's Laonao Mountain was discovered. The *Taiwan Daily News* also reported about the asbestos mine. In 1937, Sunata Rintaro founded 'Sunata Asbestos Mining Company' in Fengtian, which was purchased by Taiwan Development Company in 1940. After the outbreak of World War II, the mine was commandeered by the Japanese Navy, who started running large-scale mining operations until the mine was blasted in May 1945. After Japan surrendered in August, the mining stopped for years. After the war, Taiwan Asbestos Company changed hands several times. In 1956, China Mining Company started managing the mining operations, producing asbestos, serpentine and talc. The refuse from the operations was left in the valley. The economic value of these nephrite rocks that were treated as refuse was only proven during the 1950s to the 1960s.

夏爾芭・古普塔
Shilpa GUPTA

1976 年生，現工作居住於印度孟買，1992 年至 1997 年間於此地的 J. J. 爵士藝術學院研習雕塑。

古普塔曾於辛辛那提的當代藝術中心、布里斯托的阿諾菲尼當代藝術中心、林茲的 OK 當代藝術中心、阿納姆現代藝術博物館、新德里的國家美術院等機構舉辦個展。

參展經歷包括柏林雙年展（2014）、「比耶穌還年輕的一代」三年展（紐約新美術館，紐約）、沙迦雙年展（2013）、里昂雙年展（2009）、光州雙年展（2008）、橫濱三年展（2008）、利物浦雙年展（2006）。參加納夫・海克策展的哥德堡雙年（2017），該展展名即是取自吉普塔的燈光作品〈在哪裡我結束你開始〉（Wheredoiendandyoubegin）。古普塔的作品曾在泰德現代美術館、現代藝術博物館、路易斯安那博物館、龐畢度藝術中心、蛇形畫廊、古根漢博物館，ZKM 及齊蘭・納達藝術博物館展出。2005 年擔任在阿雷格里港舉行的世界社會論壇「跨界與重寫：亞洲邊界」展協同策展人，並為「阿爾－帕爾」活動發起人，這是一項於 2002 年至 2006 年間進行的印度與巴基斯坦公共藝術交流計畫。2018 年，她在位於卡特路住家附近，設置戶外燈光作品〈我們改變彼此〉（We change each other）。2019 年，她參與由拉爾夫・魯格夫（Ralph Rugoff）策劃的第 58 屆威尼斯雙年展。

Shilpa Gupta was born in 1976, and currently lives and works in Mumbai, India. Between 1992 and 1997, she studied sculpture at the Sir J. J. School of Fine Arts.

Gupta has exhibited in solo shows at the Contemporary Arts Centre in Cincinnati, Arnolfini in Bristol, OK in Linz, Museum voor Moderne Kunst Arnhem and Lalit Kala Akademi in New Delhi.

Shilpa Gupta has participated in *Berlin Biennale* (2014), *Younger Than Jesus Triennial* (New Museum, New York, 2009), *Sharjah Biennial* (2013), *Lyon Biennale* (2009), *Gwangju Biennale* (2008), *Yokohama Triennale* (2008) and *Liverpool Biennial* (2006). In 2017, she participated in *Gothenburg Biennial*, curated by Nav Haq and which was titled after her light work *Wheredoiendandyoubegin*. Gupta's work has been shown in group shows at Tate Modern, Museum of Modern Art, Louisiana Museum, Centre Pompidou, Serpentine Gallery, Solomon R. Guggenheim Museum, ZKM and Kiran Nadar Museum.

Gupta co-curated *Crossovers & Rewrites: Borders over Asia* at the 2005 World Social Forum in Porto Alegre, and Aar Paar, a public art exchange project between India and Pakistan, from 2002 to 2006. In 2018, she installed *We change each other*, an outdoor light work in her neighbourhood on Carter Road. In 2019, she participated in the *58th Venice Biennale* curated by Ralph Rugoff.

〈地之歌〉
2017，機械裝置、邊境拾得的石頭，79×22×18 公分
藝術家及常青畫廊，聖吉米納諾／北京／穆林／哈瓦那提供作品
由比勒費爾德藝術協會、代爾姆當代藝術中心、根特的 KIOSK 畫廊委託製作

——

Song of the Ground
2017, mechanical installation with borderland river stones. 79×22×18 cm
Courtesy of the artist and GALLERIA CONTINUA, San Gimignano/Beijing/Les Moulins/Habana
Commissioned by Bi-elefelder Kunstverein, Centre d'Art Contemporain La Synagogue de Delme, and KIOSK, Ghent

〈地之歌〉

觀眾在〈地之歌〉一作中會先聽見節奏緩慢、不斷重覆、如擊掌般由二粒石頭碰撞所發出的聲音，這些石頭是藝術家在印度及孟加拉交界區域的提斯塔河畔所撿拾而來，印度在該區域立起了全世界最長的柵欄，幾乎要把鄰國孟加拉給圍起來，然而此區域的日常生活卻不斷打破國家豎立柵欄的目的，人員及物資的流動，因歷史社會因素、地理相連性及經濟所需而持續進行，據傳非法交易的數量比合法貿易行為多出三倍之多，在這件作品中，石頭的相互碰撞猶如顛覆性的鼓勵違法越界，在沉默中見證了柵欄二端那些可見和不可見的行動，也像在抗爭活動中相互擊掌的手臂，隨著撞擊節奏穿透展間，彷彿正在召喚著自然的生命力；一如川流的河水推動這些石頭，這首土地之歌也成為一首自由之歌。

Song of the Ground

In *Song of the Ground*, what is first encountered is a slow repetitive sound as two stones come together as if clapping in rhythm. These stones were collected by the artist from the area around the Teesta River, in the border areas where the waters flow between India and Bangladesh. It is here that the world's longest fence is being built by India, almost encircling its neighbour Bangladesh.

However, daily life in the borderland belies the state's intentions, and the flow of people and goods persist, prompted by historical and social affinities, geographical continuities and economic imperatives. This illegal trade is said to be three times the size of legal trade in the region.

In this artwork, the stones come together in a subversive applause for the people's transgressions —they have been silent witnesses to the visible and invisible movements on either side of the fence. Like two hands clapping in protest, the rhythm echoes throughout the exhibition space, recalling the life forces of nature in motion. Like the rivers that carry these stones, this song of the ground is a song of freedom.

a

b

b 〈邊境界碑〉 （圖片由藝術家提供）
Border Pillar (Photo by Artist)

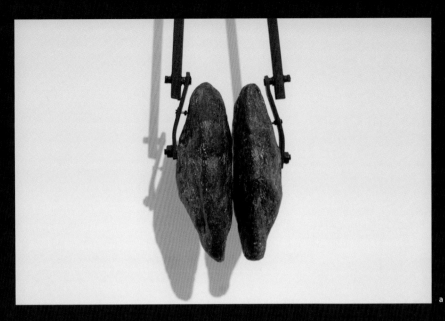

a

b

a 〈地之歌〉
2017，機械裝置、邊境拾得的石頭，79×22×18 公分（攝影：提姆・卡列敏）
藝術家及常青畫廊，聖吉米納諾／北京／穆林／哈瓦那提供作品
由比勒費爾德藝術協會、代爾姆當代藝術中心、根特的 KIOSK 畫廊委託製作

Song of the Ground
2017, mechanical installation with borderland river stones. 79×22×18 cm (Photo by Tim Callemin)
Courtesy of the artist and GALLERIA CONTINUA, San Gimignano/Beijing/Les Moulins/Habana
Commissioned by Bi-elefelder Kunstverein, Centre d'Art Contemporain La Synagogue de Delme, and KIOSK, Ghent

王虹凱
WANG Hong-Kai

生於臺灣虎尾，王虹凱的研究取向、創作關注殖民與離散的勞動歷史，探究「聽」於權力、生存經歷和歷史交錯點上被遮蔽排除或消失的知識政治，以表演、聲音、工作坊、裝置、出版等形式，實驗不同的聆聽與聚集模式，探觸時／空交錯中欲望生成、共存想像和知識維度之間複雜與多變的關係。

作品計畫曾於 Theater Commons Tokyo 2019、紐約雕塑中心、第 14 屆德國卡塞爾文件展、2016 台北雙年展、澳洲液體聲音藝術節、紐約現代美術館等地發表。

Wang Hong-Kai was born in Huwei, Taiwan. Her research-based practice confronts the politics of knowledges lost in colonial and diasporic encounters, at the intersection of lived experience, power, and "listening." Through experimental modes of sonic sociality, her multidisciplinary work seeks to conceive of other time-spaces that critically interweave the production of desire, histories of labour, the economies of co-habitation, and formations of knowledge.

Wang has presented her practice internationally at *Theater Commons Tokyo 2019*; Sculpture Center New York, *documenta 14*, *Taipei Biennial 2016*, Liquid Architecture, Museum of Modern Art New York, among others.

「完全感懷到巴勒斯坦人經歷的所有一切，他在約旦和黎巴嫩之間的移動，像地震儀式地閱讀，繪製與揭露著看似正常的地表所暗藏的斷層線」。

"fully intuited the scope and drama of what the Palestinians were living through... his movement through Jordan and Lebanon had something like the effect of a seismographic reading, drawing and exposing the fault lines" In Edward Said's words.

〈這不是國境音樂〉

2019，工作坊、多媒體裝置，尺寸依場地而異

藝術家提供

2019 亞洲藝術雙年展委託新作

本計畫由國立臺灣美術館、臺中國家歌劇院以及國立中央大學地震災害鏈風險評估及管理研究中心協助製作

———

This is no country music

2019, workshop, multi-media installation. Dimensions variable

Courtesy of the artist

Commissioned by *2019 Asian Art Biennial* (Taiwan). With the support of National Taiwan Museum of Fine Art,

National Taichung Theatre and Earthquake-Disaster & Risk Evaluation and Management, National Central University

〈這不是國境音樂〉

〈這不是國境音樂〉追溯臺裔作曲家江文也的音樂軌跡，將聽／感覺放在臺灣史上傷亡最慘重的自然災害：1935 年的「新竹－臺中大地震」。當時江文也應《臺灣新民報》之邀譜寫《賑災歌》，縱然有研究者聲稱此歌曾傳頌一時，可惜無任何樂譜或錄音留下。作品以尋找遺失的《賑災歌》為起點，企圖穿越地質、災害、身體、社會、歷史等面向，搜索地震發生前後的觀測資料和倖存者互助共存的檔案及口傳記憶等，以及殖民政府引進的現代地震測報和統治技術。試問：彼此要如何學習共同「閱讀、繪製與揭露被看似正常的地表所覆蓋的斷層線」（Edward Said, 2007）和人類意識形態之間的糾結難解，如同想像建立某種超越人類／自然、國／族、人類／非人類等全球現代性界定劃分的【臆測合成地震儀】？

此計畫以一種移動式開放性的「彩排」形式做為技術和方法，邀請音樂學者劉麟玉，和地震學家馬國鳳與鄭世楠團隊，舉行一系列「共學」彩排，與學員在 1935 大地震和江文也相關的不同地點與遺跡之間踏查，探究如何批判性地感知互異的物質性與生存韻律，從嘗試不同的實驗性合作對話中，或許一場試驗性的「音樂會」將逐漸展開。

This is no country music

This is no country music traces the musical trajectory of Taiwan-born composer, Koh Bunya. It positions a "listening/feeling" prism onto the geopolitical time-space of the 1935 Hsinchu-Taichung Earthquake. At the invitation of *Taiwan People News*, Koh Bunya composed the *Earthquake Relief Song* for a relief concert soon after the natural disaster. Taking this lost *Earthquake Relief Song* as a point of departure, Wang's work attempts to traverse geology, catastrophe, body, society and history.

The project scours the archive not only for historical seismic data, but also written and oral records of mutual aid and survival strategies, modern paradigms of seismic monitoring, and technologies of colonial governance. The question is: how to record a "seismographic reading, drawing and exposing the fault lines" of the earth as well as the entanglements between human ideologies "that a largely normal surface had hidden?" (Edward Said, 2007). In the process of probing, the work seeks to collectively imagine a kind of apparatus constructed beyond the binaries of human/nature, nation/state, science/humanity, or human/nonhuman, as defined by global modernity — thus creating something perhaps like a "speculative seismographic hybrid".

This is no country music takes the form of an "open rehearsal" to navigate between sites relevant to the 1935 earthquake, and Koh in Taichung. Together with musicologist Liou Lin-Yu, and the team of seismologists Ma Kuo-Fong and Cheng Shih-Nan, the rehearsals' participants query how to critically feel and grapple with a heterogeneity of materialities and rhythms. As we experiment with various modes of cooperation, and exchange at once with one another and everything else around us, a tentative "concert" may unfold.

〈這不是國境音樂〉

2019，工作坊、多媒體裝置，尺寸依場地而異

藝術家提供

2019 亞洲藝術雙年展委託新作

本計畫由國立臺灣美術館、臺中國家歌劇院以及國立中央大學地震災害鏈風險評估及管理研究中心協助製作

This is no country music

2019, workshop, multi-media installation. Dimensions variable

Courtesy of the artist

Commissioned by *2019 Asian Art Biennial* (Taiwan). With the support of National Taiwan Museum of Fine Art,

National Taichung Theatre and Earthquake-Disaster & Risk Evaluation and Management, National Central University

〈這不是國境音樂〉

2019，工作坊、多媒體裝置，尺寸依場地而異

影像截圖

2019 亞洲藝術雙年展委託新作

本計畫由國立臺灣美術館、臺中國家歌劇院以及國立中央大學地震災害鏈風險評估及管理研究中心協助製作

———

This is no country music

2019, workshop, multi-media installation. Dimensions variable.

Video still

Commissioned by *2019 Asian Art Biennial* (Taiwan). With the support of National Taiwan Museum of Fine Art,

National Taichung Theatre and Earthquake-Disaster & Risk Evaluation and Management, National Central University

概念、導演｜王虹凱

工作坊指導｜劉麟玉（日本國立大學法人奈良教育大學音樂教育講座教授）、鄭世楠（健行科技大學應用空間資訊系副教授）

敘事人｜余樾琪、郭承達

表演｜瑟勒卜・吉琳、黃可萱、古拉斯・寶打萬、魏婉庭、管紹宇、周郁齡、鮑沛蘭、劉冠昀、許修豪、許文柔、郭承達、廖惠理、張若萃、張睿碧、張靖瑩

特別表演｜劉麟玉

工作坊成員｜瑟勒卜・吉琳、黃可萱、古拉斯・寶打萬、魏婉庭、管紹宇、周郁齡、鮑沛蘭、許修豪、許文柔、郭承達、張若萃、張靖瑩

研究執行助理｜余樾琪

助理導演｜許修豪

攝影剪接｜蔡音璟、陳怡如

錄音｜羅頌策

英文字幕翻譯｜吳中平

特別支持｜吳少凱、劉冠昀、洪瑞駿

特別感謝

Bill Dietz、王信凱、臺中市清水國小、蔣偉光、林太崴、相馬千秋、東京劇場公社、原舞曲文化藝術團、馬國鳳、國立臺灣歷史博物館、單信瑜、吳長錕、何義麟、周婉窈、徐文瑞、鄭曉麗、曾伯豪、六然居資料室、清水三山國王廟及蔡明森主委、江小韻、沈雕龍、張睿碧、張己任、陳穎禎、陳義雄

合作單位｜臺中國家歌劇院、國立中央大學地震災害鏈風險評估及管理研究中心

《這不是國境音樂》裡演奏使用的江文也樂譜獲家屬江小韻授權

Concept & Direction | WANG Hong-Kai

Workshop Facilitation | LIOU Lin-Yu (Professor, Department of Music Education, Nara University of Education, Japan); CHENG Shih-Nan (Associate Professor, Department of Applied Geomatics, Chien Hsin University of Science and Technology)

Narrators | YU Yue-Qi, KUO Cheng-Da

Performers | Selep GILING, HWANG Ke-Hsuan, Kulas POATAWAN, WEI Wan-Ting, GUAN Shao-Yu, CHOU Yu-Ling, PAO Pei-Lan, LIU Kuan-Yun, SHIU Shiou-Hau, HSU Wen-Jou, KUO Cheng-Da, Eri LIAO ISAKA, CHANG Juo-Hsin, CHANG Jui-Pi, ZHANG Jing-Ying

Special Performance | LIOU Lin-Yu

Workshop Particpants | Selep GILING, HWANG Ke-Hsuan, Kulas POATAWAN, WEI Wan-Ting, GUAN Shao-Yu, CHOU Yu-Ling, PAO Pei-Lan, HSU Wen-Jou, KUO Cheng-Da, CHANG Juo-Hsin, ZHANG Jing-Ying

Research & Coordination | YU Yue-Qi

Assistant Director | SHIU Shiou-Hau

Videographer & Editor | TSAI Pei-Ching, CHEN I-Ju

Sound Recordist | LO Song-Ce

English Subtitle Translator | Michael WU

Special Support | WU Shao-Kai, LIU Kuan-Yun, HUNG Ruei-Jiun

Special Thanks to

Bill DIETZ, WANG Hsin-Kai, Chingshui Elementary School of Taichung, Gingerol CEMELESAI, LIN Tai-Wei, Chiaki SOMA, Theater Commons Tokyo, Taiwan Aboriginal Dance Cultural & Arts Group, MA Kuo-Fong, National Museum of Taiwan History, SHAN Hsin-Yu, WU Chang-Kun, HO I-Lin, CHOU Wan-Yao, HSU Manray, ZHENG Xiao-Li, TSENG Po-Hao, Liu Ran Ju Reference Room, Chingshui Three Mountain Kings Temple & Chairman TSAI Ming-Sen, JIANG Xiao-Yun, SHEN Diau-Long, CHANG Jui-Pi, CHANG Chi-Jen, CHEN Ying-Chen, CHEN I-Hsiung

In collaboration with National Taichung Theatre, Earthquake-Disaster & Risk Evaluation and Management (E-DREaM) of National Central University

All scores by KOH Bunya performed in *This is no country music* are authorized by JIANG Xiao-Yun.

渡邊麻耶
Maya WATANABE

出生於 1983 年，祕魯視覺藝術家，擅長錄像裝置創作。渡邊也與祕魯、西班牙、奧地利、義大利等地舞台劇合作，參與場景設計與音像藝術指導工作。目前為倫敦大學金匠學院視覺文化博士生，現居住於阿姆斯特丹。

她的作品曾於法國東京宮、馬德里屠宰場文創中心、舊金山卡蒂斯特基金會、弗里德里希阿魯門博物館、利馬當代藝術館、京都藝術中心等處展出。其他參展經歷包括巴西錄像藝術節、LOOP 錄像藝術節、巴西國際電子語言藝術節、Transitio MX 電子藝術節、馬德里不設防、哈瓦那電影節、北京雙年展、哈瓦那雙年展等。

Maya Watanabe was born in 1983 in Peru. She is a visual artist whose works comprise of video installations. Watanabe has also collaborated as a set designer and audio-visual art director for a number of theatrical productions in Peru, Spain, Austria and Italy. Watanabe is currently a PhD researcher in Visual Cultures at Goldsmiths, University of London. She is based in Amsterdam.

Her work has been exhibited at various venues, such as Palais de Tokyo, Paris; Matadero Madrid; Kadist Art Foundation SF, USA; Das Fridericianum; Museo de Arte Contemporáneo of Lima, Peru; Kyoto Art Centre, among others. She has been featured in festivals, including *Videobrasil*, *LOOP*, *FILE*, *Transitio MX*, *Madrid Abierto*, *Havana Film Festival*, *Beijing Biennale* and *Havana Biennale*.

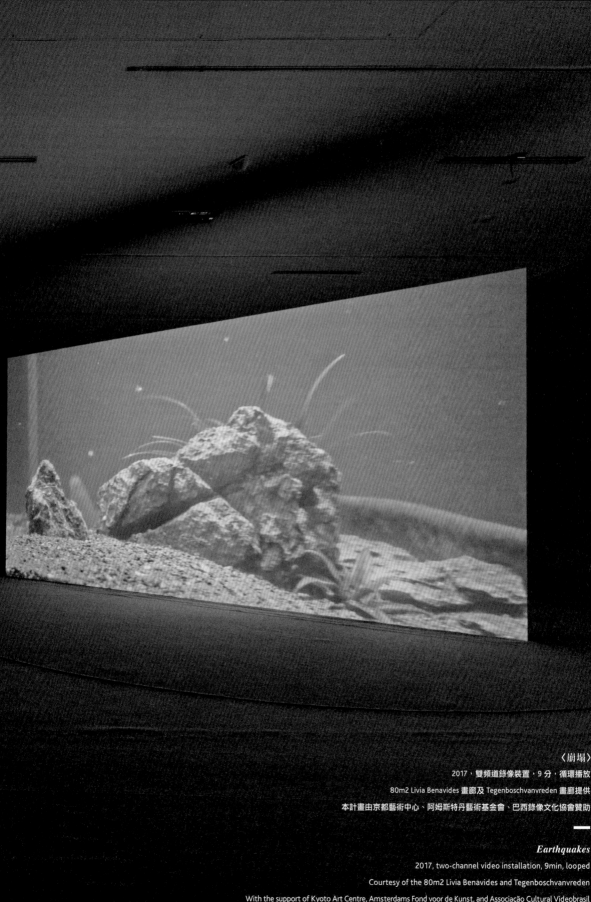

〈崩塌〉

2017，雙頻道錄像裝置，9 分，循環播放

80m2 Livia Benavides 畫廊及 Tegenboschvanvreden 畫廊提供

本計畫由京都藝術中心、阿姆斯特丹藝術基金會、巴西錄像文化協會贊助

Earthquakes

2017, two-channel video installation, 9min, looped

Courtesy of the 80m2 Livia Benavides and Tegenboschvanvreden

With the support of Kyoto Art Centre, Amsterdams Fond voor de Kunst, and Associação Cultural Videobrasil

〈崩塌〉

空蕩蕩的劇場裡出現一幅不太自然的風景，在沒有任何人為的介入下，一連串狀況開始迸發。人造的災難讓靜止的畫面突然中斷。敘事空間瓦解，巧置的風景崩塌。隨著鏡頭繼續拉遠，原本被遺留下的殘跡再度出現，不知所以然地被重組起來。

災難被用來象徵阻斷敘事建立連貫性的巨大變動。透過用劇場形式表現自然的人為性，「地震」一詞也從舞台場景的角度重新考慮和制定。在〈崩塌〉中，我們感受到不同時間層的共存——長鏡頭的時間、（缺席的）人類歷史時間與板塊運動的地質時間。

Earthquakes

In *Earthquakes*, an unnatural landscape appears in an empty theatre. Without any human action, a series of events begins to unfold. The motionless scene is abruptly interrupted by artificial disasters. The scenography breaks down and the staged landscape collapses. As the long-shot continues, the remnants left behind appear again, inexplicably recomposed.

Disasters are taken as metaphors of upheavals that impede the narrative impulse to build a coherent sequence. By dramatising the artificiality of nature, the term "earthquake" is itself reconsidered and reformulated from a scenographic perspective. In *Earthquakes*, we sense the co-existence of different layers of time—the duration of the long shot, the historical time of the (absent) humans, and the geologic time of tectonic plates moving.

〈崩塌〉

2017，雙頻道錄像裝置，9分，循環播放

80m2 Livia Benavides 畫廊及 Tegenboschvanvreden 畫廊提供

本計畫由京都藝術中心、阿姆斯特丹藝術基金會、巴西錄像文化協會贊助

———

Earthquakes

2017, two-channel video installation, 9min, looped

Courtesy of the 80m2 Livia Benavides and Tegenboschvanvreden

〈崩塌〉

2017，雙頻道錄像裝置，9分，循環播放

80m2 Livia Benavides 畫廊及 Tegenboschvanvreden 畫廊提供

本計畫由京都藝術中心、阿姆斯特丹藝術基金會、巴西錄像文化協會贊助

——

Earthquakes

2017, two-channel video installation, 9min, looped

Courtesy of the 80m2 Livia Benavides and Tegenboschvanvreden

With the support of Kyoto Art Centre, Amsterdams Fond voor de Kunst, and Associação Cultural Videobrasil

工作人員

導演｜渡邊麻耶

攝影指導｜藤井翔

攝影助理｜詹姆士・拉提默爾

美術指導｜宮下忠也

聲音｜OMFO（日耳曼・帕波夫）

製片經理｜宮本吉雄（-L .S .C-）

燈光｜三和專業燈光株式會社、十河陽平 (RYU 株式會社)

翻譯｜荒川幸祐

特別感謝

平野春菜｜亞倫・柏曼、神馬啓介｜森田具海｜向井麻里

西田範次｜嶋田好孝｜蠆恒太郎｜好光義也

塞瑞札・法克斯｜萊昂・契普洛特｜喬爾迪・阿布薩達

塞巴斯迪安・狄亞茲・莫拉雷斯

Credits

Director | Maya WATANABE

Director of Photography | Fujii SHO

Focus Puller | James LATIMER

Art Director | Miyashita TADAYA

Sound | German POPOV, OMFO

Production Manager | Miyamoto YOSHIO (-L .S .C-)

Lighting | Sanwa Pro Light, Inc., SOGO (i RYU, Inc.)

Translator | Arakawa KOSUKE

Special Thanks to

Haruna HIRANO | Aaron BERMAN | Jimba KEISUKE

Morita TAKUMI | Mukai MARI | Nishida HANJI | Shimada

YOSHITAKA | Tategami KOTARO | Yoshimitsu YOSHIYA

Thereza FARKAS | León CHIPROUT

Jordi ABUSADA, and Sebastián Díaz MORALES

安塔日沙
Antariksa

安塔日沙出生於 1975 年，為印尼獨立歷史學者及日惹藝術團體 KUNCI 文化研究中心的共同創辦人，他同時也是《藝術與印尼人民文化協會的關聯性 1950–1965》（Tuan Tanah Kawin Muda: The Relation Between Art and the Institute of People's Culture 1950–1965）（2005）一書的作者。安塔日沙目前的研究專注於日殖時期東南亞地區的藝術及思想流動，2017 年獲得巴黎法國世界研究院的世界文化研究學院全球南方學獎助。

Antariksa was born in 1976 in Yogyakarta, Indonesia, where he currently lives and works as an independent historian and a co-founding member of the KUNCI research collective. He is the author of *Tuan Tanah Kawin Muda: Hubungan LEKRA-Seni Rupa 1950-1965* (*Tuan Tanah Kawin Muda: The Relation Between Art and the Institute of People's Culture 1950–1965*) (2005). His current body of research concerns art and the mobility of ideas in Japanese-occupied Southeast Asia.

In 2017, Antariksa was awarded the Collège d'études mondiales's Global South(s) fellowship, which forms part of the Fondation Maison des sciences de l'homme in Paris.

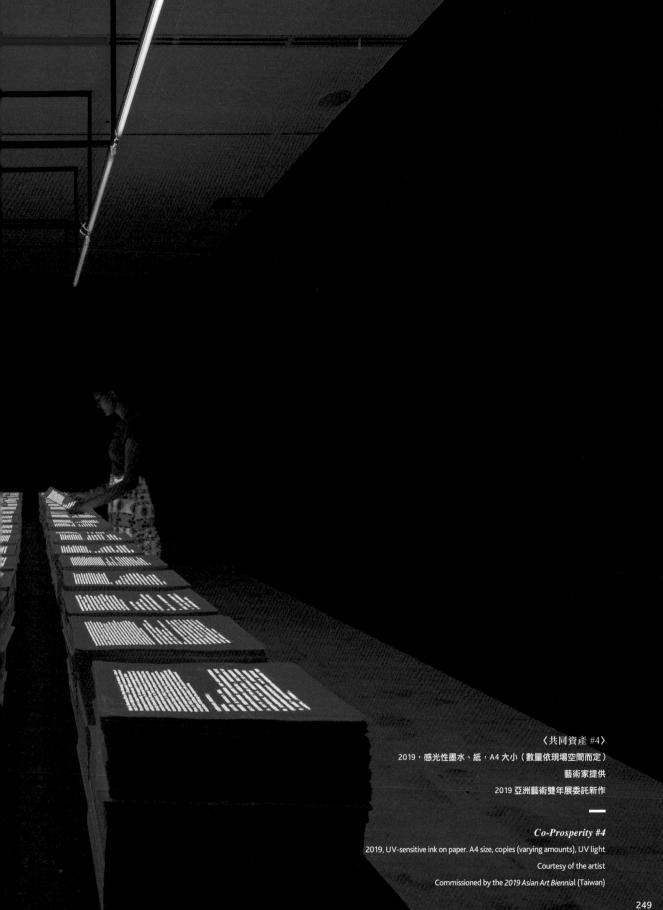

〈共同資產 #4〉
2019，感光性墨水、紙，A4 大小（數量依現場空間而定）
藝術家提供
2019 亞洲藝術雙年展委託新作

Co-Prosperity #4
2019, UV-sensitive ink on paper. A4 size, copies (varying amounts), UV light
Courtesy of the artist
Commissioned by the *2019 Asian Art Biennial* (Taiwan)

〈共同資產 #4〉

早在甲午戰爭及日俄戰爭期間，日本藝術家就被送上戰場以圖像紀錄戰時景況，這樣的做法在 1930 年代後期至 1940 年代初期以前所未有的規模進行，數以千計的日本知識份子同時被送上戰場，其中又有三分之一被要求與日本殖民地的戰宣部門合作，網羅大量聲望卓越的在地知識分子，參與當地的政治宣傳活動。

安塔日沙以這些知識份子們正式及非正式的傳記內容創作了這件裝置作品，傳記——特別是軍方所撰寫的傳記——一般來說，可以解讀或當做「硬性」歷史證據，然而，安塔日沙希望只利用這樣的硬性歷史證據，挑戰歷史學者敘述過去的方法，挑戰這種認為證據需要「夠硬」——即不帶任何情感——才客觀的必要性，這樣的客觀性並不表示沒有任何偏頗，也許我們只是被看似客觀的語言所蒙蔽，若將語言移除，我們還會發現什麼？

安塔日沙運用這種「軟性證據」來質問、反駁我們所知的硬性歷史證據的語言。〈共同資產 #4〉是他透過裝置作品主題，持續進行拓展觀眾感官經驗的實驗，藉此不斷反思各種方法，好讓公眾能依據他們的當下生活、感受及感官經驗，參與、介入歷史並詮釋過去。

Co-Prosperity #4

Japanese artists were creating images of the battlefield as early as the first Sino-Japanese War and the Russo-Japanese War, but by the late 1930s and the early 1940s the practice had grown to an unprecedented scale. By that point, hundreds of Japanese intellectuals had been enlisted to service in the military. A third of them were sent to work in propaganda departments across numerous Japanese-occupied countries, where they recruited a large number of prominent, local intellectuals to join in their activities.

Antariksa's exhibited work was created in response to both the official and unofficial biographies of these intellectuals. A biography, especially a military one, can be read or experienced as hard historical evidence. Antariksa seeks to challenge the notion that the evidence used by historians to narrate the past can be measured as being "hard enough" based on assumed objectivity—which for the artist means conferred without feeling. "Objectivity" in this sense is not defined as interpretation without bias, but rather the language of objectivity that might fool us—what happens when we remove language? What might we find then?

In this exhibit, the artist approaches these intellectuals' biographies by using "soft evidence" to counter the conventional language of "hard historical evidence". *Co-Prosperity #4* is a continuation of Antariksa's artistic experiments in developing audiences' sensory experiences and perceptions of his research subjects. The work seeks to rethink the ways in which the public can experience, participate and intervene in history—and in doing so, reinterpret their past in relation to the present.

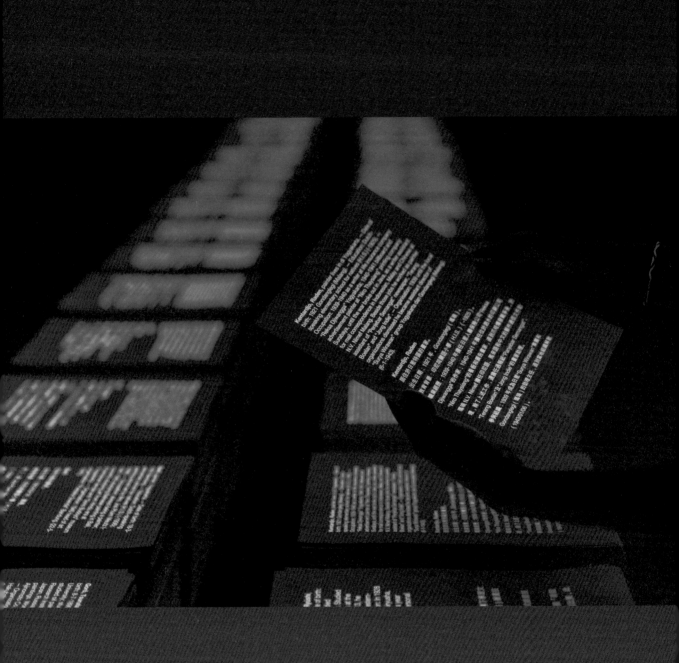

〈共同資産 #4〉
2019，感光性墨水、紙，A4 大小（數量依現場空間而定）
藝術家提供
2019 亞洲藝術雙年展委託新作

———

Co-Prosperity #4
2019, UV-sensitive ink on paper. A4 size, copies (varying amounts), UV light
Courtesy of the artist
Commissioned by the *2019 Asian Art Biennial* (Taiwan)

〈共同資產 #4〉

2019，感光性墨水、紙，A4 大小（數量依現場空間而定）

藝術家提供

2019 亞洲藝術雙年展委託新作

———

Co-Prosperity #4

2019, UV-sensitive ink on paper. A4 size, copies (varying amounts), UV light

Courtesy of the artist

Commissioned by the *2019 Asian Art Biennial* (Taiwan)

祖列伊哈‧喬杜里
Zuleikha CHAUDHARI

祖列伊哈‧喬杜里是德里的一名劇場導演與燈光設計師，作品游移於劇場與裝置藝術之間，探索觀者在表演中的角色以及觀看與表演間的張力。喬杜里持續研究表演的架構與符碼，以及演員身為真相傳達者的功能與身份。喬杜里當前的研究運用檔案（包括文字與照片）發展劇場式的演出，反思記憶的製造、檔案的角色，以及事件在其中的檢索與回溯。

2015 年起，喬杜里持續探索法規作為表演的一種框架，也就是律法以及法律呈現真相的過程中的表演性質。法律的表演性質描述了世界如透過既定的符號架構成形與呈現，而這些架構同時也是一種程予以及對於（歷史）符號與（新）脈絡的連結。「表演」在此所描述的是對於世界的一種刻意作為。喬杜里的作品曾於維也納藝術節、比利時布魯塞爾藝術節、巴黎秋季藝術節、首爾表演藝術節、亞洲表演藝術節、東京（2012）、柏林雙年展（2018）、柯欽雙年展（2016）、達卡藝術高峰會、嵌入（2014）、新德里（2014）、 新時線媒體藝術中心、上海（2013）、埃索博物館、維也納（2010）、藝法畫廊、 斯圖加特和柏林、約翰尼斯堡畫廊（2014）、不期而遇藝術節、大象設計（2018）等展出。

Zuleikha Chaudhari is a theatre director and lighting designer based in Delhi. Her works shift between theatre and installation, in an effort to investigate both the role of the viewer in performative experiences and the tension between looking or watching, doing or acting. She is currently researching the structures and codes of performance, as well the functions and processes of the actor as a producer of reality and truth. Her project employs archival documents (texts and photographs) as the basis for developing theatrical performances as a way of thinking about the relationships between the production of memory, the role of the archive, and how they pertain to the retrieval and reliving of an event.

Since 2015, she has been exploring the framework of law as performance, the role of performance in law, and the performativity of legal truth-production. The performativity of law references a way of forming, of per-forming the world through a certain structure of the use of signs that is always, at the same time both a procedure and a connection of a (historical) sign to a (new) context. The concept of "performativity" here describes a mode of doing something to the world.

Her works have been shown at the *Weiner Festwochen*; *Kunsten FestivaldesArts*; *Festival D'Automne*; *Seoul Performing Arts Festival*; *Asian Performing Arts Festival*, Tokyo (2012); *Berlin Biennale* (2018); *Kochi Biennale* (2016), *Dhaka Art Summit; INSERT2014*, New Delhi (2014); the

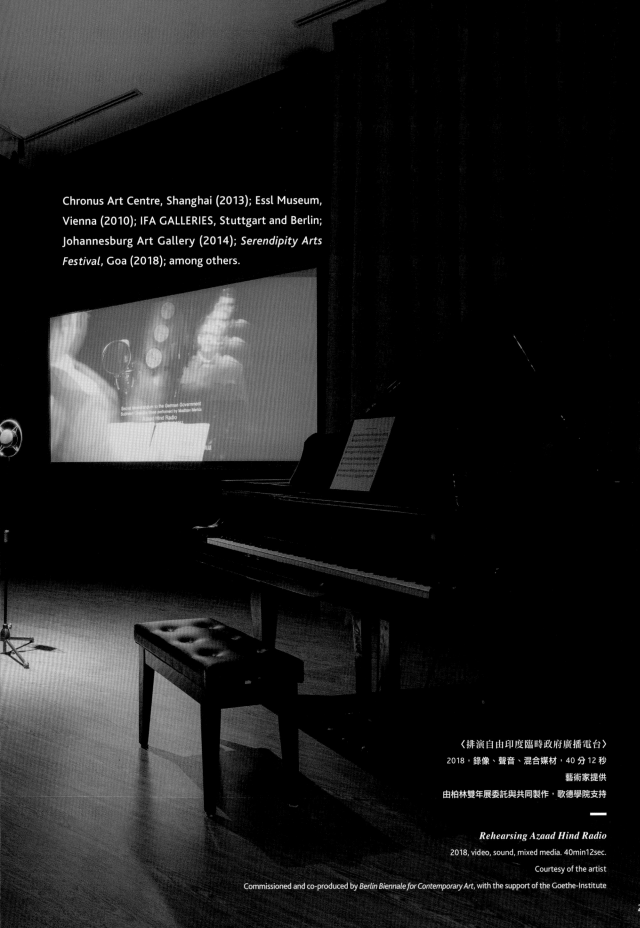

Chronus Art Centre, Shanghai (2013); Essl Museum, Vienna (2010); IFA GALLERIES, Stuttgart and Berlin; Johannesburg Art Gallery (2014); *Serendipity Arts Festival*, Goa (2018); among others.

〈排演自由印度臨時政府廣播電台〉
2018，錄像、聲音、混合媒材，40 分 12 秒
藝術家提供
由柏林雙年展委託與共同製作，歌德學院支持

Rehearsing Azaad Hind Radio
2018, video, sound, mixed media. 40min12sec.
Courtesy of the artist
Commissioned and co-produced by *Berlin Biennale for Contemporary Art*, with the support of the Goethe-Institute

〈排演自由印度臨時政府廣播電台〉

蘇巴斯・錢德拉・鮑斯（1897 年 1 月 23 日－1945 年 8 月 18 日）是一名印度民族主義者，他企圖透過德國納粹與日本帝國的勢力，使印度脫離英國統治。

鮑斯在 1943 年從印度逃至喀布爾的過程中喬裝成齊亞烏先生，經莫斯科轉往柏林途中則喬裝成義大利人奧蘭多・馬佐塔。鮑斯最終認清希特勒對於印度獨立興趣缺缺，並於 1943 年以松田先生的假名，乘坐德國潛水艇離開納粹德國，接著轉搭日本潛艇前往東京，終於化身錢德拉・鮑斯。後來，鮑斯前往仰光領導自由印度臨時政府，並以 T 先生的身份對抗英國勢力。據聞，傳鮑斯在 1945 年 8 月 18 日死於發生在臺北的墜機事件，當時他正要前往東京，接著由東京轉往前蘇聯。

祖列伊哈・喬杜里的空間裝置，揭露了 1941 年 11 月自由印度中心在德國資金的援助下於柏林成立，並指出由鮑斯成立、以英文及多種印度語每晚播放的自由印度臨時政府廣播電台，實為納粹向印度進行政治宣傳的電台。在作品中，藝術家將 2016 年新德里賈瓦哈拉爾尼赫魯大學（Jawaharlal Nehru University, New Delhi）學運期間，有關民族主義的演講片段與鮑斯的政宣廣播交錯，藉此提出在不同的時間脈絡下，關於歷史、意識形態、集體記憶的差異與質疑。

Rehearsing Azaad Hind Radio

Subhas Chandra BOSE (January 23, 1897–August 18, 1945) was an Indian nationalist who attempted to rid India of British rule with the help of Nazi Germany and Imperial Japan. He escaped India in 1943 by disguising himself as a "Mr. Ziauddin", and would later journey to Berlin via Moscow masked as a "Mr. Orlando Mazzotta", an Italian.

The lack of interest shown by Hitler towards the cause of Indian independence eventually caused Bose to become disillusioned. He left Nazi Germany in 1943 on a German submarine in the guise of "Mr. Matsuda", after which he journeyed on a Japanese submarine to Tokyo, where he eventually became Chandra Bose. When Bose left for Rangoon to lead the Azaad Hind Fauj (India National Army), he went into battle against the British as "Mr. T". It is alleged that Bose died in a plane crash in Taipei, Taiwan, on August 18, 1945, while on his way to the former Soviet Union via Tokyo.

Chaudhari's spatial installation features Berlin's Free India Centre, which was founded by Bose with funding from Germany in November 1941. The work exposes the fact that the Free India Radio—a station that broadcasted in English and various Indian languages every night—was in fact a tool of Nazi propaganda. In *Rehearsing Azaad Hind Radio*, the artist interweaves footages of a speech given during the 2016 student movement at the Jawaharlal Nehru University campus, with the content of Bose's propagandist radio station. The work questions and highlights the differences in histories, ideologies and collective memories from these two distinct contexts and times.

〈排演自由印度臨時政府廣播電台〉
2018，錄像、聲音、混合媒材，40 分 12 秒
藝術家提供
由柏林雙年展委託與共同製作，歌德學院支持

———

Rehearsing Azaad Hind Radio
2018, video, sound, mixed media. 40min12sec.
Courtesy of the artist
Commissioned and co-produced by *Berlin Biennale for Contemporary Art*, with the support of the Goethe-Institute

〈排演自由印度臨時政府廣播電台〉
2018，錄像、聲音、混合媒材，40 分 12 秒
藝術家提供
由柏林雙年展委託與共同製作，歌德學院支持

▬

Rehearsing Azaad Hind Radio
2018, video, sound, mixed media. 40min12sec.
Courtesy of the artist
Commissioned and co-produced by *Berlin Biennale for Contemporary Art*, with the support of the Goethe-Institute

導演｜德斯蒙德‧羅勃茲

聲音設計｜Ish S

服裝設計｜阿邁勒‧雅納拉

編輯｜伽內什‧普拉賽德

妝髮｜普拉地‧察哈

背景製作｜薩廷德爾‧辛格

文字｜廣播內容由蘇巴斯‧錢德拉‧鮑斯、賈瓦哈拉
爾‧尼赫魯大學民族主義課程，以及海納‧穆勒提供
〈哈姆雷特機器〉

Cinematographer | Desmond ROBERTS

Sound Designer | Ish S

Costume Designer | AMAL Allana

Editor | Ganesh PRASAD

Make-up | Pardeep CHAHAR

Backdrops painted by | Satinder SINGH

Texts | Radio broadcasts by Subhash Chandra BOSE,
JNU lectures on Nationalism and from Heiner Muller's
Hamletmachine.

1990 年生於新加坡，藝術家及作家，創作跨足當代藝術、電影、行為、理論等範疇，並以演講、論述、影片等多元形式，探討影像與權力的變動關係，聚焦於影像在全球主義和統治的語境下如何產生、傳播與消失。主要參展經歷包括光州雙年展（2018）、雅加達雙年展（2017）、第 13 屆沙迦雙年展（2017）、科欽－穆吉里斯雙年展（2014）、世界文化中心（柏林，2017）、瓦爾加斯博物館與菲律賓研究中心（馬尼拉，2017）、南洋理工大學當代藝術中心（新加坡，2017）、Para Site 藝術空間（香港，2015）、巴德學院赫塞爾美術館及策展研究中心展覽廳（安娜黛爾鎮，2015）等。2018 年獲選為德國學術交流總署的藝術家駐柏林創作計畫的駐村藝術家。現工作居住於新加坡及柏林。

Ho Rui An was born in 1990 in Singapore. He works in both Singapore and Berlin as a writer and artist at the intersections of contemporary art, cinema, performance and theory. Ho's body of work probes into the shifting relations between image and power, focusing on the ways by which images are produced, circulated and vanished, within the contexts of globalism and governance. His main mediums of work are the lecture, the essay and film.

He has presented projects at a number of exhibitions and venues, including the *Gwangju Biennale* (2018), *Jakarta Biennale* (2017), *Sharjah Biennial 13* (2017), *Kochi-Muziris Biennale* (2014), the Haus de Kulturen der Welt, Berlin (2017), the Jorge B. Vargas Museum and Filipiniana Research Centre, Manila (2017), the NTU Centre for Contemporary Art Singapore (2017), Para Site (Hong Kong, 2015) and the Hessel Museum of Art and CCS Bard Galleries (Annandale-on-Hudson, New York, USA, 2015). He is a recipient of the 2018 DAAD Berliner Künstlerprogramm.

SHINTARO: Today the modern era is in its terminal phase.

慎太郎：現代已經進入尾聲。

〈學子們〉
2019，高畫質有聲單頻錄像，26 分 30 秒

〈學子們〉

〈學子們〉是一件關於教育學的恐怖記事，透過學子這一意象，審視在東亞及東南亞地區的資本主義現代性和激進文化。作品以日本幕末時期首批到西方求學的薩摩藩和長州藩出身的學生作為開場，從集體和單數、隱喻和肉身的雙重角度，來思考學子的涵義，也用它來代表該地區世代更迭迄今歷經過種種發展「奇蹟」和興衰起伏的政治實體與國家。而這個被查默斯·詹森（Chalmers Johnson）稱為美國的「資本主義明星學生」的戰後日本，到了影片中段成了陳屍街頭的抗議學生——每一回的轉世，都將立基在階級、文化、民族國家的既定分析框架擊得粉碎。影片以未現身的「鬼魂」來敘述學子們隨時代演進所經歷過的可怕轉變，但只能靠字幕才能理解那些「鬼話」所言為何。

影片繼續爬梳做為肉體能指（carnal signifier）的學子的各種轉折，目的不在講述該地區的歷史，而是為了探討一種說教的／辯證的周期性變化——這種變化一步步讓學子既能成為孕育它的教育系統的具體化身，也同時體現此種系統的矛盾。

Student Bodies

Student Bodies is a work of pedagogical horror that approaches the fraught history of capitalist modernity and radical culture in East and Southeast Asia through the figure of the student body. The work begins with the students of Satsuma and Choshu, who were the first students from Japan to study in the West during the Bakumatsu era (between the 1850s and 1860s). The student body is considered both collective and singular—a metaphor and the flesh—while also standing in for the region's body politic as Japan underwent successive periods of "miraculous" development, crises and recoveries, through today.

Chalmers Johnson called post-war Japan the "star capitalist pupil" of the United States—a figure that would, in the next moment, transform into the dead body of a student protestor, lying in the streets. In Ho's film, the student body's monstrous transformations throughout history are given voice by unseen "ghosts", whose utterances are understandable only through the subtitles.

The film is less interested in narrating the region's history than it is in attending to the didactic and dialectic rhythms that naturally shape the figure of a student. By emphasising the carnality of the body, the film shows that the student embodies the pedagogical system that created him or her, while also contradicting it.

〈學子們〉

2019，高畫質有聲單頻錄像，26 分 30 秒

藝術家提供

聲音：蔡唐

you may sometimes look East and sometimes may travel East

〈學子們〉
2019，高畫質有聲單頻錄像，26 分 30 秒
藝術家提供
聲音：蔡唐

Student Bodies
2019, HD video, 26min30sec
Courtesy of the artist
Sound: Zai Tang

t, they are now exporting not just goods, but ideas.

朴贊景
PARK Chan-Kyong

身兼藝術家及導演身分的朴贊景出生於 1965 年，現居首爾，創作主題涵蓋冷戰、韓國傳統宗教文化等主題，代表影像作品包括〈場景〉（2000）、〈權力通道〉（2004）、〈飛行〉（2005）、〈新都案〉（2008）、〈光輝〉（2010）、〈轉世在安養〉（2011）、〈夜釣〉（2011，朴贊郁共同導演）、〈萬神〉（2013）、〈公民森林〉（2016）及〈京都學派〉（2017）等。

朴贊景的作品曾在許多國際機構播放展出，包括德國柏林世界文化之家、美國洛杉磯紅貓藝廊、倫敦國際視覺藝術機構、首爾國際藝廊等，曾獲獎項如愛馬仕韓國美術獎（2004）、柏林國際影展競賽短片金熊獎（2011）及全州國際電影節的最佳韓國影片（2011）等，他也是 2014 年首爾媒體城市雙年展「鬼魂、間諜與祖母」的藝術總監。

Park Chan-Kyong was born in 1965, and is an artist and a filmmaker based in Seoul. His subjects are have extended from the Cold War to traditional Korean religious culture. He has produced a number of media based works such as *Sets* (2000), *Power Passage* (2004), *Flying* (2005), *Sindoan* (2008), *Radiance* (2010), *Anyang Paradise City* (2011), *Night Fishing* (2011, co-directed with Park Chan-wook), *Manshin* (2013), *Citizen's Forest* (2016), *and Kyoto School* (2017)

His works have been exhibited in international venues, such as Haus der Kunst der Welt in Berlin; RedCat Gallery in Los Angeles; INIVA in London; Kukje Gallery in Seoul, and many others. He has won various prizes including Hermès Korea Misulsang (2004), the Golden Bear Prize for short films at the *Berlin International Film Festival* (2011) and Best Korean Film of the *Jeonju International Film Festival* (2011). He worked as an artistic director of *SeMA Biennale Mediacity Seoul 2014 Ghosts, Spies and Grandmothers*.

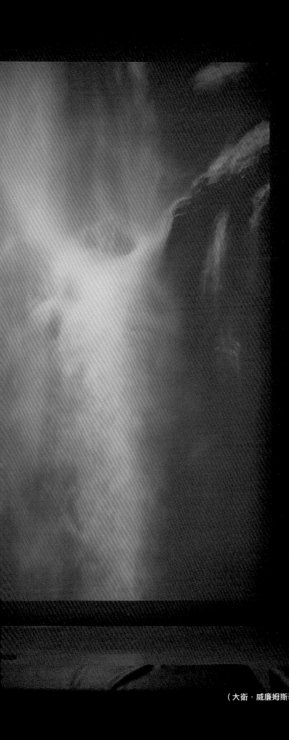

〈京都學派〉
2017，雙頻道圖像投影、書
（大衛・威廉姆斯著《日本戰時抵抗活動的哲學思想：閱讀與評論，京都學派「世界歷史觀點與日本」》），
尺寸依場地而異
藝術家提供

—

Kyoto School
2017, two-channel photography projection, and book
(*The Philosophy of Japanese Wartime Resistance: A Reading, with Commentary, of the Complete Texts of the Kyoto School Discussions*
of The Standpoint of World History and Japan by David Williams)
Dimensions variable
Courtesy of the artist

〈京都學派〉

這件雙頻道圖像投影，其中一個頻道重覆呈現日本華嚴瀑布的影像，同時引用來自日本進入二次大戰時，四個京都學派學者之間的圓桌討論《世界史的立場與日本》（1941）的內容。這個被廣泛認為是 20 世紀初期最重要的日本哲學流派，他們的理論嘗試以禪宗和佛教思想揉合西方哲學體系，「絕對無」（Zettai Mu）是其最著名的概念。另一個頻道，則呈現神風特攻隊預備飛行員的日記摘錄文字。從針對特定歷史事件的微妙反思開始，這件作品思考日本二戰期間國族主義與世界主義的問題，同時也形塑出一個用於思考哲學形象與絕望書寫的可能空間。

Kyoto School

This work is a two-channel projection of photographic stills. One channel is occupied by images of the famous Kegon waterfall in Japan, alongside quotations of text from *The Standpoint of World History and Japan* (1941), a roundtable discussion between four scholars of the Kyoto School on the cusp of Japan's entry into World War II. Widely regarded as the most important Japanese philosophical school of the early 20th century, their work attempted to synthesise Western philosophical systems with Zen and Buddhist ideas, most notably with the concept of "Zettai Mu", or "Absolute Nothingness". On the other channel, textual extracts from the diaries of student Kamikaze pilots are projected. Beginning as a subtle reflection on a specific historical event, this work meditates on questions of nationalism and cosmopolitanism in Japan during World War II, while also opening up a discursive space for thinking through the possibilities of a "philosophical image" and "desperate writing".

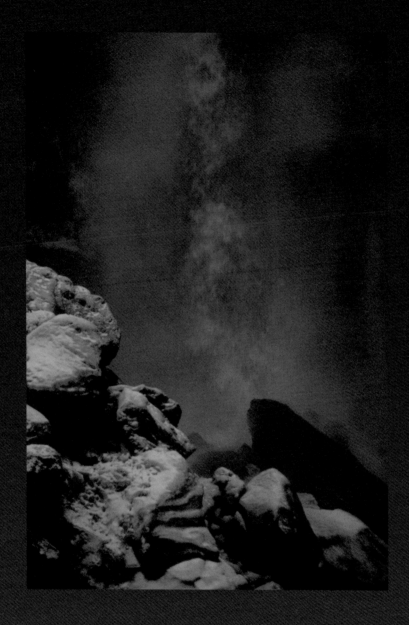

〈京都學派〉

2017，雙頻道圖像投影、書

（大衛・威廉姆斯著《日本戰時抵抗活動的哲學思想：閱讀與評論，京都學派「世界歷史觀點與日本」》），

尺寸依場地而異

藝術家提供

—

Kyoto School

2017, two-channel photography projection, and book

(*The Philosophy of Japanese Wartime Resistance: A Reading, with Commentary, of the Complete Texts of the Kyoto School Discussions*

of The Standpoint of World History and Japan by David Williams)

Dimensions variable

Courtesy of the artist

While reading Memoirs of Revolutionist (by Pyotr Alekseyvich Kropotkin), I was struck by the spiritual strength of the Russians, which was demonstrated by those women of pre-revolutionary Russia.

Hayashi Tadao, Jun 16, 1943

Nishitani :

This is what contemporary philosophers has to do. But I might add that I think that it is good thing that our own philosophers have a Kegon dimension, that is a Kegon water-fall dimension...

〈京都學派〉

2017，雙頻道圖像投影、書

（大衛・威廉姆斯著《日本戰時抵抗活動的哲學思想：閱讀與評論，京都學派「世界歷史觀點與日本」》），

尺寸依場地而異

藝術家提供

—

Kyoto School

2017, two-channel photography projection, and book

(*The Philosophy of Japanese Wartime Resistance: A Reading, with Commentary, of the Complete Texts of the Kyoto School Discussions of The Standpoint of World History and Japan* by David Williams)

Dimensions variable

Courtesy of the artist

〈天象列次分野之圖〉

今年是「非物質影像論文百科」（Intangible Video Essay-pedia，IVE）計畫的首年，此計畫支持短片影像論文的拍攝製作，旨在建構如非物質事物百科全書般的資料庫，包含從字母 A 到 Z 的豐富內容，希望未來非物質影像論文百科計畫可補滿所有與非物質事物相關的詞條項目，例如夜空中的北極星、奧菲修斯的笛聲、莎樂美之舞、水底龍王的怒吼、霧津之霧、蘇格蘭的海霧等。藝術家兼電影工作者朴贊景創作這件關於「星辰」的影像論文作品，做為這項計劃在 2015 年推出的第一件創作。（2015 國際非物質遺產電影節，韓國全州）

〈天象列次分野之圖〉是為 2015 年於韓國全州開幕之「國際非物質遺產電影節」（International Intangible Heritage Film Festival）的預告片所製作的作品，要將電影節的主題「星辰」給表現出來。藉此得以探索他所著迷的兩幅朝鮮王朝古代天文圖「天象列次分野之圖」和「渾天全圖」。因為它們融合儒家的宇宙觀和近代西歐的天文學知識，是個獨特的 18 世紀圖像，同時擁有了科學資訊及哲學特質（儘管現在兩者都被認為在科學上是不準確的）。對朴贊景來説，他們是一座橋樑，或是時光機的隱喻，將我們現在和古老過去連結在一起。

Chun-sang-yeol-cha-bun-ya-jido

The inaugural Intangible Video Essay-pedia (IVE) Project supports the production of short video essays with the concept of making an encyclopaedia-like archive of all things intangible, from A to Z. With future IVE projects, we hope to fill in all encyclopaedia entries related to the intangible, such as the North Star in the night sky, the sound of Orpheus' flute, Salome's dance, the roar of the Dragon King underwater, Mujin's fog, and Scotland's sea fog, Harr.

As IVE's first project in 2015, artist and cineaste Chan-kyong Park provided a video essay on "stars", which was presented at the *International Intangible Heritage Film Festival 2015* in Jeonju, Korea. *Chun-sang-yeol-cha-bun-ya-jido* was created as a promotional trailer for the *2015 International Intangible Heritage Film Festival* that took place in Jeonju, Korea. It was essential for the artist that the work conveyed the theme of the festival: "stars". This in turn became a way by which he could explore his fascination with two ancient astronomical drawings from the Joseon dynasty: *Chun-sang-yeol-cha-bun-ya-jido and Hon-cheon jeondo*. These two 18th century graphical representations amalgamate Confucian cosmology and Western European astronomical knowledge from the early modern period, and are unique in their simultaneous embodiment of scientific understanding and philosophical qualities (though both are now judged to be scientifically inaccurate). For Park, they function as a bridge or a metaphorical time machine which connects our present with the ancient past.

〈天象列次分野之圖〉
2015，高畫質影片，5 分 10 秒
國際非物質遺產電影節提供

Chun-sang-yeol-cha-bun-ya-jido
2015, HD film. 5min10sec
Courtesy of *International Intangible Heritage Film Festival*

丁昶文
TING Chaong-Wen

1979 年生於臺灣高雄，2006 年畢業於國立臺南藝術大學，目前居住和工作在臺南。其作品擅長處理影像及物件等混合媒材的空間裝置，這些作品深受個人經驗啟發，常以現成物置於特定展覽背景下，演變成為特定的歷史敘事。在令人驚訝的創新當中，他嘗試解構、闡釋和重新詮釋著我們共享的歷史，並審視物質文化、歷史衝突、集體記憶和跨境存在等現象及問題。他的作品曾在諸多美術館、雙年展展出，代表性展覽包含：「漲潮17：費利利曼圖雙年展」（費利利曼圖，2017）、「中之條雙年展」，舊廣盛酒造（日本群馬，2017）、「工藝援引」，金澤 21 世紀美術館（金澤，2017）、「當下檔案・未來系譜：雙年展新語台北雙年展」，臺北市立美術館（臺北，2016）、「Koganecho Bazaar 2016」，黃金町管理中心（橫濱，2016）、「城市・魅感」，高雄市立美術館（高雄，2015）、「投機性粉塵」，Corner Art Space（首爾，2015）、「影像／聲音：理念與立場」，104 藝術中心（巴黎，2014）、「無河不流 有河必流」，關渡美術館（臺北，2013）等。

Ting Chaong-Wen was born in Kaohsiung, Taiwan in 1979. He graduated from the Tainan National University of the Arts in 2006, and currently lives and works in Tainan. Ting specialises in mixed media installations that incorporate images and objects. Drawing inspiration from his personal experience, his works often reveal specific historical narratives created by embedding ready-mades into specific exhibition contexts. With surprising and innovative attempts, the artist unpacks, extends and re-interprets collective history through examinations of material culture, historic conflicts, collective memory, and transnational phenomena and problems.

His works have been extensively exhibited in numerous art museums and biennials, among which are *High Tide 17—Fremantle Biennale* at Artsource, Fremantle (2017); *Nakanojo Biennale 2017* at the Former Hirozakari Brewery, Gunma, Japan (2017); *Citation from Craft* at The 21st Century Museum of Contemporary Art, Kanazawa (2017); *Taipei Biennial 2016: Gestures and Archives of the Present, Genealogies of the Future* in Taipei Fine Arts Museum, Taipei (2016); *Koganecho Bazaar 2016* at Koganecho Area Management Centre, Yokohama (2016); *Urban Synaesthesia* at Kaohsiung Museum of Fine Arts, Kaohsiung (2015); *Speculative Dust* at Corner Art Space, Seoul (2015); *Image/Sound: Concept and Position* at Le Centquatre 104, Paris (2014); and *No One River Flows* at Kuandu Museum of Fine Arts, Taipei (2013).

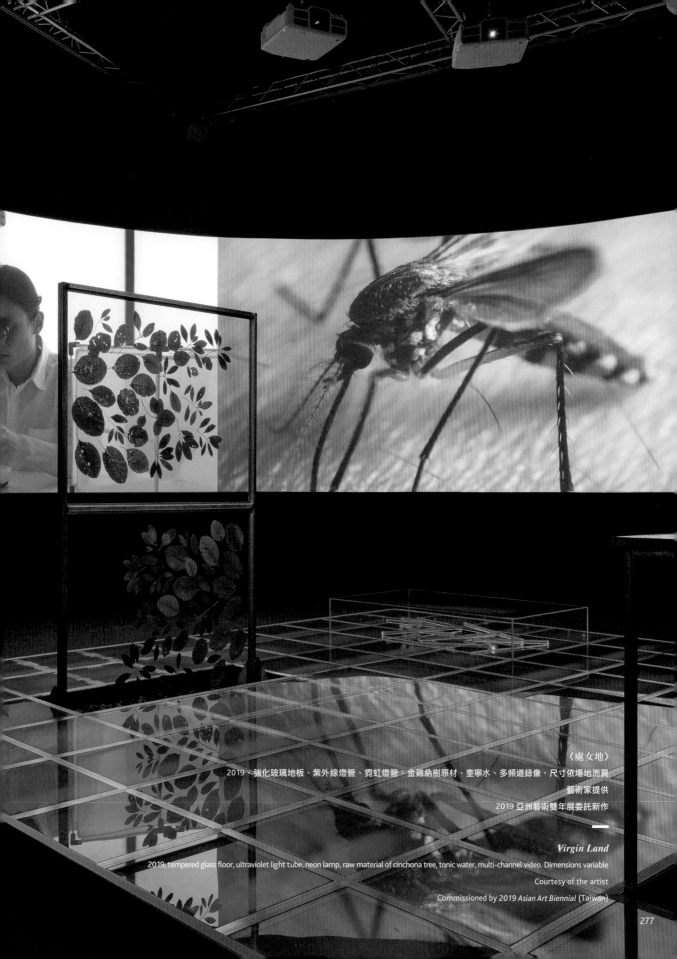

〈處女地〉
2019，強化玻璃地板、紫外線燈管、霓虹燈管、金雞納樹原材、奎寧水、多頻道錄像，尺寸依場地而異
藝術家提供
2019 亞洲藝術雙年展委託新作
—
Virgin Land

2019, tempered glass floor, ultraviolet light tube, neon lamp, raw material of cinchona tree, tonic water, multi-channel video. Dimensions variable
Courtesy of the artist
Commissioned by *2019 Asian Art Biennial* (Taiwan)

〈處女地〉

大正七年（1918）出版的科幻小説《三十年後》，描述一個沒有戰爭的未來日本，人們透過藥物得以延長壽命，小説作者星一是星製藥株式會社的社長，從 1920 年代初起，做為世界第二大奎寧製造商的日本星製藥，開始在臺灣的金雞納樹耕植事業，小説所預示的烏托邦想像，與現實中日本對帝國主義的追求，產生了戲劇性的強烈對比。

日治時期是臺灣史上最大規模的熱帶植物引進與試驗階段，臺灣由於地理位置、氣候、生態環境的因素，亦是瘧蚊的理想繁殖地，歐洲在過去的殖民過程，發現南美原住民以金雞納樹皮來治療瘧疾。於是金雞納樹提煉的奎寧成為人工疫苗發明前，防瘧的唯一解藥。奎寧的功效為殖民者提供了深入熱帶島嶼的新機會，昔日的瘴癘之島一躍成為製造藥品的寶庫，金雞納樹與植物學成為另類的帝國武器，讓殖民地成為有利可圖的新領土。〈處女地〉以一座臨時性的酒吧為舞台，地板上散落的玻璃管透著螢光，管內裝填琴酒與奎寧混合成的液體，奎寧作為「解藥」帶有多重含義，殖民性亦如同病毒，深入血液、骨髓，深藏在我們意識之中。

Virgin Land

The 1918 sci-fi novel *Thirty Years Later* depicts a future Japan without wars, where people are able to extend their lives with the help of medicine. The author, Hoshi HAJIMEI, was the president of Hoshi Pharmaceutical Co., Ltd., the second largest quinine producer in the world, which started a plantation of cinchona trees in Taiwan in the early 1920s. The novel conveys a utopian vision that is intensely contrasted with the reality of Japan's imperial dreams.

During its colonial period under Japanese rule, Taiwan witnessed the large—scale introduction and experimentation of tropical plants. Taiwan's geographic location, climate and ecological environment makes the island an ideal habitat for the Anopheles mosquitoes, which are known for spreading malaria. Over the course of their colonial conquest, European colonisers discovered that certain groups of indigenous South American people used cinchona tree barks to treat malaria. Before the emergence of technologies for producing artificial vaccines, quinine extracted from cinchona trees was the only form of treatment and preventive measure against malaria.

Quinine thus provided colonisers with the protection needed to venture further into new territories of primal forests and tropical islands. All of a sudden, islands that threatened humans with dangerous diseases became treasure vaults for the pharmaceutical industry, as cinchona trees and botany were turned into forms of "alternative imperial weaponry", through with which the process of colonisation could be extended and transformed more thoroughly into profit-making territories.

Virgin Land is conceived of as a stage in the form of a pop-up bar. Glass tubes filled with a gin and quinine concoction are scattered on the floor and emit fluorescent light. As a "cure", quinine has multivalent meaning. In a way, colonialism is like a virus sieving through our veins and bones, permeating through our consciousness.

〈處女地〉
2019，強化玻璃地板、紫外線燈管、霓虹燈管、金雞納樹原材、奎寧水、多頻道錄像，尺寸依場地而異
藝術家提供
2019 亞洲藝術雙年展委託新作

———

Virgin Land
2019, tempered glass floor, ultraviolet light tube, neon lamp, raw material of cinchona tree, tonic water, multi-channel video. Dimensions variable
Courtesy of the artist
Commissioned by *2019 Asian Art Biennial* (Taiwan)

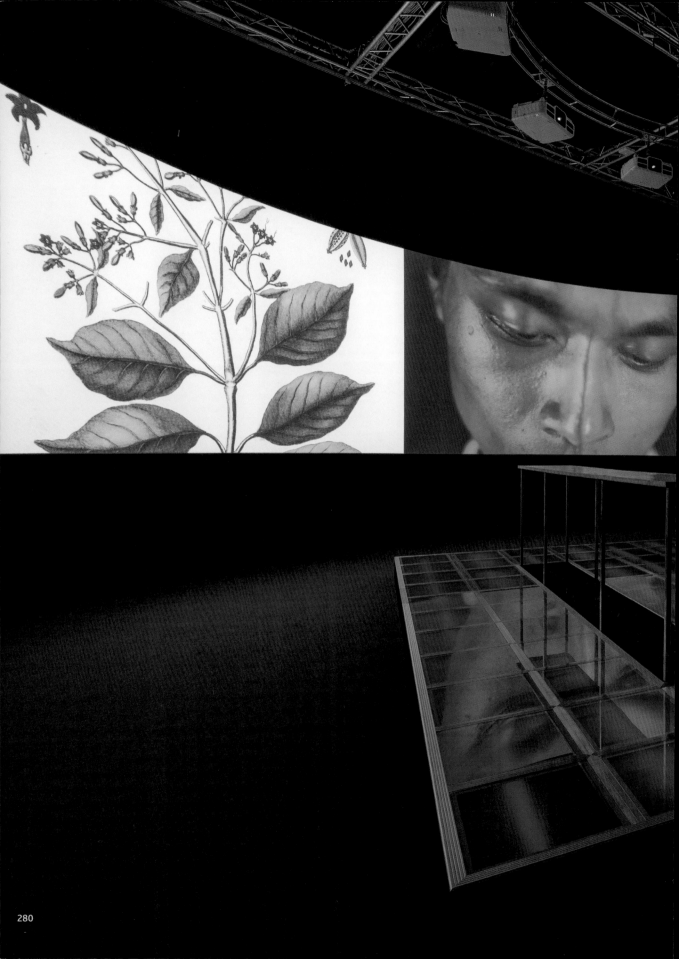

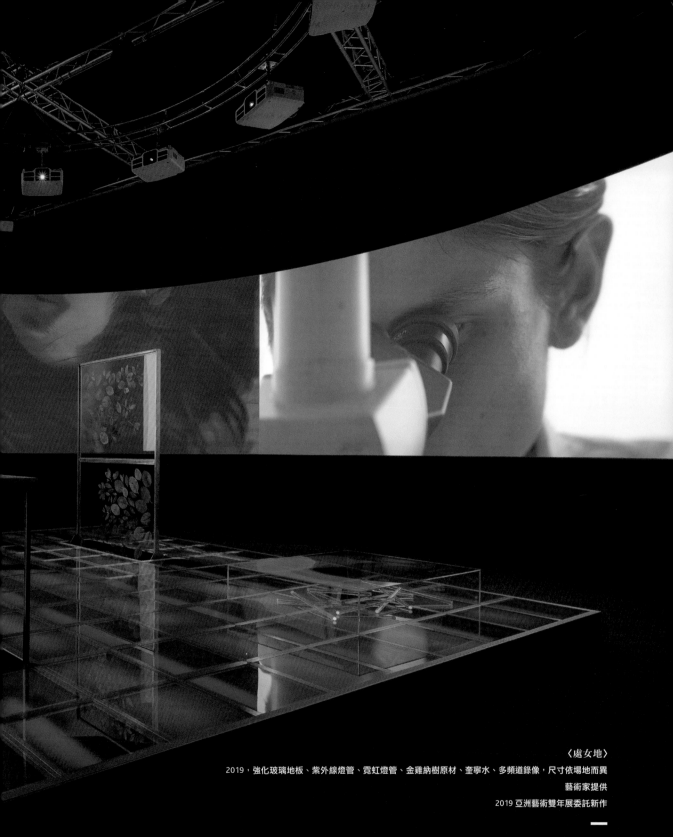

〈處女地〉
2019，強化玻璃地板、紫外線燈管、霓虹燈管、金雞納樹原材、奎寧水、多頻道錄像，尺寸依場地而異
藝術家提供
2019 亞洲藝術雙年展委託新作

———

Virgin Land
2019, tempered glass floor, ultraviolet light tube, neon lamp, raw material of cinchona tree, tonic water, multi-channel video. Dimensions variable
Courtesy of the artist
Commissioned by *2019 Asian Art Biennial* (Taiwan)

註腳 FOOTNOTES

第四展區 Zone 4

＃地震＃邊境＃叛徒＃神風特攻隊＃奎寧

＃ Earthquake ＃ Border ＃ Traitor ＃ Kamikaze ＃ Quinine

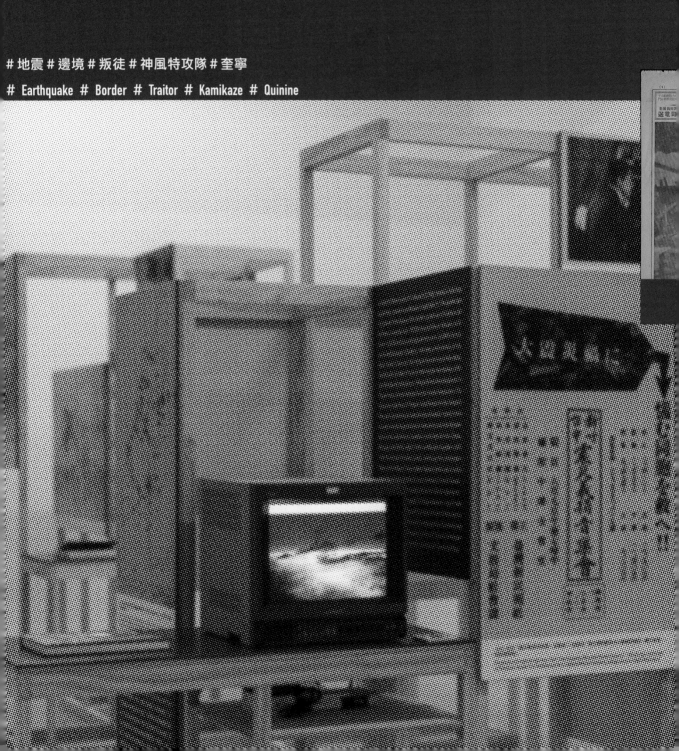

我們並不以為自然處於休憩狀態；任何微小的聲響—空氣中細微的顫動—都使我們正襟危坐。這是我們第一次不信任長久以來所踩踏的土地。

——亞歷山大・馮・洪堡，《Kosmos：宇宙物理現象概論》，第一卷，1845。

We are undeceived as to the repose of nature; every sound—the slightest rustle in the air—sets attention on the stretch; for the first time we mistrust the ground, which we have put our feet on for so long.

—— Alexander von Humboldt, *Kosmos: A General Survey of Physical Phenomena of the Universe*, Volume 1, 1845.

「環太平洋火山地震帶」（Pacific Volcanic Seismic Zone）涵蓋太平洋週邊，包括南美洲的智利、秘魯，北美洲的瓜地馬拉、墨西哥、美國等國家的西海岸，阿留申群島、千島群島、日本、琉球群島、臺灣以及菲律賓、印度尼西亞和紐西蘭等國家和地區。因地殼板塊移動碰撞，為全球地震活動最強烈與頻繁的地帶，全球約有 80% 的淺層地震、90% 的中層地震和幾乎全部的深層地震都發生在這個地震帶上，也因全球 75% 火山分佈其上，所以也有太平洋火環（Pacific Ring of Fire）之稱。1923 年日本關東地震（芮氏規模 8.1 級）、1960 年的智利瓦爾迪維亞地震（9.6 級）、1964 年阿拉斯加地震（9.2 級）、2004 年蘇門答臘安達曼地震（9.1 級）、2010 年智利 Maule 地震（8.8 級）、2011 年日本東北地震（9.0 級）、2019 年智利秘魯地震（8.0 級）。

▲ 1935 年 4 月 24 日臺中 – 新竹地震《東京日日新聞》號外。（圖片來源：維基共享資源媒體庫）
A special edition of The *Tokyo Nichi Nichi Shimbun (Tokyo Daily News)* reporting the Taichung-Hsinchu Earthquake on April 24th, 1935. (Image source: Wikimedia Commons, the free media repository)

The "Pacific Volcanic Seismic Zone" covers the surrounding areas of the Pacific Ocean, including the west coast of Chile and Peru in South America, North American countries including Guatemala, Mexico, and the United States, as well as countries and areas such as the Aleutian Islands, Thousand Islands, Japan, Ryukyu Islands, Taiwan and the Philippines, Indonesia, and New Zealand. Due to plate movements and collisions, the Pacific Volcanic Seismic Zone is the area with the most intense and frequent earthquakes in the world. 80% of shallow earthquakes, 90% of intermediate earthquakes, and almost all deep earthquakes in the world occur within this area. Since 75% of the world's volcanoes are located within the zone, the "Pacific Volcanic Seismic Zone" is also known as the "Pacific Ring of Fire". The Japan Tokyo-Yokohama Earthquake of 1923 (magnitude 8.1), Chile Valdivia Earthquake of 1960 (magnitude 9.6), the Alaskan Earthquake of 1964 (magnitude 9.2), Sumatra Earthquake of 2004 (magnitude 9.1), the Chilean (Maule) Earthquake of 2010 (magnitude 8.8), the Japan Tokohu Earthquake of 2011 (magnitude 9.0), and the Chile Peru Earthquake of 2019 (magnitude 8.0).

▲ 環太平洋火山地震帶。（圖片來源：維基共享資源媒體庫）
Pacific Volcanic Seismic Zone.
(Image source: Wikimedia Commons, the free media repository)

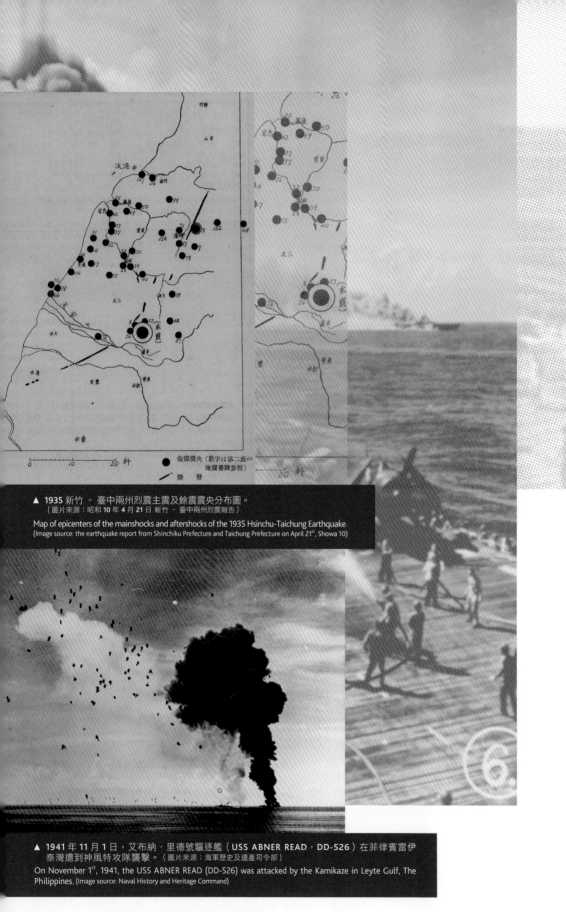

▲ **1935 新竹 - 臺中兩州烈震主震及餘震震央分布圖。**
（圖片來源：昭和 10 年 4 月 21 日 新竹 - 臺中兩州烈震報告）

Map of epicenters of the mainshocks and aftershocks of the 1935 Hsinchu-Taichung Earthquake.
(Image source: the earthquake report from Shinchiku Prefecture and Taichung Prefecture on April 21st, Showa 10)

▲ **1941 年 11 月 1 日，艾布納 · 里德號驅逐艦（USS ABNER READ，DD-526）在菲律賓雷伊**
泰灣遭到神風特攻隊襲擊。（圖片來源：海軍歷史及遺產司令部）

On November 1st, 1941, the USS ABNER READ (DD-526) was attacked by the Kamikaze in Leyte Gulf, The
Philippines. (Image source: Naval History and Heritage Command)

▲ 1944 年 10 月 30 日，富蘭克林號航空母艦（**CV-13**）遭神風特攻隊襲擊。（圖片來源：海軍歷史及遺產司令部）
October 30th, 1944, aircraft carrier USS Franklin (CV-13) was attacked by the Kamikaze. (Image source: Naval History and Heritage Command)

當你消除所有關於生與死的想法時，你將完全忽略你的塵世生活。這也將使你能夠集中精力以堅定不移的決心消滅敵人，同時加強你在飛行技能方面的卓越表現。

When you eliminate all thoughts about life and death, you will be able to totally disregard your earthly life. This will also enable you to concentrate your attention on eradicating the enemy with unwavering determination, meanwhile reinforcing your excellence in flight skills.

——摘自《神風飛行員手冊》

—— Excerpt from *kamikaze pilots' manual*

感謝誌

我們對於下列個人、參展藝術家以及機構團體表達誠摯的謝意，因為他們的慷慨支持及合作促使本展得以圓滿且順利的完成。

借展單位

BANGKOK CITYCITY GALLERY｜泰國
長征空間｜中國
SCAI THE BATHHOUSE Inc.｜日本
臺灣白石畫廊股份有限公司｜臺灣
Yuka Tsuruno Gallery｜日本

Galleria Continua｜義大利
Project Space · Pha Tad Ke｜寮國
Silverlens 畫廊｜菲律賓
魔金石空間｜中國
Pieree Lorinet｜新加坡

特別感謝

新加坡雙年展｜財團法人文化臺灣基金會
臺中市政府文化局｜臺中國家歌劇院｜陳維德
馬克斯 – 菲利普 · 阿申布倫納｜弗里 · 萊森
亞洲藝術文獻庫｜林立騏｜陳璽安｜楊北辰
任傑｜李燕｜木彭措｜德卓｜寧琤｜翁笑雨
魏穎｜半路咖啡｜南方時驗室｜謝詩平｜聶克
張進富｜黃西准｜高郁宜｜鄭宏正｜陳妍蓁
徐建宇｜陳沛妤｜花崎草｜曹淳｜楊清仁
蔡惠羽｜林燕｜劉紹揚｜陳冰綾｜莫登峰
吳浩宇｜賴聲寬｜森純平｜木村繪理子｜TKG+
荷蘭皇家視覺藝術學院｜黛安娜 · 坎貝爾 · 貝坦柯特
桑塔尼藝術基金會｜達卡藝術峰會
柔依 · 柏特｜埃德溫娜 · 布倫南
花蓮縣臺灣豐田玉協會｜凱瑟琳 · 迪吉格

伊謝的家人（羅斯拉瓦蒂 · 伊斯梅爾、羅斯蘭 · 伊斯梅爾、羅斯尼 · 伊斯梅爾、魯斯納 · 伊斯梅爾、穆尼拉 · 伊斯梅爾、努魯 · 瓦希達 · 尼克哈斯布拉、努爾 · 阿里亞 · 塞西達 · 尼克哈斯布拉、艾哈邁德 · 哈齊克 · 穆罕默德）｜阿德里亞娜 · 布利達魯
Société（柏林）｜歐亞藝術網絡組織
《數位荒原》駐站暨群島資料庫計畫｜洞穴
藝術家甘朝陽（甘丹）｜台元紡織股份有限公司
財團法人石材暨資源產業研究發展中心
騰發企業有限公司｜服裝設計師陳怡年團隊

Acknowledgements

We would like to thank the following individuals, participating artists and institutions for their generous assistance to the realization of this exhibition.

Lenders to the Exhibition

BANGKOK CITYCITY GALLERY | Thailand
Long March Space | China
SCAI THE BATHHOUSE Inc. | Japan
Whitestone Gallery Taipei | Taiwan
Yuka Tsuruno Gallery | Japan

Galleria Continua | Italy
Project Space · Pha Tad Ke | Laos
Silverlens Galleries | Philippines
Magician Space | China
Pieree Lorinet | Singapore

Special Thanks

Singapore Biennale | The Cultural Taiwan
Foundation | Cultural Affairs Bureau
Taichung City Government
National Taichung Theater | Eugene Tan
Max-Philip Aschenbrenner | Frie Leysen
Asia Art Archive | Tatsuki Hayashi | Zian Chen
Yang Beichen | Ren Jie | Li Yan | Mu Pengcuo
De Zhuo Kathryn Weir | Laura Ning
Weng Xiaoyu | Jo Wei | Halfway Café | SEAT
Pia Hsieh | Nicholas Coulson | Zhang Jin Fu
Calaw Piyo | Kao Yu I | Jeng Hong Zheng
Tia Chen | Xu Jian Yu | Doris Chen Pei Yu
Kaya Hanasaki | Tsao Chun | CJ Yang | Ida Tsai
MELISA MUSTIKA | Liu Shao Yang | Chen Ping Lin
Mo Deng Fong | Wu Hao Yu | Kevin Lai
Junpei Mori | Eriko Kimura | TKG+

Rijksakademie van beeldende Kunsten
Diana Campbell Betancourt
Samdani Art Foundation | Dhaka Art Summit
Zoe Butt | Edwina Brennan
Taiwan Fengtian Jade Association in Hualine
Kathleen Ditzig | Ise's family (Roslawati Ismail,
Roslan Ismail, Rosni Ismail, Rusnah Ismail, Munira
Ismail, Nurul Wahidah Nik Hasbullah, Nur Alia
Syahida Nik Hasbullah, Ahmad Haziq Mohamad)
Adriana Blidaru | Société (Berlin) | Idolon studio
NML Residency & Nusantara Archive Project
The Cave | Kan Tan (Kan Chao-Yang)
Tai Yuen Textile Co.,Ltd.
Stone & Resource Industries R&D Center
Tengfa Enterprise Co.,Ltd. | CHEN Yi-Nien Studio

來自
山與海的異人
The Strangers from
beyond the Mountain and the Sea
二〇一九亞洲藝術雙年展　　2019 Asian Art Biennial

國家圖書館出版品預行編目 (CIP) 資料

來自山與海的異人：亞洲藝術雙年展 . 2019 / 黃舒屏主編 . -- 臺中市：臺灣美術館，
2019.12　288 面；25.4×19.2 公分
ISBN 978-986-5437-60-2 (精裝)

1. 現代藝術　2. 作品集　3. 亞洲

902.3　　　　　　　　　　　　　　　　　　　　　108019187

展覽

指導單位	文化部
主辦單位	國立臺灣美術館
總 策 劃	林志明
副總策劃	梁晉誌
展覽總監	黃舒屏
策 展 人	許家維、何子彥
協同研究	林怡秀
展覽執行	范馨予、修天容、杜依玲、賴信宇、陳力榆、張慧玲、林學敏、陳奕翔、莊雅雯、黃昭文、曲秀娥
視覺設計	理式意象設計有限公司
空間設計	宜東文化創意有限公司
影音技術及展場燈光	歷險創意事業有限公司、奇享科技有限公司
展場攝影	黃嘉達
展覽紀錄片	泰墨創藝影像有限公司
網站設計	張博智、璞藝資訊股份有限公司
秘書室	劉木鎮
主計室	周益宏

雙年展網站	www.asianartbiennial.org
展覽日期	2019 年 10 月 05 日至 2020 年 02 月 09 日
展覽地點	國立臺灣美術館 大廳、美術街、102-108 展覽室、202-205 展覽室

專輯

指導單位	文化部
主辦單位	國立臺灣美術館
發 行 人	林志明
編輯委員	梁晉誌、汪佳政、蔡昭儀、黃舒屏、蔡雅純、薛燕玲、林晉仲、周益宏、張智傑、楊媚姿、劉木鎮
總 編 輯	梁晉誌
主編	黃舒屏
責任編輯	林怡秀
執行編輯	范馨予、修天容、杜依玲
撰稿	許家維、何子彥、林怡秀
校對	范馨予、修天容、杜依玲、林學敏、陳力榆、張慧玲、陳奕翔、莊雅雯、林郁馨
平面設計	理式意象設計有限公司
編排設計	李孟杰、何真
翻譯	韓伯龍、沈怡寧、黃亮融、韞藝術工作室、楊爾寧、羅雪柔

出版單位	國立臺灣美術館	製版印刷	弘運彩色印刷製版有限公司
40359 臺中市五權西路一段二號		出版日期	2019 年 12 月
電話	04-2372-3552	GPN	1010802042
傳真	04-2372-1195	ISBN	978-986-5437-60-2
www.ntmofa.gov.tw		定 價	新臺幣 1,000 元

EXHIBITION

Supervisor	Ministry of Culture
Organizer	National Taiwan Museum of Fine Arts
Commissioner	LIN Chi-Ming
Vice Commissioner	LIANG Chin-Chih
Artistic Director	Iris HUANG Shu-Ping
Curators	HSU Chia-Wei, HO Tzu-Nyen
Research Collaborator	LIN Yi-Hsiu
Exhibition Coordination	FAN Hsing-Yu, Daisy SHIOU, Ileana TU, LAI Shin-Yu, CHEN Li-Yu, CHANG Hui-Ling, LIN Hsieh-Min, CHEN Yi-Hsiang, CHUANG Ya-Wen, HUANG Chao-Wen, CHE Hsiu-E
Graphic Design	Idealform Co.
Exhibition Design	Art Happening Ltd.
Technical Executive & Lighting Design	Future Pass Creative Inc., JI XIANG Technology
Photographer	JD Huang
Documentary Video	TimeMotion Visual Design Co., Ltd.
Website Design	Poki CHANG, Pro2e Information Corp
General Affairs	LIU Mu-Chun
Accountant	CHOW I-Houng

The Official Website of Biennial | www.asianartbiennial.org
Exhibition Dates | 2019.10.05-2020.02.09
Venue | Lobby, Street Gallery 102-108, Gallery 202-205, National Taiwan Museum of Fine Art.

CATALOGUE

Supervisor	Ministry of Culture
Organizer	National Taiwan Museum of Fine Arts
Director	LIN Chi-Ming
Editorial Committee	LIANG Chin-Chih, WANG Chia-Cheng, TSAI Chao-Yi, Iris HUANG Shu-Ping, TSAI Ya-Chuen, HSUEH Yen-Ling, LIN Chin-Chung, CHOW I-Houng, CHANG Chih-Chieh, YANG Mei-Tzu, LIU Mu-Chun
Chief Editor	LIANG Chin-Chih
Editor	Iris HUANG Shu-Ping
Responsible Editor	LIN Yi-Hsiu
Executive Editors	FAN Hsing-Yu, Daisy SHIOU, Ileana TU
Writers	HSU Chia-Wei, HO Tzu-Nyen, LIN Yi-Hsiu
Proof Readers	FAN Hsing-Yu, Daisy SHIOU, Ileana TU, LIN Hsieh-Min, CHEN Li-Yu, CHANG Hui-Ling, CHEN Yi-Hsiang, CHUANG Ya-Wen, LIN Yu-Hsin
Graphic Design	Idealform Co.
Layout Design	LI Meng-Chieh, HO Chen
Translators	Brent Heinrich, SHEN Yi-Ning, HUANG Liang-Jung, Yun Art Studio, Ernie YANG, Cheryl Robbins

Publisher	National Taiwan Museum of Fine Arts	Printer	Hung Yun Color Printing Co., Ltd.
		Publishing Date	December, 2019
2, Sec. 1, Wu-Chuan W. Road,		GPN	1010802042
40359, Taichung, Taiwan		ISBN	978-986-5437-60-2
TEL	+886-4-2372-3552	Price	NTD 1,000
FAX	+886-4-2372-1195	www.ntmofa.gov.tw	